WOMEN'S VOICES

IN

HEALTH PROMOTION

edited by
**Margaret Denton, Maroussia Hajdukowski-Ahmed,
Mary O'Connor, and Isik Urla Zeytinoglu**

Canadian Scholars' Press Toronto 1999

Women's Voices in Health Promotion

Edited by Margaret Denton, Maroussia Hajdukowski-Ahmed, Mary O'Connor, and Isik Urla Zeytinoglu

First published in 1999 by
Canadian Scholars' Press Inc.
180 Bloor Street West, Ste. 1202
Toronto, Ontario
M5S 2V6

We acknowledge the financial support of the Government of Canada through the Book Publishing Industry Development Programme for our publishing activities.

Canadian Cataloguing in Publication Data

Main entry under title:
Women's voices in health promotion

Text in English; abstracts in French.
Includes bibliographical references and index.
ISBN 1-55130-152-0

1. Women—Health and hygiene. 2. Health promotion. I. Denton, Margaret A. (Margaret Anne), date.

RA564.85.W665 1999 613'.0424 C99-931793-8

Page layout and cover design by Brad Horning

We acknowledge with gratitude the assistance of the Social Sciences and Humanities Research Council of Canada and Health Canada. This book would not be possible without the many authors who have contributed and whose research and writing we believe in. For technical support we thank Ann Greene, Sandra Costa and Sharon Webb. We would like to thank Brad Lambertus, of Canadian Scholars' Press, for his support of this project. We are grateful for the contributions of our affiliates, our research assistants, our deans, the Arts Research Board and the Women's Studies Program at McMaster University, and of our managing editor, Lori Chambers. And, perhaps most of all, we thank the women of this community who participated in the many projects which went into the making of this book.

Co-Editors

Denton, Margaret (PhD) is an Associate Professor at McMaster University. She holds a joint appointment in Gerontological Studies and the Department of Sociology. She is a Principal Investigator at the McMaster Research Centre for the Promotion of Women's Health. Her research interests include women's health, income inequality in later life and issues in the delivery of health-care services.

Hajdukowski-Ahmed, Maroussia (PhD) is an Associate Professor of French and Women's Studies at McMaster University. She is a Principal Investigator at the McMaster Research Centre for the Promotion of Women's Health and has undertaken several health promotion projects with immigrant women. Her research interests and publications include feminist theories, participatory action research, immigrant women and health, cultural studies, women writers of Quebec, the philosophy of Mikhail Bakhtin and interdisciplinary research.

O'Connor, Mary (PhD) is an Associate Professor in the Department of English and Women's Studies and Principal Investigator at the McMaster Research Centre for the Promotion of Women's Health. She has published on cultural and feminist theory, on women with disabilities, on health promotion, and on the determinants of health. She has been a member of the Health Canada Round Table on Population Health and Health Promotion (1996) and the Social Sciences and Humanities Research Council of Canada Health Theme Advisory Committee (1998).

Zeytinoglu, Isik Urla (PhD) is a Professor of Industrial Relations in the MGD School of Business and Principal Investigator at the McMaster Research Centre for the Promotion of Women's Health. Her PhD and MA are from the Wharton Business School, University of Pennsylvania, USA, and her MBA and BA are from Bogazici University, Turkey. She conducts research on non-standard work and flexible employment issues, women and paid/unpaid work, women's occupational health and comparative industrial relations/ global human resource management.

Contributors

Barber, Karen (MA) is a doctoral candidate in the Department of Sociology at McMaster University. She held a graduate research assistantship with the McMaster Research Centre for the Promotion of Women's Health in 1995-1996. Her doctoral thesis looks at the impact of health-care restructuring on the receipt of homemaking services.

Bayne, Ronald MD, FRCPC, FACP is Emeritus Professor of Medicine, McMaster University. He is a past president of the Canadian Association on Gerontology/association canadienne de gerontologi, past president of the Gerontology Research Council of Ontario, a charter member of the Ontario Gerontology Association, one of the founders of the McMaster Office of Gerontological Studies and a life member of the Ontario Medical Association. His research publications are in the area of gerontology and health services evaluation.

Bridgman-Acker, Karen is a social worker and educator who has a personal and professional passion and interest in women's issues, particularly in relation to how the family law system impacts on the lives of women and children.

Chambers, Lori (PhD) teaches at McMaster University in history and women's studies and was managing editor for *Women's Voices in Health Promotion*. Her research interests include married women and family property law, unmarried motherhood and women's health.

Chouinard, Vera (PhD) Professor of Geography at McMaster University. Her PhD is from McMaster. Her research interests include the political economy of urban and regional change, feminist geography, state regulation of community-based housing and services, disabled women's struggles.

Cummings, Allison is a research assistant at Baycrest Hospital. She has an honours BA in gerontology and sociology from McMaster. Her honours thesis contributed to the evaluation of the Intergenerational Volunteer Program in elementary schools.

Dolina, Lili is a public health nurse with the Hamilton-Wentworth Regional Public Health Department. She coordinates the Intergenerational Volunteer Program in elementary schools and the advisory group of seniors.

Dye, Penny is currently employed as a staff nurse at Cape Fear Valley Medical Centre, Fayetteville, North Carolina. She has published work relating to the use of problem-

based learning in a multiprofessional curriculum and was a contributor to a handbook of resources for health-care professionals counselling abused women.

Ellis, Sarah graduated from McMaster University School of Nursing. Her interests include women's issues, community health and nursing research. She is currently employed as a public health nurse in Owen Sound, Ontario, focussing on child health.

Garvin, Theresa (PhD) is an Assistant Professor in the Department of Earth and Atmospheric Sciences at the University of Alberta in Edmonton. Her doctoral research examined the transformation of international evidence and knowledge regarding ozone depletion and skin cancer. Her current research interests include policy, women's health and the social role of science in environmental and health issues.

Gold, Nora (PhD) is an Associate Professor in the School of Social Work, McMaster University. Her research interests include antisemitism and sexism as experienced by Jewish women and the intersections between these two forms of oppression, the impact on the family of long-term disability or illness and the social construction of disability in the media.

Hopwood, Catherine (MA) is a senior doctoral candidate in sociology at McMaster University. She teaches sociology and women's health and conducts research on television talk shows.

Hoyle, Jennifer (MA) increasing social awareness around the importance of honouring bodily differences has been the focus of her paid and unpaid work. Her master's thesis explored the leisure experiences of women with disabilities. She is presently employed in a community resource/crisis centre and teaches part time in the continuing education department at the local community college.

Khanlou, Nazilla is a PhD candidate in the clinical health sciences (nursing) at McMaster University. Her clinical background is in psychiatric nursing. Her research interests include the impact of migration on mental health, the development of cultural identity amongst adolescents living within a multicultural context and its association with other indicators of mental health such as self-esteem.

Lian, Jason (PhD) worked as a research assistant for the McMaster Research Centre for the Promotion of Women's Health. His research interests include ethnic inequality in terms of income and occupational status.

Low, Jacqueline (MA) is a senior doctoral candidate in sociology at McMaster University. She teaches sociology and health and conducts research on the use of alternate health therapies. She has published on disability, hardiness, and caregiving.

Majumdar, Basanti (PhD) is an Associate Professor at McMaster University. Instrumental in bridging universities with ethnocultural communities, Basanti published the first Canadian manual on culture sensitive training for health/social care providers. Her research contributions include transcultural communication and health behaviour. She has done presentations and publications at the national and international levels.

McKinnon, Allison L. (PhD) is Executive Director of the Population Research Laboratory, Department of Sociology, University of Alberta. Her research interests include survey research, health services research and program evaluation.

McMullan, Colin (MA) is a doctoral candidate in the School of Geography and Geology at McMaster University. His doctoral research centres on the evaluation of healthy and

sustainable community initiatives. Other areas of interest include the development and use of indicators of urban sustainability and the social construction and framing of environmental health problems in policy disputes.

Pond, Myrna (B.N.Sc; R.N.; MA) has taught in the McMaster School of Nursing. Her MA thesis is entitled "The perceptions and experiences of newcomers to Canada in English as a Second Language." She has worked as a research assistant and community researcher for the McMaster Research Centre for the Promotion of Women's Health with immigrants and refugee women. She is presently involved in community development in Hamilton.

Pringle, Pam (MBA) is lecturer of human resources and labour relations at McMaster University, MGD School of Business. Her MBA is from McMaster. Her research interests are employment issues, organizational behaviour issues, creative problem solving facilitation and employment and health issues.

Romaine, Janet (MBA) is a doctoral candidate in the Human Resources and Management Program at McMaster University. Her main research interests include organizational culture, gender in organizations, participative management and organizational learning.

Shelley, Julia (MA) is employed with the Ontario Ministry of Community and Social Services. She has interests in cross-disciplinary and gender studies and has worked as a teaching and research assistant at McMaster University.

Sinding, Chris is active in women's health issues locally and provincially and is currently engaged in PhD studies in community health at the University of Toronto.

Walsh, Christine is a member of the Canadian Centre for Studies of Children at Risk, McMaster University and a doctoral candidate in the Faculty of Social Work, University of Toronto. Ms Walsh has been involved in research for more than ten years, primarily managing large-scale community surveys. Currently she is a co-principal investigator in a particpatory action research project with First Nations' youth residing on reserves in Ontario. Her research interests include child maltreatment, First Nations' health and young mothers.

Webb, Sharon is a graduate student in the Department of Sociology at McMaster University. She works as a research assistant for the McMaster Research Centre for the Promotion of Women's Health. Her MA thesis focuses on the impact of divorce on the financial security of women in later life. Other research interests include home care, aging and women and work.

Westmorland, Muriel (MHSc) is an Associate Professor and Associate Dean of Health Sciences and Director of the School of Rehabilitation Science at McMaster University. She is an occupational therapist with over 30 years of clinical and academic experience in the disability and work field. She has been a workplace consultant to many industrial companies, including Procter and Gamble.

Williams, Karen (MA) was a Community Research Co-ordinator, McMaster Research Centre for the Promotion of Women's Health, 1993-1994. She has published on woman abuse and elderly women, lesbian parenting and gender bias in medical research.

Wilson, Kathleen (MA) is a doctoral candidate in geography at Queen's University. Her doctoral research focuses on the role of the land in First Nations' health and healing. Her research interests also include the restructuring of health-care services in Canada, Aboriginal health and women's health issues.

PREFACE

In 1993 six health promotion research centres were established in Canada, funded for five years as a joint initiative of Health Canada and the Social Sciences and Humanities Research Council of Canada. The McMaster Research Centre for the Promotion of Women's Health (MRCPOWH) was the only one of these to focus on women's health. It is a noteworthy venture for a number of reasons. As a balance to the very strong biomedical emphasis that has characterized so much research on women's health, MRCPOWH chose to focus on the social correlates of health and illness among women. This is important, for it helps to complement biomedical research as well as bring gender to the forefront in debates concerning the social bases of health. Even though a population health model has been embraced in recent years, leading to a greater recognition of the social determinants of health, little attention has been devoted to gender, and so the work of the centre has been particularly important.

In focussing on the social aspects of women's health and illness MRCPOWH chose to concentrate on women's paid and unpaid work, thereby helping to correct the undue emphasis in the past on women's reproductive health. At the same time this focus has allowed the researchers to explore these two key spheres of women's lives, looking at women's caring roles within the home as well as their roles in the paid labour force. The research presented here includes a variety of work settings and shows how changes in these have implications for women's health. This sense of variety is crucial to the work of the centre, for in addition to showing what women share, the participants in this venture have also sought to focus on diversity among women. Represented in these pages are the concerns of immigrant women, lesbians, older and younger women, professional women, homemakers and others whose distinctive experiences are often ignored.

Too often, research and writing on health has focussed on either individual action (as in many health promotion activities that have stressed lifestyle changes) or else the need for structural change to address the roots of women's health problems. Of course both are important, and so the chapters here recognize individual and collective actions as well as the steps that might be taken to achieve more enduring cultural and structural changes. The breadth of the task the researchers set for themselves is further illustrated by their concern with both understanding the social bases of health and illness and developing strategies to help women cope with and change the situations that threaten their health.

But perhaps the most important feature of this collective effort is that it gives voice to the concerns of women themselves. In recognizing the professional dominance that has so often silenced women's voices, MRCPOWH has chosen to provide a vehicle for the articulation of women's concerns. It has focussed on 'ordinary' women and the health issues that influence their lives. This volume captures the wide range of work achieved by those involved with the centre and it is especially important because it includes and also steps beyond the realm of academe. It seeks to explore the social bases of health problems at the same time as it also considers individual and collective strategies to cope and to achieve change.

Early in its life the centre chose to fund community-based projects which emphasized participatory research. Some projects cannot be conveyed in a book such as this—the plays and events that are not so readily captured in this form. Yet in this volume we see a diverse collection of work which is testimony to the success of this venture and the commitment of all those involved in it.

<div style="text-align: right">

Vivienne Walters, PhD
Professor of Sociology
January 1999

</div>

Contents

**Margaret Denton, Maroussia Hajdukowski-Ahmed,
Mary O'Connor, Isik Urla Zeytinoglu**

Women's health promotion has been the subject of considerable inquiry in the last decade by researchers. As yet, however, work on women's health promotion has not been integrated into a single, accessible volume. Our aim has been to fill this void with studies that highlight women's voices. This book contributes to feminist health promotion by setting out a theoretical basis for women's health promotion; by applying a feminist participatory action research framework to health promotion research; by describing the current state of the discipline; by providing a forum for the dissemination of recent research; by encouraging readers to expand upon this research; and by articulating new questions and goals for the promotion of women's health.

Women experience distinctive health problems, yet there is limited medical research and even less in the social sciences and humanities with respect to women's health, particularly their own perspectives and priorities (Walters, 1991). Women are the main health-care providers. They comprise the majority of workers in the health-care system and are almost wholly responsible for care within the family and community. They make the greatest use of health services. Thus the need for women's health promotion.

ESTABLISHING THE MCMASTER RESEARCH CENTRE FOR THE PROMOTION OF WOMEN'S HEALTH

The McMaster Research Centre for the Promotion of Women's Health (MRCPOWH) is one of six centres that were set up in 1993 across Canada, part of a five-year national program funded by Health Canada and the Social Sciences and Humanities Research Council of Canada to develop research on health promotion. Our centre was the only one to focus specifically on women's health. For the first five years of the centre, our main goal was to give emphasis to research on work, paid and unpaid, and health.

Two recent shifts in the area of health provided impetus to the development of our research program. First there was a movement away from a biomedical model of health to a focus on the determinants of health. These were expanded from lifestyle, environment and

human biology approaches (Lalonde, 1974) to include a much broader range of social determinants, including social structures such as work or family life as well as social relations, including gender, social supports and culture.

Second, there was a shift in focus occurring in the health promotion field. The Ottawa Charter (World Health Organization, 1994) and, in Canada, Epp's *Achieving Health for All* (1986), emphasized the broader determinants of health and enabled people to increase control over their health. They outlined strategies for improving health by building healthy public policy, creating supportive environments, strengthening community action, developing personal skills and reorienting health services. This shifted the focus of health promotion from a concentration on lifestyle or behavioural change to promote healthy living to a consideration of structural change, community development and empowerment.

Our research program attempted to integrate these separate but complementary fields in health promotion research. We chose to focus the scope of the centre's research activities around a specific social determinant of health: the impact of work, paid and unpaid, on women's health. We defined work very broadly to include both work outside and inside the home, including caregiving and self-care. We explored the consequences of work for women's physical and mental health and well-being. In principle, we were interested in women's views of their own health needs, and the research was guided by women's articulation of those needs. The choice of projects was guided by an awareness of the diversity of the community in terms of race, income level, culture, language, sexual orientation, age, union/non-unionized workers, religion, and disability as well as other factors of difference. We thus recognized the diversity of women's participation in the workforce, paid or unpaid, and broke the dichotomy between private and public spheres.

At the same time, we were interested in doing community-based health promotion research. We wished to effect structural change through policy-making, community development and empowerment of the women themselves to promote health. We understood community to include: women's groups, associations, support groups, committees, consumer groups, labour unions, organizations, and employers or employer organizations as long as these groups were investigating their own health needs.

Research fell within three main areas: the impact of work, paid and unpaid, inside the home and outside the home, on women's health; work/health in specific populations of women, e.g., women with disabilities, immigrant women, seniors; and the effectiveness of individual coping strategies and collective social change in promoting women's health. We made an effort to work with individuals and groups not usually involved in research, such as immigrant women, while protecting their anonymity and confidentiality.

In order to fulfil our research mandate, we developed a set of research guidelines including criteria for selecting research sites and research methods. We chose three criteria that would influence our choice of research sites: type of work; high-risk segment of the population; and specific health problem. We developed several women's health promotion research projects in each of these three sites. For example, several projects studied different working environments such as factory work and community-based health and social service agencies. Other research sites were constituted by a particular population segment, for example, lower-income women, the elderly, refugees, lesbians, young women and persons with disabilities. Other research sites would focus on specific health problems, for example, women who have

identified stress and tiredness as health problems, women with multiple sclerosis or women with physical and mental disabilities.

To facilitate this research, we developed a research grants program to fund participatory action research projects on women and health promotion. Faculty and graduate students were encouraged to apply for funding on behalf of a community group interested in conducting a participatory action research project. In all we funded 28 projects; priority was given to projects which used a participatory action framework, although we did support a few excellent projects on women's health promotion which did not use this approach. Projects were presented in report form and discussed in our workshop series, newsletters and at conferences.

In terms of research methods, the projects worked within a feminist participatory action research (PAR) framework which we outline in more detail in Chapter 1. Briefly, its four principles are: the research problem is defined by those people who share the problem, rather than by the academic researcher; the people who define the problem participate in the research process from beginning to end to ensure they are creating their own research products; the goal of the research is the transformation of oppressive social structures for the improvement of their daily lives; and the academic researchers who were involved because they had access to institutional funding as well as their training in research skills had to be willing to relinquish a good deal of their usual academic role in order to encourage the transfer of knowledge-making from the academy to the people in their local communities (Hall, 1981). Furthermore, MRCPOWH was committed to ensuring that the community groups which helped create research knowledge would also have the opportunity to determine how their contribution was to be recognized and to what other uses their knowledge could be put beyond the academic knowledge dissemination forums of books, journal articles and conference presentations. Several community groups took up this challenge. For example, one group wrote and performed a play for their community, a second put on a 'Share and Tell' event, others published results of their projects in newsletters, presented their findings at the MRCPOWH workshop series and at several conferences (i.e., the Summer Institute on Women's Health Promotion and at the National Health Promotion Research Conference).

Research within the groups generally progressed in two stages. The first entailed work with focus groups or with feedback from the larger constituencies, if they existed, to establish the main concerns about their health. What are the major problems and issues? Are there any identifiable health concerns in the workplace? Do they have any specific causes? How do women cope with the problem? Do they see changes that can be made? The second stage had to do with implementing changes to promote health and documenting the success of those changes. Some groups spent most of their time on the first, while others quickly moved on to the second.

As academics, our main involvement in the process was as researchers documenting the process and the results. We helped collect data and tell the women's stories of health problems and health promotion activities. It was their own and the group's activities and consensus that motivated those involved; nevertheless, within the participatory research model, we were also involved in facilitating their action for change.

The research projects have used a range of definitions of PAR in their health promotion research. On one side of the spectrum, they relied on the academic researchers to design the methodology, collect the data, control the budget and analyse the data with community

participants deciding on issues to be examined and action to be taken. On the other side of the spectrum, community participants chose the methodology, collected the data, conducted the action and controlled the budget assigned to them. Some projects stopped at the level of recommendations, others facilitated the implementation of action and in others still, the action was embedded in the project.

As noted, a fundamental principle of PAR is the transformation of social structures for the improvement of daily lives. In the health promotion research projects presented here, this was accomplished in different ways. Some of these can be easily measured, others cannot. In many, action was embedded as part of the process. In the projects presented, we can identify eight different ways in which health promotion occurred. They were:

1) Empowerment of participants: the process of PAR is itself empowering, as according to its own definition the process is also a product. Women who participated in projects in focus groups, discussion groups and workshops reported empowerment verbalized as enhanced self-concept and self-esteem.

2) Development of leadership skills: during the course of projects, several women took a leadership role organizing health promoting events, such as a South Asian student organized a cultural event; several Latin American women organized health promotion workshops, a health promotion play and the first International Women's Day for Latin American Women in Hamilton.

3) Development of critical thinking skills: through group discussions, women developed critical thinking skills and questioned inequities, discrimination and silencing procedures. For example, women in the Women's Worksite Action Group noticed that there was a frequent shifting in their assigned tasks and linked this practice with a possible prevention of collective action on the part of the plant management. In another example, women and men with disabilities together identified factors which contribute to healthier work environments for persons with disabilities.

4) Transfer of knowledge and skills: women shared their knowledge, coping strategies and recommendations for change. Community participants learned about conducting research from the academic participants, and academic participants learned about the health concerns and health promoting activities from the community participants. Knowledge was transferred beyond the group as well. For example, young mothers receiving social support spoke to health-care providers about their experiences and concerns. Academic participants were invited by a medical school to discuss how to be gender and culture sensitive practitioners.

5) Action for change: research participants used research to find a resolution to an identified problem. For example, a group of women with multiple sclerosis used the results of their study to lobby for change in transportation for people with disabilities. Another group of women researched information about health and safety in the workplace and produced a brochure for their fellow employees. And, based on findings from focus groups and a questionnaire, changes were made at several home-care agencies to create healthier working environments for their employees.

6) Mutual aid and support groups: many of the PAR groups met over 6 to 24 months on a regular basis and constituted themselves as support groups by sharing experiences and information. For example, Latin American women, women with

MS, young mothers on social support all continued meeting even after the specific projects were over. Many made lasting friendships thereby decreasing their loneliness and isolation.

7) Knowledge development and dissemination: knowledge was disseminated through reports, presentations at workshops and conferences, working papers, journal articles and through the publication of this book.

8) Policy-making: academic participants were sought by health promoting agencies, policy-making agencies and community health centres to participate in policy-making at local, regional, national and international levels.

We believe that there will be long-term effects of these PAR projects and the knowledge that has been created. Community participants are continuing the work, becoming leaders, policy-makers and teachers in the area of health promotion. Academic participants will start new research and action as a result of this research. As the basis of this next stage of research and to fill a void in health promotion research, we compiled this edited work, *Women's Voices in Health Promotion*.

WHAT IS THE BOOK ABOUT?

The introductory chapters of the book offer the reader a feminist theoretical framework for research on women and health promotion. In "A Theoretical Framework for Research on Women's Health Promotion," contributions to feminist health promotion theory are reviewed and a theoretical basis for women's health promotion research is outlined. This framework is explicitly feminist and participatory and, as such, both challenges and supplements the medical model of health promotion; it is preventative, enabling and it accounts for diversity. We assert that research must address the determinants of health identified by population health studies and apply the Ottawa Charter strategies in implementing community solutions to problems. This approach is described also in the N. Hamilton and T. Bhatti model of *Population Health Promotion* (1996) which integrated the findings and objectives of the Ottawa Charter with strategies for population health. Participatory action research facilitates this approach. It is argued in this chapter that by encouraging women to be involved in the centre of official knowledge-making about their own lives, the research process itself will improve women's health because women together, talking about their lives, can challenge the gaps and misrepresentations in existing research. In "Women's Work, Women's Voices: From Invisibility to Visibility," the authors review existing literature with regard to the relationship between womens work, paid and unpaid, and women's health. Justice and equity at work and in the home, the authors assert, are central to the successful promotion of women's health. "Women's Voices in Health Promotion: Theoretical and Methodological Implications" analyses the epistemological importance and signification of women's voices in feminist scholarship and the methodological implications of knowledge/action based on women's voices in participatory action research in the field of health promotion.

The remainder of the text presents the MRCPOWH research in women's health promotion. Using the participatory action model and philosophy, a diverse research community explored issues related to women and health promotion. These projects address

varied determinants of health and use the Ottawa Charter strategies as a starting point for community-based action to improve women's health. What these projects all share in common is a determination to bring together the voices of varied communities of women and men to determine and implement the solutions to their own health concerns. The findings of these research projects have important implications for health and social policy. Also, the projects themselves provide examples of participatory action research in the health promotion field upon which others can build. These projects are presented thematically: women workers in health and social service agencies; women with disabilities and health promotion; cultural and racial diversity and the promotion of women's health; the health needs of women across the life span and of lesbian women.

In "Healthy Work Environments in Home-care Agencies" the health and work life of home-care workers in three non-profit community-based health and social service agencies in Hamilton are examined. This project suggests that health services should be reoriented to address the health concerns of workers who provide health-care services. In the following chapter women working in child welfare agencies are also shown to be at risk of poor health; women in focus groups report chronic exhaustion, as well as other stress related problems, as work related. It is argued in "Promoting the Physical and Mental Health of Female Social Workers Working in Child Welfare" that the working conditions of such work must change. In "Work and Health Issues Among Public Sector Employees" it is argued that chronic debilitating stress and chronic fatigue are the two most common health issues faced by public employees who asserted that integrating their paid work and family responsibilities was difficult. The women called for fundamental changes in the work environment to make this integration more manageable.

"Promoting Health with Women with Multiple Sclerosis" asserts that a fundamental difficulty in living with a chronic or progressive condition like MS is coping with loneliness and isolation. This chapter addresses social support networks, health services and coping skills as determinants of health. Focus groups in this study served a dual purpose as a research methodology and a health promotion activity for women with MS. It was the purpose of "Positive Work Environments for Women and Men with Disabilities" to listen to the voices of men and women with disabilities as they shared their insights about factors that contribute to creating positive work environments for them. Overall, the central theme of the participants was that they wanted dignity in the workplace and to be treated with respect; a key recommendation was the provision of education on disabilities for employers and co-workers, in addition to the physical improvement of the work environments. Despite the potential physical, social and emotional benefits of leisure for persons with disabilities, it is often overlooked as an important aspect of their health and well-being. The women asserted that their leisure options were limited by their dependence on care-givers, by government incomes, by the cost of equipment and by transportation problems. In "Health, Leisure and Women with Mobility Disabilities," the voices of women with mobility impairments are heard.

In "We Are Making A Difference," a project initiated by a small group of immigrant women in a food processing plant is described. The women identified for themselves the aspects of their work that were unhealthy and devised the strategy to be employed in combatting these problems. The participants developed knowledge and skills transferable to

other projects and were empowered by their participation in the project. "Adolescent Self-Concept and Mental Health Promotion in a Cross-Cultural Context" examines the mental health concerns of young South Asian women. While the young women consistently reported their concern with maintaining traditions and customs, they felt stress resulting from gendered expectations and interactions with the dominant culture. In "Stress Indicators and Management for Immigrant, Refugee and Minority Women," the authors examined how familial and workplace supports, or the lack thereof, impact upon the ability of immigrant women to manage daily life and stress. In focus groups, the women shared self-help techniques and it would appear that they began looking inward for their own strength, which was congruent with workshop objectives.

In "Young Mothers: A Poverty of Support," the experience of young motherhood is illustrated from qualitative and quantitative perspectives. The paper analyses the social supports available to high-risk mothers from the insider perspective and makes recommendations for improvements in such programs. "Promoting Health Through Intergenerational Volunteering" examines an intergenerational volunteer program in elementary schools. Results indicated that seniors felt that volunteering had positively affected their mental health; the program also had positive results for the children involved. "Counting on Desire: Supporting a Lesbian with Breast Cancer" describes an informal care network amongst some lesbians in Hamilton. The ways in which these women resisted some of the more coercive and uncomfortable aspects of informal caring are documented. In "The Bronzed Aesthetic," the social context of tanning is examined. This study used informant interviews to explore the degree to which young women considered tanned skin healthy and appealing in themselves and other women. Findings from this project support the growing literature from Australia showing that sun exposure behaviours are most effectively changed by reconstructing the social milieu that equates tanned skin with beauty.

Negotiating child custody, support and access in an institutional system that is often unsupportive of women and children can have long-term negative implications for their physical, emotional and financial well-being. "Outsiders Within: Women's Experiences in the Family Law System" reports, from an insider perspective, on women's needs and concerns with regard to the family law system. The women asserted that the first step in improving this system would be to include women who had been through it at all levels of planning, development and delivery of any service or program. In "Stop the Violence: A Community-Based Violence Prevention Project," a community effort to reduce violence is described. A coalition was formed in Hamilton amongst a wide variety of citizens and service providers concerned with violence. "Promoting Women's Health Through Volunteering" examines the health and volunteer life of those who volunteer in community-based health and social service agencies. Although the volunteers reported feeling empowered by their work, they also provided recommendations of ways in which the safety and well-being of volunteers could be improved. Finally, "Work Related Health Issues for Managerial Women and Men: The Case of Chartered Accountants" examines the physical and emotional consequence of the pressures and demands on chartered accountants. These findings substantiated the higher pressures of the work-family balancing act on mothers with young children. The article concludes that the crucial advantage to employers in trying to make the workplace more

friendly to the needs of families is the value of trained employees to the firm; because of a shortage of trained accountants, organizational change is occurring although it is contested and incomplete.

CONCLUSIONS

By providing a forum for the articulation of women's experiences by women themselves, this book contributes to a growing feminist scholarship about women's particular health concerns, issues that have previously been silenced or overlooked. The feminist participatory model exemplified in this book more accurately accounts for the diversity of women and their health needs. It serves as a validation of community-based health promotion, particularly for women and disenfranchised and isolated groups during hard economic or harsh political times.

Where do we go from here? Women's health promotion research is a growing field. We encourage readers to expand upon this research. To gain both legitimacy and validity, research which uses feminist theory, women's voices and a participatory action research approach needs to be implemented at other sites. Knowledge needs to be furthered in order to build healthy public policy with regard to women's paid and unpaid work, to create supportive environments in which women's work is valued, to strengthen community action by and for women, to develop personal skills and reorient health services to provide healthier work environments. Finally, we hope that this contribution to the relationship between women's labour and their health will give a new perspective on women's lives and serve to make women's invisible lives more visible.

A THEORETICAL FRAMEWORK FOR RESEARCH ON WOMEN'S HEALTH PROMOTION[1]

Margaret Denton, Maroussia Hajdukowski-Ahmed, Mary O'Connor, Isik Urla Zeytinoglu

Ce chapitre passe en revue les contributions apportées à la théorie de la promotion de la santé féministe et développe une base théorique de recherches sur la promotion de la santé des femmes. Partant des principes de la théorie féministe, de la théorie de la promotion de la santé et d'un modèle intégré de promotion de la santé, ce chapitre présente des principes de pratiques. Le terme féministe employé dans ce chapitre se réfère à une prise de position critique qui vérifie l'impact que des théories, des politiques et des pratiques spécifiques ont sur les femmes. Cette prise de position critique les normes qui ignorent la portée des différences importantes qui existent entre les hommes et les femmes. Féministes et autres ont critiqué les modèles de promotion de la santé pour leur manque d'attention au genre et à la perte des détails contextuels de vécus différents. La méthodologie féministe préconisée dans ce chapitre inclut les femmes dans la production du savoir. Cette méthodologie permettrait de créer un savoir et des théories qui présentent la femme comme un être concret, historiquement et socialement situé dans les discours et les structures sociales. Elle viserait aussi à éliminer les discours et les structures sociales oppressives afin d'améliorer la vie quotidienne des femmes, celle de leurs familles, et de créer un mieux-être dans les communautés et les quartiers.

ଔ ଔ ଔ ଔ ଔ

"Given the different varieties of health promotion and of feminism, there can be no simple, universal feminist critique of health promotion" (Daykin and Naidoo, 1995, 59). Nevertheless, it is possible to map out a variety of approaches to what might be called a feminist health promotion practice. One can begin with an argument for the specific need for women's health promotion and, based on numerous feminist critiques of health promotion, posit a model for an appropriate approach to promoting women's health. This chapter reviews

[1] This paper is a revised version of O'Connor, M., Denton, M., Hajdukowski, Ahmed, M., Williams, K. and Zeytinoglu, I.U. (1998). Women and health promotion: A feminist participatory model. In Thurston et al. (1998), 60-83.

contributions to feminist health promotion theory and sets out a theoretical basis for women's health promotion research.

Why women's health promotion? Although women live longer than men in Canada, they experience more illnesses and spend a larger proportion of their lives in poor health. Women are also greater consumers of health-care services than are men. There are diseases specific to women (e.g., pelvic inflammatory disease, gynaecological tumours) and there are diseases and chronic health problems that are more prevalent in women than in men (arthritis/ rheumatism, breast cancer, eating disorders, lupus, multiple sclerosis) (Verbrugge, 1989; Wilkins and Park, 1996). Women also report more stress and mental health problems than men. They are the main health-care providers. They comprise the majority of workers in the health-care system and they are usually responsible for care within the family and community.

The term feminist in this chapter refers to a critical standpoint that monitors the impact on women of specific theories, policies and practices. This standpoint critiques norms which ignore significant differences between men and women. Inequities and disadvantages that women experience are identified and acted upon. The structures of labour and social relationships in women's everyday lives, and their understandings of the barriers to good physical and emotional health, are often lost in the gaps of traditional research or silenced by institutional policy because researchers have failed to listen to women's point of view.

The term health promotion, like all practical terms, has a history. Many approaches to health promotion are practised and the term is contested (Labonte, 1995; Naidoo and Wills, 1994; Raeburn and Rootman, 1998; Robertson and Minkler, 1994; Thurston, Sieppert and Wiebe, 1998). We can point to its early use in 1974 in the Lalonde Report (Lalonde, 1974) with its focus on lifestyle or behavioural change, and to a later focus on structural change, community development and empowerment. The Ottawa Charter (World Health Organization, 1986) and, in Canada, Epp's *Achieving Health for All* (Epp, 1986) emphasized the broader determinants of health and the objective of empowering or enabling populations to take control of their health. They broadened the field of health promotion from one that focussed on lifestyle changes and individual prevention to one that promised to redress inequities within the health and social system. In theory, they moved toward social reform and action, addressing the issue of healthy environments and questions of power and control (World Health Organization, 1986; Vertinsky, 1992). Population health refers to an epidemiological field attending to the varied determinants of health. We include it in our discussion of health promotion because of its emphasis on the determinants of health and because of its current prominence in Canadian health policy.

FEMINIST CRITIQUES OF HEALTH PROMOTION

As models of health promotion have developed, feminists have found it necessary to articulate related gender issues that have been forgotten or disregarded. Gender may not have been incorporated into the model at all or the differences in women's social, economic and political (let alone physiological) conditions have not been taken into account. What follows is a review of feminist comments on five major approaches to health promotion: medical, lifestyle, social determinants of health, population health and empowerment.

Medical Approach

The medical approach is exemplified in immunization and screening programs which focus on the prevention of specific diseases and public health initiatives on healthy environments such as clean water. On the one hand critics have pointed out that a good deal of health promotion has been based on male-centred epidemiology (leaving women out of the picture), and on the other hand that women's health problems are often medicalized, bringing women into the wrong model for intervention (Clarke, 1992; Daykin and Naidoo, 1995). A medical model of health promotion has focused on premature mortality as the key area for intervention, when women's excess morbidity, with its problems with arthritis, osteoporosis and other chronic problems, needs attention (Miles, 1991; Roberts, 1990). Furthermore, the causes of women's mortality also need more research. The major causes of women's death are: cancer, ischemic heart disease and stroke (Stein, 1997), with a sharp rise in women's death rate from lung cancer, now the leading cause of deaths (Nault, 1997; National Cancer Institute of Canada, 1997). Between 1979 and 1995 the life expectancy of men has increased at a greater rate than that of women (Nault, 1997).

Health promotion has focussed less on mental health than physical diseases. Women are more likely than men to suffer from symptoms of stress, anxiety and depression. In a Canadian study of women's perceptions and priorities of their health, stress and other mental health problems were persistent themes in interviews with women (Walters, 1992b). Stress was identified as the most frequently mentioned health problem followed by anxiety and depression. Blaxter (1990) demonstrated the importance to women of good mental health. She reported that for women of all ages, the main index of their own state of health was being psychologically fit. Women saw stress and psychological factors as being the most important sources of ill health for society as a whole as well as for themselves. Furthermore, poor women seeking help for mental health concerns are more likely to receive intrusive physical treatments (Canadian Mental Health Association, 1989). Recent immigrants to Canada with diverse ethno-cultural backgrounds experience mental health problems that have been overlooked in health promotion (Canadian Task Force on Mental Health Issues, 1988).

Violence has a major impact on health in our society, and women are the primary victims of violence in the home, yet a medical health promotion approach can miss this determinant to women's health. A recent report by the federal Department of the Secretary of State indicates that one million Canadian women are abused by their husbands or live-in partners annually. As well, one in four Canadian women can expect to be sexually assaulted at some time in their lives. Assault has been estimated to be the cause of trauma injuries in 6% of women who visit emergency rooms. In addition to the physical injuries caused by violence against women, women often suffer psychological complications (Canadian Panel on Violence Against Women, 1993).

Lifestyle and Behaviour Change Approach

The lifestyle approach to health promotion aims to reduce individuals' risk behaviour. If smoking, drinking and driving, or not exercising increase the chances of becoming ill and dying, then health promotion tries to change those behaviours. Trends in risk factors for some leading causes of death, particularly smoking and being overweight, have narrowed the

gap in Canadian male and female life expectancy. The sex difference in smoking rates for 1978 to 1995 shrank from 11 to 4 percent. The number of women age 20 to 64 who were overweight increased at a rate of 4% more than that of men (Nault, 1997). These gender differences in risk factors related to death suggest that new health promotion techniques need to be developed with gender in mind.

The advance made to health promotion by the lifestyle approach was that it recognized influences other than health care on the health of populations (e.g., diet, exercise, etc.); its weakness was that it did not recognize the larger structural determinants of those lifestyle behaviours (Walters, Lenton and McKeary, 1995). Feminists and other critics are now pointing out that behaviours themselves are determined by larger structural forces. Another criticism of lifestyle interventions that target individual behaviour is that they may be most effective with those who need the interventions least: middle- and upper-class people who have money, time and motivation to exercise or buy healthy food (Barsky, 1988; Labonte, 1989). Health promotion activity that focuses on diet, smoking cessation and exercise without addressing broader determinants such as poverty, occupational hazards, racism, socio-economic inequalities and environmental pollution are not in women's best interests (Green, 1994; Labonte and Penfold, 1981; McDaniel, 1987; Navarro, 1986).

There are significant dangers for women responding to certain lifestyle health promotion strategies. Women have been the victims of various lifestyle advertising promotions resulting in significant physical and mental ill health, with a prime example of young girls and women responding to dieting advertisements (Bordo, 1988, 1993). Women also are easily subject to victim-blaming and guilt; most health promotion campaigns target women as keepers of the family health, often while their own needs are neglected. Self-care promotion is targeted at those who have power over their lives, and many women do not. It is a case of demanding responsibility without offering power (Clarke, 1992; Nettleton, 1996). The result is increased anxiety and stress (Daykin and Naidoo, 1995; Doyal, 1995). The health promotion practice of targeting certain women as 'at risk' also can produce negative consequences: raising anxiety, lowering quality of life, changing self-esteem and identity (Davison, Macintyre and Davey Smith, 1994; Daykin and Naidoo, 1995; Nettleton, 1996; Oakley, 1992).

Research which has focused for instance on the dangers of smoking has often not made inquiries into the motives of women who smoke. There are notable exceptions (Colin et al, 1992; Graham, 1990; Greaves, 1993; Oakely, 1989; Walsh, Sorenson and Leonard, 1995). Women who smoke are often materially disadvantaged, have stress and lack social support (Oakely, 1989; Greaves, 1993). They often turn to smoking as an alternative to other tension-release mechanisms such as alcohol or drugs or hitting their children. Smoking ironically is resorted to for health promoting reasons: to alleviate tension, to build self-esteem, to prevent violence (Colin et al, 1992; Graham, 1990). Smoking can also be linked to other gendered practices such as controlling weight (Greaves, 1993).

Social and Structural Change

Building on the principles accepted at the 1977 World Health Assembly at Alma Ata, the World Health Organization committed itself to action on the determinants of health. Certain fundamental conditions are prerequisites for health: peace and freedom from the fear of war, equal opportunity for all and social justice, satisfaction of basic needs, political

commitment and public support (World Health Organization, 1988). Health promotion that addresses the causes or determinants of health will be engaged in structural and social change.

The evidence of structural sources of ill health is mounting. Poverty, women's labour, violence, lack of social support and medical intervention have been cited as the causes of women's ill health (Doyal, 1995), yet health promotion policies have focused on smoking, eating, drinking, exercise, etc. (Daykin and Naidoo, 1995; Nettleton, 1996). This discrepancy points to the bias that has gone into the conceptualizing of health promotion for women. Denton and Walters (1997) in their analysis of the 1994 Canadian National Population Health Survey found that: "the structures of social inequality are the most important determinants of health acting both independently and through their influence on the behavioural determinants of health" (p. iv).

People with lower incomes experience worse health and die sooner than those with higher incomes (Ontario Premier's Council on Health Strategy, 1991) and women face a much higher risk of living in poverty than men—20% of Canadian women; 15% of Canadian men (Canadian National Council of Welfare, 1990; Statistics Canada, 1995c). Income level has a direct impact on the health of women: on nutrition, prevention and treatment of illness, risk behaviours, stress and mental health (Canadian Public Health Association, 1997). Societal context shapes our definition of health and illness, the way we try to maintain health and how we deal with illness (Walters et al., 1995a). Women's income levels are directly linked to preventive cancer screening measures (breast examination, pap smears, mammograms (Canadian Public Health Association, 1997). Walters et al. (1995a), in their gender analysis of the health promotion survey data, find there is a consistent association for women between social class and health.

In as much as poverty is a high-risk factor to poor health, health promotion for women must occur by raising the economic position of women in society. The real roots of women's poverty lie in their position within the socio-economic structures of society and in their gendered roles as care-givers to children and other dependents. Feminist health promotion will address these structural constraints to women's health.

Population Health

A broad definition of population health is "an approach that addresses the entire range of factors that determine health and, by so doing, affects the health of the entire population" (Hayes and Dunn, 1998). As such, this approach attends to what we have been calling the determinants of health. In Canada, under the leadership of the Canadian Institute for Advanced Research (CIAR), the term "population health" has gained dominance. The field is based on epidemiological studies which point to factors other than health care that determine the health of large aggregates of people. Researchers have been developing models of the determinants of health which include social, physical and genetic environments as well as health care. A notable example is the "Feedback loop for human well-being and economic costs" in Evans et al. (1994, 83). Building on a key finding of the Black Report in England (Townsend, Davidson and Whitehead, 1992) as well as Wilkinson's work (1996) that the gradient in health status between social groups is consistently linked to income and social status, the proponents of population health have recommended a transfer of investment from the health-care sector to the increase in the prosperity of the nation.

Critiques of population health have come from various perspectives, not just from feminists. The study of the social determinants of health fits with health promotion and feminist work on the structural context of health. However, the CIAR and its population health project, particularly with its emphasis on national economic growth and prosperity as a solution to health inequities, has been criticized for fitting too easily into a neo-conservative fiscal agenda of cutting government funding and weakening the welfare state. Critics have pointed out that within population health analyses there has been no analysis of the relation between specific fiscal policies or economic systems (e.g., capitalism) and health (Labonte, 1995; Poland et al., 1998). Poland et al. have argued that the evidence offered by both Marmot et al. (1978) and Wilkinson (1996) suggests that "equity" might be a far more significant determinant of health than "prosperity," since a key indicator of population health seems to be a gap between the rich and poor.

Feminist critiques have focused particularly on the lack of attention to gender and on the complexities hidden by the distinct boxes in such models as Evans et al. cited above (1994). Notably missing was the place of women in the formal health-care system and the gendered implications of moving health care into the community (Kaufert, 1996; Love et al., 1997). Love et al. and others point out that the reduction of health-care spending primarily affects the large female-dominated workforce in the health-care sector within and outside of hospitals. They suggest that the high population health status of countries such as Japan and Sweden may depend not so much on the average income of the country but on the hidden labour of women or the state welfare system that provides such services as day care and parental leave (Lock, 1993; Love et al., 1997). Kaufert (1996) points out that in the determinants evidence "women are over-represented at the bottom and under-represented in the upper reaches along most of the gradients considered important," such as those for satisfying employment, secure and supportive social environment, and equitable distribution of income (p. 6). She also complains that little attention is paid to extreme conditions, such as the impact on health of homelessness, long-term unemployment or malnourishment; the relationship between health, poverty and race/ethnicity; and the relationship between health and gender. Population health has relied heavily on epidemiological research and as such has been criticized for losing the contextual details of differently lived lives (Labonte, 1995). It can also lack a theory of agency (Poland et al., 1998).

Some new work on the determinants of health is being done to enlarge our understanding of gender and cultural differences (Corin, 1994; King and Williams, 1995; Walsh et al., 1995). Some are working on a hermeneutics or semiotics of health, thus enlarging our understanding of the social determinants of health (Corin, 1995). Others are working on a model of gender as a modifiable health determinant (Davidson et al., 1997).

Hamilton and Bhatti (1996) (Figure 1) offer a population health promotion model that combines certain determinants of health (income and social status, social support networks, education, employment and working conditions, physical environment, biology and genetic endowment, personal health practices and coping skills, healthy child development, health services) with the Ottawa Charter's five health promotion strategies (strengthen community action, build healthy public policy, create supportive environments, develop personal skills, reorient health services).

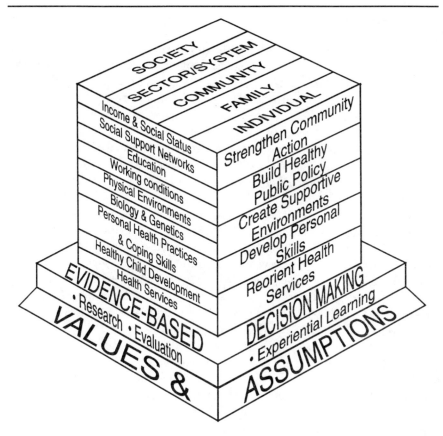

Figure 1
Population Health Promotion (Source: Hamilton and Bhatti, Health Promotion Development Division, 1996)

In such a model one might choose to work on multiple strategies to address a specific determinant such as healthy child development. A third dimension of the model identifies five levels of population groups to work with, from society at large to the individual. Hamilton and Bhatti also provide a base on which these interventions will be constructed. That base includes evidence-based decision-making when evidence is defined as research, experiential learning and evaluation, and a series of "values and assumptions" including a commitment to comprehensive action on the determinants of health and to social justice and equity. As a model of research or intervention, the Hamilton and Bhatti model offers an outline of possible modes of action. It still needs to come alive in the complex details of contextual study (Hayes and Dunn, 1998).

Empowerment

The medical or behaviour change approach to health promotion can be seen as authoritative in its mode of intervention (Beattie, 1991). The broad determinants of health approach, although welcome, can leave out the complex diversities within populations. The Ottawa Charter of 1986 has emphasized the agency of people: health promotion is the "enabling [of] people to increase control over, and to improve, their health" (World Health Organization, 1986). This enabling is now taken as an essential element in any health promotion program and in some cases is at the forefront of a theoretical and practical model (Raeburn and Rootman, 1998). Yet how do we define empowerment and how is it used? Even a negotiated mode of intervention and a collective target site can be used for authoritative ends (Beattie, 1991).

Feminists have argued that community development with empowerment is the approach that most closely meets women's needs (Aird, 1986; Daykin and Naidoo, 1995; Roberts, Smith and Lloyd, 1992; Rodmell and Watt, 1986). Many are writing about a "'new health promotion movement' in which empowering political strategies, such as community participation and coalition building, are used to address the social inequities of health" (Ward-Griffin and Ploeg, 1997, 282; Labonte, 1992, 1993; Raeburn and Rootman, 1998; Robertson and Minkler, 1994). In our own model (Figure 2), women's participation and women's voicing are central. See chapter 3 for a broader discussion of the latter.

Nevertheless, Nettleton warns against the links between the language of empowerment and the language of marketing (e.g., consumers identifying self-defined needs) and the fit between voluntarism and consumerism, which can exploit women's work (Nettleton, 1996). Health promotion notions of self-care and mutual aid (Epp, 1986) can be allied with processes of empowerment, as long as they do not translate into women taking on increased "caring" at the expense of their own health. With women socialized as care-givers, with the institution of the family and with a tendency to a gendered workforce in the caring professions, women's work has been undervalued, underpaid and often invisible.

Mutual aid can refer to certain self-help, peer support or survivor groups that function as political advocacy and action groups as well as coping environments for women. It can be argued that such group work fosters empowerment not just to change individual lifestyle practices or to increase coping skills, but also to advocate for institutional and community change. As such, mutual aid might lead to social reform and long-term benefits as well as short-term relief.

Empowerment is also defined as participation, particularly in designing public policies that affect health. Yet, "community participation" often stops at the level of service providers or the leaders in the communities and does not reach those who have no institutionalized power and voice. Even the new strategies for developing public participation, such as including community leaders on advisory boards or on research committees, may exclude underprivileged women whose voices need to be heard. Structural constraints on women's participation also need to be overcome: the time burden of work and family commitments, the costs of child care and transportation, the gendered and classed mode of committee interaction.

Feminist health promotion empowerment then would begin with women's participation in the design of research, policy and programming. It would encourage collective action for reflection and action. It would guard against exploitation of women's time and labour and it would work towards structural change.

HEALTH PROMOTION RESEARCH: A FEMINIST PARTICIPATORY MODEL

Taking into account the feminist critiques of various health promotion approaches, what then would be a possible feminist model for research on women and health promotion? Feminist theorists continue to engage in active discussion about how to create a feminist epistemology and do feminist research in ways which work toward the elimination of androcentrism, ethnocentrism, as well as heterosexism in existing products of research such as public policy, published theories, prevention and intervention programs. Such a feminist model would include women in the activities of knowledge-making. It would create knowledge and theories which present women as embodied, socially and historically situated in social structures and discourses. And it would work to eliminate structures and discourses which are oppressive in order to improve women's daily lives, the lives of their family members, and to create healthier neighbourhoods and communities.

Toward this end, feminists have participated in the systematic challenge of positivism, challenging the dichotomy between knowing and doing (Westkott, 1990); objective and subjective (Fonow and Cook, 1991); the hierarchy of the traditional research relationship (Mies, 1991); and the dehumanization of people by the ways they are often inserted as research objects into academic research practices such as collecting and interpreting data and creating theories and official accounts (Stanley and Wise, 1990). Feminists have used a plethora of methods (e.g., consciousness-raising, autobiography, popular education, popular theatre) in their attempt to do research in ways which attend to women's ways of knowing and most effectively eliminate structures of oppression (Maguire, 1987; Reinharz, 1992; Tomm, 1989). Theories have been challenged, policies changed and practices transformed as a result of this feminist challenge.

At the same time, primarily in the fields of adult education and international development, participatory action research emerged and is re-emerging as one translation of such challenges into an alternative research framework. Concerned primarily about people being turned into "research objects" and theorized about within ethnocentric Western frameworks, a group of academics articulated this approach which has been used and modified in various fields (Brown and Tandon, 1983; Fals-Borda and Rahman, 1991; Green, et al., 1995; Hall, 1981; Israel et al., 1989; Maguire, 1987; Park et al., 1993; Ralph, 1988; Ristock and Pennell, 1996).

Participatory research provides a method that is potentially compatible with feminist research in health promotion. Whereas women's conditions were formerly excluded from research, participatory action researchers can encourage women to bring their lives to the forefront by supporting them in taking their daily lives as the starting place for research and action. Women can be at the centre of knowledge-making about their own lives through setting their own agendas about what needs to be researched, how it needs to be researched and what needs to be changed. Through this process, women can be empowered. No longer

objectified by research, they become their own investigators. In this process of collective articulation of problems, women develop an awareness of how their lives are affected by social structures. Feminism brings to participatory action research greater attention to gender as a social structure (Maguire, 1987) and a more systematically articulated critique of positivism and its corresponding scientific method.

THE MODEL

Figure 2 offers our model of women's health promotion priorities. "Women's Voices" as a code for the health promotion term *public participation* initiates the process. The model recognizes the ability of women, at some level, to identify their problems, to suggest strategies for change, to advise on public policy, to identify structural contexts and determinants, and to provide exemplary narratives. The women's group activities can be categorized generally as peer support, knowledge development and action (which may include lobbying or specific health promotion activities). In this model of health promotion research, the central agents of change will be the women acting together. Women may include various groupings of agents: researchers, policy-makers, service providers and the community at large. The process will lead: 1) on the individual level to mutual aid and self-care, which in turn lead to enhanced coping and short-term and/or long-term gains; and 2) on the collective level to coordinated public policy, strengthened community health services and providing healthy environments. These in turn both can facilitate mutual aid or self-care and can effect structural change. It is this structural change on the determinants of health which will ultimately offer long-term gains through reduced inequities and increased prevention. The agents in this process thus influence knowledge development, public policy and program development, all leading to long-term gains. They also influence the individual lives of the research subjects. These short-term and long-term gains will in turn feed back into the process of women's participation in their own health promotion.

To take an example from a research project with women with multiple sclerosis (O'Connor, Low and Shelley, 1996 and chapter 7 in this volume), service providers and researchers planned a participatory project that aimed to increase women's control over their ongoing care. Rather than interviews or a one-time focus group, a series of ongoing group meetings was developed with low moderator involvement. The women were invited through the home-care agency to participate in the project, but they were allowed to set their own agenda for the meetings—to speak about the issues that mattered to them most as women living with their disability. In terms of immediate benefits, the women reported that the group offered them a chance to speak with others who shared their disability. Some had never had this opportunity. The group countered their isolation and allowed them to share advice and coping strategies. The group developed into its own self-help group with individuals offering mutual aid during the group meetings and beyond. From the knowledge and self-esteem gained in the group, the women were able to increase their self-care. Sometimes in conjunction with the researchers, the group was able to work on long-term gains by lobbying various bodies for strengthened community health services, for coordinated public policy and healthy environments. The knowledge the women developed collectively

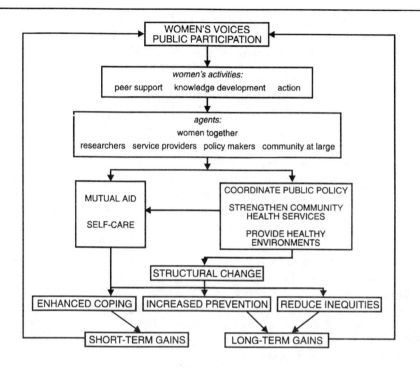

Figure 2
A Feminist Participatory Model for Health Promotion Research

and in conjunction with the researchers was used for both academic papers and various lobbying initiatives, including the home-care agency about their support needs and the regional government about the bus service for people with disabilities. The research process worked to increase the opportunity for the women to feel more in control of their lives; it facilitated mutual aid; and through knowledge development and action, it began to work towards structural change in different areas.

In another PAR project, "Immigrant/Women/Work and Health" (Hajdukowski-Ahmed, forthcoming), the Latin American group *De Mujer a Mujer*, working broadly within the same model, chose their own format. The advisory committee of eight immigrant women focused their research/action on mental health issues. They constituted themselves into a support group for each other and an advisory committee to organize workshops on mental health issues for Latin American women in their community. They met every two weeks. Each meeting was divided in two parts: during the first part, women shared personal concerns around which they would brainstorm in order to look for solutions and/or coping strategies, while providing emotional comfort and support to each other. During the second part of the meeting, they researched the question of self-esteem. They also researched methodologies to

answer appropriately the needs of their community and they organized a series of workshops for Latin American women conducted by a Latin American social worker.

All activities took place in Spanish. The choice of language was essential to the success of the project but posed the problem of translation and reporting (cost, time and format). Trust and confidentiality were perceived as vital to the project and often tested. Sustainability (the group is still meeting after two-and-one-half years) and effectiveness (12 workshops had a maximum attendance rate) constituted the outcome of this approach to PAR and the rewards for *De Mujer a Mujer*. For the principal investigator who attended all meetings, all the components of this version of PAR (knowledge creation, health promotion action and community development, peer support and friendship) made this experience invaluable.

There are various modes of knowing, and people from different cultural, class or institutional backgrounds will experience and articulate their lives in different ways. Women's "empowerment" is not to be seen as just an added factor but an essential mechanism for changing systems. Public participation is not mere consultation but women's active participation at all levels of research and policy-making (Vertinsky, 1992).

A feminist participatory research for health promotion would enlarge present official understandings of women's lives by filling some of the gaps in traditional research: the structures of labour, the gendered roles of women's everyday lives, women's understandings of physical and emotional health. Instead of women being studied only as mothers, wives or reproductive agents, women can also be studied in relation to their work, with the knowledge that women's labour, having been invisible, underpaid or unpaid, is crucial to the quality of life and health in women's lives (Hall, 1990).

A feminist participatory action research model includes women in the setting up of the research question, design, implementation and interpretation; it includes strategies for change with an immediate benefit to the women as well as analyses of structural determinants of ill health and steps towards eliminating these. By encouraging women to be involved at the centre of official knowledge-making about their own lives, the research process itself, we believe, will improve women's health because women together, talking about their lives, can challenge the gaps, the misinterpretations and take back the knowledge—the knowledge that it is not women with the problem, but the systemic organization of unhealthy living and workplaces.

WOMEN'S WORK, WOMEN'S VOICES: FROM INVISIBILITY TO VISIBILITY[1]

Isik Urla Zeytinoglu, Margaret Denton, Maroussia Hajdukowski-Ahmed, Mary O'Connor, Lori Chambers

Les auteures passent en revue la littérature existante sur la relation entre le travail des femmes, qu'il soit rémunéré ou non-rémunéré, et leur santé. Définissant la santé comme "un état de bien-être physique, mental et social complet", les auteures soutiennent que la promotion de la santé de la femme repose sur la réalisation d'un travail enrichissant, sur la stabilité économique, sur un environnement de travail sain et sur le soutien de l'environnement social pour toutes les femmes. Les comportements discriminatoires envers les femmes dans le milieu du travail rémunéré affectent la santé mentale de la femme, et les femmes immigrantes ainsi que les femmes appartenant à une minorité sont particulièrement vulnérables à ce genre de harcèlement. Le fait que beaucoup de femmes travaillent dans un environnement dans lequel elles ont très peu de contrôle ou de pouvoir sur leur propre travail, entraîne aussi des conséquences négatives sur leur santé mentale et physique. De plus, le fait que les femmes accomplissent la plus grande partie des tâches domestiques familiales, ainsi que le manque de respect et de valeur accordés à ce genre de travail dans le monde occidental, affectent aussi la santé de la femme. Les auteures maintiennent que la justice et l'équité au travail et à la maison sont essentielles pour que la promotion de la santé de la femme puisse être menée à bien.

CB CB CB CB CB

Work has traditionally been defined as paid work that is largely performed outside the home. This definition rendered much of the traditional work of women invisible and ensured that women's work was neither acknowledged nor recorded by historians and social scientists (Armstrong, Armstrong, Choiniere, Feldberg and White, 1994; Bradbury, 1992; Chambers

[1] The study was funded by McMaster Research Centre for the Promotion of Women's Health. This paper is a revised version of Zeytinoglu, I.U., Denton, M., Hajdukowski-Ahmed, M. and O'Connor, M. (1997). The Impact of Work on Women's Health: A Review of Recent Literature and Future Research Directions. *Canadian Journal of Women's Health Care 8*, (2), 18-27.

and Montigny, 1998; Messing, Neis and Dumais, 1995; O'Connor, 1995; Prentice, Bourne, Cuthbert-Brandt, Light, Mitchinson and Black, 1996; Teiger, 1995; Zeytinoglu, Denton, Hajdukowski-Ahmed and O'Connor, 1997). It has been argued that women's working conditions have been understudied because of the sex-role ideology that assumes men to be breadwinners working outside the home and women to be wives and mothers "staying at home." Academic neglect has been "justified" on the basis of the false belief that women's work, paid and unpaid, is less hazardous than the work of men (Doyal, 1996; Messing, 1997).

More recently, under the influence of feminist researchers, the definition of work has been expanded to include unpaid work, whether performed at home or outside the home in volunteering. New definitions, therefore, render women's work more visible and attempt to ensure that such work will be accorded social value. The work of women, in its various forms, is not only poorly remunerated but lacks status and respect within Western societies. Women's work is undervalued and underpaid when knowledge and mental effort involved in the tasks are not acknowledged (Teghtsoonian, 1997; Teiger, 1995). The emotional labour of home-care work, neither recognized nor paid, is an example of the invisible work of women (Aronson and Neysmith, 1997; Denton and Zeytinoglu, 1996). This problem is equally evident in the unpaid work that women perform in the home and as volunteers. To overcome this invisibility women's work must be documented and its impact in women's lives and health must be studied from the perspective of women themselves.

There is a growing interest in examining women's work and occupational health issues accounting for the diversity of women's experiences (Hajdukowski-Ahmed, Pond, Zeytinoglu and Chambers, in this book; Messing, 1997; Simkin, 1993; Zeytinoglu, Westmorland, Pringle, Denton, Chouinard and Webb, in this book). The purpose of this paper is to review recent literature on women's health in relation to their paid employment and the unpaid work of homemaking and volunteering. After defining health and diversity, we discuss women's paid work and health, various factors related to work affecting women's health, and women's unpaid domestic labour, volunteering and health. The paper concludes with a discussion of the need for women's voices in future research.

DEFINING HEALTH AND DIVERSITY

Health was traditionally defined as the absence of illness or injury. The specific health concerns of women were frequently obscured in research based within the medical model; women have been excluded from clinical research, findings based only on white males have been generalized to the entire population, or women's health concerns have been ignored altogether. The efforts of feminist researchers have helped to expand the definition of health (Armstrong et al., 1997; Doyal, 1996; MacIntyre, Hunt and Sweeting, 1996; Rutten, 1995; Thurston, Scott and Crow, 1997; Walters, Lenton and McKeary, 1995a). The need for specific research about women's health (Gijsbers, Van Vliet and Kolk, 1996; Rutten, 1995) and for appropriate and sensitive health care for women has also been asserted. Such care must not only aim to "cure" illness but to promote well-being.

In this study we define health as "a state of complete physical, mental and social well-being and not merely the absence of disease or infirmity" (World Health Organization, 1994). This definition emphasizes that health is interrelated with access to food, money, housing, a clean environment, supportive social networks, work, information and the ability to act on this information (Canadian Advisory Council on the Status of Women, 1995; Charles and Walters, 1994).

Research shows that when women are given the opportunity to define health for themselves, they define it in a similarly broad way (Women's Wellness Project, 1993). The promotion of women's health also involves a transformation of wider societal conditions. Of particular relevance to this study, meaningful employment, economic stability, healthy work environments and supportive social environments are recognized as being of central importance in the health of individuals (Hamilton and Bhatti, 1996). Women, however, remain an at-risk population until women's work, paid and unpaid, is valued and recognized (Collins, Hollander, Koffman, Reeve and Seidler, 1997).

Until recently, not only medical research but also feminist research did not take the diversity of women into consideration (Canadian Advisory Council on the Status of Women, 1995; Zeytinoglu et al., 1997). Possible health differences among women of different racial or ethnic backgrounds, different age groups or income levels were not considered. When persons with disabilities and their health were the topic of research, the gender factor was ignored and it was assumed that findings would apply similarly to males and females (Zeytinoglu et al., in this book). Lesbian health issues have been totally ignored in research (Simkin, 1993). Although all women share the common experience of gender, and gender discrimination, the health issues of women cannot be assumed to be homogenous; research and health promotion strategies must address the diversity of the lived experiences of Canadian women.

PAID LABOUR AND WOMEN'S HEALTH: A COMPLEX RELATIONSHIP

In focussing on women's paid work and health, research documents a complex relationship. Generally, studies show that women's paid work has positive effects on their long-term physical and mental health (Collins et al., 1997; Dennerstein, 1995; Pugliesi, 1995; Walters et al., 1995a). Compared to women who are not in paid employment, women in paid work report fewer chronic illnesses, activity limitations and doctors' visits and they are less likely to rate their health as poor or fair. Studies also show that the financial rewards of paid work, and the resultant increase in self-esteem, benefit women's mental health (Canadian Advisory Council on the Status of Women, 1995; Dennerstein, 1995; Pugliesi, 1995; Walters et al., 1995a). Research with women with disabilities, home-care workers in community-based health and social service agencies and immigrant women supports this perceived positive impact of paid work on women's mental health (Denton, Zeytinoglu, Webb and Lian, in this book; Hajdukowski-Ahmed et al., in this book; Zeytinoglu et al., in this book).

Despite the overall positive impact of work on women's health, new studies illustrate that female workers, like males, face considerable occupational health and safety risks (Messing, 1997). For example, there are occupational health hazards for health-care workers having

backaches or other injuries caused by lifting patients or because of inadequate or inappropriate equipment, poor posture or exposure to chemical agents (Collins et al., 1997; Denton et al., in this book; Skillen, 1995; Sprout and Yassi, 1995; Walters, Beardwood, Eyles and French, 1995b). Exposure to infectious diseases, being physically attacked by patients and sexual assault are other occupational health problems. Other female-dominated jobs such as teaching, daycare work, flight attendance, social service jobs, cleaning and laundry jobs, food and beverage service work, hairdressing, clerical and sales jobs show a variety of physical health and safety problems (Collins et al., 1997; Mayhew, Quinlan and Bennetti, 1996; Messing, 1997; Sprout and Yassi, 1995; Stock, 1995).

Repetitive strain injuries and other work-related musculoskeletal disorders in sedentary data entry jobs or assembly-line types of work in food processing are increasing, and women in these jobs are suffering from chronic pain (Denton et al., in this book; Hajdukowski-Ahmed et al., in this book; King, Grats, Scheuer and Claffey, 1996; Messing, 1997; Neis, 1995; Stock, 1995; Vezina, Courville and Geoffrion, 1995). Immigrant women face extensive occupational problems because a substantial number of them work in unsafe, poorly remunerated jobs that no one else is willing to do (Hajdukowski-Ahmed et al., in this book; Ng, 1993; Satzevich, 1992). Heavy workloads, night shift work, stress and work involving chemical agents can also create reproductive health risks that are specific to women and are more common in poorly remunerated, unpleasant work environments (Bisanti, Osen, Basso, Thonneau and Karmaus, 1996; Blatter, Roeleveld and Zielhuis, 1996; Infante-Rivard, David, Gauthier and Rivard, 1993; Robson, 1992; Roman, Doyle, Ansell, Bull and Beral, 1996).

Often it is difficult to separate the physical and mental impact of work on the health of individuals. For example, sex and race discrimination and/or harassment at work produce both physical and mental ill health in women (Bolaria, 1994a; Boyd, 1992; Zeytinoglu et al., 1997). Sexual harassment, violence and discrimination against women exist in all types of workplaces: in office environments, factories, restaurants, hotels and other workplaces in the hospitality sector, hospitals and nursing homes, and in home-care work and for all types of workers from the lowest level of staff to the highest level of managerial and professional employees (Daenzer, 1993; Denton et al., in this book; Macdonald, 1996; Rollins, 1996; Skillen, 1995; Sprout and Yassi, 1995). For example, research shows that in female-dominated home-care work some workers are sexually or racially harassed by their clients or the clients' family members (Denton et al., in this book). Similarly, black domestic workers express resentment of the injustice of the oppressive conditions under which they labour (Rollins, 1996). Women with disabilities in the paid workforce also experience sexual harassment at work but rarely raise their voices for fear that they might lose their hard-found jobs (Zeytinoglu et al., in this book). Immigrant women face racial harassment at work but again keep quiet for fear of losing their paid employment (Aronson and Neysmith, 1997; Hajdukowski-Ahmed et al., in this book; Ng, 1993; Satzevich, 1992). Women who are harassed at work feel angry and stressed and report a high desire to change jobs.

The discriminatory attitudes towards women in managerial and professional occupations are well-known, and recent studies are showing that very little has changed throughout the years (Denton and Zeytinoglu, 1993; Northcraft and Gutek, 1993; Romaine and Zeytinoglu, in this book). It is clear that work pressure, and the demands of balancing family and career,

have physical and emotional consequences for female professionals, problems that are less acute for men (Collins et al., 1997; Kay, 1997). It has recently been suggested that such pressures are related to high levels of psychotropic drug use by professional women (Morissette and Dedobbeleer, 1997). Women in male-dominated fields face additional hostility and racism when they are women of colour (Bell, Denton and Nkomo, 1993). The backlash against women's hard-earned gains in paid employment, against human rights and sexual harassment policies in organizations and against legislation such as employment equity and pay equity creates a general harassment, adversely affecting women's mental health.

The impact of paid work on women's mental health is also closely related to whether or not they have control over their work. The feeling of having control over work is a well-known positive aspect of work (Link, Lennon and Dohrenwend, 1993; Walters et al., 1995a). It increases job satisfaction, empowers workers and is associated with positive outcomes of emotional well-being, successful coping with stress, good physical health and improved job performance. For example, studies show that women who work in health-care institutions or provide health care in clients' homes identify lack of control over their work as an important source of stress and poor emotional health (Armstrong et al., 1994; Aronson and Neysmith, 1997; Denton et al., in this book; Skillen, 1995; Walters et al., 1995a). Most women work in low-level, low-status jobs and are under constant supervision while working, without freedom to make decisions about their immediate tasks and with restrictions on contact with co-workers during work hours. The work is often performed in confining physical spaces. Such adverse working conditions are shown to negatively influence female workers' mental health (Canadian Advisory Council on the Status of Women, 1995; Lennon, 1994; Messing et al., 1995; Stock, 1995; Walters et al., 1995a). Many women work in jobs perceived by employers as appropriate female work since the jobs require skills that are perceived as "natural" extensions of women's abilities. For example, women employed as hospital cleaners describe their place in the hospital hierarchy as being "hospital trash" and say that their work is represented as easy, despite the importance of hygiene as a component of disease prevention and overall health care (Messing et al., 1995).

Research on immigrant women shows that they generally have achieved significant educational goals in their home countries, but these skills and achievements are often not recognized in the Canadian job market, and women report stress because they are forced to work in low-skilled jobs or are unable to find paid work (Hajdukowski-Ahmed et al., in this book; Ng, 1993; Pandakur and Pandakur, 1996; Satzevich, 1992). Studies show that minority status increases the likelihood of being underemployed or unemployed, of occupying lower paying and unsafe jobs (Beach and Worswick, 1993; Christofides, 1993), and of facing stress related to minority status and societal racism (Hajdukowski-Ahmed et al., in this book; Ng, 1993).

There is also an argument that a relationship exists between the type of work arrangement women have and their mental and physical health. Most studies implicitly refer to full-time work. The health effects of part-time, temporary and other non-standard work dominated by women have not been well studied (Zeytinoglu, 1999). The few studies that exist show conflicting results. For women with disabilities, part-time or other flexible work options are the type of work arrangements under which some would like to work. When they are given the choice to work in paid jobs, but on a part-time basis, they perceive improved mental health (Zeytinoglu et al., in this book). On the other hand, there is an ongoing concern that

part-time and other non-standard jobs might negatively influence women's mental health (Canadian Advisory Council on the Status of Women, 1995; Doyal, 1996). Most part-time work does not provide job security, has few benefits, lacks sufficient old-age security and is intermittent in nature (Zeytinoglu, 1999). This type of work has long-term repercussions for women in the form of lower income and thus poverty in old age. For women working in part-time and other non-standard jobs concerns for their future could result in mental health problems. For example, in a recent study, women's part-time work was associated with poorer health, especially when women worked part-time due to a lack of options rather than by personal choice (Ross and Bird, 1994).

Unemployment and the fear of unemployment can negatively influence women's mental health (Balka, 1995; Denton et al., in this book; Hajdukowski-Ahmed et al., in this book; Ross and Bird, 1994; Zeytinoglu et al., 1997). However, the health impact of unemployment for women should be examined in relation to their multiple roles. Unemployed women who are content with their role as primarily (unpaid) homemakers and who seek paid employment to complement this primary role show lower symptoms of mental health problems. Unemployed women seeking paid employment as their primary role, however, suffer from a variety of mental health problems (Leeflang, Klein-Hesseling and Spruit, 1992). Unemployment affects the mental health of women of diverse backgrounds and abilities. Immigrant women are often the last hired and the first fired, and thus are more likely to suffer from unemployment-related stress than are Canadian-born women (Bhayana, 1991; Boyd, 1992; Christofides, 1993; Hajdukowski-Ahmed et al., in this book). For women with disabilities, unemployment often results in stress, depression, isolation and loneliness. They suffer significant stress because they are both disabled and female in an "able-bodied male-normed work world" (Lloyd, 1992). They want paid work, but they are doubly discriminated against while attempting to enter an often unwelcoming labour market (Zeytinoglu et al., in this book).

Career-family interface and off-the-job support are important factors that affect both female and male workers' health, although the effect on women is more explicit (Offerman and Armitage, 1993). The sexual division of labour in the family has a bearing on women's physical and mental health. Studies show that regardless of their physical or mental capabilities, occupational status and income level, ethnic or cultural background, or age, women carry the dual workload of paid work and unpaid domestic labour (Denton et al., in this book; Hajdukowski-Ahmed et al., in this book; Walters et al., 1995a; 1995b; Zeytinoglu et al., in this book). Women spend more time with children than do men and are more likely than men to be absent from work due to personal obligations such as child care and elder care; absence from work for such reasons not only affects perceptions of women's dedication to work but makes it difficult for women to stay home when they are ill themselves (Collins et al., 1997; Zeytinoglu et al., 1997). Women employed full time in the paid workforce remain responsible for 60 percent or more of the housework (Ross and Bird, 1994). This dual workload creates physical and mental health problems such as tiredness, stress and anxiety among women (Dennerstein, 1995; Denton et al., in this book; Hajdukowski-Ahmed et al., in this book; King et al., 1996; Offerman and Armitage, 1993; Pugliesi, 1995; Romaine and Zeytinoglu, in this book; Stock, 1995; Walters and Denton, 1997; Zeytinoglu et al., in this book). These health problems are symptoms of women's decreased leisure/personal time.

Research suggests that while women in paid jobs show symptoms of stress and tiredness, they are less likely to report depression than are women without paid employment (Glass and Fujimoto, 1994; Walters and Denton, 1997). Single, employed mothers with dependent children may be the exception, as recent studies suggest that such women are at particular risk of poor psycho-social health (Macran, Clarke and Joshi, 1996; McGovern, Gjeringen and Froberg, 1992; Walsh, in this book). Overall, however, evidence suggests that well-remunerated, satisfying and challenging work has a positive impact on women's physical and mental health; public policy, therefore, must ensure that the disadvantages, pay inequity and discrimination faced by women in the workplace are overcome. This is particularly true with regard to women who are multiply disadvantaged by race, language, religion, sexual orientation, sole parenting concerns or disability. Since the dual workload endured by women is a significant source of tiredness, stress and anxiety, the value of women's unpaid labour must also be acknowledged.

UNPAID DOMESTIC LABOUR AND WOMEN'S HEALTH

For women, unpaid work in the home may be categorized as: housework, reproduction and care of dependent children, care of working adults and care of dependent adults (Strong-Boag, 1986). The invisibility and devaluation of women's unpaid domestic labour has ensured that, until recently, little research was conducted with regard to the health consequences of this work. There is, however, an emerging feminist literature examining working conditions in women's unpaid domestic labour and the physical and mental health concerns in this type of work (Armstrong et al., 1994; Armstrong et al., 1997; Aronson, 1990; McKeary, 1993; Rosenberg,1990).

Unpaid domestic work is hard labour, demanding physical fitness, for example, in carrying heavy objects, climbing ladders or taking care of children. Women often have to bend or work in awkward positions, such as in cleaning bathrooms. There are chemicals used at home in cleaning work with often minimum information provided on the labels; there are health hazards of dust, fumes or flames at work (Rosenthal, 1996). These dangers, however, are rarely publicly acknowledged or discussed; the very lack of recognition of the importance of domestic labour may be related to the fact that, overall, women who work without pay in the home report more chronic illnesses, activity limitations and doctors' visits and are more likely to rate their health as poor or fair than are women with paid employment (Walters et al., 1995a).

Loneliness is an important feature of homemakers' lives. Specific family situations, such as problems with dependent children, elderly relatives or the spouse, having a large family, single parenting, a heavy domestic workload, limited financial or other resources, problems with other family members, or social acceptance of the family, influence homemakers' mental health (Walsh, in this book). It appears to be the accumulation or combination of these problems that leads to the mental health problems of stress, tiredness and depression that homemakers experience (Walters and Denton, 1997). Mental health problems suffered by homemakers are related to the perceived value of the job. Homemaking work traditionally has low value in our society. Moreover, the job neither provides skills that are sought after

by the paid labour market nor provides old-age security. The full-time homemaker is dependent on one employer—the spouse or someone else earning the family income—for her future. This dependency can create a situation of powerlessness. She might have a happy and valued worklife as a homemaker; she might, however, work in an environment (her home) in which she faces harassment from the spouse or other family members affecting her mental health.

For immigrant women, there can be increased isolation because of language or cultural differences, adaptation problems, an increased workload at home because of the loss of social support previously provided by extended family, or because of cultural expectations. As yet, also, there has been limited exploration of the ways in which care-giving responsibilities in the lesbian community, outside the organizational framework of the "traditional" family, influence women's mental health (Sinding, in this book). It is clear, however, that working conditions in the unpaid work of homemaking influence the mental health of women.

WOMEN'S VOLUNTEER WORK AND HEALTH

The unpaid work of volunteering and its impact on women's health have been studied even less than the relationship between homemaking and women's health. The limited number of studies show that volunteering has many similarities to paid work (Fischer and Banister-Schaffer, 1993). They are both task and achievement oriented and require the use of one's skills and creativity. A major difference, however, is that volunteer work is an act of free will; individuals engage in volunteering and discontinue such work at their own discretion. Volunteering is an important activity in our society, much of which is performed by women.

Volunteering does not seem to negatively influence physical health (Denton et al., in this book; Zeytinoglu et al., in this book). In fact, women and men with disabilities perceive improved physical health as a result of their volunteering work because through such work they see themselves as contributing to society.

Mental health is also influenced by volunteering; it is presumed to provide increased life satisfaction, contributing to one's overall sense of well-being (Cnaan and Cwikel, 1992; Novak, 1993; Turner, 1992). A study of volunteers in home-care work shows that, in general, volunteering has a positive impact on women's mental health; however, the death of a client, or the lack of control they find when a client's needs are not being adequately addressed, are causes of stress (Denton et al., in this book). Other studies show that emotional labour in home-care volunteering affects mental health in the form of burnout, anxiety or depression, often resulting in physical illnesses (Corrigan, 1994). Perceived control over the work environment also affects volunteers' mental health with lack of control resulting in stress, decreased job satisfaction or even depression (Thompson and Spacapan, 1991).

Research with immigrant women shows that they do not volunteer as much in mainstream organizations, but that they are the backbone of their ethno-cultural organizations and community and familial care-giving. Their volunteering seems to have a positive impact on their mental health because of perceived contributions to society and increased self-esteem. In a study of women and men with disabilities, volunteering seemed to have both positive and negative impacts on mental health by increasing self-esteem but at the same time

engendering resentment that people with disabilities must work on an unpaid basis to prove to society that they are capable of performing the tasks of a job (Zeytinoglu et al., in this book).

THE NEED FOR WOMEN'S VOICES IN FUTURE RESEARCH

As this literature review illustrates, women's work is multi-faceted. It includes paid and unpaid work, both within and outside the home. Although women have worked in paid and unpaid jobs for centuries, research on the impact of such work on their physical and mental health is still in its infancy and is often inconclusive. What is known is that there is a significant relationship between women's work, paid and unpaid, and their health; however, whether paid and unpaid work positively or negatively influence women's health is still debated. More research is needed on work-related health issues in specific occupations and workplaces. The physical and mental impacts of homemaking and volunteering on women's health are particularly in need of study. Research is needed on the impact of immigration on women's work and health and on the impact of the volunteering and care-giving work of immigrant and refugee women on their health and well-being. Similarly, research on the work-related health of visible minority women, women with disabilities, young women, older women and lesbian women is needed.

Contemporary changes in the socio-economic environment, including the creation of primarily part-time, temporary or contractually limited jobs, the rapid expansion of computer and information-based technology, and the federal and provincial governments' budgetary cutbacks and fiscal and social reform policies, dramatically influence the work environments of women. The impact of such changes on diverse groups of women and their health should be studied.

Even under existing unfavourable economic conditions, women are achieving individual and collective successes, developing coping strategies for work-related problems. These strategies are now being discussed publicly (Hajdukowski-Ahmed et al., in this book; Long and Kahn, 1993; White, 1990). This knowledge needs to be furthered in order to build healthy public policy with regard to women and work, to create supportive environments in which women's work is valued and to strengthen community action by and for women (Hamilton and Bhatti, 1996). Women have yet to achieve equality in Canadian society; justice and equity at work and in the home are central to the successful promotion of women's health.

Women's Voices in Health Promotion: Theoretical and Methodological Implications

Maroussia Hajdukowski-Ahmed, Margaret Denton, Mary O'Connor, Isik Urla Zeytinoglu

Le terme "voix" ("voices") se réfère à une forme de communication organique qui comprend à la fois son expression phonique (timbre ou ton) et les formes de communication non verbalisées telles que le silence, le rire ou la gestuelle. L'expression "prise de parole" ("voicing") fonde un paradigme épistémologique à l'encontre du paradigme basé sur le muselage ("silencing") du sujet, comme c'est par exemple le cas de l'observation directe par un chercheur masculin. La prise en considération des voix par le biais de la prise de parole pose une épistémologie basée sur l'expérience, qui pousse des corollaires dans les domaines méthodologique, éthique et politique. Ce paradigme revêt une importance et une signification particulières dans les domaines de recherche sur les femmes dont les voix ont été longtemps étouffées, et plus précisément dans le domaine de la recherche sur la promotion de la santé des femmes. Dans ce chapitre, nous analyserons l'importance et la signification de la prise de parole pour les femmes et de l'inclusion de leurs voix dans les théories féministes, ainsi que les défis qu'elles posent. Nous en discuterons les implications méthodologiques dans la recherche participante en promotion de la santé des femmes. Nous prendrons en considération différentes formes de prise de parole utilisées dans la recherche qualitative ou servant à informer une recherche quantitative, dans le but de créer un savoir et une praxis précis et pertinents en promotion de la santé. Nous évoquerons l'importance et la fonction d'une approche dialogique à la fois comme outil de pratique critique et de promotion de la santé. L'interdisciplinarité de ce chapitre se dessinera à travers l'inclusion de savoirs appartenant à des champs divers et à travers le lien symbiotique qui se tissera entre la théorie et la praxis. Nous envisagerons les effets de la prise de parole sur la promotion de la santé des femmes ainsi que les défis qu'elle pose, en particulier pour les femmes en situation de désavantage, telles les femmes affectées d'incapacités ou les immigrantes. Le Centre de recherche de McMaster en promotion de la santé des femmes (MRCPOWH) s'est particulièrement appliqué à faciliter cette prise de parole, dans tous les aspects de sa recherche et de ses activités. Nous terminerons par des considérations éthiques et politiques, particulièrement dans le contexte socio-politique actuel, tant au niveau local que global.

"There is a story in every line of theory,... It takes a great deal of work to erase people from theoretical discussion" (Lee Maracle, "Oratory," 1994, 236)

"Nobody knows, but my body knows" (Barbara, an immigrant woman participant in a MRCPOWH health promotion project, 1997)

Women have been creating and disseminating knowledge on health promotion and have practised health promotion in their everyday lives without realizing it. Whenever and wherever they meet, women talk, creating knowledge to promote their physical, mental, social and spiritual well-being and that of their families. Women's voicing of their knowledge of health promotion has always existed, but has largely remained undocumented and trivialized. Women's voices represent the concreteness of women, their corporeal and social anchoring. The silencing of voices goes along with the erasure of women's bodies, of their needs and contributions. Women's voices have been all too long stripped of their meaning, function, value and usefulness in an androcentric science and society (Smith, 1987; Harding, 1991; Gottfried, 1996; Longino, 1987) concealing the fact that the science of health and everyday life are interconnected. There is a link between gender, voicing (or silencing) and the exercise of power (Gal, 1994). What we propose here is to contribute to the scientific and social validation of voices of women in health promotion.

Women's voices are foundational to health promotion (O'Connor, Denton, Hajdukowski-Ahmed, Williams and Zeytinoglu, 1998). The concept of health promotion or "new public health" refers to social or ecological public health and "has become almost synonymous with empowerment" (Labonte and Robertson, 1998, 43), which implies the legitimisation of the perception and involvement of women as lay participants in the process of knowledge production and action in health promotion (Walters, 1991). Health promotion comprises a theoretical element and a methodological element (O'Neill, 1998), both of which we shall consider.

While reviewing literature on the subject,[1] we shall discuss the importance of voicing in contemporary feminist research, social research and research on women's health. We shall not only examine voices as they are articulated through verbal interaction, but also the voices of silence, as well as non-verbal and cultural forms of voicing from a gendered perspective. In the course of this chapter, we shall try to answer the following questions: What methods of voicing are used in health promotion and how are women empowered by them? What challenges do such methods present and how can those challenges be overcome? Particular attention will be paid to dialogue and dialogism as they constitute the empowering force in feminist participatory action research (PAR) and health promotion, both of which have guided the research and activities in health promotion conducted by MRCPOWH.

[1] This chapter was written with the financial assistance of the McMaster Research Centre for the Promotion of Women's Health for which we are grateful. We also would like to thank Priti Kohli for her assistance in reviewing literature for this chapter.

THEORETICAL CONSIDERATIONS

Voicing connotes an organic form of communication which signals the existence of the body in time and space, that is, in a socio-historical context (Butler, 1997). Voicing connects body and mind. We hear voices, we internalize them, with or without question, and they mould our identity. Women are particularly conditioned to "listen" to and internalize social voices and the expectations they carry. Those socio-patriarchal norms have for long reduced to an imitative function women's multi-faceted and shifting identity, stifled their resisting voices and anger (Kulick, 1993) and glorified their silence. Language is more than a strand of words, it carries social and cultural values, memory and imaginary. It is commonly accepted that the use of language and the emergence of the self and agency are concomitant (Gal, 1994). Voice and speech have become metaphors for women's self-definition and identity construction "that countervail the construction of others" (Heng, 1988, 206). Giving voice to a woman is to make her into a historical agent who is affected by her environment but can in turn change her life and other lives and the course of history itself (Yee, 1994). For women, the possibility of moving beyond silence and listening to expressing one's agency has a positive effect on mental health.

Voicing in all its forms was not validated as an epistemological paradigm until the argument was advanced that the creation and acquisition of knowledge is not "objective" or value-free, but is based on a set of rules upon which specific knowledge communities agree. Voicing is part of a new constructivist approach in which it is acknowledged that "realities are socially constructed, local and specific, dependent for their form and content on the persons who hold them" (Stivers, 1993). This new paradigm is grounded in the social and political movements which emerged in contemporary history such as decolonization, feminism or gay and lesbian activism. In contemporary social research, voicing is part of a new form of inquiry that challenges the claim of hegemonic groups to knowledge and power (de Certeau, 1997) which have privileged the androcentric, white, Western, heterosexual standpoint. Voicing seeks to end the silencing of subjugated groups. "This is essentially a claim that each human being occupies a legitimate position from which to experience, interpret, and constitute the world" (Stivers, 1993, 411). Voicing represents more than a methodology, it implies a vision of the world which privileges the relational between subjects who were silenced or marginalized (de Certeau, 1968, 1997). It constitutes an antidote to the violence that can result from the silencing subject/object power relationship. Silencing and powerlessness are known to be deleterious to mental health (Bolaria, 1988). The new epistemological paradigm based on voicing blurs domination-inducing dichotomies (hooks, 1994; Creese and Stasiulis, 1996) that separate theory from practice, the private from the public sphere, popular from elite culture, the personal from the political. Voicing thus represents the essence of true democracy based on interactive reciprocity between subjects (de Certeau, 1968).

For feminist researchers, voicing is of particular importance. Feminism is about the pursuit of awareness towards action and social change (McKinnon, 1982; Razack, 1998) and the objective of feminist research is "to correct both the invisibility and the distortion of female experience in ways relevant to ending women's unequal social position" (Lather, 1995, 295). "Having rejected women's historical status as the object of the male subjects' defining gaze, feminism demands that those who have been objectified now be able to define themselves,

to tell their own stories" (Stivers, 1993, 411). Having had to look at women's health through men's eyes, we are learning to understand it through women's voices. Voicing substitutes a discourse of a reclaimed "I" to the prevailing "discourse of the eye" which objectified women, particularly in the medical discourse (Miller and Findlay, 1994; Hajdukowski-Ahmed, 1992). Erroneous knowledge with regard to women's health, knowledge that passed for science, was sustained by the silencing and ignoring of women's voices (Clarke, 1983; Hajdukowski-Ahmed, 1992; Theriot, 1993).

In recent years, feminism and post-colonial criticism have deconstructed the universalist, monologic, heterosexist, androcentric and ethnocentric approach to knowledge (Harding, 1998; Ristock and Pennel, 1996). "[U]niversality claims legitimate the devaluation and even the destruction of knowledge traditions that have enabled women, the poor and less powerful cultures to interact effectively with their environments" (Harding, 1998, 168). Feminist theories have in turn evolved towards the inclusion of a multiplicity of voices. Black women, indigenous women, women in the developing world, women with disabilities, lesbian women and immigrant women have reclaimed their voices, their spaces, their difference against universal sisterhood which was exposed as the expression of white, Western, middle-class feminist hegemony. Diverse women gradually took control over knowledge production on themselves, thus opening the feminist epistemological and ethical framework (Agnew, 1996; Anzaldua, 1990; Bannerji, 1994a; hooks, 1994; Lugones and Spellman, 1999; Maracle, 1994; Mohanty, 1991; Spivak, 1990; Trinh, 1986). Voicing exposes claims of universality as dysfunctional.[2]

DIALOGUE, DIALOGISM, HYBRIDITY

Voicing in the form of dialogue offers the best potential for the empowerment of women: dialogue between women, between researcher and participants, between communities, dialogue within women's own consciousness (falsely called monologue). In feminist practice, dialogue erases power differences, as it "implies talk between two subjects, not the speech of subject and object. It is a humanizing speech, one that challenges and resists domination" (hooks, 1994, 224). In the practice of dialogue, "connectedness rather than separation validates the process of knowledge" (Belenky, 1986, 18). It is through dialogue that participants collectively investigate an issue and act on it. "As a tool of research, dialogue produces not just factual

[2] Jenny Douglas offers the following example related to the reclaiming of their voices by culturally diverse women when health education strategies to prevent rickets among the South Asian population in Britain consisted in having South Asian women change their behaviour by exposing their bodies to the sun, while to the white population which suffered from the same deficiency it was recommended that vitamin D supplements be added to certain foods, a mistake was made that voicing would have probably corrected because: 1) not all South Asian communities are the same and 2) exposing the body to the sun may not be culturally acceptable. Asking women to change behaviour culpabilizes them by emphasizing "bad cultural practices," whereas possible malnourishment and vitamin D deficiency caused by poverty were overlooked (Douglas, 1995, 72).

knowledge but also interpersonal and critical knowledge, which defines humans as autonomous social beings" (Park, 1993, 12; Cancian, 1996; Gorelick, 1996; Smith, 1997), all of which transform the subject into an empowered agent of her own well-being. We are not talking here about mere speaking but about "coming to voice which is a gesture of resistance" (hooks, 1989, quoted by Hall, 1993, xvii). It is the points of tension, the expressions of difference—that constitute the dialogical aspect of voicing—which have the potential for producing knowledge, empowerment and well-being. Dialogue is a speech practice, whereas dialogism is a discursive concept which was articulated by Mikhail Bakhtin, a Russian anthropological philosopher and literary critic. The understanding of dialogism and its discursive manifestations helps pick up different strands of ideologies in a dialogue, their points of tension and their contradictions within the same person, between individuals and between groups. For example, through their words women can reveal a stressful inner struggle between an allegiance to the values of their original culture and their host culture (Meleis, 1991) or a conflict between a medico-pharmaceutical model of healing and a spiritual one. In a group, women can be caught in a conflict between the interests of a union and those of management, or in a racial conflict or a conflict of generations. The voices of women who straddle two cultures or more, two value systems or more, the women who have internalized norms of oppression, are typically dialogical. The researcher herself can be dialogically torn between her answerability to community and her answerability to a granting agency.

Hybridity in language is simply a form of dialogism as "hybridization is a mixture of two social languages within the limits of a single utterance...between two linguistic consciousness, separated from one another by an epoch, by social differentiation or by some other factor" (Bakhtin, 1981, 358; 1986). Since voicing is about the use of language, being able to distinguish those differences adds to the richness of interpretation and creates a more precise knowledge which in turn informs a more relevant action or policy change. When we talk about voicing in health promotion, we talk about interdisciplinarity in which the researchers/practitioners are at once linguists, anthropologists, sociologists and health promoters.

We all have multi-faceted identities (citizen, worker, parent, immigrant, etc) which emerge in different contexts of interaction, and we all experience multiple realities (Jhappan, 1996), thus we all speak with more than one voice. Some feminist philosophers such as Gilligan (1982) or Irigaray (1985) even formulated theories according to which women speak in an inherently different voice. Thus, an epistemology in which theory translates into polarities (black/white, oppressor/oppressed, healthy/unhealthy) proves to be reductionist and unscientific. It does not account for all the voices that are braided in a single voicing, nor for their transformations. Voicing takes into account the interplay of gender, class and cultural context as well as the increasing hybridity of cultural identities. The same woman can at once be the oppressor at some level and the oppressed at another one; she can be of both Irish and Indian descent and celebrate both Saint Patrick's Day and Divali. When women's experiences are conveyed through their voices, we can better capture the subtle differences, the grey areas or the flux of change, the shifting of identies and realities. Thus health promotion is more accurate and more effective when the interpreter can capture women's voices in their diachrony and their synchrony. In any research project, it is important to acknowledge all voices in their flux and diversity and not to silence them.

THE VOICES OF SILENCE

A methodology based on voicing must also confront the meaning of the voices of silence. Silence has been embedded in a patriarchal epistemology based on the discourse of the eye, the discourse of power and its methodologies which rely on observation, on description in the third person and on monologism or unilateral view. Popular culture has glorified women's silence and vilified her voicing (Roman, Juhasz and Miller, 1994). There are two kinds of silences that women experience, either by force or by choice.

Silencing is an imposed silence when power is at play, such as under a political dictatorship or in any authoritarian setting: a workplace, a religious organization, a patriarchal family. It is important to identify such forms of silencing as they are indicators of health problems which need to be addressed. Silencing can originate from a political context. Silencing can be social. Lesbian women often feel silenced about their health concerns (Brydon-Miller, 1993; Ramsay, 1994). Poor women may feel that health is an issue they cannot afford and thus ignore it (Wong, Burris and Xiang, 1995). Vulnerable groups of women may have internalized their powerlessness to the point of self-deprecation and self-silencing. As keepers of family and community health, as care-givers, women are also socialized to silence their own health needs. In health research, prioritizing and ranking health issues involves the gendered subjectivity as well as the ideology of the researcher or policy-maker; it constitutes a form of silencing of perceived "less important issues."

But silence can also be a choice for a woman, a form of protest or self-protection. A woman can choose to withdraw information when she believes voicing can harm her or her community, or she can simply reproduce the speech that is socially expected of her. She can refuse to confess to a priest, she can refuse to divulge a health practice to a sceptical doctor, or information to an academic researcher. She can choose to interrupt communication as a form of empowerment and keep her agency and knowledge protected outside of the mainstream power and norms that could threaten her well-being. Having to speak can be felt as coercion in a relation of power or in a different culture. Immigrant women who are self-conscious about the limitations of their language proficiency can feel better protected when they remain silent (Kingston, 1981). Thus silence can also connote power (Razack, 1998; Duras and Gauthier, 1974). But ultimately the voices of silence need to be heard for positive changes to occur at a collective level, as Trinh Minh-ha observes: "Without other silences, however, my silence goes unheard, unnoticed; it is simply one voice less, or more points given to the silencers" (Trinh, 1989, 83).

One should not infer that verbal silence means that the subject is silent. In many cultures, women are socialized to be non-verbal and non-explicit, but issues and values can be expressed through body language such as dance, through arts and crafts such as mask making, through community activities such as popular kitchen and through religious rituals. A feminist approach to anthropology and ethnology (Stacey, 1996) contributes to our knowledge on a diversity of women's cultural voicing and their effect on their well-being. Such forms of communication, sometimes perceived as inarticulate in a Western context (Cruishank, 1994), can convey information or be experienced as healing practices. As Abdo states: "feminist innovations into social science research methodologies...are often ignored by conventional/ traditional research methods on immigrants and refugees. While survey methods based on

questionnaires can collect certain data, they fail to read lips, fail to capture feelings and fail to report true life experiences, all of which can only be gathered if research is gender focused and directed (Abdo, 1997). In the end, we need "to strike a balance between raising muted voices, and respecting women's silence" (Bowes and Domokos, 1996, 57).

Listening to silence means also identifying spaces of silence and creating speech-friendly spaces. For example, some women will not talk in certain spaces which can be perceived as silencing, and in the presence of certain individuals—husbands, children, employers or academics. Meeting in the spaces chosen by women themselves gives them control and recognition and facilitates dialogue while it decreases the difference of power between participants and researchers who find themselves outside of their familiar academic spaces (Myles and Tarrago, 1988). Reinvesting some spaces goes together with breaking silence.[3]

VOICES IN PARTICIPATORY ACTION RESEARCH

The moment of voicing is already itself a moment of transformation and empowerment (hooks, 1994), thus health promoting. Participatory action research (PAR) is a framework for inquiry grounded in the right to speak and the practice of dialogue (Maguire, 1987; Gottfried 1996; Park, Brydon-Miller, Hall and Jackson, 1993; Smith, 1997). It constitutes an effective tool in the research and practice of health promotion. PAR should be viewed as a hybrid approach (Gottfried, 1996), which includes quantitative methods often triangulated with diverse methods of voicing (Carey, 1993). In health promotion based on PAR, focus groups and interviews can inform a survey, or strictly qualitative methods can be used. MRCPOWH's researchers have used a range of methods in their projects. Voicing is a way to make an epistemological and methodological statement which validates qualitative research without excluding the quantitative form of inquiry. In feminist PAR, the participants' knowledge and daily life experiences and practices are interactively connected, validated and made useful. Process and product, knowing and doing are united in the empowering coming to consciousness of women through dialogue.

The ethics of PAR is one of respect of the other in interaction, of confidentiality with regard to voices and of answerability to the participants and their communities. In retaining its contextual immediacy, PAR follows an ethics of answerability towards the participants, preventing their voices from being stifled, disposable and forgotten (Dagenais, 1994; Hajdukowski-Ahmed, 1992). The process of theory-making starts with women's voices and their commonalities and follows a bottom-up topology. The validity of a research instrument does not depend on extrinsic criteria such as the recourse to randomized control groups (Oakley, 1993). It does not rely on its adequation to a pre-established theory, but on its usefulness in transforming a situation according to the participants' experiential input (Smith, 1997).

[3] For example, there is a difference between "birthing" and "borning" for Aboriginal women in Australia, as "borning" integrates the child in a filiation of ancestors, "which affects the rights and responsibilities which the child will assume in adulthood" (Myles, 1988, 187). For Aboriginal women, reclaiming their space amounts to reclaiming their connections with the voices of their foremothers, with their language and history.

METHODOLOGICAL IMPLICATIONS: DIVERSE FORMS OF VOICING; VOICING AND DIVERSITY

When women conduct PAR projects in health promotion, they can use different forms of voicing, each chosen by women participants to better suit their contextual needs and cultural practices. Those methods include dialogue/conversation, focus groups, consciousness raising, group diaries, story telling, popular theatre, role playing, talking pictures, interviews and oral questionnaires for surveys. They also include culturally grounded methods such as *fotonovellas, arpilleras, pasantias, kros* or prophecy narratives. In a dialogue or a conversation, women talk in an unthreatening environment and feel free to choose their topics. This methodology allows for the assessment of a health situation and helps researchers to discover new themes or issues. Focus groups have a specific theme. They are apt at delineating attitudes, patterns and practices in a community from the perspective of the participants (Wong, Li, Burris and Xiang, 1995; Denny, 1994) or at explaining survey findings (Saint-Germain, Bassford and Montans, 1993).

Consciousness raising sessions allow women to discuss shared experiences often with a facilitator who helps articulate connections and provide analysis. Its value can be therapeutic, educational and political at the same time (Reinharz, 1992). Group diaries are used by women who read their writing to each other and discuss them in group to share knowledge and engage in critical thinking. In story telling, as described by Labonte and Feather, a person tells a story in a group and others engage in a structured dialogue on it in a "reflection circle" (1996, 10). Story telling is an interactive activity (Heng, 1988); it raises consciousness and is a fertile ground for critical pedagogy (Razack, 1998). Popular theatre can be a very effective tool in health promotion. A play is written—often collaboratively—and incorporates identified issues, options, strategies, reflexions. It can call for "interactive solutions" from the audience. It is portable and can be adapted to different communities and needs (Reinharz, 1992). Role playing is a form of interaction whereby participants take a role and represent someone else's issues and reactions. It is empowering (hooks, 1994), alleviates fears, demystifies power, opens possibilities and helps understand the other. Role playing includes forms of voicing by proxy; a woman may be reluctant to disclose a health issue and thus engage in role playing, pretending she "knows a friend who," and thus discusses her issue safely by proxy. A group of women can choose the talking picture technique, which involves taking many snaps of an identified situation and then showing the process to participants who offer comments, followed by suggestions and action for change. The photographs can also be shared with a larger community through an exhibition and become a collective form of health promotion (Reinharz, 1992). Interviews and questionnaires can help in obtaining a detailed account of a life story, which then acquires an exemplary value. The interviews and oral questionnaires can include open-ended or closed questions. Those methods are also recommended for women who wish not to disclose their issues in public.

The inclusion of culturally grounded forms of voicing contributed by studies in cultural anthropology compels us to open up not only the range of methods used in PAR and health promotion but its epistemological foundations as well. It helps us reflect on the way we learn, on the sources of knowledge beyond focus groups and questionaires and on the diversity of agency in knowledge production. For example, *fotonovellas* consist of booklets with

photographs, the sequence of which tell a story (Hondagneu-Sotelo, 1993). For Latin American women who are familiar with this medium, *fotonovellas* can be used to voice issues or disseminate information on health promotion. The medium of *arpillera* (a narrative or message in the form of patchwork used first in Chile to convey a social or political message) was adopted by the participants-researchers in the Women's Worksite Action Group to inform women in a food processing factory of the effects of repetitive strain injuries and of their rights (Hajdukowski-Ahmed, Pond, Zeytinoglu and Chambers, this volume). Gender-specific rituals such as prophecy narratives (Cruishank, 1994) or social practices such as popular kitchens as well as *pasantias* (Ornelas, 1997) or *kros* (Kulick, 1993) can yield important information on issues women experience, they contribute to their well-being and are conducive to community building.

Prophecy narratives are indigenous narratives which contain the experiences of elders and connect generations; they are often used by women to make sense of a present crisis situation and resolve it. During *pasantias*—which means "passing through" in Spanish— women gather and bring their personal reality, investigate it collectively and seek ways of improving it. *Kros* is specifically a women's form of voicing practised in Papua New Guinea to publicly express women's anger and articulate a complaint against anyone who has offended them. Women from other cultures can learn from those practices; it is also relevant for health promotion researchers and practitioners to acquire knowledge of other cultures in the light of the diversification in the immigrant population that has taken place during the past two decades in Canada. But we ultimately face the question: Is a practice a "good" health promoting practice just because it helps women "feel good"? Should all those practices be validated and by whom? Ultimately, there are as many forms of health promoting practices as there are individuals. It is the interplay of determinants such as gender, race and culture in a critical dialogue that is helpful in selecting the appropriate action in a group setting.

WOMEN'S VOICES AND RESEARCH ON HEALTH PROMOTION

The Ottawa Charter for Health Promotion states: "Health promotion works through concrete and effective community action in setting priorities, making decisions, planning strategies and implementing them to achieve better health. At the heart of this process is the empowerment of communities, their ownership and control of their own endeavours and destinies" (1986). Both the new community-based approach to health and the women's health movement create a space for women's voices and their legitimization in health promotion research and activities.

The women's health movement, which has developed in the last two decades, contends that women's health has been defined and controlled by men (Clarke, 1983; Cohen, 1991; O'Connor et al., 1998; Walters, 1994b), which led to scientific inaccuracies and omissions with harmful results for women's health.

It is through women's own voices that a different and more accurate picture of women's health is emerging. Thus, and as V. Walters, R. Lenton and M. McKeary remark: "With the women's health movement, feminist research and the broader shift to recognizing the importance of lay participation, there is increasing acknowledgement of the validity of the women's own perceptions" (1995a, 5). Through their self-reporting, women can articulate a

better insight in their issues, help researchers understand the deeper causes of their health concerns, and thereby generate more precise and accurate data which will in turn be more relevant to policy-makers.[4] Voicing gives visibility to an issue: the word is flesh.

What is not voiced does not exist and cannot be acted upon, thus through their voicing, women have enabled the transformation of the invisible into the visible. They have given visibility to women's work such as the work of homemakers, of volunteers and care-givers and to their health needs (Denton and Zeytinoglu, 1996); to women's specific health issues such as certain mental health issues (sexual violence or eating disorders); to voiceless communities of women such as immigrant women. Voicing has helped uncover deeper structural causes of ill health through dialogical critical thinking. For example, ill health could be caused by racial discrimination or inequity in the distribution of power or resources in community and society (Cancian, 1996). Voicing has enriched our knowledge of coping strategies, particularly with women affected by chronic illnesses that have no medical cure—arthritis, migraines or multiple sclerosis. Voicing also deconstructs assumptions such as the belief that a person who has a visible disability is the only one in need of help. In a family or a community, the same person can be both a carer and a cared for, receive physical assistance and in turn provide emotional and spiritual support to her care-giver (Morris, 1995). Thus, to reject dichotomies and to recognize the value of the contribution to their communities of people with disabilities or chronically ill people, a larger proportion of them being women, empowers them, enhances their self-esteem and dignity and promotes their health.

As consumers of health care, women are susceptible to the pressures created by health industries such as the industry of the "beauty myth" and the pharmaceutical industry, which encourage the consumption of their products through aggressive forms of marketing. Voicing creates the space for a counter-discourse to those pressures. This leads to research on structural causes and solutions as well as on alternative and non-invasive health promoting practices.

For these reasons, women's voices are central to health promotion strategies aimed at women. Women's voices are "used as a code to indicate women's public participation in health promotion: they identify the question, contribute to knowledge development, suggest strategies for change, advise on public policies, identify determinants, and provide their experiential narratives to that effect" (O'Connor et al., 1998). It is central to the voicing paradigm to assert that there is no dichotomy between "adaptive strategies" (action) and "expressive forms" (voicing), as in this context the process is also the product.

Voicing validates the everydayness of women's experiential knowledge and offsets isolation, particularly when voicing occurs in groups. This reduces self-blame and the sense of personal unworthiness. Voicing is educational, as women share knowledge and skills through dialogue. It is therefore conducive to mutual support (within the group) and to community building/strengthening. Listening to voices also gives a sense of urgency to research (Raeburn

[4] For example, Lorraine Greaves reported that smoking is traditionally considered as an illness-causing personal habit that requires personal changes in lifestyle. However, listening to the voices of women in context made her conclude that smoking can be a coping strategy in a time of stress, or a way to curb appetite when women want to lose weight or when they are too poor to afford healthy food (1993).

Smoking could also be considered as belonging to a culture of addiction, and a culture of addiction is often a form of reaction to a culture of domination (hooks, 1994).

and Rootman, 1998; Dagenais, 1994). The voices of participants cannot be forgotten as easily as the numbers that represent them; they remind us of the urgency of the participants' needs and of the researchers' responsibility towards them. Voicing therefore contributes to the visibility of women's bodies, to their occupational and social agency, to their needs and practices, particularly in contexts where the social construction of women and knowledge on them renders them invisible and unheard.

Voicing accounts for the diversity and specificity of people, cultures, practices and modes of communication. It enriches the common pool of knowledge and practices and allows for corrections and clarifications.[5] Moreover, by including the voice of the academic researcher, voicing accounts for the subjective and ideological component of any social research (Reinharz, 1992). Theories are no less accurate or scientific because they are grounded in voices and, conversely, as it has been amply demonstrated, a "hard" scientific approach can operate from an androcentric or ethno-cultural bias which falsifies science (Susman and Evered, 1978). However, legitimizing bodies in research and granting agencies are still slow in recognizing the scientific value of women's voices (Messing, 1995).

An essential objective of voicing in health promotion is to effect policy changes. In the course of policy-making, the voices of "outsiders" are often excluded and new knowledge is easily discarded for fear of destabilizing the system (Rutten, 1995). Voicing can help design a "multiplicity of intervention levels" (1634). However, there is a recurring complaint that there are not enough "conveyor belts" that link researchers and policy-makers, as it appeared clearly at the conference From Research to Policy organized jointly by MRCPOWH and the Atlantic Health Promotion Centre in Halifax in 1997. Talking about feminist policy researchers, Sandra Burt laments: "during the past twenty years they have developed the skills needed to listen to women's needs, perspectives, and experiences as they are articulated in different racial, class, and situational positions. To date the voices they hear have not reached the policy-making community" (Burt, 1995, 378).

Voicing constitutes a modality of participatory democracy. Raeburn and Rootman discuss health promotion research in communities and conclude that: "Our overwhelming impression from years of community work is that what the vast majority of ordinary people want for themselves and their communities is ... to have maximal opportunity for self-determination, and to develop knowledge, strengths and skills according to one's own agendas" (Raeburn and Rootman 1998, 219). It is only through participation that consciousness can be raised and empowerment achieved (Raeburn and Rootman,1998; Hall, 1993). Voicing is conducive to participatory democracy; it connects the personal and the political as we can see in the French language which does not distinguish "voice" from "vote" ("la voix").

Such consideration is important because of the changing demographics of Canada towards a greater diversification and because of the health reform which devolves more responsibility to women, local agencies and communities.

5 The contextual meaning of words has to be known to researchers in order to avoid errors of understanding and interpretation. For example, there are questions which can be misunderstood in a different context; asking "Do you drink?" to women from cultures where "drinking" is not permissible can elicit an unanimous "yes" answer, because for them, drinking can only refer to non-alcoholic beverages. Voicing prevents erroneous data and can thus be more conducive to scientific accuracy.

OVERCOMING RESEARCH CHALLENGES IN VOICING

Voicing is not always possible, safe, easy or recommended, and it can present challenges for researchers in health promotion. People in vulnerable and muted groups have difficulty voicing complaints. For example, women with disabilities would not disclose abusive relationships for fear of losing their sole support (Morris, 1995). Thus "feminist researchers—with their particular aim of 'creating a space for an absent subject'—have a clear responsibility for ensuring that disabled women's voices are heard" (Morris, 1995, 69) and their civil and human rights respected. Voices inform advocacy research in such contexts.

Due to time and budgetary constraints, health promotion researchers can hear only a limited number of voices. As Raeburn and Rootman remarked, individuals' visibility, availability and willingness to participate are all factors that limit the choice of participants in health promotion projects, with the result that "those 'most in need' are generally also those who are the most disempowered [voiceless] in terms of education, financial resources, political power, self-esteem, and so on, and who may tend not to come forward if things are left on a purely voluntary basis" (Raeburn and Rootman, 1998, 31). Often, it is the already visible and organized groups that come forward (Raeburn and Rootman, 1998, 142) and act as "professional" informants and participants.

Another challenge emerges when a researcher is brought to question the validity of some voices (Jhappan, 1996). Voicing changes according to who is speaking and who is listening (Jhappan, 1996, quoting Alcoff, 1991, 62) and according to where the interaction takes place. Participants can have their own motivation and agenda in altering authenticity. A participant can try to please her listener by telling an exotic story or a dramatic one (Razack, 1998). Women may think their voices are genuine without realizing that they may have internalized social constructions, in which case their voices have become echoes of the social norm (Smith, 1997; Gorelick, 1996). However difficult such dialogical discrepancies may be for researchers, critical thinking is stimulated when discrepancy between self-reporting and public discourse occurs (Aronson, 1990).

Eventually, "The question "Who should speak?" is less crucial than "*Who will listen?*" notes Gayatri Chakravorty Spivak (1990, 59). Listening means not only "lending an ear to voices" but making sense of them and facilitating their transformation into health promoting action. Reports can collect dust on shelves, policy-makers may have differing ideologies or limited budgets, academics may separate "pure" research from action, voices may be misused or may have fallen into distracted ears. Voicing is not enough to guarantee successful health promotion. Even when muted groups express their views or needs, those can be silenced (ignored) by the dominant groups. Muting can also be carried into analysis (Bowes and Domokos, 1996) by a researcher who dismisses voices or alters them to suit his/her agenda. "Muting and the negotiation of power are themes which run through the entire research process, from formulating questions to writing up, and that empowerment of the researched may, in the end, make researchers more powerful" (Bowes and Domokos, 1996, 49).

In an academic setting, particularly when funded, research in health promotion requires various forms of written dissemination, mostly by the academic researcher who then becomes an author. And as Acker et al. rightly state: "The act of looking at interviews, summarizing

another life, and placing it within a context is an act of objectification" (Acker, Barry and Esseveld, 1996, 71), thus an act of silencing.

Since voicing aims at enlarging understanding rather than control (Stivers, 1993), direct and precise quotation offers the best guarantee of accuracy and ethics. But interpretation still retains an important function in health promotion, as the researcher is better located to hear all the voices of all the partners involved and make sense of them for the purpose of knowledge, advocacy and policy-making.

With culturally diverse women, hearing the voice of others is particularly complicated when the participants and the researcher don't share the same language proficiency or the same language. There is always an element of betrayal in any translation as it already implies interpretation (Hitchcock, 1993). The researcher should preferably know the language of culturally diverse women as well as understand their culture as they left it; immigrant women (and men) often reify their culture (Bannerji, 1994b), which becomes frozen in time. This can create various mental stresses, particularly inter-generational conflicts and stresses. The translator can in turn reify the voices of immigrant women to suit his/her personal stereotypical views of them and ignore potentially more meaningful information that he/she does not understand. Because there is a difference and slippage between world knowledge and word knowledge, errors can occur in the interpretation and translation of culturally informed words or body language. For example, when an immigrant from South India wishes to convey a "yes" answer, she/he nods her/his head sideways, which would be automatically be translated as a "no" in English.

Furthermore, since men and women are socialized to communicate differently, male researchers may not always understand certain aspects of women's speech, such as the use of periphrasis when women talk about their bodies; or a heterosexual woman could misunderstand the meaning, weight or value of the voices of lesbian women. It is known that it is the less powerful who have to be bilingual and learn the language/culture of the other, and the person who belongs to the dominant group (and the researcher often finds herself in that position) is therefore more likely to misinterpret the voices of the muted group (Henley and Kramarae, 1994).

Sometimes, researchers face the challenge that their interpretation of voices may be at odds with that of the participants themselves. As Taylor asked: "Suppose they offer very different, even incompatible views of the world and of the subject's actions? Does the scientist have the last word? Can he [sic] set the world-view of his [sic] subjects aside as erroneous?" (Taylor, 1983, 29). Hearing a multiplicity of voices helps build a consensus (Kishwar, 1990) and avoid oppositional standpoints.

The practice of dialogical critical analysis should aim at understanding those contradictions. Such contradictions could appear in a hybrid discourse as a manifestation of the internalization of oppression (Gorelick, 1996) leading sometimes to the denial of a problem. But should we consider that bringing to light denial or false consciousness is always health promoting?

The power imbalance is a sensitive question for researchers in the health and social sciences (Acker et al., 1996; Mason and Boutillier, 1996). Friendships and empathy can be used for the purpose of obtaining disclosures (Acker et al., 1996), and the end product of research still benefits the researcher (Stacey, 1993). Such disclosures can be experienced as

disempowering by the participants or put them at risk. If women tell their stories and share their life experiences, it is important to protect confidentiality and to make them aware of the element of risk involved in disclosure (Simard, O'Neill, Frankish, George, Daniel and Doyle-Waters, 1997). Reflecting on story telling with immigrant women, Razack wondered: "To what uses will these stories be put?" The same concern has been expressed by many diverse women. Knowledge production is a major industry (Gaventa, 1993) that benefits the knowledge producers; thus it is important that what is produced by the participants goes back to them. A researcher is the guardian of voices not their owner.

It is difficult to avoid power differences, but there are safeguards: mutual disclosure, sharing authorship or royalties with individual/communities; transfer of skills so that women publish their own stories (Lugones and Spelman, 1999); and the right to silence (Kishwar, 1990). If all voiceless people are given a chance to speak, "the vision and view of the world that is produced by the many in their interests will be vastly different than that produced by the few" (Gaventa, 1993, 40).

VOICING AT THE MCMASTER RESEARCH CENTRE FOR THE PROMOTION OF WOMEN'S HEALTH

The McMaster Research Centre for the Promotion of Women's Health has been committed to voicing in its diverse use of participatory action research, as exemplified in its research proposal (1992, 1) or in its "Framework for Research in the Community" (1994), as well as in its many projects and activities. MRCPOWH has strived to create an academic and a community forum for the multiple voices of women to be heard who were involved in health promotion. For example, jointly with the programme of gerontology, MRCPOWH organized the McMaster Summer Institute of 1997. Researchers, community health promoters, policy-makers, students and community partners were invited to share and discuss their findings, their views and practices. Two evenings of "share and tell" were organized with immigrant women's organizations in the community (1996). We also participated in an interactive national tele-debate on "Health promotion through popular theatre: Immigrant women and empowerment" organized by the Prairie Region Health Promotion Research Centre (1995). These are only a few of many examples of MRCPOWH's efforts to create a forum for women's voices. The projects and activities conducted under the auspices of MRCPOWH and guided by a feminist approach to PAR have allowed us to confirm the relevance of PAR in health promotion with women, to refine its concepts and to enrich its use.

CONCLUSION

If, as Michel de Certeau claimed, "the future enters the present in the mode of alterities" (1997, 131), voicing represents an approach to knowledge creation and the practice of health promotion that respects and integrates the voices of alterity, or rather—in a less dichotomizing wording—the voices of difference. Drawing on the reflections of theoreticians and practitioners

from many different disciplines, we have attempted within the constraints of this chapter to demonstrate the importance and the particular relevance of voicing for women in the science of action that is indeed health promotion (Thurston, Sieppert, and Wiebe, 1998). Voicing constitutes an alternative epistemological discourse, the mandate of which is to preserve the diversity of knowledge and practices informed by cultures, races, genders, sexual orientations and abilities, as well as the urgency of needs. Theories and practices which validate voicing in health promotion can be disseminated internationally (Labonte and Robertson, 1998) and help women define their issues and act on them within their local environments. Voicing in health promotion gives an opportunity for women to experience participatory democracy, to be visible and audible and to have control over their well-being and that of their communities. Participatory democracy nurtures a politics of recognition (Taylor, 1992) and offers a strong guarantee for the protection of the civil and human rights of disenfranchised groups. Participatory democracy offers the most fertile terrain for health promotion, provided it is not used by governments as a pretext for further budget compressions at the expense of women's well-being, as it appears to be the case in our present socio-political context (Wuest, 1996).

Finally, some have asserted that the process of voicing is incompatible with theory and theorization. Theory proceeds from generalization to conceptualization. Voicing constitutes a process of personalization and privileges the standpoint position, thus making generalizations difficult and temporary at best. Voicing risks privileging fragmentation, the exceptional and the different (Butler, 1992; Bordo, 1992).

Such a politics of location can lead to political dislocation, if we make differences more operational than commonalities (Marchand and Parpart, 1995). But, as Butler says, "we are not privileging heterogeneity against abstraction but a democratizing effort to redirect both abstraction and theory to the task of addressing and compelling an enabling complexity" (1992, 164). We could argue that the more we include the complexities of an issue in knowledge creation and all aspects of health promotion, the more differences are made operational, the more relevant health promotion will become for participants; and that group voicing and community-based health promotion (rather than individual-based) constitute a more comprehensive and empowering form of health promotion. Voicing, therefore, is both a theory and a methodology grounded in respect for difference and human rights.

HEALTHY WORK ENVIRONMENTS IN HOME-CARE AGENCIES

Margaret Denton, Isik Urla Zeytinoglu, Sharon Webb, Jason Lian

Ce chapitre résume une étude faite sur la santé et la vie au travail des femmes dans le domaine des soins à domicile au sein de trois agences de services sociaux et de santé communautaires à but non lucratif dans la région d' Hamilton. L'étude portait sur un échantillon d'infirmières, de thérapeutes, d'aides pour les soins à domicile, de chefs de bureaux, de surveillants et de responsables de dossiers. Les auteures ont dirigé 19 groupes de discussion thématique composés de 99 travailleuses en soins à domicile. 892 travailleuses en soins à domicile rémunérées ont fait l'objet d'un sondage. Le stress et l'épuisement, et de mauvaises conditions de travail chez certains clients sont les problèmes associés aux soins à domicile, mentionnés par les travailleuses. Ces dernières ont aussi mentionné des problèmes de santé d'ordre physique et psychologique associés à leur travail. Les problèmes physiques rapportés sont: les douleurs musculaires dans le dos, l'arthrite, la tension artérielle élevée, les migraines, les maux de tête et l'asthme. Les aspects du travail appréciés des travailleuses sont l'administration des soins et le défi que cela représente, la flexibilité, la variété des tâches, l'appréciation des autres et le soutien administratif. Cependant, l'immense charge de travail, et le manque de contrôle que les femmes ont sur leurs conditions de travail sont des sources de stress. Les femmes ont exprimé leur inquiétude face aux politiques gouvernementales et aux coupures budgétaires récentes. De plus, les travailleuses ont manifesté leur frustration d'être constamment mal rémunérées. Les auteures recommandent que l'aspect émotionnel du travail soit pris en considération comme étant un élément important des soins à domicile. Les agences doivent hausser les salaires et les bénéfices, et augmenter leurs ressources pour maintenir le nombre d'employées à un niveau satisfaisant. Il ressort de ce projet que les services de santé devraient modifier leur orientation pour répondre aux préoccupations de santé des travailleuses qui dispensent des soins de santé à domicile.

CB CB CB CB CB

The home-care sector has experienced tremendous growth in the last decade. Home-care and home support services are the primary vehicles throughout Canada by which in-home health services are provided to clients. Home care is defined as "an array of services which enables clients incapacitated in whole or in part to live at home, often with the effect of delaying or substituting for long term care or acute care alternatives" (Federal/Provincial/ Teritorial Working Group on Home Care, 1990, 2). Home-care workers are the team of workers who provide health and social services to clients in their homes. This includes both visiting (nurses, therapists and homesupport workers) and office (managers, supervisors, and co-ordinators, case managers and office support staff) home-care workers. In this chapter we summarize a study of the health and work life of home-care workers in three non-profit community-based health and social service agencies. We focus on the work environment as a determinant of health. Health is defined as "a state of complete physical, mental and social well-being and not merely the absence of disease or infirmity" (WHO, 1994). Work life encompasses the physical, mental and social aspects of work for home-care workers.

This project consists of three stages. Stage one involved an extensive literature review and 16 focus groups conducted with 99 paid home-care workers. Stage two involved a survey of 892 paid home-care workers. Stage three is the implementation of policies and practices to ensure healthy work environments. This is the final stage of the research project and will involve comprehensive action on the part of the agencies. This chapter focuses on the first two stages and concludes with a discussion of the third.

This project utilizes participatory action research, a research methodology that gives primacy to community control over the research process. By allowing women to participate in all aspects of the research, from participation in focus groups to helping develop the questionnaire, women at all levels in the agencies were given a voice to express their work and health related concerns. Ultimately these concerns will be reflected in health promotion strategies to improve working conditions at the agencies with the intention of making the work environment healthy.

BACKGROUND

The research project was initiated in 1994 by managers from the three agencies and academic researchers from the McMaster Research Centre for the Promotion of Women's Health. The three agencies had been in contact with one another while working together to address restructuring issues in the home-care industry. The managers also had concerns about the stress that they and their employees were feeling in the workplace. They were concerned with occupational health and safety issues of employees who work in clients' homes. They wanted to see if the concerns they had were also concerns to their employees and, if so, to document the extent of such concerns and to take appropriate actions to eliminate the problems.

Researchers from MRCPOWH worked with the members of the agencies throughout the research project. Upper-level managers from the three agencies and the principal investigators from MRCPOWH formed a Community Agencies' Steering Committee (CASC). The role of the CASC was to define and guide research. The CASC developed the purpose

of the study, helped organize focus groups, assisted in the development of focus group questions, helped develop the Health and Work Life Questionnaire and provided feedback on both the focus group and employee questionnaire reports (Denton and Zeytinoglu, 1996). This project has therefore given the women in these agencies a mechanism through which they could voice their concerns about their work-related health and well-being in their own terms.

During this study, the participant agencies were undergoing rapid changes as a result of several factors: a tremendous growth in the home-care industry; changes in technology have affected work design and location; agencies have been part of pilot projects; legislative changes have occurred that reorganize the delivery of community care in the province; increasing caseloads and increases in the severity of cases; economic restraints; changes in public awareness and the demand for home-based health and social services. Examples of changes in technology include the introduction of voicemail and fax, which means that visiting home-care workers no longer make daily visits to the office but work with greater autonomy and isolation in the community. Examples of pilot projects include the introduction of computer software and hardware for case management, emergency response teams in hospitals and a pilot project that delivers homemaking by teams. Bill 173 and the introduction of the Integrated Homemaking Program are examples of legislative changes. Finally, economic restraints that agencies have experienced include decreased or capped budgets.

At the time of the study, one agency was primarily a visiting homemaker agency, another agency provided a volunteer program—visiting homemaking and visiting nursing programs—and a third agency administered a home care program, placement co-ordination services, a volunteer program, a visiting nurses program and a therapy service. Following the completion of the first two stages of the project, there were major changes in the structure and functions of two of the agencies. The third agency no longer administers the home-care program, the placement co-ordination services (PCS) or the therapy program. It is primarily a visiting nursing agency, with the exception of the volunteer program. The second agency closed its visiting homemaker program. These changes were due to a government decision to establish Community Care Access Centres (CCACs) and place the home-care programs and PCS in the CCACs. The therapy program was included in the CCAC for a period of two years, by which time it was expected that the therapists would join or form therapy service organizations. The objective of the CCACs is to provide consumers with a single point of access to home-care services. These changes have had an impact on the third stage of the study—the implementation of health promotion strategies in the workplace.

LITERATURE REVIEW

Home care, a female-dominated sector, has experienced tremendous growth in the last decade (Martin Matthews, 1992; Havens, 1995; Deber and Williams, 1995). Despite this growth, research is limited in this area as few studies examine the health of home-care workers. Investigation into occupational health issues in female-dominated jobs started only recently (Messing et al., 1995; Zeytinoglu et al., 1997) and research on the occupational health of homesupport workers is almost non-existent, with the exception of a few studies (Aronson

and Neysmith, 1996a, 1996b; Martin Matthews 1992; Donovan, 1989; Bartoldus et al., 1989). Despite limited available research, we will attempt to synthesize existing literature in this area. Evidence from focus groups is used in the literature review as well as to illustrate research findings. Literature regarding health issues will be examined first, followed by work life issues.

OCCUPATIONAL HEALTH ISSUES

Work can affect one's mental and physical health in both positive and negative ways. Studies demonstrate that work increases self-esteem, benefiting women's mental health and showing perceived improvement in physical health (Canadian Advisory Council on the Status of Women, 1995; Dennerstein, 1995; Pugliesi, 1995; Walters, Beardwood, Eyles and French, 1995). Work-related stress is a central health issue for community-based health and social service providers (Walcott-McQuigg, 1994; Bartoldus, Gillery and Sturgess, 1989). There is also reason to believe that female managers are subject to more job-related stress than men in comparable positions (Korabik, McDonald and Rosin, 1993). Literature shows several work environment stressors that were included in the conceptual model. Work environment stressors in home-care work include: limited control of tasks and scheduling; feelings of powerlessness and little impact with respect to agency policy; job dissatisfaction; shift work; repetitive monotonous work; problem clientele; job changes; stagnancy; poor supervision or supervisors; prejudice; sexism; employment instability; restricted social interaction with and isolation from co-workers; lack of institutional and organizational support; lack of communication; transportation difficulties; and low wages (Martin Matthews, 1992).

Studies show that office workers report a variety of physical health problems including repetitive strain (motion) injuries, with symptoms of pain, weakness, swelling, tingling burning sensation or dull ache all over affected areas (Stephens and Smith, 1996; Bertolini and Drewczynski, 1990), fatigue, feeling heavy headed, headache, nausea/dizziness and difficulty concentrating (Stenberg and Wall, 1995; Bachmann and Myers, 1995), vision, posture (OML, 1995) and/or respiratory problems. Clinical studies on the 'sick building syndrome' have found mucosal irritation, lower respiratory symptoms and skin symptoms to be prevalent particularly among female workers (Bachmann and Myers, 1995; Stenberg and Wall, 1995).

To date, little if any research has focused specifically on work-related physical health problems for home-care workers (Juhl et al., 1993; O'Brien-Pallas and Bauman, 1992). Studies on work-related physical health for workers in the nursing profession, focusing primarily on nurses and nursing assistants in institutions and public health departments, demonstrate that workers acquire illnesses from various chemicals they deal with in the work environment, they are attacked by patients, have backaches, muscle pains or other injuries in lifting patients, have physical adjustment problems in shift work and are mentally and physically exhausted from overwork (Ahlberg-Hulten et al., 1995; Messing et al., 1995). In a study of the nursing professions, Walters et al. (1997) found that workers were exhausted at the end of the day, had headaches, migraines, insomnia, difficulty in 'getting going,' had backaches, felt tired on the job and were depressed.

In the community, home-care workers face safety hazards such as unsafe homes and neighbourhoods, risks from physical, emotional and sexual violence (including intimidation,

harassment and assault) and sexual or racial harassment by clients or the clients' family members. In addition, transportation and travel can be hazardous for home-care workers as they are at risk of traffic accidents and personal injuries, especially those which occur in bad weather (Donovan, 1989; Martin Matthews, 1992).

WORK ENVIRONMENT AS A DETERMINANT OF HEALTH

Most research into work life for home-care workers concentrates on job issues for visiting homemakers or home aides. A positive feature and source of job motivation for visiting homemakers is the close relationships they develop with clients (Feldman et al., 1994). James (1989) defines emotional labour as labour involved in dealing with other people's feelings. While this "caring" aspect of home-care work is important for both clients and workers, policies often place emphasis on the importance of completing instrumental tasks rather than on the caring aspect of the job (Aronson and Neysmith, 1996a).

Other characteristics of the jobs of visiting homemakers include: difficult clients; low wages and minimal benefits; problems associated with irregular and unstable hours and scheduling; travel difficulties; isolation and lack of support from peers and supervisors; negative public images and lack of recognition for their work (Suprin, Haslanger and Dawson, 1994; Donovan, Kurzman and Rotman, 1993; Eustis, Fischer and Kane, 1994; Crown, Ahlburg, and McAdam, 1995; Aronson and Neysmith 1996a, 1996b; Denton and Zeytinoglu, 1996). Visiting homemakers, who are over-represented by women of visible ethnic and immigrant minority groups, also face barriers on the job due to prejudices on the part of their clients (Denton and Zeytinoglu, 1996).

Nurses also have specific concerns in their work life including negative features such as occupational hazards (Villeneuve, Semogas, Peereboom, Irvine, McGillis-Hall, Walsh, O'Brien-Pallas and Baumann, 1995) and job demands (Hatrick and Hills, 1993). Examples of job demands are: physical labour, contagious diseases, toxic chemicals, the need for emotional stability in the face of traumas and death, and technical competence (Glazer, 1988). Positive features of nursing include the impact of peer support in attaining quality work life (Attridge and Callahan, 1989).

As the literature has demonstrated, work life affects a person's health in both positive and negative ways. In the next section, a summary of findings from 19 focus groups with 99 home-care workers and a survey of 892 home-care workers further explain how work can affect home-care workers' health.

METHODS

Methods include 16 focus groups with paid home-care workers (N=99) and a self-administered, mail-out questionnaire to paid home-care workers from the three agencies (N=1346). Focus group participants were asked nine open-ended questions developed by the CASC to generate discussion about their work and health. Participants were asked to

describe their work, the positive and negative aspects of their work, if things were different in their job from last year, if they expected things to be different next year, what things in their life affect how they do their job, and if they think their work affects their health, meaning overall wellness encompassing physical, emotional and social components.

Results from the focus group were used, along with the literature review, to create a conceptual model. The conceptual model draws on Karasek's and Theorell's (1990) model to outline several factors that predict work-related health and well-being. Five types of factors are conceptualized as influencing work-related health and well-being: external/social structural factors; organizational/managerial factors; client factors; occupational characteristics; and individual/personal factors.

Guided by the conceptual model and information from the literature review and focus group results, the CASC constructed a Health and Work Life Questionnaire. All 1346 employees from the three agencies were mailed a questionnaire, with a response rate of 66% (892 respondents). In order to make generalizations, some questions replicated those in the Statistics Canada 1994 National Population Health Survey (NPHS) and the 1990 General Social Survey. Most work life questions asked respondents to agree or disagree according to a five point scale, and most health questions asked respondents to describe how they felt from "none of the time" to "most of the time" using a five point scale. Later in the analysis, these categories were compressed into three point scales for descriptive purposes.

The questionnaire includes sections on: health; work life; working directly in clients' homes; working in the office; supervisors; technological change; training; family/friends; and background demographics. Mental health questions included self-reported health, job satisfaction, self-esteem, mastery, control or sense of coherence, and exhaustion. Physical health was measured by examining long-term health conditions diagnosed by health professionals and self-reported health conditions ranging from musculoskeletal problems to allergies and infections. Occupational safety issues for both visiting and office home-care workers were also incorporated into the questionnaire. Work life issues included positive features of work (support, challenging job content, flexibility, variety appreciation and control over work) and negative features (government policy, organizational issues, excessive workload, pay and benefits, office co-ordination and lack of organizational and peer support). Other sections of the questionnaire were organized into separate sections for those who work directly with clients and those who supervise others. Technological changes and training were issues also covered in the questionnaire. Finally, respondents were asked about their demographic characteristics including information on family and friends.

Focus group findings were analyzed using NUD*IST, a software package for qualitative data. Frequencies were used to describe questionnaire results. Cross tabulations were used to make comparisons between five occupational groups: managers, supervisors and co-ordinators; other office support staff; case managers; nurses and therapists; and visiting homemakers. Where applicable, comparisons are drawn between home-care workers and a NPHS sample of all employed Canadian women aged 20 to 64. This allows us to determine issues unique to home-care workers.

RESULTS

In reporting the results we interweave quotations from the focus groups with questionnaire results to give voice to home-care workers.

Most of the respondents are female (92%), fall within the age range 35 to 54 (62%), are Canadian born (68%), have education level of some college or higher (77%) and are married or living with a partner (69%). The NPHS sample differed from home-care workers in several ways: all working women aged 20 to 64 were less likely than home-care workers to fall within ages 35 to 54 (49%) and to report some college or more education (70%). And the NPHS respondents (87%) were more likely to be Canadian born.

OCCUPATIONAL HEALTH ISSUES

Mental Health

In terms of mental health, most (95%) home-care workers responding to our questionnaire reported good to excellent health. Like the NPHS comparison group, home-care workers indicated relatively high levels of self-esteem and mastery. They also report relatively high levels of control. They said:

> "I think it keeps me healthy. That the challenge of working and feeling
> needed at work, feeling valued at work is an important part of self esteem
> and makes you feel healthy." (manager)

> "I enjoy my job. It gives me a sense of well-being, it gives me a sense of
> accomplishment. I like the social aspect." (office support staff)

Stress was a problem for 29% of home-care workers who described their lives as stressful or very stressful and 28% who described their jobs as stressful or very stressful. This was especially a problem for managers, supervisors and co-ordinators, case mangers and nurses. In fact, 58% of managers, supervisors and co-ordinators described their lives as stressful and 70% described their jobs as stressful. One supervisor put it this way:

> "But sometimes I find that I really feel very much like one more thing to
> deal with and I'm going to start to cry."

Exhaustion was a problem, with 75% of home-care workers reporting feeling exhausted at the end of the day either some, most or all of the time. To illustrate this point, one co-ordinator notes:

> "It's not that I'm physically tired at the end of the day, I'm more
> sometimes emotionally tired. I just think I've done so many things today
> I just can't do one more thing."

A visiting homemaker says:

> "Stress makes it more, come out, it makes you feel tired, fatigued, really
> tired, can't sleep at night, don't sleep right at night."

Physical Health, Injuries and Hazards

Overall, home-care workers show relatively higher levels of long-term health problems than the NPHS comparison group. Home-care workers were more likely than the comparison group to have been diagnosed with arthritis or rheumatism, back problems excluding arthritis, high blood pressure, migraine headaches and asthma. A specific problem area for managers, supervisors and co-ordinators was high blood pressure. Case managers reported high blood pressure, carpal tunnel syndrome, migraine headaches and other musculoskeletal disorders. Health conditions for nurses and therapists were back problems, allergies, migraine headaches, arthritis or rheumatism, pain in the back, neck or shoulders, and sore or sprained muscles. Visiting homemakers reported allergies, back problems, arthritis or rheumatism, and pain in the back, neck or shoulder, arm, elbow or hand, and knees.

Approximately 14% of home-care workers reported a work-related injury. The average number of days home-care workers spent absent from work due to work-related injuries was 89 days. Of those who had injuries, one-half made a Workers' Compensation claim. Office staff were more likely than other occupations to report sprains or strains, injuries to the arms or hands and injuries resulting from repetitive motion. One office support staff member says:

> "Physically my job has affected me by stretching some muscles in my
> neck and shoulder and I've looked at rearranging my desk and those kinds
> of things...".

Visiting staff were most likely to report multiple injures, injuries to the back or spine, occurrences of injuries at clients' homes, and injuries as a result of lifting/moving and bending/ straining. One nurse describes:

> "I was off for twelve weeks last year, it was awful.... He slipped and I
> just went down to help break his fall and it was kind of like I could
> hardly get out of that place. I've never had so much pain."

Nurses and therapists were the most likely occupational category to report injuries with 17% of nurses and therapists reporting work-related injuries in the past 12 months. Visiting homemakers (14%) were the second most likely occupation to report injuries.

Occupational safety hazards were a concern for both visiting and office home-care workers. Most visiting home-care workers agreed that they are exposed to infectious diseases, poor physical conditions in clients' homes, hazards in clients' homes and neighbourhoods, and second-hand smoke. As well, most agreed that they travel between clients' homes in bad weather and that clients' homes are excessively hot. One nurse expresses her concern regarding infectious diseases:

"...not always knowing who has got what...when for instance, bodily fluids...you sort of assume that everybody has AIDS because we're not always notified, or something may come through five days later."

Visiting home-care workers also described car accidents, physical threats and assaults and sexual harassment. Sexual harassment was a problem encountered by visiting staff, especially by nurses and therapists. Almost one-half of nurses and therapists reported having been exposed to inappropriate sexual comments or behaviour by clients or their family members. A nurse says:

"Some of them are quite embarrassed actually, because they think it is expected, and they are actually embarrassed when you tell them that you don't like that and some will even apologize. The demented ones don't apologize, they just persevere."

Exposure to inappropriate racial/ethnic comments or behaviour was reported by 17% of visiting homemakers.

Approximately one-half of office workers were concerned with the air quality, temperature and an unsafe neighbourhood surrounding the office. Some comments make note of the poor air in the office:

"Well I've had respiratory problems ever since I started to work here." (supervisor)

"...There are some people that refer to this as a sick building...." (manager)

CHARACTERISTICS OF THE WORK ENVIRONMENT

Positive Features of the Work Environment

Positive features of home-care work were identified by home-care workers. A considerable number of respondents agreed that their job requires them to learn new things and use their skills, and that the people they work with and their supervisors are helpful. In general, home-care workers reported that their work environment is supportive, although they tended to report less peer support than organizational support. Only one-half of home-care workers reported that the people they work with take a personal interest in them, and two-thirds of home-care workers agreed that their co-workers were supportive in times of personal crisis, illness or needing time off to care for other family members. This may be because there is little contact with peers for nurses and visiting homemakers. Nurses no longer report to the office on a daily basis but receive their cases by fax to their homes.

Workers reported challenging job content, flexibility, variety and appreciation as positive aspects of their work. In one nurse's voice:

"Well what I like about working in the community is you can be your own boss, to a point. You're out there with the challenge of making decisions, a little more freely...and I like that."

One therapist comments on the flexibility in her job:

"What I value most about working for home care is the autonomy and the flexibility, and those are extremely important at this stage of my life and my career."

A visiting homemaker says:

"I have presently seven different clients a week and I find that it is far from boring, it's a real experience because I feel that this is a 'jack of all trades.' I have done just absolutely everything, looked after every kind of illness going."

Relationships with clients were also identified as a positive feature of home-care work. For visiting home-care workers, almost all agreed that they have the opportunity to care for/ about clients, they enjoy working one-on-one with clients and they gain knowledge and learn from clients.

Negative Features of the Work Environment

On the negative side of work life, questionnaire results indicate a lack of control over work as an issue faced by home-care workers. One visiting homemaker puts it this way:

"Many the time I worked with the client who, you see changes, they need more care, they need more help and you report it and you report it and report it and you know like you feel there's nothing being done."

With the exception of managers, supervisors and co-ordinators, respondents who agreed they have much to say about what happens on the job were in the minority. As well, repetitive, monotonous work was identified as a problem by almost one-half of home-care workers who agreed that their job requires them to do the same tasks over and over. This was especially a concern for visiting homemakers and office support staff. The majority of visiting home-care workers agreed that their job requires physical effort.

Home care workers also expressed concern with government policies. An office support staff member says:

"Then you have the MSA coming and people saying—we don't know where we're going to be in four years, just hang on for the ride—and people are kind of going—I can't take anymore, I just can't take anymore."

Most home-care workers agreed that they are worried that legislation and government policies will affect their jobs. Especially noteworthy is that over two-thirds of home-care workers are concerned about losing their jobs due to changes in the long-term care sector and potential downsizing at their respective agencies. Job security is clearly a work difficulty, as only 25.9% of home-care workers agreed that their job security is good. This is in stark contrast to the NPHS, in which 66.8% agreed that their job security is good. Home-care workers express their concerns about losing their jobs due to legislative changes:

> "...and for two years at least we've been wondering if we're going to have a job tomorrow." (therapist)

> "The legislation says there will be jobs for front-line workers and there is no guarantee for mangers, so theoretically we could all say—well, I guess it's me." (manager)

Managers, supervisors and co-ordinators were more likely than other occupations to report excessive workload as a negative aspect of work. A manager noted:

> "I have felt sometimes pushed to my limit, to the end—emotionally and physically...."

One supervisor expresses it this way:

> "We're just running all the time. And you're running from one meeting to another or you're running to whatever....

They described lacking time for lunch and coffee breaks and concern about not being able to spend as much time as they want to with their staff. It is important to place these issues within the context of the agencies' increased caseloads and capped budgets.

Pay and benefits emerged as a negative aspect of home-care work for home-care workers as only about one-half of workers agreed that they feel that they are fairly paid, their earnings are predictable and their benefits are good. This is a particular problem for visiting homemakers who are paid by the hour and do not have a guaranteed number of hours per week. One visiting homemaker comments on the inconsistent nature of her earnings:

> "We don't know how much money we're going to earn and you have to have a certain amount of money to live...."

A supervisor says:

> "Salaries are a real downer because comparable to other comparable positions within hospitals and other health-care facilities the supervisory staff here earn substantially less and our benefits could be much improved."

Again, with the capped budgets, there have been no salary increases in the past several years and they have also had several days without pay (Rae days).

Office co-ordination was also a concern for many. Substantial numbers of home-care workers were not satisfied with the number of hours they are given per week, and only 55.9% agreed that their hours of work are predictable. Supervisors and visiting homemakers describe office co-ordination or scheduling as a work difficulty. A supervisor notes:

> "We're delivering a service that has unpredictable needs and we don't have a set number of clients that we're servicing...."

A visiting homemaker states:

> "I was getting maybe 45 hours...then all of a sudden you're getting 30 hours, 32 hours.... There's never a notice of change...its not fair...."

They described the difficulties of being on call:

> "If they don't call you the night before, you phone your voice mail... there's no messages, so they want you to sit home the next day waiting to see if they're going to call. So you can't make any plans."

TECHNOLOGY ISSUES

Questionnaire findings indicate that technology has an impact on the work lives of these workers in a positive way. Over two-thirds of respondents felt that technology has led to an increase in efficiency and over one-half reported that they use more skills as a result of technological change. Focus group participants, however, identified several concerns related to the introduction of voice mail and a new computer system in their work environment. One case manager notes:

> "At times I feel I'm not getting information promptly. I am getting a whole series of different messages going in and I'm expected to sit in front of a computer and update all these programs when I've heard nothing from any of the cases so I don't know what's going on, this since we've had CASIS going on in the computer system. I feel I have less and less control over what's happening out there and I've less and less time to get out and do the home visits."

In the words of one nurse:

> "If you leave too many messages and you don't get response back, it's like uggh, too many dangling ends, and that's frustrating when you're out there."

Supervisors expressed concerns about losing personal contact with those whom they supervise:

> "I think this whole thing about technology and how it depersonalizes our interactions with other people takes away the work that we used to give to other people, as well, like gee, how's your son doing today...you lose that whole thing about somebody caring."

The differences between focus group and questionnaire findings could be explained by timing. At the time of the focus groups, technological changes were just being implemented. Therefore, it is likely that, since the focus groups, home-care workers have had the time to become familiar with the new technology.

WORK ENVIRONMENT CONCERNS OF SPECIFIC OCCUPATIONAL GROUPS

Findings highlight important areas of concern for those who supervise others. Very few (9%) supervisors spend more than half of their time supervising others. Furthermore, only one-half agreed that they have enough personal contact with staff. One-fifth of those who supervise others agreed they are too busy to provide emotional support to their staff. One supervisor states, "I really think that we're almost too busy to be caring anymore...." Next, we will outline work life issues for visiting home-care workers.

James (1989) defines emotional labour as labour involved in dealing with other peoples' feelings. Visiting home-care workers face the challenges of emotional labour on a daily basis. Most home-care workers worry about clients and many report developing close personal relationships with clients. At the same time, approximately one-half of home-care workers agreed that they do not have enough time to provide emotional support to clients and to clients' family members. Dealing with the declining health and death of some clients are job difficulties faced by visiting staff. One visiting homemaker puts it this way:

> "Because we take care of the elderly, palliative care, the chronic care, we know the end is going to come and so if you're there for a year you become attached, you can't stop, they tell you don't get attached, but forget that, that's impossible. I mean, I'm a human being and I feel...and it's hard and that's the part that no matter how many times the hurt is always there and you know you shed a tear."

While 75% of home-care workers find the death of some clients to be upsetting, only 34% of nurses and therapists and 8% of visiting homemakers are allowed a paid bereavement to attend a funeral or to visit family members after the death of a client. Work life issues for visiting homemakers will be examined next.

Results indicate that several issues are unique to the job of the visiting homemaker. One-half of visiting homemakers agreed that their clients view them as a 'cleaning person'. One visiting homemaker put it this way:

> "I went to one place right before Christmas and she though it was wonderful that they were having a cleaning lady before the holidays then last week they told me they hired another cleaning lady cause I wasn't doing the job properly. I said thank you, I'm not your cleaning lady...."

Approximately three-quarters of visiting homemakers agreed that they deal with difficult clients. They describe how some clients can make excessive demands, while others are simply unpleasant.

HEALTH PROMOTION STRATEGIES

Consistent with population health promotion principles, results of this research are intended to be translated into policy development and practice that will improve workers' health. All five health promotion strategies as outlined by the Ottawa Charter (1986) were suggested by this research.

Build Healthy Public Policy

By making several policy recommendations, this study addresses the strategy to build healthy public policy. One recommendation is for governments and funding bodies to recognize emotional labour as an important part of home-care work. Home-care workers in this study reported caring relationships with clients as a feature of their jobs. Still, considerable numbers of visiting home-care workers agreed that they do not have enough time to provide emotional support to clients and their families. Therefore, policy must provide visiting staff with sufficient time to provide emotional support for clients and their families. Policy must also grant supervisors the necessary time to be spent supervising others. Few supervisors reported spending more than half of their time supervising others and many reported being too busy to provide emotional support to their staff.

It is also recommended that future policy address the aspect of bereavement for paid home-care workers. Workers should be allowed a paid bereavement visit to attend a client's funeral or visit family members.

In addition, policy must grant agencies adequate resources to promote healthy work environments. This means addressing concerns of those workers who did not agree that they receive adequate pay and benefits. In addition, agencies should be provided with resources to maintain an adequate level of staff. This may reduce stress associated with excessive workloads reported by managers, supervisors and co-ordinators in this study.

Create Supportive Environments

This project helped to create supportive environments by identifying problems and strengths in the physical and social work environment for home-care workers. As a result, a number of positive changes have already occurred. Since the focus groups, the nursing agency has made several renovations to their office building in an attempt to improve air quality. Union organization at this agency was partly a response to legislative changes that threatened

job security. At another agency, changes have been made to ensure more flexible work schedules. A third agency has made changes to reduce "on call" weekends, has introduced pilot projects involving teams of homemakers and is making more effort to inform their staff of policy changes. While these changes are a start, the process of achieving healthy work environments has only begun. Results show a number of areas that need to be improved in order to create healthy work environments. It is recommended that funding agencies acknowledge and understand these problem areas faced by providing adequate funds to community-based health and social service agencies in support of their efforts to eliminate health problems for their employees.

In order to create supportive environments, agencies must address the issues raised in this study. Recommendations to the agencies are extensive. They must make efforts to reduce workload and overtime for managers. To ease home-care workers' concerns regarding policies, detailed information on government policies and changes in long-term care should be provided to home-care workers. As change is occurring so rapidly, frequent agency meetings would be helpful in keeping workers abreast of the latest developments. Information should also be available in written format, perhaps in agency newsletters and/or information pamphlets sent to staff members.

Mandatory training sessions could ensure that workers have adequate knowledge regarding proper safety procedures and techniques, such as lifting clients and how to avoid falls. Communication between office support staff, including those who plan the home-care visits and visiting home-care staff, is also essential, as management and office staff members do not work in clients' homes and may not be aware of possible safety hazards. As repetitive motion injuries are prevalent among office workers, it may be imperative to allow workers to rotate tasks, so they are not performing the same tasks over and over.

Feedback and input from staff is essential in the provision of healthy work environments. In order to provide workers with a voice in their work environment, workers will need to be provided with a forum such as weekly or monthly meetings or suggestion boxes in which they can express their views related to work issues.

Results of this study have indicated that peer support lags behind organizational support for home-care workers. As such, agencies must attempt to improve peer support. This could be accomplished through enhancing an atmosphere in which workers could identify themselves as part of a team. This is especially important for visiting home-care workers who may not see their peers on a frequent basis. Suggestions to enhance a teamwork environment include conducting weekly team meetings. Support groups, special interest and friendship groups could also be encouraged both within and outside of the workplace.

Strengthen Community Action

As MRCPOWH members and the agencies worked together, community action was strengthened. This research project strengthened community action in several ways. Community action was strengthened as MRCPOWH members worked with the CASC to develop strategies to achieve healthy work environments. Community action was also strengthened as partnerships were developed between the three agencies. As well, women were given voices in the process of participatory action research that empowered women as participants in this study. As three non-profit community-based health and social service

agencies, they became aware of their commonalities as they worked together to achieve similar goals. The research process itself also contributed to the strengthening of community action as focus groups and questionnaires provided workers with a mechanism to express their views. Workers were able to express issues that they felt were of importance in their own words.

Develop Personal Skills

The research project developed personal skills by helping agencies to define and solve their own problems. In accordance with principles of participatory action research, members of the agencies participated in all aspects of the research, ranging from identifying key issues, to helping with focus group and questionnaire construction, and implementing health promotion strategies. These activities were part of a learning process which helped agency members to develop personal skills. As well, agency members and their employees were empowered to use their personal skills to make changes in their work environments. It is hoped that agencies will make more changes in their work environments by heeding the recommendations of this study. This will further help enhance their development of personal skills.

Reorient Health Services

By focusing on the health of those who provide health services, this study addressed the health promotion strategy to reorient health services. This research project is unique because instead of focusing on clients or users of the health-care system, this study has focused on the health of health-care workers. This project suggests that health services should be reoriented to address the health concerns of workers who provide health services. Ultimately this study allowed women to tell us in their own voices how to reorient health services. As home-care services expand, it will be increasingly important to ensure that the providers of community-based health and social services are healthy. This study also shows that workers' own views and perceptions of health services are important in the reorientation of health services.

LEVEL AT WHICH ACTION IS TO BE TAKEN

Health promotion is an ongoing process and requires continual effort. While some changes have been made as a result of this study, more changes are necessary. Stage three of this project will require agencies to develop and implement strategies to address the health and work life concerns of their workers. Ultimately, results should encourage action at the community, sector/system and society levels. At the community level, agencies must address the practical suggestions that have developed from these findings. At the sector/system level, government must consider the policy recommendations put forth in this project. Finally, at the society level, the importance of home-care work must receive the recognition that it deserves. This is especially important in light of the rapid growth in the home-care industry.

PROMOTING THE PHYSICAL AND MENTAL HEALTH OF FEMALE SOCIAL WORKERS WORKING IN CHILD WELFARE[1]

Nora Gold

Dans la recherche que nous résumons dans ce chapitre, les femmes qui travaillent dans les agences de La protection de l'enfance à Hamilton sont considérées comme un groupe à risque au niveau de la santé à cause des conditions dans lesquelles elles travaillent. Conditions où la nature même du travail et son environnement sont associés à un niveau de stress extrêmement élevé et sur lesquelles elles ne peuvent exercer aucun contrôle. Avec deux Sociétés de protection de l'enfance, des groupes de discussion thématique ont été formés et se sont réunis. En tout, les entrevues on été menées avec 40 travailleuses dans six groupes. Les femmes trouvaient leur travail stimulant et en étaient très fières, mais mentionnaient aussi le stress causé par une charge de travail excessivement lourde, par la nature imprévisible du travail, par les décisions de la cour qui minaient sans cesse leur autorité et par le manque de ressources. Elles se plaignaient aussi souvent du manque d'appréciation de la part de l'organisation et affirmaient que leur faible salaire était bien la preuve du peu de considération que la société en général accordait à la valeur de leur travail. Elles étaient très offensées du sexisme perceptible dans leur milieu de travail et savaient que les responsabilités familiales ne faisaient qu'aggraver le stress. Le travail dans le domaine de la protection de l'enfance était vu par la grande majorité comme ayant un effet négatif sur leur santé physique; les femmes mentionnaient surtout l'épuisement chronique comme étant directement lié à leur travail. Elles ont rapporté que l'épuisement mental était aussi intense que l'épuisement physique. Les femmes ont élaboré diverses stratégies pour faire face au stress.

ೞ ೞ ೞ ೞ ೞ

[1] This paper, in somewhat different form, previously appeared in *Child Welfare*. The author would like to gratefully acknowledge both the financial and the moral support of the McMaster Research Centre for the Promotion of Women's Health at McMaster University. She also thanks Joanne Loughlin, who worked as her research assistant on this project.

In the research summarized in this chapter, women working in child welfare agencies in Hamilton were seen as a group at risk because of *risk conditions*—more specifically certain features of their work and work environments that, in the literature, are associated with little control and extremely high levels of stress (Callahan and Attridge, 1990; Esposito and Fine, 1985; Harrison, 1980). The nature of this work is not unrelated to the gender of those who do it: front-line child welfare work is predominantly "women's work," with more than 70% of the front-line workers being women (Callahan, 1993a). Men working in child welfare rise faster than women through the ranks, are disproportionately represented in senior management and supervisory positions, and earn more money (Callahan, 1993b; Deardorf, Brown, Baker, Meyer, Brandwein, Giibelman and Schervish, 1995). Many of the women who do this work do so at considerable personal cost and out of a female ethic of "caring" that, although experienced as personal, is structurally determined (Baines, Evans and Neysmith, 1991; Callahan, 1993a, Esposito and Fine, 1985; Swift, 1995).

The research in this area has thus far studied the stress of child welfare work and its emotional impact on the women who do it, but has not yet examined the costs to their physical and mental health. This is surprising, given the sizable body of research that shows a direct association between care-giving work and problems with both physical health (Baldwin and Glendinning, 1983; Fisman, 1988; Simon, 1986) and mental health (Berry and Zimmerman, 1983; DeMyer, 1979; Farber, 1959; Featherstone, 1982; Finch and Groves, 1983; Gold, 1990; Goldberg, Marcovitch, MacGregor and Lojkasek, 1985; Simon, 1986; Wikler, Wasow and Hatfield, 1981). Furthermore, there is very little written in the literature about programs or interventions designed to help these workers. In response to these two gaps in knowledge, then, as well as strong interest from the field,[2] this study was undertaken (a) to explore the physical and mental health effects of working in child welfare, and (b) to help the women doing this work develop strategies for the protection and promotion of their health.

METHOD

Participatory research was selected as the methodology for this study, because it is committed to helping to solve the problems it studies, not just to describing them (Hall, 1981, 1975; Maguire, 1987); it facilitates the empowerment of those involved (the "participants," rather than the "subjects") (Ibid.); and it is consistent with a feminist analysis and with feminist research methods (Hall, 1981; Maguire, 1987; Reinharz, 1992; Stanley and Wise, 1983). For this study, two children's aid societies[3] were approached to take part and both agreed. Letters briefly describing the research were then sent out to the supervisors of all the units at these agencies, asking them to suggest optimal times for a focus group meeting with their female social workers. The purpose of the first phase in participatory research (the investigation phase) is to collectively problem-pose and sometimes problem-solve (Hall,

[2] In participatory research, it is important that the research project comes not only from an outside researcher but also from the field (Hall, 1981, 1975; Maguire, 1987).

[3] Children's Aid Societies (or CASs) are the agencies responsible for all aspects of child welfare in the province of Ontario. Unlike some other systems, which have separate agencies

1981; Maguire, 1987), and focus groups are an effective means of doing this (Krueger, 1988). About one-half of the female social workers at each agency were available at the appointed times. In total, 40 workers were interviewed in six focus groups over a two-month period. To facilitate open and frank discussion, front-line workers and supervisors met in separate groups. Four of the groups contained 30 women working together in front-line positions in different units (e.g., foster care, intake). The remaining two groups were made up of ten supervisors in middle management.

Each of the focus groups met once for approximately an hour-and-a-half. All of the groups were led by the same research assistant, and all of the women who took part participated voluntarily and with informed consent. The content of the discussions focused on participants' perceptions of both the positive and the negative aspects of their work; what they considered to be the effects of the job on their physical and mental health; and what they did in response either to cope or to protect or promote their own health. The women in this study spoke openly and eagerly about their thoughts and feelings regarding their work in child welfare. Many of them expressed appreciation, even gratitude, for the opportunity to talk about these matters with other colleagues and felt validated and supported by the experience. These discussions were audiotaped and transcribed, and then analyzed in terms of the salient issues and themes.

RESULTS OF THE FOCUS GROUPS

Positive Aspects of the Work

Almost without exception, the women in this study had positive things to say about their work. They felt the work was important, they were proud of being in child welfare and overall they found it exciting, challenging and rewarding. The single most rewarding aspect of the work was getting results or seeing people change. One woman was even more explicit about this theme of professional efficacy, saying that she liked this field because "here social workers make decisions." Women also mentioned as positive aspects of their work the support they receive from other workers on their teams and the support, trust and flexibility of their supervisors.

Negative Aspects of the Work

The negative and stressful aspects of the job identified by these women included many of the same elements previously described in the literature (Callahan, 1993a; Callahan and Attridge, 1990; Esposito and Fine, 1985; Harrison, 1980). The women in this study felt that the expectations placed upon them were impossible, first of all (and at the most obvious level) in terms of workload. They had no control over caseload size, because according to their agencies' mandate, they were not allowed to refuse service to anyone who applied for

for child protection and for other aspects of child welfare, CASs provide all child welfare services under one roof (adoption, foster care, long-term care). CASs receive their referrals both from private individuals and other professionals in the community.

it. Because of this, one frustrated worker described her agency as a "dumping-ground" for the rest of the professional community: "What no one else wants to do, we have to pick up." Another worker rejected the suggestion that the workload is reasonable and that the problem is merely one of time management. "It's not that," she said. "You just can't fit, ten pounds of shit into a five pound bag."

Lack of control was a major issue for these workers, not only regarding caseload size but also concerning the unpredictability of the work and their resulting inability to schedule or pace themselves, court decisions that undermined their authority and insufficient resources. (Regarding the latter, one worker blamed lack of resources for several children's removal from their homes, because if the appropriate resources had been in place, they would have been able to stay.) In one focus group, one worker summarized the essence of her job stress as "having to make very important decisions without very much power or control," consistent with the theme of "responsibility without authority" in Esposito and Fine (1985, 729).[4] Several others echoed this sentiment and said that they felt quite disempowered, even powerless, at work although they were perceived as very powerful by the parents, foster parents and children. Some of this feeling of powerlessness was related to the bureaucratic hierarchy within which they worked and the constant awareness of their legal accountability. "You must not make mistakes," said one. "You can't slip," said another. "One wrong step, and you could get sued...." "It's like O.J. Simpson: you are on trial all the time."

In this context, an unsupportive or critical supervisor was seen as a major source of stress.[5] In addition, the lack of organizational recognition and praise was mentioned repeatedly as problematic. "You don't feel successful," said one woman. "You don't feel good about yourself in this job."[6] Reinforcing this feeling is the low salary they receive which, apart from its material implications, is a symbolic expression of the low value placed on their work by the society at large.[7] Furthermore, other social workers outside the child welfare field, friends and even family members often denigrate this work, compounding the stress and eroded self-esteem of these women.

Role strain, role ambiguity and role conflict, identified in previous studies as factors contributing to work stress in child welfare (Callahan, 1993a; Esposito and Fine, 1985; Harrison, 1980; Herbert and Mould, 1992; Jayaratne and Chess, 1985), were also found to be a problem for the women in this study. Both front-line workers and middle-management

[4] It is interesting and relevant to note here that "jobs with high task demands and little decision making latitude create stress by violating human needs for autonomy and self-esteem" (Lowe, 1989 citing Karasek).

[5] Having supportive supervisors is positively associated with job satisfaction; they help workers to cope with work-related stresses and mobilize the emotional energy needed for effective performance. The benefits of supportive supervision are lost in work environments with excessive demands (high workload). Similarly, Edmonton postal workers who found their job pressures to be a problem reported having non-supportive supervisors Lowe, 1989: 44).

[6] One worker, desperate for some positive feedback, has saved over the years the four or five stickies she received from her supervisor containing nice comments about her work.

[7] Social workers were found in one study to earn the lowest salary of three female professions (Ozawa and Law, 1993). They have earned less than men since this was first studied in 1925 and continue to do so to the present (Deardorf et al., 1995). In Jayaratne and Chess's (1985) research, 55.7% of the workers in their sample felt underpaid.

supervisors spoke of role ambiguity and interpersonal role conflict, such as being torn between parents and children, between foster parents and placement workers, and between the front-line staff and the senior management staff. At a more conceptual level, too, they struggled with the conflict between their supportive, counselling role and their role as authority figures and agents of social control. "It's like playing Arnold Schwartzenegger's kindergarten cop," said one worker. "How can you be the enforcer and the buddy, too?"

Finally, these women talked about three ways in which being female added to the stress of their work. First, physical danger—although they recognized that both men and women face physical danger in this job, they felt that it was different for them as women, and many of them were often afraid of being attacked or hurt, especially when out on home visits. Those who had children (born or unborn) worried about their children's safety as well. Second, sexism—women gave various examples of sexism in the courts, the schools and the agency. Regarding the latter, the women in this study recognized and resented how quickly the males at their agency are "moved up" to administrative positions and how females "seem to run the majority of the hands-on type of work." Finally, "women's double day"—having major family responsibilities was also seen as significantly compounding the stress of work. This was mentioned as being gender-related because "It is still the female who manages and co-ordinates things at home.... Men in child welfare do not have to deal with this." This is consistent with research that has linked women's stress at the workplace to "women's double day:" to coming home and doing a second full-time job (Lowe, 1989; Women and Mental Health Committee, 1987).

Although all of these negatives combine to create an extremely stressful work situation, there is another contributing factor: "It's seeing people's pain and being part of their pain." One worker said,

> "Removing children from their families is painful for everybody, including the workers[8].... You have all this pain coming at you, and it keeps hitting you and hitting you and hitting you.[9] That's the root of the stress."

Another worker agreed:

> "It's being day-to-day, hour-to-hour, minute-to-minute, face-to-face with human suffering. It doesn't matter what the case number is, these are human beings, and there is so much suffering in this job, and you cannot become totally inured to it. You can't if you're going to be effective in this job.... Sometimes I think we use our busyness as a way of protecting ourselves from that, but there are other times when you sit and think of the enormity of it, and it just overwhelms you."

[8] Women are generally more concerned than men with separation and loss, connectedness and the maintenance of the family (Hartman and Vinokur-Kaplan, 1985) and therefore may find removing children from their families particularly stressful. Palmer (1995) also discusses attachment and connectedness in child welfare and the worker experience.

[9] An interesting, and obviously abusive, image.

A third woman said, "We are sponges for pain. We just soak it up."

The workers in this study responded to client pain and need by giving a great deal of themselves, but mentioned this "constant giving" as one of the most difficult aspects of their work:

> "You have to give, 110%, your needs don't matter.... You nurture everyone but yourself, and you're totally drained at the end of the day."

The issue of boundaries was a recurring theme in these discussions. "It is hard to separate yourself emotionally, to protect yourself," said one woman. "Some of these kids, they climb on your lap." Supervisors and front-line workers alike talked about "not having any boundaries," because they have to respond immediately whenever people need them. "You can't even go to the bathroom half the time," said one supervisor. Others spoke of the incursion into their personal, private space: "You never get a mental break. They call you at home, even if you're on vacation, even if you're sick." A number of women mentioned how hard it is to "leave the job behind" at the end of a day, but one of them added, "You have to learn to, or you can't stay in child welfare."

Physical Health

These women felt overwhelmingly that working in child welfare had an adverse effect on their physical health.[10] They saw their jobs as either causing or exacerbating various physical conditions, because when they felt themselves "coming down with something," they never had time to go to the doctor or take a day off to "nip it in the bud" due to the pressures of the job. Furthermore, once they actually got sick, they still were often made to feel that they could not be spared at work and that they should not take off the time that they needed to recover. One worker had bronchitis for two months, which never went away because she kept getting called back into work. She then developed asthma, which in her doctor's opinion was triggered by the chronic bronchitis. This worker was furious. Similar stories were told about workers taking time off to try and get well but being disturbed so often at home that they finally concluded, "There's no point staying home, I can't rest, anyway, so I might as well go back to work." The list of conditions that they saw as caused or exacerbated by their jobs included: colds, flus, chest infections, pneumonia, strep throat, bronchitis, asthma, endometriosis, anaemia, stomach upsets, constipation, fertility problems, shingles, weight loss, weight gain, roseola, muscle aches and pains, headaches and dizziness.

In addition to specific illnesses, many of the women mentioned being chronically exhausted. A number of others suffered from insomnia, particularly on Sunday nights before going back to work, and some mentioned that even after sleeping, they still do not feel rested. A few sleep "right around the clock" on weekends. "This job has just drained away my energy," said one young woman. "I used to have this little bounce, now I just don't have it any more." This chronic exhaustion, in addition to being intrinsically problematic, then

[10] This perception is consistent with literature showing that job factors predict health (Karasek et al., 1987).

increases these women's susceptibility to illness, particularly when combined with the stress of the job.

> "It becomes a domino effect," said one worker. "When people are pushing themselves to the limit at the maximum stress level, and your physical well-being takes second place to your work... that's when the illnesses start."

One woman made the important point that she doesn't often get ill as a result of working in child welfare, but she also rarely feels well.[11] Equally significantly, she said "We no longer *expect* to feel well, we don't expect to have energy." Others in the group agreed with her, indicating that they have to some extent readjusted their expectations regarding their health and well-being and have accepted a new, and lower, norm. One result of this is the tendency to discount or minimize any symptoms they might have, attributing them to their work stress and not checking them out, and in this way further jeopardizing their health.

A second effect mentioned by some of these women was a certain alienation from their bodies. One said:

> "Sometimes you get through a whole day and you realize, 'I didn't eat lunch' or 'I didn't go to the bathroom,' and actually it's gotten to the point now where I can't tell if I need to go to the bathroom any more. I'll be in the car driving home, and I'll realize 'That's why I've been so uncomfortable for the last two hours, because I had to go to the bathroom, and I haven't had time to think about it.'"

A number of other women in the group shared similar experiences and mentioned constipation as another health problem associated with their job. This very personal example illustrates the extent to which this kind of work crosses even the most intimate of boundaries and points to some of the health implications of regularly "putting one's own needs on hold" in order to meet the needs of others.

Mental Health

The women in this study felt that their mental health, like their physical health, had been adversely affected by their work. Many reported emotional exhaustion parallelling their physical exhaustion. "I have nothing left at the end of a day, nothing left for my family," said one woman. "You're bottomed out, you're drained. You can't be Suzy Sunshine." In addition, women mentioned mood swings, anger, depression, fearfulness, anxiety, paranoia, low self-esteem and self-doubt. Some had nightmares (one dreams once a month that she is being chased by someone who wants to murder her, and she is running with a child or

[11] An interesting parallel here to mothers of children with autism feeling that they are "lacking in good health" (Fisman, 1988). Health, of course, is more than the absence of illness, and therefore lacking health, even if not ill, is still a significant category and a basis for concern.

adolescent and trying to hide). One woman who had a nervous breakdown felt that it was caused at least in part by the pressures of her job. Another was worried about how "confused" she has become lately because of being overwhelmed by work: the previous week, she double-booked not only several appointments with her clients but even the plane tickets for her holiday.

More existentially, these women talked about a real pessimism that has pervaded their lives as a result of their work. "You see things in a more negative way," said one woman. "You no longer have that idealistic view." One young woman spoke sadly of feeling "jaded" and "cynical" as a result of working at Children's Aid. "I've seen it all at 25," she said, and felt that in a way she had "lost her twenties." Others described a profound mistrust of other people that they had not felt before taking this job, and many who were parents reported excessive fear and overprotectiveness regarding their own children. For example, one woman left her child with a new babysitter and worried all day long at work about whether the babysitter belonged to a pedophile ring. Someone else summarized the feelings of the others in the group when she said, "I don't see the world with any normalcy any more. I only see it through the eyes of child abuse."

Coping: Preserving and Protecting Their Health

The women in this study employed a number of strategies to cope with their job-related stress and its effects on their health. They made use of both emotion-focused and problem-solving strategies, interesting in light of the literature showing that the former is associated with health-related stresses and the latter with stresses related to work (Lazarus and Folkman, 1984). Consistent also with one of the five action strategies delineated in the Ottawa Charter for Health Promotion (World Health Organization, 1986), these women developed various personal skills to enable them to cope. A number of them tried cognitive approaches, telling themselves, for example, "Like AA, change what you can, know what you can't, and have the wisdom to know the difference," "Don't frustrate yourself by trying to do something you can't possibly do," and "Redefine what you see as success." Other personal skills involved "learning to absorb the pain and stress and let it just run through you," not thinking about work when away from it, taking care of their needs instead of ignoring them, finding hobbies they feel successful at, and exercising. They also tried going on long vacations ("less than three weeks is useless, it takes that long to unwind"), lying on the couch, cleaning cupboards, vacuuming and playing Nintendo ("mindless stuff"). Comfort strategies included eating and drinking, and diversions like gardening, reading, shopping, playing the piano, cooking, meditation and prayer (in the words of one woman, "inward things").

At the interpersonal level, the women in this study used a second action strategy from the Ottawa Charter: they did what they could to create a more supportive work environment, using humour whenever possible with their colleagues and turning to them for mutual support ("we cling to each other"). They also mentioned venting to other trusted people (or even pets, "the dog won't criticize"), spending time with people who are important to them to put some balance into their lives, and having sex ("It's a great stress-reliever, it puts that glow in your cheeks, that smile on your face").

One particular strategy seen as necessary to surviving the stress of this work was erecting boundaries at the end of the day:

"My health is fragile," said one woman, "I have to set boundaries."

"I have to be able to put walls around me," said another. "The job's over there and don't you dare come in my wall, my little protective hole. My little protective hole has gotten smaller over the years.

Some women talked about their inner walls, about becoming "hardened." Others establish boundaries by leaving on their answering machines when they are at home, "turning into turtles," or hiding in various ways. One woman, for example, shops outside of her neighbourhood on weekends so that she won't bump into any of her clients; another uses her maiden name at work so that she won't be traceable after she goes home. One woman shared with the group the technique she uses at the end of each day in order to separate herself from her work:

"I try to visualize that I'm leaving the last case on the street, on the sidewalk, and then I go into my van and I start talking and singing.... The case stays behind me, physically, actually behind me, and I lock the door and it doesn't come in with me.... You have to do this, because there are cases that just stick to you.... You can try it, it works."

RESULTS OF THE FOLLOW-UP MEETINGS

An hour-long follow-up meeting at each agency took place several months after the initial focus groups.[12] Participatory research combines three activities: investigation, education and action (Hall, 1981; Maguire, 1987; Tandon, 1981). The initial focus group meetings focused on investigation; the follow-up meetings on education and action. Education in participatory research refers to the education of both the researcher and the participants, who reflect through discussion on the structural causes that underlie the problem being studied. Action refers to collective action, the goals of which are short-term and long-term social change (Maguire, 1987). About 15 women attended each group (three-quarters of those in the original groups), including both supervisors and front-line workers. The meetings began by reflecting back to the participants the data they had shared in the groups, the main points of which were summarized on overheads. The women were then invited to respond to the data in terms of how they understood it, what they thought it meant and what they saw as structural factors operating in this situation.[13] A discussion ensued with a variety of opinions and views: many

[12] It was originally hoped that these would be the first of several meetings, but this did not eventuate because of the time constraints on these workers.

[13] To put the latter question into "Marxian terms.... 'What are the hidden structures that shape society?'" (Hall, 1981:13).

of them were quite struck by the transformation of their individual comments into collective data, and found it sobering to see what they as a group had identified as health hazards associated with their work. When everyone had spoken who wanted to, the researcher briefly put forth a feminist structural analysis to the group, being careful to present her view not as the "right" one, but rather as "another way to understand the data." Some women immediately resonated with this analysis, others were less comfortable with it and others still had difficulty assimilating such complex ideas in so brief a meeting. Developing "skills in... analyzing and utilizing information" as a source of empowerment (Maguire, 1987, 30; Tandon, 1981) obviously involves a process, and the limited time available meant that this exercise could be just the beginning of this process for these women. However, it appeared to be something of a real beginning for at least some of them, especially those who lingered afterwards to talk, who said that they had never before thought about their work in quite this way.

In the second half of the meeting (the action component), it was suggested to the participants that although many of them had worked out individualized strategies for protecting themselves and their health from their jobs, there were other ways to approach their work problems if they chose to think about them collectively. The women responded by talking about various ways they could try to change things at their agency to make them more closely resemble what child welfare could and should be.[14] One woman suggested a meeting with all the staff and the executive director concerning workload, salary and safety, but this was seen by many as too threatening, particularly in an economic climate where some of the women already felt insecure in their jobs. Someone else proposed working with the union to advocate for better working conditions, but there were different unions for front-line workers and management, which would have pitted the women against each other rather than uniting them. Continuing this discussion in further meetings was also unworkable, given the conflicting schedules and locations of the different units and how overextended these women already were, but the participants in both groups asked for copies of the overheads. One supervisor mentioned the possibility of sharing them "sometime" with senior management, and another woman said she wanted to have them to look at when she felt overwhelmed by her work, to remind her "it wasn't all in her head."

[14] At the beginning of these discussions, the women began by quickly generating a collective child welfare fantasy that took many of the work-related stressors they had mentioned in the first meetings and stood them on their heads: for example, reduced and more equitable caseloads, a less parent-focused court, more resources (if possible, in-house), more prevention, more staff (capable, independent workers who don't need to be "hand-held"), more autonomy, more recognition and appreciation, more opportunities for professional growth, better salaries and better work incentives to reduce turnover ("Never allow anyone to leave again"), and more government and community support. One worker said, "I have a dream," and went on to describe in very moving terms her personal child welfare dream, which included not just adequate but plentiful resources, play therapy, family therapy, prevention and community education (such as courses in the schools to teach young parents about parenting and child development). Some women also mentioned, half in jest, "resources" for them at the agency: a relaxation room where they could take breaks, a gym to work out in, and a big fridge.

Although the primary achievement of this participatory research was educational since no collective actions were taken at the time by these women, this lack of action is acceptable in Maguire's view and does not necessarily delegitimize or devalue the importance of what has taken place.

> While direct community action is an intended outcome of participatory research, people may also decide not to act at a particular point in time.... Having identified and investigated important problems in their lives, people can decide how to use the knowledge gained. The important point is (not whether or not action is taken, but) that those who are involved in the production of knowledge are involved in the decision-making regarding its use and application to their everyday lives. (Maguire, 1987, 30)

DISCUSSION

Despite the rewards associated with child welfare work, the women in this study experienced their jobs as damaging to their physical and mental health. In the discussions, this was related to feelings of powerlessness and lack of control regarding central features of their jobs: caseload size, resources, interactions with the courts, personal/professional boundaries, role definitions, community perceptions of child welfare, physical danger, salary, sexism and the enormous needs and pain of clients. This concurs with other research that related the difficulties of this work to feelings of powerlessness (Callahan and Attridge, 1990). Callahan and Attridge (1990) explored critical incidents of powerfulness and powerlessness among women working in child welfare and found that the incidents during which these women experienced themselves as powerful were also overwhelmingly identified by them as incidents with positive outcomes both for them and their clients.[15] Similarly, Guterman and Jayaratne (1994) found that, in a sample of male and female child welfare workers, those who perceived themselves as having control over their jobs also perceived themselves as effective at their work, and they also experienced reduced stress in certain areas. It appears, then, that the interests of worker and client converge when it comes to increased worker power, perhaps not unlike the association pointed out by Hutchison (1992) between the interests of mothers and their children and the consequent importance of attending not only to the needs of the latter.

Increasing worker autonomy is also in the interest of the administrators of child welfare agencies. According to Jarayatne and Chess (1985), high staff turnover (a major problem for agency administrators) is significantly associated with low financial reward, and job satisfaction

[15] The women in Callahan and Attridge's (1990) qualitative study understood power in terms similar to Miller and Cummins's (1992) formulation, that is, as "personal authority" (e.g., "the ability to shape my own destiny"), rather than as personal resources or "control over," which is the more conventional and male view.

is significantly associated with feeling "challenged" at work; both of these factors relate to the theme of power in Miller and Cummins's terms (Miller and Cummins, 1992).

Finally, increasing one's power or control at work has important implications for health. Karasek, Gardell and Lindell (1987) showed that decision-making control at work is one of three job factors (after age) that are the best predictors of health and health-related behaviours.

Increasing the power and control available to female workers in child welfare is a challenging idea, but not utopian. Weil (1988) described a program for sexually abused children located within a large social service agency that operates according to a collaborative, feminist-oriented organizational subculture and provides workers with considerable autonomy and control over their work. Such a model could be replicated elsewhere if certain organizational characteristics are present, namely internal and external environmental support, organizational readiness and leadership with vision, creativity and power (Weil, 1988). Even where these are not the immediate reality, it is possible to work toward these characteristics if there is a willing collectivity, even a small subgroup, within an agency.

A second implication from this study is the value of using participatory research and other non-traditional empowering methodologies, which integrate rather than dichotomize social action and scholarship. Such methodologies represent unique approaches to community building, which is another of the five action strategies alluded to in the Ottawa Charter. At the same time, though, the difficulties encountered in facilitating collective action in this research point up how crucial it is in health promotion to intervene simultaneously, as the Ottawa Charter suggests, at various levels and with multiple strategies. This study focused its attention at the micro level, on the individual and organizational experiences of these women; however, it is abundantly clear that the health problems they experienced were fundamentally structural in their roots.[16] One woman in this study called her work "the catch-all profession," an apt image in that workers like her are constantly scrambling to catch whatever, or whoever, has fallen through the cracks of society's basic faults. Similarly, Callahan (1985) and others have written passionately about the need to radically reconceptualize and reorganize the child welfare system such that it addresses the structural inequities that are the roots of its problems (the fact, for example, that the child welfare population is made up of women and children who are predominantly poor and from racial minority groups). Consistent with this, the Ottawa Charter recognizes as necessary prerequisites for health not only the obvious things like nutritious food and preventative health care but also peace, shelter, education, income, a stable eco-system, sustainable resources, social justice and equity. It therefore identifies as one of its key action strategies the building of "healthy public policies" that will promote health in the broadest sense for both individuals and communities. Indeed, as the results of this research make clear, it is only as we begin to work in a co-ordinated and committed fashion at both the macro and micro levels that we can succeed in creating healthier work environments, a society that is able to effectively care for its vulnerable children and (in the words of Epp, 1986) "health for all."

[16] Lowe (1989) points out that approaching health promotion through workplace strategies will provide only partial relief to women: minimizing stress must begin with recognizing that, for women, stress is largely derived from an unequal division of labour between men and women in society, and a victim-blaming mentality about the women experiencing such pressures and stress is an impediment to initiating change.

WORK AND HEALTH ISSUES AMONG PUBLIC SECTOR EMPLOYEES

Allison McKinnon

L'auteure a utilisé des méthodes tant qualitatives que quantitatives pour comprendre l'intégration du travail rémunéré avec les responsabilités familiales en tant qu'expériences vécues quotidiennement par les femmes. Les deux problèmes de santé les plus souvent identifiés par les femmes étaient un stress chronique débilitant et la fatigue chronique. Prendre soin des autres membres de la famille, surtout des enfants malades, occupait aussi une place prépondérante sur la liste des problèmes de santé. Les femmes attribuaient leurs problèmes de santé à plusieurs facteurs comme les horaires rigides, le sentiment de ne pas être appréciées à la maison ou au travail, et le manque d'appui accordé aux employeurs ou aux familles, pour aider les femmes à faire face aux multiples pressions venant de leur travail, qu'il soit rémunéré ou non rémunéré. Les femmes ont demandé des changements fondamentaux dans l'environnement du travail pour permettre l'éstablissement d'un climat positif et pour répondre aux problèmes du travail et de la famille. Elles pensaient que ce n'est pas parce qu'elles avaient des responsabilités familiales que leur travail devait être dévalorisé. La question de la flexibilité des horaires revenait sans cesse comme étant le moyen propice pour aider les employées à mieux équilibrer les obligations familiales avec le travail. La création d'une garderie sur les lieux du travail a aussi été considérée comme importante.

ଔ ଔ ଔ ଔ ଔ

Too little is known about what women consider to be their own health problems and how these problems are, or are not, linked to the structural conditions of their paid employment and family responsibilities. This study was designed to give voice to women regarding the most important health issues facing them today, environmental stressors influencing their health and paid/unpaid work and their preferred strategies for health promotion. It also yielded some important lessons about the process of conducting research based on the principles of health promotion named in the Ottawa Charter for Health Promotion.

The specific goals of the study were to identify: impacts of combined work and family responsibilities on the health and absenteeism of specific groups of women employed by a mid-size public sector employer in southwestern Ontario; the opinions and experiences of these women related to the impacts of work and family responsibilities on their health and absenteeism; and preferences and recommendations for changes in their working condition so as to assist them in effectively balancing work and family responsibilities and to promote their health and well-being.

Why is this information important? Concerns about the health impacts of women's combined work and family responsibilities have been mounting. These concerns are linked to wider questions about the negative impacts of job stress, but they also reflect a recognition of the interrelatedness of paid and unpaid work. There is growing recognition of the importance of examining stressors resulting from the "complex interplay of all forms of women's work, both in the household and in the labour force" (Lowe, 1989, 1).

Relationships between women's health and their paid and unpaid work have been largely neglected by researchers, just as women have been too often ignored in studies of occupational health. As Karen Messing (1991, 3) states, "Governments, workers and the general public may think that women's jobs are safe and healthy when in fact the relevant studies have not yet been done and in some cases the relevant variables have not been identified." While balancing employment and family responsibilities are health challenges in many women's lives, occupational health and safety research has given little attention to the double work day (Messing, 1991).

More research in this area is needed because of the rapidly changing nature and conditions of work itself. Economic pressures on public and private sector organizations have led to major changes in the conditions of employment, evidenced by less job security, layoffs, fewer paid work days and the restructuring of individual and organizational roles and responsibilities. Further, the increasingly diverse composition of families in Canada, and the complex social relationships within families and extended kin networks, are undergoing fundamental social changes. All call into question "traditional" gender roles and responsibilities in families. Taken together, the implications of these changes in the conditions of work and family relationships for the health of women, and men, have not been sufficiently studied. As yet, too little is known about how employment conditions can be changed so as to promote the health of working people.

Researchers are also just beginning to understand what women consider to be their own health problems, and how these problems are (not) linked to their paid employment and family life. Too little attention has been devoted to understanding women's own perceptions and priorities for their health, particularly with regard to the social structural bases of their illness and health problems (Walters, 1992a). In this respect, the women who participated in the study were keenly interested and highly motivated to share their ideas, opinions and experiences as a means to facilitate changes in their working conditions so as to assist employees faced with health, work and family problems. In focus groups the women voiced why they thought these issues were important:

> "A lot of women's issues with respect to child care and women's needs
> are just starting to be addressed, and the survey touched on some issues

that certainly hadn't been considered by a lot of co-workers and my supervisor at the time."

"I came because I'm very interested in this and I think it's very important. I've also had some problems with health because of stresses in my daily life."

"I'm angry and I'm thinking, "What kind of an impact might this have if enough women say that they are having difficulty coping because of balancing work and family?"

"I found the survey very interesting and thought this group would be a good way to see what other women are feeling and to find out if it's not just myself who is having problems. What are some of the solutions we can come up with?"

This study aimed to contribute to the development of knowledge in all of these areas. It may also provide an information base for development of policies and actions that will promote the health of individuals and organizations in other settings.

METHODOLOGY

Multiple research methods, both quantitative and qualitative, were used to give voice to the women concerned and to collect information relevant to the goals of the study. These included survey research methods, focus group discussions, interviews and meetings with the child care task force of the region/city, presentations and discussions with representatives of union groups and document reviews of employee benefit plans.

A mail survey questionnaire, the Health, Work and Family Questionnaire, was developed to obtain information on women's views of their main health problems, their opinions on health, work and family issues, the perceived impacts of balancing work and family responsibilities on their health and absenteeism, their preferences for alternative work arrangements as ways to cope effectively with these impacts, their comments and recommendations on these issues, and their socio-demographic characteristics.

THE SURVEY SAMPLE

All women employed by the Regional Municipality of Hamilton-Wentworth or the Corporation of the City of Hamilton, and who were members of the Amalgamated Transit Workers Union Local #107, CUPE Local #167 (Administration) or the Hamilton-Wentworth Police Association as of September, 1993 were invited to respond to the survey questionnaire. From a pool of about 900 potential respondents, 318 women completed the questionnaire (a

response rate of 34%). Selected socio-demographic characteristics of the survey sample are contained in Table I. While the survey sample was not representative of all employees, or all women employed by the Regional Municipality of Hamilton-Wentworth/Corporation of the City of Hamilton, it included women employed in a broad cross-section of occupations, departments and work sites of the employing organization.

Focus Groups

Twenty women who had responded to the questionnaire volunteered to participate in focus groups to discuss the issues raised in the survey. These discussions contributed to a better understanding of the issues and included suggestions for changes to promote their health. The questions addressed in the focus group discussions were:

1. What are some examples, drawn from your own experience as an employee, of problems women experience in balancing paid work and family responsibilities?
2. What do you think are the sources of the stress and other health problems women experience in balancing their paid work and family responsibilities?
3. What changes in employment conditions would you recommend as a means to reduce stress and promote the health and productivity of employees of the [employing organization]?

Principles and Mechanisms of Health Promotion in the Research Design

The study was designed so as to incorporate four major principles of health promotion (i.e., health promotion is participatory, intersectoral, integrative and a continuous process). In this regard, the active participation of people in identifying their preferences and recommendations for changes in their working conditions were as essential to the research process as they were to promoting their health. The contributions of diverse groups of women to the study reflect the intersectoral nature of the research process. They included a university-based researcher, a public sector employer, three union groups, managers in corporate health services, women employed in various sectors of that organization and an intersectoral child care task force with representatives from all sectors of the organization. The methods for collecting information relevant to the goals of the study integrated diverse, but complementary, approaches. Finally, the research study entailed a series of steps implemented as a continuous process and linked to the larger processes of health promotion within the organization where the study was conducted.

"Doing" health promotion, including health promotion research, requires skills in enabling, mediating and advocating (Letts, Fraser, Finlayson and Walls, 1993; Ottawa Charter for Health Promotion, 1986). In my role as a researcher, the process of enabling was operationalized by providing the participants with information and support to identify their health issues related to balancing work and family responsibilities.

Table 1
Selected Characteristics of Women Responding to the Health, Work and Family Questionnaire (N=318)

	%	(n)
Employment Status		
Full-time	95%	(n=302)
Part-time	5%	(n=16)
Occupation		
Clerical	40%	(n=127)
Professional	26%	(n=83)
Administrative	14%	(n=45)
Technical	6%	(n=19)
Police officer	5%	(n=17)
Other	9%	(n=29)
Age Group		
18 to 30 years	33%	(n=104)
31 to 40 years	46%	(n=146)
41 to 64 years	21%	(n=67)
Marital Status		
Married	67%	(n=213)
Single	18%	(n=57)
Separated/divorced/widowed	15%	(n=48)
Parental Status		
No children	35%	(n=108)
Single parent	14%	(n=45)
Dual parent family	51%	(n=165)
Number of Children (N=210)		
One	34%	(n=71)
Two	53%	(n=112)
Three or more	13%	(n=27)
Age of Children (N=210)		
(Some respondents had children in more than one age group)		
Under 6 years	65%	(n=136)
6 to 12 years	37%	(n=78)
13 to 18 years	24%	(n=51)
18+ years	18%	(n=37)
Elder Care Responsibilities (Yes)	14%	(n=45)

The process of mediating involved linking the many sectors in the organization that influence the health of employees, including individual employees who volunteered to participate in the study, corporate health services, the medical officer of health, a child care task force, three union groups, management staff, and elected politicians. Within the host organization, these mediating functions were primarily performed by an occupational therapist employed as coordinator of corporate health services by the region/city. As the research project developed, much of the responsibility for mediating between the many sectors of the organization was delegated to an employment equity officer in corporate health services. As a researcher, I was in contact with each of these groups at various times during the study, and the objectives of the study served to bring together various stakeholder groups who otherwise had never sat down in the same room to talk about health, work and family issues and strategies for health promotion.

Advocating involves supporting favourable conditions for health. Critical to the success of this process is the adoption of the issues that are advocated by the community, and "communities are enabled to advocate for themselves" (Letts, Fraser, Finlayson and Walls, 1993, 9). As a researcher, it was my intention to develop a foundation of information which could be used by any and all groups within the organization to advocate for changes needed to promote the health of employees within that organization.

FINDINGS

Health Issues and Problems Related to Work and Family Responsibilities

Chronic debilitating stress, followed by chronic fatigue, were the two most frequently identified health issues cited by the women who responded to the questionnaire. As one focus group member pointed out, "There's an enormous amount of juggling from beginning to end and that adds a lot of stress, and part of it is because there isn't legitimacy to the fact that you have children and that there are needs associated with that." Another explained, "Fatigue is a problem—not enough hours to get things done—no time for myself as my needs are at the bottom of the list." A third woman in a high-profile position emphasized that, "It's the pressure...to prove that you can do it all; you can do your job and have a family and cope with everything that goes with it without complaining."

Caring for other family members, especially for sick children, also ranked highly among the important health issues identified by these women. That is, the health problems and illnesses of dependents were seen by many women as their own health problems. This finding underlines the importance placed by women on their role and responsibilities as family care-givers, and the strong linkages they make between their own health and that of others for whom they care. As a focus group participant stated, "For me, the biggest stress centres around my children and my responsibilities as a mother for my children. When my children are sick and when my children have appointments I have to get them to, these are stressful points for me."

There was tremendous diversity in the ways individual women experienced and interpreted what a "typical" work day was for them. Opinions varied widely about whether

balancing work and family responsibilities was "problematic" or not. Still, there was a substantial degree of consensus among the 318 women who responded to the survey about the perceived effects of the combined demands of balancing work and family responsibilities on their personal stress. Fully 65% agreed with the opinion statement, "The combined demands placed on me by work and family responsibilities are stressful." Most women agreed with this statement to some extent, regardless of their age, occupation, union affiliation, marital status, number or age of their children. Further, 45% of all 318 women surveyed agreed that, "My health has been negatively affected by the combined demands of my job and family responsibilities."

For the 195 women who agreed with this opinion statement, "Often feeling tired" headed the list of most frequently identified health problems (81%), followed by "difficulty sleeping" (60%) and "not getting enough exercise" (53%). A focus group member described her experiences this way:

> "One of the things we talked about today was that women don't feel like they get their free time. And when they do get it, its like, "I'm going to go to bed a half hour early tonight. "It's like, by the time you get it [the time], what you end up using it for isn't something you really wanted to use it for. I think that one of the questions on that survey was about exercising and stuff like that. Women just don't feel like they have the time to do it. [...]Their whole day from the time they get up 'til the time they get home is just going, going."

Almost half (49%) of the women experienced "chronic stress" due to the challenges of balancing the demands of work and family. Changes in weight and appetite, and feelings of anxiety and depression, were reported by approximately one-third of the women who reported health impacts. Six women revealed they had been the victims of family violence which they linked to the pressures of balancing their jobs and family responsibilities.

Health impacts include utilization of health-care services, particularly the services of family physicians, as individual women sought professional advice and support in coping with health problems. Almost half (49%, n = 156) of all women surveyed said they had seen a physician in the past 12 months for help with health and social problems related to balancing work and family responsibilities.

Environmental Stressors Influencing Women's Health and Work

Women related their health problems to various sources, including rigid time schedules, not feeling valued on the job and/or at home and lack of support from their employer and families in coping with multiple pressures associated with their paid and unpaid work. A focus group member reinforced that many women in the labour force "carry the load of home responsibilities, groceries, bills, cleaning [...] as well as carry a full-time job." In her words, "You're always thinking of what you have to get done, and of others, never yourself, until you get sick and are forced to take a breather." Another woman in a clerical position described her situation and that of her co-workers this way:

"We all feel pressured to figure everything out. You're the organizer. When something goes wrong with your child care, you're sick, or you're snowed in, your child's school is closed, you're the one who has to figure out what to do. A lot of people have a hard time with that in the workplace because their supervisor isn't flexible."

Employment conditions and job requirements were repeatedly identified as sources of stress among the women in the study, stresses which spilled over into their family lives. Promoting the emotional wellness of workers on the job was not always felt to be a high priority by their employer compared to expectations that tasks would be completed according to schedule. As one women indicated, "While care is taken to ensure safety on the job, your mental well-being is sometimes secondary to the amount of work and quality and speed of your work."

The introduction of mandatory days off without pay in the months prior to the survey was linked by some women to health problems on and off the job. One comment, recorded on a respondent's questionnaire, represents the views expressed by many of the women surveyed. It reads:

"There is a definite negative impact on my health due to the shorter work week. I am in a very demanding and highly pressurized position. Repeatedly I have informed my supervisor that it is impossible to produce the same amount of work in a shortened work week (4 days). I am sick and tired of hearing that we're all in the same boat. We are NOT! Some positions are more demanding and have more deadlines than others!"

Work and family issues were contextualized within more fundamental concerns about job security and loss of wages among the women surveyed. As one women emphasized:

"Stress levels of most city and regional workers have increased substantially...as workers fear their job security. Lay-offs and subsequent wage reductions are inflating stress levels of many employees who are already trying feverishly to cope with workloads that are ever-increasing."

These threats to employment placed increased pressures on resources for balancing work and family responsibilities. Yet few saw quitting their jobs, getting a different job or changing hours of work as options for coping with health problems and the daily hassles stemming from their multiple roles and responsibilities. Married women spoke of the necessity of two incomes in their families to meet the rising costs of living and of being the sole earner in situations where their husbands were unemployed or disabled. Single women, with and without children, saw few options but working for pay as a means of economic support. In a tight job market, and with rising concerns about lay-offs or cutbacks in working hours, reducing hours of work, getting a different job or quitting a job were economic risks which most women were unwilling to take. Rather, what many hoped for was that their current working

arrangements would be made more flexible and responsive to their individual needs, while protecting their job security and ensuring an adequate income for themselves and their families.

STRATEGIES FOR HEALTH PROMOTION IN THE WORKPLACE

It was possible to classify the many health promotion strategies suggested by the women in this study under the five main headings identified in the Ottawa Charter for Health Promotion (1986): (1) creating supportive environments; (2) building healthy public policy; (3) strengthening community action; (4) developing personal skills; and (5) re-orienting health services. It is instructive to note that considerably more emphasis was placed on strategies in the first three areas, while suggestions on how individual women could develop their personal skills in coping with health impacts of work and family issues, or how health-care services could be made more responsive to working women's needs, were rarely mentioned.

Pragmatic lessons learned about health promotion strategies in the workplace integrated diverse approaches to organizational change, communication among various sectors of the organization, education of all partners and development of resources internal and external to the organization.

Creating a Supportive Environment to Address Work and Family Issues

Women called for fundamental changes in their working environment so that a positive climate would be established for addressing work and family issues. They also identified needs for greater recognition and respect for the contributions they make to the organization as employees, and as women. Women felt they should not be under-valued on the job because they are women who have family responsibilities which they must integrate with paid work.

The study participants also identified the need for more support from their supervisors and managers, their unions and the employing organization in addressing work and family issues. Only half (49%) of the 314 women surveyed agreed to some extent with the statement, "I have a lot of support that helps me balance my work and family responsibilities." Spouses, mothers, other relatives, friends and community agencies such as day-care centres were most often mentioned as sources of support. But only 38% of respondents agreed that "My manager/supervisor is supportive of employees with family caregiving responsibilities." A commonly held view was that:

> "Managers need to be educated on the stress we're under to try to meet deadlines not only at home but at work, and to balance things... because some of these managers don't have a clue. Their whole life is their work, not their family, and when you try to care for your family, they ask, 'What are you doing?'"

Similarly, only three in ten (31%) women agreed that, "My employer promotes the overall physical and emotional wellness of employees." None of the union groups fared much better in their perceived supportiveness of work and family issues, although the Hamilton-Wentworth Police Association was generally seen to be the most progressive in this area.

Building Healthy Public Policy: Building Healthy Workplace Policies

When asked to identify their preferences for alternative work arrangements so as to assist in balancing work and family responsibilities, flexitime headed the list of preferences. Fully 75% of these women preferred flexibility in the times when they started and finished work as a means to assist them in balancing work and family responsibilities. Flexitime was followed, in descending order of popularity, by compressed work weeks (44%), working at home (40%), job sharing (29%) and having a part-time job (17%) instead of full-time paid employment.

Flexible benefit packages, responsive to individual needs, were repeatedly suggested as ways to assist employees in balancing work and family responsibilities. It was recognized that not all employees, women and men, have the same needs and concerns about work and family issues. Not every employee benefits equally from the same work arrangements.

The introduction and/or improvement of family leave provisions in collective agreements were often mentioned as ways to enhance the ability of employees to cope with competing responsibilities for work and family. This idea for change was identified among members of all three union groups in the study sample, but seemed especially important among respondents with young children.

The development of on-site day care for children, with provisions for care of sick or disabled children, was advocated by many women with preschool-age children. It was recommended that day-care facilities be available on-site over a 24-hour basis to accommodate the schedules of employees working shifts with starting and finishing times not fitting a "9 to 5" work day schedule.

Strengthening Community Action: Strengthening Intersectoral
Policy and Action

Development and implementation of these policies and actions requires strong partnerships among all stakeholder groups. There emerged a general consensus that work and family issues are inextricably related in employees' lives. The premise that finding solutions to work and family problems is the shared responsibility of the employee, their family and their employer was widely supported among most of the women who participated in the study. Members of other stakeholder groups, particularly those in management and unions, seemed less convinced of this notion of shared responsibilities.

Many of the women who participated in this study were optimistic that these ideas for change would be implemented with beneficial outcomes for themselves, other employees and the wider community. Others were more cynical, suggesting that no one is "really listening" to the concerns of employees about work and family issues, and that improvements to employment conditions are unlikely to occur in the near, or distant, future. The pessimists emphasized the apparently weak partnerships among employees, unions and the employment organization in addressing work and family issues. In the apparent absence of these strong partnerships, oganizational changes to promote the health and well-being of employees are likely to be fragmented, slow to evolve and not widely apparent to most employees.

Development of Personal Skills

Expansion of supportive counselling services through the Employment Assistance Plan was also suggested as a way to promote the health of women experiencing difficulties coping with the stresses in their lives. Further efforts to reduce the stigma, real or perceived, of needing help to cope with these stresses was suggested so that women would feel more comfortable in seeking help from others.

Many employees also needed more information about the family related benefits currently available to them so that they could access them when needed. About 70% of women who responded to the survey indicated they were not aware of the family-related benefits available to them through their collective agreement. This finding held true across all three union groups included in the study, suggesting a need for more education of workers about the nature and extent of family-related benefits formally negotiated on their behalf.

Others spoke of the benefits of informal self-help groups among co-workers who shared information, advice and emotional support about coping with the stresses and daily hassles of balancing work and family responsibilities.

Reorienting Health Services

This study found evidence of very high utilization of physician services (50%) among the women who reported health impacts of balancing work and family pressures. Yet most women surveyed did not mention health-care services as health promotion strategies. Going to the doctor was seen as a necessary task to legitimate absences from work, or the only widely available and socially acceptable way of trying to get some help. A discouraging lesson learned here is that women are encouraged to seek biomedical solutions to essentially social, economic and political problems, and that we have a long way to go in re-orienting our solutions to these problems away from traditional models of health care and into the health promotion arenas of everyday life. Clearly, more flexible work arrangements, improved family-related benefits, greater valuation of women's contributions to the economy, enhanced job security and stronger partnerships between employees, unions and the employing organization, not more health-care services, are needed in order to address the identified structural and attitudinal barriers to achieving health for all.

PROMOTING HEALTH WITH WOMEN WITH MULTIPLE SCLEROSIS

Mary O'Connor, Jacqueline Low, Julia Shelley, Catherine Hopwood and Sharon Webb

Une des difficultés fondamentales que rencontrent ceux qui souffrent d'une maladie chronique ou progressive comme la sclérose en plaques (SP), c'est de vivre dans la solitude et l'isolement. Ce chapitre démontre que l'établissement de réseaux sociaux de soutien est un facteur déterminant de la santé chez les femmes atteintes de SP. Deux autres déterminants de la santé sont examinés: les services de santé et les pratiques de santé personnelles, et les aptitudes pour faire face à la situation. L'on peut aussi avancer l'argument qu'en essayant de répondre aux déterminants de la santé, les groupes de discussion thématique dans cette étude ont réalisé deux objectifs; d'une part ils ont contribué à la recherche méthodologique et d'autre part à la promotion de la santé des femmes atteintes de SP. Le projet comprenait un compte-rendu sur la littérature existante et l'analyse des activités d'une durée de 36 heures au sein d'un groupe de discussion thématique de 24 femmes atteintes de SP dans la région de Hamilton-Wentworth. Ce projet a d'abord examiné l'isolement des femmes atteintes de SP dans la communauté, et l'élimination totale de leur voix dans l'élaboration des politiques de santé qui en résultent. En faisant ressortir ces questions, ce projet de recherches a voulu conférer aux femmes atteintes de SP le pouvoir d'apporter des informations directement qui contribueraient au savoir existant sur les femmes atteintes de SP, à la politique générale et aux pratiques des agences de services à domicile, ainsi qu'aux futurs programmes de soutien.

ೞ ೞ ೞ ೞ ೞ

We're the loneliest bunch. (Alice, Focus Group A)

I lost all my girlfriends...when I got diagnosed they just went away. (Colette, Focus Group A)

I feel more in control of my MS... I feel braver... since I've started coming to this group. (Sarah, Focus Group B)

These voices from women with multiple sclerosis (MS) point to a fundamental difficulty in living with a chronic or chronic progressive condition like MS: coping with loneliness and isolation.[1] This chapter addresses social support networks as a key determinant of health for women with MS. Women's voices are also brought to bear on two other determinants of health: health services and personal health practices and coping skills. By addressing these determinants of health, focus groups used in this study serve a dual purpose as a research methodology and a health promoting activity for women with MS. They can counteract isolation, enable women to develop and share appropriate health practices and coping skills, and empower women to help reorient health services to meet their needs. For the 24 women with MS who participated in this study, self-care and the care of home were an important part of their daily labour. This research project sought to empower women with MS to inform policy and practice at home-care agencies and future programming for their support.

This chapter incorporates the underlying assumptions of feminists with disabilities (that women experience MS differently than men because their social roles are different; disability and the accompanying pain and suffering must be recognized and not denied; women should be empowered and self-determined; and personal issues should be made political) into a population health promotion framework (Hamilton and Bhatti, 1996). The women's voices and the research process address the Ottawa Charter's call for action in five areas: building healthy public policy; creating supportive environments; strengthening community action; developing personal skills; and reorienting health services.

BACKGROUND: MULTIPLE SCLEROSIS, SUPPORTS AND HEALTH PROMOTION

After trauma and arthritic disorders, multiple sclerosis is the most important cause of moderate to severe disability of adult life (Lawry, 1987, vii). The reported ratio of female to male incidence of multiple sclerosis has varied between 2.5:1 to 1.4:1, but it has always been shown to be more prevalent in women than men.[2] Multiple sclerosis is a neurological disorder in which plaques damage the insulation (myelin) surrounding nerve fibres of the central nervous system, "disrupting transmissions of messages that communicate desired action from the brain through the spinal chord to various parts of the body" (Holland, Murray and Reingold, 1996, 1). Symptoms vary, the most frequent being: numbness, weakness, blurred vision, vertigo, poor balance and difficulty walking. Other symptoms include bladder control problems, visual problems (Holland et al., 1996), sexual problems, cognitive difficulties, depression, problems with coordination and balance, tremor, abnormal sensation and speech, and fatigue (Scheinberg and Smith, 1987). Presently, there is no known cause of MS; although

[1] This study was funded by the McMaster Research Centre for the Promotion of Women's Health, the McMaster University Arts Research Board, and by a local non-profit community health agency.

[2] Ratios have been given at more than 2:1 (Scheinberg and Holland, 1987,44); at 1.5:1 (Poser, 1987,9); worldwide at 1.4.:1 (Thornton and Lea, 1992); but 2.5:1 with a specific population in South Africa of 77.5% whites (Thornton and Lea, 1992).

it appears to be an auto-immune disease, there seems to be a clear genetic susceptibility and triggering factor(s) seem to be involved (Holland et al., 1996).

Diagnosis of MS is problematic because the symptoms fluctuate dramatically between exacerbations (or flare-ups) and remissions (where they ease up or disappear) and also because symptoms may have other causes.[3] Four basic types of MS have been discerned: relapsing-remitting; progressive relapsing; secondary progressive; and primary progressive— each with different combinations of relapses, remissions and progression (Whitaker and Mitchell, 1997). Our research supports the findings of Russell (1985) that diagnoses may be especially problematic for women whose accounts of their symptoms have been dismissed by doctors as "hysterical" or psychological. Women are more likely to find out about the MS diagnosis by chance (through reading medical charts or self-diagnosing) and to be informed indirectly by spouses and family members than by doctors (Robinson, 1988; Russell, 1985).

Even after MS has been diagnosed, prognosis is problematic because the course of the illness is variable and not easily predicted in any individual case. The variety and unpredictability, the "sometime-ness" of the symptoms, present difficulties for planning and produce psychological and social stress (Peters, 1993). The invisibility of the symptoms force MS suffers to make tedious explanations or choose to live closer to the social margins (Falvo, Allen and Maki, 1982; Lloyd, 1987). Because of the invisibility or mundaneness of MS fatigue, for instance, the disease is not always respected as a disability by others.

With MS "striking" during the peak years for relationships, parenting and careers, the social consequences for women are often devastating. For example, Russell (1985) found that soon after MS diagnosis, many relationships and marriages break up, with women being less likely to have care-taking spouses that stay than men. Lyons and Meade (1993) found that women's chronic fatigue caused them to conserve energy for parent-related activities and, as a result, to lead restricted, somewhat socially deprived lives. Women with MS also experience difficulties in combining work with responsibilities at home (Jongbloed, 1996), have concerns about the effects of MS on pregnancy or vice versa (Smeltzer, 1994) and have higher rates of unemployment (Russell, 1985).

Persons with MS may need medical, social and community resources to cope with MS. MS patients require at least two kinds of medical services: (i) those oriented to acute, episodic medical needs involving the disease-oriented interventions of diagnostics and/or medical management[4] (via in- or out-patient care) and (ii) chronic long-term or rehabilitative care, which is "wellness" oriented. The latter may be provided by primary care physicians, neurologists or multidisciplinary teams of rehabilitation professionals (Geronemus, 1987)

[3] Clinical diagnostic criteria include: onset usually between 10 and 60 years of age, symptoms and signs indicating lesions of CNS white matter, evidence of two or more lesions on examination, objective evidence of CNS disease on neurologic examination, a course following one of two patterns: (1) two or more episodes lasting at least 24 hours and occurring at least 1 month apart, (2) a progressive course of signs and symptoms over at least 6 months; no better explanation for the patient's symptoms and signs (Poser and Aisen, 1987, 29).

[4] Treatments for MS (pharmacological, surgical, physical and psychological) are primarily symptom-oriented, not restorative (Scheinberg and Geisser, 1987).

working in outpatient clinics.[5] In addition, this study shows that persons with MS also may require a variety of home health-care services that range from visiting homemaking services (assistance with personal care, laundry, light housekeeping etc.) to visiting therapy and nursing services and facilitated peer-support activities. Other available supports may include the local Multiple Sclerosis Society (MSS) (Blackford, 1993); electronic self-help groups; and services from advocacy groups and the disabled consumers' movement (see Hopwood, 1994 for more detail).

Some research has been done on health promotion strategies with persons with MS suggesting that social support/relationships can have a positive effect on their health and well-being (Jones Crigger, 1996; Stuifbergen and Rogers, 1997). Women, however, may receive less social support than men (Gulick, 1994). Taking a lifestyle or behaviour approach to health promotion, some researchers (Stuifbergen and Rogers, 1997) have identified various health promotion actions adopted by persons with MS: for instance, physical activity; nutritional strategies; lifestyle adjustments (learning their limits, monitoring, prioritizing etc.); maintaining a positive attitude; health responsibility behaviours (e.g., seeking information); and seeking and receiving interpersonal support as health promoting. They point out that barriers (fatigue, demands related to the illness, time, other responsibilities, safety concerns and lack of accessible facilities) and resources (emotional, informational and instrumental support) influence the selection and use of these health promoting behaviours.

PERSPECTIVES ON DISABILITY

There are several perspectives one may take when analyzing MS. The medical model of illness presents MS as a type of deviance from physical norms of health or able-bodied-ness. A related perspective, the individualizing model of disability, assumes that the disease constitutes deviance from accepted and expected notions of normality (Begum, 1992). Both of these perspectives tend to be adopted by the general public and service providers and assume that the person's problems originate with changes in the physical condition, that these changes constitute a personal tragedy requiring adjustment and that coping with the loss(es) involves a number of stages (Lenny, 1993).

The social model of disability was put forward by proponents of the persons with disabilities movement (e.g., Oliver, 1983, 1990) which, subsequent to the civil rights, consumerist, self-help and women's rights movements of the 1960s and 1970s, began to campaign for the rights of the disabled (Dreidger, 1989). They argued that the dominant perspectives blamed disabled persons for their predicament and required them to adjust to a society constructed for, and by, the able-bodied. In fact, problems of persons with disabilities stem not so much from their physical condition as their social exclusion and devalued social stage. Thus, society should change and remove the barriers—attitudinal and architectural— that prevent disabled persons from participating fully in social life. Taking a consumerist approach to services, spokespersons insisted that people with disabilities were capable of defining their own needs and directing their own activities.

[5] Multidisciplinary teams may include nurses, nutritionists, occupational therapists, psychiatrists, physiotherapists, psychologists, recreation therapists, social workers and speech therapists.

The feminist approach to disability is inspired by the disabilities movement, but it recognizes the invisibility of women's issues in the "gender free" approach of the persons with disabilities movement and at the same time the physical and attitudinal barriers that have excluded women with disabilities from participating in the mainstream women's movement (Lloyd, 1992). Feminists recognize that the way gender is constructed has major implications for the way women (and men) experience disability (Begum, 1992; Fine and Asch, 1988; Lloyd, 1992; Morris, 1993). They argue that disabled women are more handicapped by their impairments than men (Altman, 1985; Quinn, 1994; Ridington, 1989d). This holds when you examine women's ability to assume or maintain normal social roles (i.e., mothering), marriage and sexual relations, self-image and sexuality, employment history and access to disability benefits, current employment situation and income, access to retraining programs, age and poverty level, and susceptibility to sexual harassment, abuse, sexual assault and violence (Dyck, 1995; Glass, 1982; Kutza, 1981; Lonsdale, 1990; Quinn, 1994; Ridington, 1989a, 1989b, 1989c; Shaul et al., 1981; Stimpson and Best, 1991; Tremain, 1992). Feminists with disabilities recognize that disabilities have implications for women in terms of their gender roles, self-image and sexuality (Begum, 1992).

Feminists with disabilities argue that we should not deny (as the social model tends to) the infirmity, pain, suffering and ill health that often accompany disability (Kent, 1994; Morris, 1992). Thus they seek to honour the whole experience, recognizing the value in owning infirmity as well as strength.[6] They appreciate the necessity and value of good health care and are careful not to "dismiss" or trivialize their desire to redefine need and reshape services (Lloyd, 1992).

Feminists with disabilities strive to make personal experiences political, give voice to women's experiences and empower women to take control of their lives (Morris, 1992, 1993). They recognize that disabled women are often isolated with few opportunities for self-determination (Stimpson and Best, 1991), little knowledge of their human rights (Lonsdale, 1990) and little opportunity to exchange information and experiences (Dyck, 1995). Morris (1995) uses interviews with women with disabilities to explain how women are not just recipients of care but are often care-givers themselves, something that is often overlooked in research. Morris notes how previous research has failed to recognize that disabilities restrict women's abilities to fulfil their roles as mothers, wives, and care-givers, roles which they describe as important. Morris argues that "independence" for disabled women means having control over their personal care and having an accessible environment. Through the voices of women, Dyck (1995) describes how they restructure their homes through processes of relocation, modification to the physical space and reorganization of their domestic work. Dyck allows the women to express how MS has contributed to their sense of "entrapment," their isolation, confinement to their homes, limited use of the neighbourhood space and lack of social contact with others. A number of women with MS have used autobiography and even poetry to convey their experiences of the disability from the inside (Barrett, 1995; Giroux, 1995; Mairs, 1986, 1989, 1990, 1996; Marsh, 1989).

[6] Writings of the feminist Nancy Mairs [especially *Carnal Acts* (1990)] reveal how she thinks through her body in order to come to terms with her MS.

THE STUDY

Although initiated by managers from three non-profit community-based health and social service agencies in the region, this project was designed as participatory action research (PAR) aiming to include both research and action for change and to allow the women to direct the agenda and outcomes of the research. PAR has been successfully conducted with other groups of women with disabilities (Young and Aries, 1993). In our study, PAR provided women with MS with a forum in which to air their concerns, a means for directing their own care and an opportunity to alleviate isolation and loneliness.

We undertook 36 hours of focus groups with 24 women with MS who at one time accessed services with a community health program in the region. It was estimated that there are 750 people with MS in the Region, 12 000 in Ontario, and 50 000 in Canada. Of the 750 people with MS in the region, it is estimated that 500 are women.[7] One hundred and twenty one letters were sent out. Researchers received responses from 39 individuals, 24 of whom were able to take part in the project. Three focus groups were formed according to the time of day individuals preferred to meet. The groups met at a local, wheelchair accessible church. Three researchers facilitated one group each and nine volunteers helped with organizational matters.

Overall, and in accordance with PAR principles, the researchers used the techniques of "low...moderator involvement" in the groups (Morgan, 1988, 49), focusing their attention on what the participants were saying and how they interacted with one another. The women who participated set the agenda for each meeting. Focus groups were held weekly over an eight-week period. A final "all group" meeting was held to give the women an opportunity to meet each other and discuss collective follow-up action. They were also presented with draft recommendations to the home-care program which they endorsed. Focus groups were tape recorded and transcribed. Transcripts were analyzed using the grounded theory method of open coding where we looked for emerging themes (Corbin and Strauss, 1990). Throughout this chapter, the women will be referred to by pseudonyms so that confidentiality is maintained while participants are presented as individual people rather than data.

The women in the focus groups ranged in age from 21 to 81 years. Fifteen of the women were married, four women were single, four were divorced and two were widowed. Only one woman was in paid employment, although many others were active in volunteer work and two were enrolled in university. Their date of diagnosis ranged from 1 to 35 years prior to the study. The severity of MS and the degree of mobility impairment varied. Some were ambulatory, many were in wheelchairs, some had to be harnessed in to sit upright. All of the women experienced fatigue, sensitivity to heat and humidity and most experienced varying degrees of pain. Many experienced bladder control problems, some had vision problems and one was legally blind. Some limitations must be noted with respect to the research sample.[8]

[7] These estimates were provided by the Hamilton-Wentworth Multiple Sclerosis Society on March 4, 1996. The estimate for the incidence of women with MS in the Hamilton-Wentworth region is based on the MS Society's use of a 2 to 1, female to male ratio.

[8] Our sample consists of mainly white women. MS appears most commonly in "young, Caucasian females living in cool, temperate climates" (Whitaker and Mitchell, 1997, 4).

This is a small, self-selected sample. All study participants volunteered to attend focus groups.

The voices of the women with MS who participated in this study support previous research which has outlined MS persons' health promoting needs, behaviours and coping strategies. Their longer narratives (O'Connor, Low and Shelley, 1996) convey the complexity of their lived lives, the intersections of gender and disability in their daily activities and social relations. They showed that focus groups are useful as both a research methodology and a health promoting activity for women with MS. Through addressing health services, personal health practices and coping skills, and social support as determinants of health, this project was health promoting for women with MS.

DETERMINANTS OF HEALTH

Results of this study show that *health services* (in this case home-care services) are an important determinant of health for women with MS. One of the objectives of this study was to develop recommendations to community health support services in the region for improving services for women with MS. In fulfilling this objective, the women in this study identified several problem areas in home care and made several recommendations. In general, the women were very grateful for the home-care services that do exist. Nevertheless, they experienced difficulties in a number of areas including: referrals to the home-care program; eligibility requirements; access to services appropriate to the chronic nature of MS; and discharge from the home-care program. A particular difficulty was that the home-care program's mandate does not appear to address adequately the chronic nature of living with MS. They noted a lack of continuous physiotherapy and occupational therapy for women with MS. They were also faced with the knowledge that they may be discharged from the home-care program. In their words:

> "As a chronically ill person with MS I feel one of our biggest beefs ... is the physical therapy Regardless of the fact that we're in wheelchairs and also the ambulatory people ... you still need to have exercise ... you have to move ... and if you don't move your legs you have serious problems in different parts of your body as a result of it You need to have this exercise." (Rose, Focus Group A)

> "With home care ... if you're on the chronic list you're S.O.L. ... [shit out of luck] ... you don't get any service if you're chronic because you can't be rehabilitated under their definition." (Margaret, Focus Group A)

Another important problem with the home-care program is that having some services appeared to be dependent on having others. In other words, if key services were terminated, other services would be lost. One particular complaint is that having a homemaker appears to be dependent on having other services:

"For two months I haven't seen [the physiotherapist] ... she was going to cut herself off but the minute they go then I don't have anybody coming to clean my house any more and if that happens then I'll be flat on my back." (Victoria, Focus Group C)

Not having homemaking services can negatively affect the health and well-being of women with MS; the exertion involved in domestic manual labour could cause a flare-up. As well, this exertion takes away from the energy that they might spend on activities which are health promoting. A recommendation from this study is that there needs to be more clarity around the role of homemakers and a recognition that help with domestic manual labour for women with MS may in itself be health promoting while preventing an exacerbation of the condition.

Areas in which the women felt services could be expanded are: access to equipment and equipment repair and respite for family care-givers. Lack of access to wheelchairs and scooters can increase the isolation of women with chronic disabilities. It is also an example of how social service regulations do not attend to the holistic nature of health status. Rules that govern equipment distribution or other services both constrict and construct these women's lives, often failing to recognize that to be healthy can mean being able to shop for yourself or spending time with your family. Krista (Focus Group B) puts it this way:

"They denied me a scooter ... The A.D.P. ... said my MS ... it just wasn't [advanced enough] ... I could use a wheelchair instead The doctor said that they gave them ... to so many people that didn't really need them ... they were just fat and didn't want to walk ... and things like that I was so excited I was goin' for a drive on my scooter ... I couldn't believe it when they said no ... I cried They said that I shouldn't ... use it for shopping and stuff like that ... that's not what the scooter is meant for."

The women saw respite programs for family care-givers as fundamental to health promotion and felt that the home care program should do more in this area. Margaret (Focus Group A) puts it this way:

"You live in fear of being cut-off [from home care] ... and then burning out your care-giver That one little piece of three hours a week is just totally invaluable particularly to the people who have to care for us for twenty-four"

Some women found the home-care program to be effective in their response to crisis situations, but others found they had to wait or could not get any service. Few women knew of any official mechanism in the home-care program for planning for their futures. This was especially an issue for younger women in need of counselling around careers and relationships.

"What I would like to know [is] ... what kind of career what kind of life [is] ... proposed for ourselves I look at my future I don't really belong

in the future I mean ... I may get the chance to go to college or
university ... I can't do ... what I had the grades to do and what I went
to college or university." (Jenna, Focus Group C)

Several women expressed the need for an advocate or mediator, some reported that
they had been given no advice on pain management from the home-care program, and many
had negative experiences with doctors, particularly around diagnosis. They said that some
doctors do not see the MS, others only see the MS and others had no advice on how to live
with MS and were not receptive to alternatives to medication. All of the women told us that
they had experienced side-effects of varying severity from medication.

This study addressed *personal health practices and coping skills* as health determinants
by providing women with a forum to share their health promoting information. Among other
things, they discussed finding out about equipment, alternatives to medication, dealing with
incontinence, pain management, diet, side-effects from medication and how to cope with the
financial pressures incurred in chronic illness. For example:

"The girls that I was talking to were taking...Primrose Oil to help with
hot flashes and it did ... it stopped them ... it also enabled them to sleep
... I just find that it makes me feel better ... and when I don't take it I
just ... feel tired ... listless." (Rose, Focus Group A)

"If you're going to try it where would you buy it?" (Iris, Focus Group
A)

"I get mine in a drugstore The drugstore is cheaper than the health
food stores." (Alice, Focus Group A)

They shared with one another a variety of other coping skills, for example, how to charge a
scooter when stranded and how to make the most out of tax deductions.

Another coping strategy that the women used in the focus groups was to share their
common experiences. In particular, the women told us that the focus groups were important
to their health and quality of life because the groups provided a venue where they "meet
other people who are going through the same thing" (Laurie, Focus Group C) and share
common experiences. They expressed it this way:

"[This is the] ... first time I've ever met anybody that I've felt completely
understood ... I think as much as other people love and support you
they really don't [understand]" (Tess, Focus Group C)

"I think it's nice just to be able to talk about things especially feelings
that you wouldn't talk about with your family and if you did they
wouldn't understand anyway It gives you an opportunity to do that
without feeling embarrassed about it." (Victoria, Focus Group C)

"I...need to be with people who understand what it's like to have MS...if I say I get extremely tired and I have to go and lie down all the time well ... Krista ... was saying how tired she gets ... so if I say how tired I get ... then I know instantly you understand." (Sarah, Focus Group B)

The women who participated in the focus groups discussed a variety of common issues. They discussed common experiences with failing eyesight, the frustration of having to rely on others who have their own way of doing housework and dealing with doctors.

Findings from this study reveal that *social support networks* are a key health determinant for women with MS. It is very difficult to cope with the isolation and loneliness that often accompany a chronic condition like MS. The members of the focus groups often described how they had lost friends and spend a great deal of time confined to their homes. They saw isolation and loneliness, coupled with the loss of abilities, as principal factors in the onset of depression. They said, "You don't get used to the loneliness" (Iris, Focus Group A). They reported that the focus group meetings were useful in coping with loneliness and isolation. They told us how much they looked forward to coming each week and that during the meetings their spirits were lifted. Through the meetings they were able to forge friendships and meet people with whom they were able to laugh and commiserate. In their words:

"I'm going to miss [the focus group] ... if we stop ... we all can laugh [in the focus group] ... and I think that's one of the important things for people with MS ... because they get depressed so easily." (Colleen, Focus Group B)

"If we can get together every so often ... maybe we'd feel better that way ... I'm always glad to just have a chat because I don't do much at home." (Corrine, Focus Group C)

"When we had the group meetings ... I was a real happy camper ... it was the best thing that could have ever happened to me ... I basically stayed in my basement before [the groups] ... started ... I would love it if we kept some kind of group going ... I'm in school now but I still need it." (Jenna, All Groups Meeting)

"Well I would like to continue it in the fall...I've enjoyed it...it's people that you meet ... I don't meet anybody really at home ... this [group] ... kind of gives ... it's kind of a break you know and nobody's really moaning there's nobody really miserable here it kind of gives you a lift." (Corrine, Focus Group C)

In terms of peer support, an aspect of the focus groups that the women found especially attractive was that they were groups for women only. They felt they were able to discuss issues and experiences that they would have been embarrassed or uncomfortable sharing in a mixed gender group. They said:

> "As women ... we have different ... [issues] ... you can't get into some
> of the issues that we as women would like to get into when you've got a
> room full of men around ... so it's kind of nice that women can have their
> own group ... [to] ... discuss ... things that are ... [of] ... concern to women
> ... like ... how to deal with your partner ... sex is a big topic." (Rose,
> Focus Group A)

Among other things, their comfort level allowed them to discuss menstruation, osteoporosis, menopause, birth control, aging and sexual relations. In their words:

> "So many with MS ... if the woman has it the man ... she doesn't want
> to perform for the man and the man therefore leaves her ... and quite
> often this is what's happened." (Grace, Focus Group B)

> "A lot of ... women are grappling with MS apart from the fact that
> they're also going into menopause and of course people are saying we
> should be getting our exercise ... in order to have strong bones." (Rose,
> Focus Group A)

> "And ... I can't ... [exercise]" (Iris, Focus Group A)

Perhaps most significant was that the women we spoke with were aware that "men don't usually get ... [MS] ... more women than men get it" (Rose, Focus Group A) and that "It's ludicrous to leave those of us who are most vulnerable ... and the majority female ... in the system without supports (Margaret, Focus Group A). They also told us of the double burden they face in living with MS along with trying to meet the role expectations of being wives and mothers. Ruby said, "Yeah but you're the mother ... you're not supposed to get ... [sick] ... you're supposed to be there you know (Focus Group B). In addition to coping with MS, they must cope with sexism and the ensuing differential treatment of women in our society. Rose (Focus Group A) says:

> "But I feel ... that people look at us and say oh it's something mechanical
> and women just can't handle that...well I'm sorry but we can"

The consequences of sexist perceptions of women with MS are not merely frustrating and degrading, they can be dangerous to health and well-being. For example, a number of women described how their MS symptoms were mistaken for mental illness:

> "Back in the fifties it was neurotic ... when I was telling them these
> crazy things [MS symptoms] ... that were happening to me In 1958
> ... they gave me shock treatments because they didn't know what to
> do." (Alice, Focus Group A)

"I went to an eye specialist cause I lost vision in one eye for awhile ...
he sent me to a psychiatrist because he thought it was psychosomatic."
(Ruby, Focus Group B)

At times the doctor's focus on the disease (MS) prevents him/her from seeing the woman as a whole. Colette described how her ectopic pregnancy was initially overlooked by a doctor who saw her only as an MS patient and not as a woman:

"I went to my doctor about two years ago ... I was telling him that I was
numb ... I was feeling big and I was bloating and ... he said it's all your
MS ... but it wasn't ... I was pregnant and I got my tubes tied ... the
baby was in the tube ... I guess he didn't want to agree ... it still hurts."
(Focus Group A)

Some women were struggling with doctors advising them about having a tubal ligation or "not even to think about" having children (Jenna, Focus Group C). Others spoke of friends with MS who had children and how that had given them something to live and work for.

"That's sad ... I know a girl though ... who got pregnant ... and she said
afterwards she went into remission through her pregnancy and then she
was tired afterwards but she wasn't really too bad ... two years later she
said I'm glad I did it and she said ... she had no idea of how much ...
[she] ... was capable of doing." (Victoria, Focus Group C)

The experiences of these women show that women experience MS differently than men because they have different social roles.

ACTION

In accordance with the principles of the feminist approach to disability, this research project made personal issues political. The women helped to *build healthy public policy* by making several recommendations to the home-care program. They wanted the home-care program to:
* Institute a maintenance program for people with chronic illnesses;
* Provide continuity of care;
* Increase access to physiotherapy for people with MS;
* Provide information to all service providers about MS, including: it's unpredictable, chronic, and changeable nature; its pain and fatigue; the invisible aspects of MS including the frustration, feelings of helplessness, social stigma, isolation and the impact of MS on relationships;
* Provide for ongoing client controlled and directed self-help support groups;
* Implement new information services or improve access to existing ones;

* Establish someone at the home-care program who will act as an advocate on the client's behalf;
* Provide respite for family care-givers; and
* Clarify the role of and increase access to homemakers.

In response to this study, the home-care program responded to the recommendations of the study with an "action plan." This plan includes working to provide more client-centred care, strategies for improving communication between service providers, focusing on "neighbourhood teams" to deliver care, and providing space for support groups for persons with MS. Implementing a more client-centred approach to care fulfils the objective of this study to identify ways of involving women in the ongoing planning and directing of their care.

The feminist approach to disability argues that we should recognize and not deny the disability as well as the pain, suffering and ill health that may accompany it. Adopting these principles, this study has helped to *create supportive environments* by acknowledging the pain and suffering of the women with MS as they experienced it. These women wanted others, including the home-care workers, to acknowledge their experiences and to know about: their fatigue (which we need to see as qualitatively different from regular overtiredness); their pain; their lack of motor control, making them stagger or drop things (which we need to see as not due to drinking or clumsiness); the invisibility of their symptoms; that not all MS sufferers have the same symptoms or the same pattern of disease progression; and the sometime-ness of their disease, that they may be all right one day and bedridden the next and their acute attacks can come on unexpectedly. They wanted people to be aware that living with MS entails feelings of helplessness, social stigma, isolation and a shift in personal relationships. They talked about the misconceptions that people have about MS:

> "Yeah ... quite a few [home-care workers] come in and say ... [it] doesn't look like there's anything wrong with you." (Tess, Focus Group C)

> "If we had big bruises or something ... or ... bleeding ... or like cancer with big sores ... well then it would be more dramatic ... they would believe it but they don't know what it's like." (Sarah, Focus Group B)

> "And then you stagger about ... I feel that some people sometimes think that you've had too much to drink cause you're staggering about." (Jill, Focus Group C)

> "I've had nurses say it's all in your head." (Alice, Focus Group A)

> "One doctor I had said you're just a neurotic." (Barbara, Focus Group A)

> "They think they know what you mean when you say you're very tired ... they don't know it means you can't stand up another minute or you're going to fall down." (Sarah, Focus Group B)

One aspect of the feminist approach to disability is the belief that women should be empowered and self-determined. This research has *strengthened community action* by providing women with the opportunity and resources to take self-directed action. Participating in focus groups and the subsequent development of recommendations to the home-care program have supported the women in becoming agents of social change. The focus group participants believed the groups provided them with a forum where they could come together to take action and to problem solve. One example of this is the collective action they took in trying to address their ongoing problems with poor regional transit service. They wrote letters, composed and circulated a petition and endorsed a report which was submitted to the regional chairman investigating the service. They recognized the need to take action on their own behalf:

> "I believe somewhere along the line what we're going to eventually have to do is form ... groups of disabled people and we're going to have to lobby...and we have to lobby at the Ontario level." (Rose, Focus Group A)

But not only did these women seek to solve problems at the societal level, they also used the focus groups to offer peer support and to work out personal problems.

Primarily because of their high degree of participant control, the focus on action or solving problems and the positive tone of the meetings, all the women were highly satisfied with their participation in the focus groups formed for this study. In contrast, almost all of the women were less complementary about "self-help groups" and "support groups" they had previously attended. Several women complained of the negative atmosphere of support groups where people only got together to complain and commented that their experiences with these focus groups were different. Jenna felt that another difference was that the focus groups gave her a sense of purpose, not only being helped by others but helping them too. Having an ongoing group would allow her to give something back to the community. Jenna said:

> "Well I asked ... could this be something that ... we could get involved in that could be ... a permanent thing ... I would love to make this ... sort of like a career project ... to help people and put something into society which I've already taken out like you know I've been taking taking taking and I really haven't given anything back." (Jenna, Focus Group C)

Also in accordance with the feminist approach to disability, women in this study were empowered through learning. They taught each other *personal skills* in dealing with health-care providers, alternative medications, incontinence, pain management, diet, side-effects of medication, equipment and the financial pressures incurred in chronic illnesses.

In the tradition of feminists with disabilities, we argue that health-care providers should recognize and address the pain, suffering and experiences of women with disabilities as, in part, qualitatively different from the experiences of men with disabilities. We also argue that women should play a strong role in the direction of their *health services*. In order for health-

care providers to adopt these principles, a partnership has to be formed between health-care users and providers. This partnership will require listening to the voices of women with MS. Health-care providers must attempt to fill the gaps in the service provided by the home-care program, as identified by women with MS. Attempts should be made to understand MS and how the disease is experienced by women with MS. This understanding includes recognizing the invisible nature of MS, including the pain, fatigue, frustration, feelings of helplessness and social stigma that these women feel. The women in this study have shown that health encompasses not only a person's physical health but also their mental health and well-being. We think Sarah puts it best:

> "Your mental health affects your physical health ... we're all one piece. ...Your MS isn't separate from your happiness ... you're all one person ...you're not made up of MS and then some other as if the other part doesn't matter." (Sarah, Focus Group B)

Only after health-care providers listen to women like Sarah can any real action for social change take place.

REFLECTIONS ON THE FUTURE

We cannot conclude this chapter without mention of the impact of cutbacks in home-care for the women in our study. At the time of the study (1995), cutbacks in assistance were just beginning. For example, a woman in one of the focus groups had learned from a fellow group member about government subsidized kitchen renovations. She contacted the government and subsequently was promised that her kitchen would be renovated to suit her needs as a woman with disabilities. Three months later, at one of the last meetings, she informed us that the service once promised to her had been denied as a result of cutbacks. These cutbacks seriously compromise the quality and quantity of services for women with MS (and other groups of vulnerable persons). Without sufficient funding for larger social institutions such as home care, it will not be possible for many women with MS to stay in their own homes. It is our hope that governments will listen to the voices of women with MS and ensure that adequate supports are in place to sustain (not compromise) the quality of life for all persons with disabilities.

Chapter 8

POSITIVE WORK ENVIRONMENTS FOR WOMEN AND MEN WITH DISABILITIES[1]

Isik Urla Zeytinoglu, Muriel Westmorland, Pam Pringle, Margaret Denton, Vera Chouinard, Sharon Webb

Ce chapitre offre un résumé d'une étude sur l'environnement de travail des femmes et des hommes souffrant d'une incapacité. L'objectif de l'étude était d'entendre les voix des hommes et des femmes souffrant d'une incapacité quand ils ont partagé avec perspicacité leur point de vue au sujet des facteurs qui contribuent à créer pour eux un environnement de travail positif. Les dispositions d'esprit négatives des éducateurs, des employeurs, des surveillants et des collègues de travail jouent un rôle dans les difficultés qu'éprouvent les femmes et les hommes souffrant d'une incapacité à trouver du travail et à le garder. L'établissement de mécanismes d'aide sociale hors du lieu de travail peuvent contribuer à créer un environnement de travail positif pour les personnes souffrant d'une incapacité. Les éléments qui créent un environnement de travail positif cités par les participants incluent: le soutien des employeurs et des collègues, l'usage de la technologie et la flexibilité d'emploi, le lieu et les horaires de travail. Lorsque ces conditions étaient absentes, l'environnement de travail était déplaisant. Fait étonnant, plus de la moitié des participants ont cité l'attitude des employeurs comme aspect négatif de l'environnement de travail. Le manque de sympathie et de compréhension de la part des collègues pouvait causer et causait parfois des problèmes similaires. Les participants insistaient sur le fait que le travail avait un impact positif sur leur perception de leur état de santé. Le travail les valorisait et haussait leur estime d'eux-mêmes. Comme thème central et de façon générale, les participants désiraient que la dignité soit présente dans l'environnement de travail et qu'ils soient traités avec respect; ils voulaient être considérés avant tout comme des personnes à part entière. Pour atteindre ces résultats, une recommandation—clé portait sur la formation des employeurs et des collègues concernant les personnes souffrant d'une incapacité. Ils ont aussi offert des suggestions pour améliorer l'environnement physique du lieu de travail.

[1] This study was funded by the McMaster Research Centre for the Promotion of Women's Health and the Arts Research Board of McMaster University.

This chapter summarizes a study of positive work environments for women and men with disabilities. The purpose of the study was to listen to the voices of women and men with disabilities as they shared their insights regarding the factors that contribute to creating positive work environments for them. In this study we argue that by creating positive work environments for women and men with disabilities, the way they perceive their health will improve. A positive work environment is defined as a non-sheltered workplace where women and men with disabilities have achieved economic and social integration through paid or volunteer work. This research adopts the WHO definition of disability as "any restriction or lack, resulting from impairment of an ability to perform an activity in the manner or within the range considered normal" (World Health Organization, 1980). Disabilities can be physical (sensory, visual or hearing impairments, learning disabilities, hidden disabilities such as epilepsy, allergies, multiple sclerosis, and mobility or physical impairment) or mental (psychiatric disabilities, mental disorders and mental disabilities resulting from brain injury) (Meister, 1992).

This project deals with one of the major determinants of health: employment and working conditions. In addition, several other health determinants were incorporated into a conceptual model that was used to guide the research project. The conceptual model shows three groups of factors that contribute to creating positive work environments for women and men with disabilities which, in return, influence their perceived health and wellness. The factors examined in this study are: workplace organizational and social factors; social supports outside the workplace; and individual characteristics. The research philosophy and the methodology of the project is participatory action research. The guidance of a steering committee and the use of focus groups as research methods were instrumental in giving women and men with disabilities an opportunity to voice their work-related health expectations. After results of the research project are summarized, we will discuss the health promotion strategies identified by women and men with disabilities.

LITERATURE REVIEW AND THE CONCEPTUAL MODEL

A review of the literature shows that work can influence women's health in both negative and positive ways. For women with disabilities, participation in the paid labour force can help to increase their life satisfaction and self-esteem. Similarly, for unemployed women with disabilities, denial of access to the paid labour force often results in depression, isolation and loneliness (Fine and Asch, 1988; Lloyd, 1992). Women and men with disabilities are underemployed in the labour force. The Canadian Council on Rehabilitation and Work (1993) shows that 7% of Canadians with disabilities are unemployed and 56% of those in working age are not seeking employment either because they are discouraged and gave up or because their disabilities do not permit them to be employed in existing work environments. Likewise, in Hamilton-Wentworth, persons with disabilities have a low unemployment rate but a large percentage of persons with disabilities are not in the labour force (Pennock, Westmorland and Baker, 1994).

The literature cites several barriers to participation in the labour market for persons with disabilities including: fear of losing income; discouragement from family and friends; familial responsibilities; past experiences with discrimination; inadequate training; accessible

transportation; and the belief that no work is available (Pennock et al., 1994). Evidence also suggests that women are doubly disadvantaged because they are both disabled and women in a male-normed work environment (Cottone and Cottone, 1992; Driedger, Feika and Batres, 1996). Furthermore, Harvey and Tepperman (1990) report that gender impacts on earning power more than disability. Women with and without disabilities earned lower income than men with and without disabilities. Factors that contribute to positive work environments for men and women with disabilities are shown in Figure 1. In particular, the discussion of workplace organizational and social factors, individual characteristics and social supports

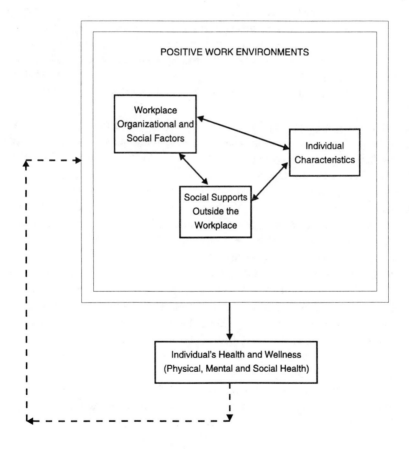

Figure 1
The Conceptual Model of Positive Work Environments for Persons with Disabilities

outside the workplace will be emphasized as factors that contribute to creating positive work environments for women and men with disabilities.

Research shows that negative attitudes of educators, employers, supervisors and co-workers play a role in the difficulties experienced by women and men with disabilities in finding and keeping paid work (Fowler and Wadsworth, 1991; Baker, Sidoruk and Pennock, 1994). Negative attitudes may prevent individuals from gaining access to or finding support while in the educational and/or training programs necessary to prepare for the labour force (Scott, 1993). M. Baker et al. (1994) report that negative attitudes by supervisors and co-workers were identified by workers with disabilities as a barrier to gaining and keeping employment. Further, close to one-third of the study respondents felt that they had been subjected to discrimination by employers and/or co-workers because of their disability. Communications and information technologies using computers can play a role in integrating persons with disabilities into the mainstream workplace (Dupuy and Thibault, 1993; Hunt and Berkowitz, 1990). Assistive/adaptive devices can provide workers with physical disabilities with mobility and access to information, and intercommunication can help persons with mental disabilities by redesigning and organizing tasks according to different levels of abilities, and can be used in new forms of work such as telework and part-time jobs (Zeytinoglu, 1992).

Gender, physical or mental ability, age and level of education can also influence an individual's participation in work environments; balancing work and family can be a problem for women, often creating stress, anxiety and tiredness. Individuals' different physical or mental abilities also influence their integration into work environments. It is also well-acknowledged that as people get older, they are less willing to seek employment. Training and education are also important in securing employment. The higher the skill or education level, the better the chances for employment. This, however, is problematic for persons with disabilities as studies show that they tend to have lower education levels than the population in general (Harvey and Tepperman, 1990).

In addition, social supports outside of the workplace can help create positive work environments for persons with disabilities. Studies show that there is a strong correlation between poor health and lack of social support mechanisms, networks or relationships (Ministry of Health, 1992). The discouragement of loved ones is a significant employment barrier for workers with disabilities, and that may be more of a problem for women than men due to societal expectations for men to be primary income earners in the family (Pennock, Westmorland and Baker, 1994).

In summary, literature suggests that workplace organizational and social factors, individual characteristics and social supports outside the workplace all contribute to creating positive work environments for women and men with disabilities.

METHODOLOGY

Using participatory action research as our research philosophy and methodology, we formed a steering committee of academic and community investigators in 1994. The steering

committee worked together in all aspects of the research project. We conducted a literature review, combined that with our personal knowledge and designed the study. The goal of the committee was to identify the factors that would create positive work environments through paid and unpaid work to improve the perceived health and well-being of women and men with disabilities. This project originally planned to include women only, but the steering committee suggested that the research should include both males and females with disabilities. The steering committee helped to refine the goals and research objectives, develop focus group questions and disseminate results of the research. They decided to use focus groups as their primary data collection method. A short personal characteristics questionnaire was also distributed at the focus groups. Six focus groups of 35 persons with disabilities who were currently working in paid or volunteer jobs were held in March and April 1995. There was one interview with a participant who could not be incorporated into a focus group. The population of the study were women and men with disabilities who were clients, members or employees of our community partners. Letters of invitation were distributed to membership of each partner organization: United Disabled Consumers (205); Path Employment Services (300); Work-Able (200); and Hamilton Automobile Club (5). These organizations have overlapping membership thus it was possible for an individual to receive four letters of invitation. We had no control over this since our community partners, due to ethical responsibility, were not willing to share their membership lists with us. There were six open-ended questions about work, what they liked and disliked in work, how worklife affected their perceived health, how they defined a good workplace and what could be done to improve workplaces. Focus groups took approximately two hours. Focus group transcriptions were analyzed with a qualitative data analysis package called Non-numeric Unstructured Data Indexing Searching and Theorizing software.

CHARACTERISTICS OF FOCUS GROUP PARTICIPANTS

Approximately three-quarters of participants were working in a paid or volunteer job, or both, with close to one-half working part-time. Approximately one-half (43%) of focus group participants were female; the average age was 42; 46% were married; 34% had school-aged children to preschool children; and 40% provided assistance/care to others either at home or outside the home. Over 80% of the participants had at least a secondary school diploma and 37% were Canadian born followed by 26% with the UK as their birthplace. With respect to perceived health, 57% considered their health to be good or excellent, 31% fair, and only 9% considered their health to be poor. In response to an open-ended question about their long-term illness, 63% reported primarily physical disabilities, 17% mental disabilities and 20% did not answer the question. Of those who listed physical or mental disabilities, one-third reported multiple illnesses or health problems.

RESULTS

When asked to explain their work, one-third of participants described their paid work roles as pastors, bookkeepers, office workers, call takers, cleaners, custodians, bricklayers

and welders. About 50% of participants were working in volunteer jobs ranging from church and community activities to helping a spouse with work at home. In general, participants felt positive about their volunteering roles because they provided a sense of self-worth and belonging as well as a way to fill up a day or evening. At the same time, many focus group participants resented their volunteering work because it was not paid. They sometimes felt "used" but continued to volunteer in the hopes that it would be a route to a paid position.

In discussing factors contributing to positive work environments, focus group participants referred to attitudes of employers, co-workers, their own attitudes, technology, flexibility in employment, job design and organizational factors as primary issues. One-third of the participants noted attitudes of employers as a positive aspect of the job. Employers who provided positive feedback, were understanding and were prepared to put time into training co-workers to work with a worker with disabilities were perceived by participants as assisting in the process of creating a positive work environment. They said:

> "I like my job because I find my boss is very, very supportive. She comes to me and she tells me when I've done a good job...."

One-third of focus group participants identified attitudes of co-workers as a positive aspect of their work. The support co-workers could provide and the understanding of participants' particular limitations on a certain day made all the difference to the ability to do the job.

> "What I like is that everyone sort of understands we've got problems, and so if you get into a mood or whatever it's accepted and so it's really nice that way."

In addition to their co-workers' attitudes, participants referred to their own attitudes towards their jobs as important in the creation of a positive work environment. They mentioned that seeing their achievements reinforced their ability to do their jobs. Having a positive impact on others through their work was also satisfying. They liked their jobs since work gave them independence and a sense of achievement. Approximately one-quarter of focus group participants discussed technology as a positive aspect of work. One focus group participant noted "...without the computer around I could basically not get employed...." Flexibility in employment forms, flexibility in work location or job design were also mentioned as positive aspects of work; in particular, flexible hours of work and working from their homes as a positive aspect of work. Work gave them some purpose in life and made them feel healthier.

Individual characteristics such as gender, disability, previous work experience, age, ethnicity or race were not commented on as factors in relation to positive aspects of work. Social supports from family, friends and agencies, however, were an important and positive component of being able to function in the work environment. One-half of focus group participants mentioned one or the other of these. They said:

> "My husband is a wonderful asset and he encourages me, even to the point that I have a client coming at 6:30, he kicks me right out of the kitchen...."

Participants were also asked to identify negative aspects of their work. The most common organizational and social factors identified as negative aspects of work were respectively: employer attitudes; co-workers attitudes; societal attitudes; job (occupational) characteristics; own attitudes; organizational policies/practices; inflexibility in employment/work location/ job design; and technology.

Approximately one-half of participants referred to employer attitudes as negative aspects of work environments. These attitudes included limited patience and understanding, not being treated as a person first, and biases in attitudes and values. Some discussed how hiring people with disabilities made an employer look good as far as employment equity was concerned, and how many employers were quick to let someone go after they had served their purpose. They believed that those with mental disabilities had a harder time in getting jobs than those with physical disabilities. Employers' lack of knowledge on disabilities, their unbending rules and unreasonable expectations from workers with disabilities to perform as non-disabled workers were criticized as well. Some said they were not given the opportunity to show their abilities in the workplace and others were discriminated against in the hiring and employment process.

> "I used to work for an insurance company at the front desk as a receptionist. One of the duties of the job was to escort clients to back offices. One day I said, 'Why can't I do the escorting?' and I went to my boss and complained about it. He said, 'Let the other receptionist walk clients in. Some people can't handle the fact that you walk with crutches and it's a very bad image for the company. I'd rather you sit there and do other duties and let others do the walking.'"

About one-half of participants mentioned examples of negative attitudes on the part of their co-workers. These were lack of knowledge and understanding of specific disabilities, perceptions that the participants were receiving "special treatment" or had been hired because they were disabled, being treated as an unintelligent person, general harassment at work, abuse of the participants' love and dedication to work and the need of participants to prove themselves in the workplace. Some comments include:

> "If a person who has a disability has to have something of a special adaptive device or equipment, they're made to feel that they're getting special treatment.... The rest of the employees say—it must be nice that the company bought you a new computer, or your chair is more comfortable than mine, I have a sore back too so therefore maybe I should get a nice comfortable chair—you know, and they make that person feel like they're getting special treatment when in fact it's just basically equality...."

One-third of focus group participants reported their own attitudes as negatively affecting their work. Their own negative attitudes ranged from low self-esteem to skill limitations.

Approximately one-half of the participants in all focus groups discussed societal attitudes about disabilities as major roadblocks to seeking employment. Again, the perception of being treated as a non-person came out strongly and had a profound effect on the participants:

> "When you're in a wheelchair, people look at you like you don't have a mind. I find it degrading sometimes."

Technology was discussed as a negative factor by a small number of participants who cited the "take over" by technology in the workplace and the complexity of some technological devices that can frustrate the worker. Inflexible hours of work were mentioned by one-quarter of participants as a negative aspect of work. Negative factors inherent in some job characteristics were identified as boredom, repetition, lack of communication, piece work, lack of appreciation and time constraints. Organizational policies and practices were of concern and ranged from changing job components without discussion, being put upon at work, to sheltered workshops who underpay their workers. Focus group participants were more critical of the discouragement they received from some of the agencies or government offices.

Twenty percent of participants discussed how their gender was a negative aspect for their work. They mentioned problems of juggling child care and work, problems of sexism in the workplace, and the need for pay equity in all female jobs. Often they referred to women as a minority in the workplace. One said:

> "With being disabled and being a woman we have two things against us so we have to be voiceless. I think a voice is a very, very valuable tool. You just have to learn how to use it and feel confident about it. And that doesn't happen overnight. That comes with years and time; and [from] people that are around you; and [as a result of] your emotional, mental support."

Participants were then asked how they thought their work/volunteering affected their perceived health. In terms of mental health, approximately two-thirds of participants stressed the positive effect of work on health. They discussed how work improved their self-worth, increased their self-esteem and gave them a reason to live and a joy in their lives. Work was giving them a goal in life, teaching them to overcome their disabilities and to gain satisfaction from helping others. They noted how their paid or volunteer work was positively affecting their physical health.

> "...If you're gainfully employed, it's good for self-esteem, if you have self-esteem you feel better."

Focus group participants were asked to define a good workplace and give suggestions to improve the workplace that the researchers could share with the employers. In defining a positive workplace, 80% of participants defined it as a friendly, understanding and collaborative work environment; a place where emotional and social barriers had disappeared; a place in which they felt happy. It should be fair, and individuals also should be treated equally, with respect, and it should be free of harassment. They said:

"[There] should be respect between the boss and co-workers. I think a good workplace is where everybody has respect, concern and consideration for each other."

Approximately one-half of focus group participants also highlighted the importance of physical elements in their suggestions for good workplaces. They emphasized the importance of layout and removal of obstacles; a clean, safe, bright environment; and responsiveness to physical needs. They said:

"The workplace has to be accessible, if you use a scooter or a wheelchair you want to be able to get in and out...."

Suggestions to improve workplaces focused on interpersonal relations at work, understanding, being socially accepted, good communication at work, being treated equally, having job security and having a good social work life. They said they wanted improvements in communication and the creation of an understanding, co-operative work environment. They wanted employers to have faith in their employees and to appreciate their work. They explained how employers can make accommodations for persons with disabilities in terms of revising the expectations from work. Examples of this were giving extended deadlines and accepting reports in different formats. They suggested a good job orientation, clear expectations of job tasks, sufficient training, providing workers with time to learn and adjust, and sensitivity. Overall, being treated as a person first came through in all responses; they wanted dignity and to be treated with respect.

A key recommendation was to provide education on disabilities for employers and co-workers. One person put it this way:

"You don't want to be treated differently, you want to be treated just like anybody else. You don't want people to make excuses for your disability, but you want them to know what your limitations are. When [my employer] started hiring persons with disabilities, they put different devices on the non-disabled workers who would be working with us [making them temporarily disabled] so they could feel, for an eight hour period, what it's like to live with that pain, what it's like to have gloves on and not being able to move your hands. It'd show them, you know, what the people they were going to be working with had to contend with...."

DISCUSSION AND IMPLICATIONS OF THE STUDY

As the investigators worked with focus group participants, listened to their concerns and analyzed their personal comments, it became very apparent that, in the main, women and men with disabilities wanted others to focus on what they could do, not what they could not. Overall, they wanted the same as most employees want, i.e., respect, clear and

open communication, support, a physically adequate and safe workplace and flexibility. These are core values that are applicable to all humankind. While the issue of accommodation might at first appear to pertain to people with disabilities only, it really has a broader application and relates to the ability of the workplace to be flexible enough to change work patterns and support the employee in their adaptation to the job tasks in many ways. Training and orientation, both for the employee as well as their co-workers, was also seen as important and relates to the principle of accommodation. The importance of dispelling typical myths about people with disabilities was also stressed, e.g., that people who are disabled will always be off sick. Better coordination between agencies was also highlighted particularly in the smooth flow between assessment profiles and matching the person to the job.

This study addresses all five health promotion strategies as articulated in the Ottawa Charter (1986). Focus group participants helped to *build healthy public policy* by suggesting ways to improve the workplace. Improvements in policy to create positive work environments must involve listening to the opinions of persons with disabilities as expressed in studies such as this one. This study utilized their opinions in several recommendations for policy. The report on the focus group was shared with focus group participants at a workshop, during which several recommendations and action strategies were made by participants. They include:

- send a copy of the report in both written and taped format to public libraries and schools in the community;
- promote education of co-workers in a work situation through information to employers;
- ensure findings are shared with those agencies who administer sheltered workshops to encourage changes in policies in these institutions and to advise them that employing persons with disabilities on an unpaid basis or for low pay is perceived by persons with disabilities as "using" them and exploiting their skills and contributions;
- develop a media program to teach community members of the needs, rights and abilities of disabled members of the community in the workplace;
- encourage people to contact MPs and MPPs to pressure them to include/integrate persons with disabilities into the work environment and to improve funding for educational programs to give children the skills needed to overcome/deal with their learning disabilities;
- enhance communication in regard to the availability and accessibility of facilities for disabled persons;
- improve work ability assessments, employment follow-ups and using standard wording and forms to assist movement from one agency to another and improve chances of finding a job for persons with disabilities; and
- develop a public forum on the issues of positive work environments for persons with disabilities.

Focus group participants also helped to *create supportive environments* by explaining in their own words what a good workplace would be. In general, persons with disabilities wanted a work environment in which they were treated with respect. *Community action was strengthened* as community agencies, persons with disabilities and MRCPOWH worked

together in this research project. Together, they sought to identify factors contributing to positive work environments for persons with disabilities and to use this information to implement appropriate changes in the workplace. Through the process of participatory action research, academic and community investigators, who are representatives of various groups of persons with disabilities, have co-learned, co-shared and held joint responsibility and ownership of results. *Personal skills were developed* as focus group participants were given a voice and a mechanism to identify important issues and make recommendations along with the steering committee. The qualitative approach of focus groups as a research method and process gave voice to individuals who will be influenced by the resulting actions of the report. Their views and ideas shaped the findings. They were all contributors to the report. They, along with the steering committee, were contributors to change as they made recommendations for action to follow this study. The steering committee adopted the following recommendations for action:

- a workshop to be held to share the findings with focus group participants and receive their feedback and recommendations;
- steering committee members to present at workshops in their own fields;
- a master list of all possible agencies, journals and magazines to be sent short information abstracts to encourage them to seek further information of this study;
- a short press release to be sent to major newspapers in the area;
- a full copy of the report given to agencies who participated; and
- a fully copy of the report to be sent to relevant government departments.

Implementation of these actions further builds the personal skills of those involved.

This study contributes to the body of knowledge related to disability and employment and also "fits" with the concept of population health. The latter particularly stresses the importance of the work environment as a determinant of health, and the outcomes discussed in this chapter emphasize these factors. The results of this study point to the gaps in our understanding of the workplace factors that affect the health and well-being of men and women with disabilities. This has *implications for those services that provide assessment, counselling and work placement for persons with disabilities*. Health, social services, labour and occupational health agencies need not only to be aware of these important factors but to work toward ensuring that they are an integral part of employment programs.

HEALTH, LEISURE AND WOMEN WITH MOBILITY DISABILITIES[1]

Jennifer Hoyle

Malgré les bénéfices physiques, sociaux et émotionnels que les loisirs peuvent engendrer chez les femmes souffrant d'une incapacité motrice, les loisirs sont souvent négligés comme facteurs importants contribuant à la santé et au bien-être de ces femmes. Afin de mieux connaître quelles sont les difficultés que rencontrent les femmes souffrant d'une incapacité et qui veulent avoir des loisirs, il est important d'examiner comment ces femmes font l'expérience de vie dans un corps sexué affecté d'une incapacité et placé dans son contexte à la fois biologique et culturel. Ces deux contextes isolent les femmes et limitent leur accès à des sources de loisirs indispensables. Il faut souvent beaucoup plus de temps et d'énergie à une femme souffrant d'une incapacité pour entreprendre une activité, qu'à une femme sans incapacité. De plus, vu le poids de la standardisation des normes culturelles relatives à la beauté, les femmes souffrant d'une incapacité sont souvent dépeintes comme étant déficientes, sans attrait, et incapables de contrôler leur corps et asexuées. Les activités de loisirs ont le potentiel de procurer un sens de bien-être émotionnel et physique, de faciliter le bien-être social et de créer un sentiment d'appartenance en offrant des opportunités de développer des rapports avec d'autres membres de la communauté. Au moyen d'entrevues orales avec des questions non structurées, le chercheur a recueilli l'histoire de la vie de neuf femmes souffrant d'une incapacité motrice. Dans la mesure où beaucoup de ces femmes dépendaient des professionnels de la santé pour s'occuper de leurs besoins physiques, la décision de prendre part à un loisir particulier dépendait souvent de l'horaire des donneurs de soins. Les femmes ont fait la remarque que les perceptions sociales basées sur les incapacités visibles tendaient à limiter leurs options de loisirs parce que l'incapacité devenait la caractéristique primordiale qui servait à les définir. Comme beaucoup de ces femmes dépendaient du gouvernement pour leur revenu, ce dernier contrôlait les décisions relatives au montant du revenu alloué et à la façon dont l'argent devait être dépensé. Même les petits plaisirs étaient affectés par le coût de l'équipement de

[1] I would like to acknowledge that partial funding for this project came from McMaster Research Centre for the Promotion of Women's Health.

soutien. Le moyen de transport est aussi un obstacle à la participation aux loisirs,
puisqu'il est pris séparément, il revient cher et il faut planifier son utilisation à
l'avance.

ᑫ ᑫ ᑫ ᑫ ᑫ

Health is a state of balance between physical, social and mental well-being (Weiss and Lonnquest, 1996). Leisure is an avenue where these aspects of well-being can be encouraged; where individuals can meet their individual needs and desires while connecting with other human beings (see Datillo, 1994; Hutchinson, 1992; Kelly, 1990; Kraus and Shank, 1992).

Despite the potential physical, social and emotional benefits of leisure for persons with disabilities, it is often overlooked as an important aspect of their health. Their needs are perceived as separate and distinct from non-disabled persons often restricting them to segregated, structured, scheduled outings and sport activities which disconnect them from their communities and limit their spontaneity and choice (Kelly, 1990, Hutchinson and McGill, 1992). This is due to a non-disabled, patriarchal view of the body, where the body that experiences and feels is seen as as separate and valued less than the body that can be controlled by the mind (Johnson, 1992). The latter is the idealized body that one possesses as an object and is reflected upon through conscious thought, but this differs from the body that one "lives" and experiences through the senses (Toombes, 1992). This body is feminized, devalued and objectified so its needs become defined by the mind which is so valued in a patriarchal culture (Ruth, 1998). People with disabilities are forced by their impairments to make connections between the sensations of their bodies and the expectations placed on the body by the mind in order to survive physically and socially (Wendell, 1993).

In a modernist, patriarchal culture, the healthy body is idealized in terms of strength, appearance, energy and ability to be controlled (Wendell, 1989, 1993). That which does not fit the ideal body is seen as separate and to be avoided. In this way individuals with disabilities become labelled as "other." Attributes associated with functional limitations such as dependence, illness and weakness are valued only negatively while those associated with being non-disabled are considered positive and universal (Morris, 1993, 67).

To understand leisure barriers for women with disabilities, it is important to consider how they experience living in a gendered, disabled body within both their biological and cultural contexts. These contexts isolate them and place perimeters on their access to necessary leisure resources. As a result, they are limited in the control they have over their personal and their much desired physical, emotional and social well-being.

While women with disabilities share some of the same constraints to leisure as non-disabled women, like lack of energy, lack of time and choices, dependency on others and concern for physical and psychological safety (Henderson, Bedini, Hecht and Schuler, 1995, 23), their physical impairments put additional demands on their bodies. For example, it often takes much more time and energy for a woman with disabilities to carry out an activity than it would for a woman without a disability.

Also, women with disabilities move within a cultural context that not only sees them as sexual objects due to their femaleness but as "objects of curiosity" (Malec, 1993, 22). Hamilton (1996) suggests that they must face social constructions of "the body beautiful" and "the

body perfect" (200). For example, female bodies in general are largely defined by male, ostensibly objective, medical, physical fitness standards which define what is a healthy, beautiful body (Bolaria and Dickinson, 1994; Cassidy, Robina and Mandell, 1995). Under the weight of these standards, women with disabilities are often viewed as defective, unattractive, unable to control their own bodies and asexual (Cassidy et al., 1995; Sherrill, 1993). These dichotomous, patriarchal ideologies teach women that they are different from each other in their ability, and this keeps them from recognizing and unifying around their similarities and common concerns as women (i.e., living in a gendered body with differing functional needs).

Leisure plays an important role in the lives of women with disabilities because it has the potential to support mind/body connections and create inclusive, non-segregated environments. It provides a sense of physical and emotional well-being by promoting physical health, rest, relaxation, self-expression, integration of mind and body and a chance to test one's abilities through risk-taking (Kelly, 1990). It also facilitates a sense of social well-being and belonging by providing opportunities for relationship-building with other members of the community around shared gifts, interests and talents (Hutchinson and McGill, 1992). This flexible, all inclusive nature of leisure encourages empowerment and the development of agency through exploration and choice. Also, interaction with non-disabled people in "informal interpersonal" ways (ways not based on obligation as in care-giving situations) helps to deconstruct the negative, exclusive stereotypes associated with disability by focusing on abilities (Nixon, 1984). This chapter explores the constraints to leisure for women with mobility disabilities and what health promotion strategies can be put in place to ensure a balanced healthy lifestyle for women with disabilities.

I define leisure as time spent doing any activity whether passive or active, recreational or not, structured or unstructured that the participants see as meaningful for them. Any movement needed to carry out leisure activity (e.g., walking, wheeling, stretching, turning on a radio or T.V., visiting) was of interest for this research as mobility was restricted for all of the women.

The definition of women with disability included any woman who was restricted or limited in her functional ability to carry out activities within the manner that is considered normal for a human being without either personal or technical supports (World Health Organization, 1980, 28). The focus was on nine women with mobility disabilities. This meant they were limited in their "ability to work, move from room to room, carry an object from 10 metres or stand for long periods of time" (Ministry of Citizenship, 1990, 3). They were chosen due to their socially disadvantaged position with regard to both gender and ability. For example, regardless of age, females report more limitations in mobility than males (Ministry of Supply and Services, 1990). Also, compared to other women with disabilities, this group is more economically disadvantaged because mobility restrictions affect their access to educational attainment and long-term employment (MSS, 1990).

The women ranged in age from 25 to 49. Two were married and living with their partners. Four of the remaining women had been married and were now divorced. Over half of the women had some post-secondary education. Eight of the women were unemployed. Over half of them received a disability pension from the provincial government. Four lived in Supportive Living Units (SLU) provided by the March of Dimes, which provided them

with the attendant care they needed to carry out activities of daily living (ADL) such as personal hygiene, feeding and dressing.

To hear their voices I chose to collect and analyze oral histories so their stories would be written from their perspective. Exchange of information was done in a "conversational" fashion to provide a less power imbalanced meeting between the women and myself the researcher. Conversations did not end until the women felt there was nothing more to say regarding their leisure activity. All of the women chose to have their real names used in the written report. They wanted their concerns voiced and made known in a tangible form that somehow bestowed validity on their experiences.

The women were asked to talk about what leisure meant to them and about their leisure experiences over time. The few requests I made were associated with demographics (i.e., age, residence, marital status, employment status, how they defined their disability and leisure). Their responses triggered further conversation and I was able to probe deeper when necessary into their statements in order to obtain a better understanding of their world.

Flexibility in data collection was important. The physical abilities of the narrators determined the location and type of conversation and/or how the information was relayed to the researcher. For example, most conversations took place in the women's homes as transportation was a problem for them. One woman who had difficulty relaying verbal information typed out her own oral history.

Also, several formats for the consent forms were implemented to accommodate choice and individual abilities. One problem did emerge regarding consent forms and their non-disabled format which assumed that everyone was able to read the font size and sign their name to give consent. The majority of the women had difficulty with this task. This suggests further research into the methodological practices used in studying persons with disabilities.

The analysis of the data involved listing responses to particular information requests such as age, residence, income, definition of leisure, education, employment if applicable. Then, I looked for clusters of patterns, differences, recurrences around certain statements. The final step examined the social context and power relations in which these themes had developed.

BARRIERS TO LEISURE

There are certain determinants that are necessary for health, several of which were either non-existent or inadequate for the women with disabilities. Biology, income and social status, social support networks, physical environment and health services were health determinants that, if addressed, could increase their access to leisure by decreasing their social isolation and meeting their personal care needs. These determinants do not operate independently of each other so steps taken to improve one of these areas would impact other barriers (Hamilton and Bhatti, 1996).

The findings suggested that the limitations of the physical body impeded the women's leisure choices by affecting their access to time and their energy levels. For example, impairments affected the ability to carry out activities of daily living (ADL) because they left less time for leisure activities. Renatta, a woman in her early twenties with cerebral palsy who uses an electric wheelchair to move about, described time constraints around ADL:

"Most of my limitations are the bathrooming, the changing, the getting
ready to go out is a really big thing for me...I can do it. It takes me a
little longer than the average...."

Also, energy levels were higher at certain times of the day. Ada has fibromyalgia, which
creates muscle weakness, pain and fatigue in both her joints and muscles. She uses a wheelchair
for mobility. She explained :

"I'm saying I can't go to anything that's in the evening...fatigue and the
muscle weakness is my functional disability."

Time constraints were also associated with time spent planning to ensure ADL needs
could be met. Pam was in a near fatal accident and sustained injuries to her body that make it
difficult for her to move around without mechanical aids. Since she has poor balance, she
expressed the importance of planning to ensure needed support was available: "I always
have to plan ahead to make sure I can get the help."

Since many of the women had to depend on health professionals to take care of their
physical needs, decisions to take part in particular leisure activities often revolved around
the care schedules of care-givers. Louise had company on weekends so she wanted her bowel
management program scheduled so as not to interfere with her visiting:

"I used to have it on Fridays so I could have Saturdays and Sundays my
whole weekend, but now it's Saturday evenings. They [the attendants]
were just too busy around here so it changed to Saturday evening."

The women hesitated to change care-giving times because they feared losing the care on
which they depended. Carol has been diagnosed with a form of muscular dystrophy called
Freidreich's Ataxia, which creates, among other things, poor muscle coordination. She talked
about quitting wheelchair dancing because it clashed with her time scheduled with home care:

"I guess I can change it but it's not always good for home care and I
have to depend on them for getting in and out of the shower."

The biological context in which the women lived had a direct effect on leisure access,
but their social status in a non-disabled, sexist culture affected income levels and ability to
access transportation, needed equipment and meaningful relationships.

One's social status is not determined by the amount of wealth but by relative access to
wealth and valued resources (Spencer, 1996; Hamilton and Bhatti, 1996). Those with more
access and opportunity have more control over their lives and the perceptions of others
(Hamilton and Bhatti, 1996). Social status for the women in the study was associated with
the social value given their bodies. The women evaluated their bodies according to social
norms about the female and non-disabled body. Several women felt this affected their ability
to build intimate relationships. Annette has been diagnosed with multiple sclerosis, an

impairment that affects the protective covering of the nerves. She has lost mobility in her arms and legs and is unable to walk. She addressed how disability affected her perceived role as a woman: "I think men do not like women to have disabilities. They'd rather have a normal woman because they want...to be cared for."

Debbie, a university student working on a degree in recreation, has cerebral palsy that affects her balance and coordination. She felt that social perceptions of disability took priority over those associated with gender because they are central to her body image as a person in general and as a woman in particular:

> "It [disability] is central to may whole body image thing, but it is not the only thing. It is something that I am constantly reminded of and something that makes me a little uneasy in social situations—my whole body image and my disability and how that is presented.... Or you'll see this really good looking person and you say to yourself. 'Wow. I wonder if they know they're so good looking.' And then in that split second you'll say, 'Oh they'd never be interested in me.'"

Social perceptions and treatment of the disabled body were associated with labels given to their visible impairments rather than functional ability. The impairment label, based on visual assessment, objectified the body, but the actual functional ability of the body personalized the condition. This was an important distinction made by women as it dispelled the idea of homogeneity in disability and valued the feeling body.

Social perceptions based on visible impairments limited leisure options because disability often became the defining feature of the women rendering them incapable. Renatta suggested that one of the problems she had was that people saw her lack of physical ability and made negative assumptions about her mental ability. She explained that when shopping, store clerks sometimes assumed her to be mentally incompetent and talked to her mother instead of her at the check-out.

The economic position of these women reflected their devalued social status. Economic constraints and policy implications had a direct affect on how leisure would be accessed, when and how often it took place and what type of supports would be available to help it transpire (e.g., equipment and care-giving).

Due to the fact that all the women were dependent on some amount of financial assistance from the government in order to live (i.e., Family Benefits and/or Canada Pension Plan), they received minimal amounts of money. The government controlled the decisions regarding how much money they would receive and where that money could be spent. For example, Ann had a heart condition, had limited use of one leg and used a manual wheelchair for mobility. She argued that those who controlled her financial situation defined the parameters of leisure for her. She referred to how budget cuts to services by the present provincial government affected her leisure because it neglected to recognize the important role it played in her life:

> "...I wrote a letter to Harris back when they were doing this [making cuts] saying that the things that they [the provincial conservative government] consider social, I don't.... My church for instance wouldn't

be considered social, 'cuss their idea of necessary is work, education, medical."

Low income also meant limited access to leisure resources due to high equipment costs, inadequate transportation and equipment needs and limited access to available recreational services. Government and private funding policies for specialized equipment (i.e., different pieces of equipment for different environmental settings) affected mobility because of their limitations and inflexibility. Policies stipulated what equipment and transportation would be publicly funded. For example, Irene has cerebral palsy, which affects her balance and her ability to speak and necessitates her using an electric wheelchair. She and her husband owned an unconverted van. Due to the high cost of installing a lift, they did not have an accessible van. Funding for such a necessary conversion is not covered through the Ontario Health Insurance Plan (OHIP).

Pam pointed out that regulations surrounding the Assistive Devices Program through the Ministry of Health controlled her equipment needs, suggested they were too demanding, and did not consider her differing mobility needs:

> "Now if I get Assistive Devices I have to trade my scooter in because ...
> [I was told] ... I shouldn't have got them to fund me for a scooter, because
> I knew [scooters] weren't allowed on the chair van. So, even though I
> would really want keep it [scooter] for the summer that's my problem,
> not theirs."

Even the simplest leisure pleasures were affected by equipment costs. Louise, for example, had a bruised spinal cord that affected her strength and her ability to use her arms and legs. She said soaking in a hot tub would be leisure for her but she did not have the funds to purchase the appropriate lift for her physical needs and assistive devices did not cover the cost either.

Private insurance companies, another funding option, determined priority of needs by requiring prior payment. This was difficult for women with low incomes. Pam was unable to get a walker she felt would be important for her mobility needs:

> "...even though my insurance will pay for it, I still have to come up with
> the money for it up front ... it boils down to what they consider is a
> necessity for your life. Well, how do they know. They're telling me I
> don't need this stuff."

Transportation for the women was usually segregated and tended to be more expensive because it was segregated. Since there was no bus transfer on buses for the disabled, the women had to pay each time they got a ride:

> "It's only $1.75 and that's not that expensive, but it can be. It's a pain
> when you come and go and you have to pay. Like if I go to three places,
> I have to pay for three places. So it can be expensive when you go all
> over the city in the bus."

Partial funding by the provincial and municipal government for transportation needs of persons with disabilities had the potential to be beneficial. For example, taxi scripts provided more spontaneous and less expensive transportation, but since these are dependent mainly upon government grants for their operation, scripts are vulnerable to funding cuts.

Policies, procedures and scheduling of transportation did not meet the desires for spontaneity and choice. Louise expressed how these important leisure components were compromised: "I have to book for a week ahead ... if I haven't got a booking by Friday I can't do anything on weekends." Pam suggested her leisure was structured by transportation providers: "There's not spontaneous buying, there's not spontaneous going out...you have to fit, yeah. Like you have to fit into ... [the schedule of the transportation providers]." This lack of social support within the community left less opportunity for social networking.

Beyond non-supportive funding systems were segregated programs that treated persons with disabilities as a homogenous group and did not consider their individual desires. They combined people from all age cohorts and types of impairments and functional abilities. For example, Carol wanted to dance and had access to a segregated wheelchair dancing program at a senior centre that met her physical but not her social needs. She had not gone for a while because it was mainly seniors: "I feel out of place with everyone being older."

Women with disabilities expressed a need for an environment that accommodated equipment and the movement of their bodies. The surface on which the women rode and walked affected their pursuit of leisure activities. For Pam, this meant a smooth surface for walking due to her balance: "Being on a stone driveway wouldn't be good at all [and] walking on the grass isn't good because...grass has bumps in it." Also, Ada suggested that policies and procedures to legislate accessibility of space could be ambiguous, exclusive and allowed for exceptions. For example, certain obstructions on sidewalks in her city (e.g., hydro poles and lamp posts) were exempt from city by-laws. These exemptions did not take into consideration the needs of people whose only mode of mobility was using the sidewalk or the room needed to manoeuvre pieces of equipment on the sidewalks.

Spatial designs were generally constructed around assumptions that certain body postures and positions were normative. For example, Ann, who uses an electric wheelchair for shopping, pointed out that businesses assumed that the vertical position was the norm and reflected this assumption: "Is it necessary to put a display in the middle of an aisle?... that's kinda hard to avoid."

Private aspects of accessibility restricted simple leisure opportunities and isolated the women from important social networks. For example, Louise was unable to visit with friends and family:

> "I can't go visit anybody because their homes aren't accessible. My family
> ... It makes me think ... 'Do they really like me coming to visit?' ...
> They're not doing anything about it...."

Social interaction was important for the women. Several of them cherished friendships with professionals and/or volunteers over the years, but personal relationships for the women needed to be non-obligatory. Ada suggested that there were problems with having care-givers

as friends because there was uncertainty and vulnerability in this type of relationship. For example, she referred to a man in her apartment building who depended on his volunteers and became friends with them:

> "He needs a volunteer to help him do the archery...but he said to me a little while ago that he's gotta be very careful about making friends with the volunteers because he gets hurt. The volunteer stops being a volunteer. I mean friends do that too, but at least you can argue with friends.... The volunteer, it's a different relationship, not a friend friend relationship."

Relationships based on obligation reinforce segregated, exclusive belief systems about women with disabilities. The constraints to leisure suggested here reveal that social structures are constructed accordingly. They are based on a cost/benefit analysis; the cost to society versus the benefits to persons with disabilities. Such an exclusive ideology suggests that meeting the leisure needs of women with disabilities is a trade-off between feelings of obligation to a special population by service providers and ensuring that nothing is taken from "the rest of society."

HEALTH PROMOTION STRATEGIES

The women felt leisure was important to their total well-being, it was constrained by physical needs and social perceptions of their bodies. To encourage society to accommodate difference, solutions need to focus on similarities between persons with and without disabilities while respecting individual functional needs and helping persons with disabilities become more independent and mobile. Building healthy public policy, reorienting health services, creating supportive environments and social activism by persons with disabilities are strategies for action that need to work conjointly for solutions to be successful.

Most of the present public and private policies implicitly reinforce perceptions of persons with disabilities as a special group separate from other members of society. Zola (1989) suggests that we need universalizing policies that recognize that the entire population is at risk of chronic illness and/or disability. Age, trauma, advances in technology to prolong and maintain life and disease are just a few of the things that can lead to a permanent change in one's health. The suggestion is that attitudes may change when similarities between those with and without disabilities are revealed.

Ada suggested that we must get beyond the false dichotomy of disabled/non-disabled in the process of policy formulation, incorporating instead the idea of functional abilities. Programs should emphasize a range of abilities among people, recognize both impairments and functional abilities, and implement resources that accommodate a range of human differences. This makes it more economically feasible to meet the leisure needs of more members of the community. For example, Ada's city purchased low floor buses that were partially funded by the provincial government. Not only would these buses be beneficial to persons with disabilities but they would be helpful for anyone who may experience difficulty

with stairs. This also challenged the perceptual distinction between persons with and without disabilities by presenting non-disabled people as a group whose needs should be met as well (e.g., the elderly, mothers with strollers, people carrying larger parcels onto the bus).

One of the main issues around public policy is the fact that leisure is not considered a necessity by decision-makers. Decision-makers who determine which programs are available, how they are run, how funds will be distributed, the amount of funding (if any) that will be allotted for leisure and who will have access to transportation, equipment and public space need to listen to those who are affected by these decisions. For example, provincial funding for disability (i.e., Family Benefits) needs to include financial support for leisure activities. Also, public (Assistive Devices Program) and private health insurances need to extend coverage to include the equipment needs of individuals with disabilities as expressed by them so that decisions can be consumer driven.

This extension of coverage could be more cost effective too. For example, everyday gadgets available in stores that served the everyday public were often less expensive than more elaborate pieces of equipment while adequately meeting the functional needs of the women (e.g., Ada purchased objects from a local hardware store to enable her to go canoeing).

Also, for women who have limited funds to purchase needed equipment, perhaps local outlets for health care could allow people to pay for their health-care needs over a period of time. This would eliminate the need to pay for equipment up front.

Funding regulations were perceived to be built on cost/benefit analysis so that helping persons with disabilities to become more employable was often the focus of recreational programs. Ann argued that funding to recreational programs should be contingent on inclusivity. This would ensure that funding dollars would not be given to rehabilitative programs alone.

A general lack of transportation was a leisure constraint identified in differing degrees by all of the women, but it is an important means of networking within the community. There needs to be accessible, affordable public transportation that is inter-city and intra-city for persons with differing functional abilities within the community.

Government subsidies for transportation need to be made permanent so that more flexible, economical and inclusive systems can be continued. For example, Ada was instrumental in the development of a program in her city called a "taxi script." It allowed for more spontaneous riding by persons with disabilities and provided a more flexible alternative to the busing system. It was subsidized 25 percent by the provincial government, 25 percent by the municipal government and 50 percent by the riders themselves. Ada explained it: "What the taxi script program does is, it enables people to get out on the spur of the moment, instead of calling busing system for persons with disabilities which must be booked ahead."

It was also less expensive if a person required assistance because the rider was paying for the use of the whole taxi and not just a seat in it as was the case with the bus: "...if you're taking your child with you or your partner or friends, the taxi still costs the same where on a DARTS (segregated bus system for persons with disabilities), you have to pay extra fares." This type of transportation is also useful because it is accessible to both disabled and non-disabled populations helping to eliminate perceptions of separateness while being cost effective.

Since personal transportation (e.g., a car) was considered the best option to ensure flexibility and spontaneity around transportation, perhaps there could be publicly funded programs to help individuals convert their vehicles as it would encourage independence for the women around leisure.

Health services need to reorient their services toward inclusivity. The women in the study were often placed in positions of dependency where their immediate needs were often dictated by a hierarchical chain of command and red tape. Health-care professionals need to value the experiential knowledge of persons with disabilities so they are free to control their care as their bodies dictate (i.e., when they have their bowel management carried out). Schedules of care-givers (i.e., families, attendant care-givers) and leisure providers (i.e., community and private run recreation programs) need to be flexible and organized around the lives of persons with disabilities where they are considered knowledgeable partners in decisions regarding their care.

A new model of recreation needs to be developed that investigates how the body and its parts move in relationship to time, space, others and objects. Such programs would meet the needs of individuals whether disabled or not. Debbie argued for the development of programs that used the concept of least restrictive environments (LRE). She described it in this way:

> Least restrictive environment can apply anywhere. Where you are removing barriers basically. You are ensuring that those things that you need, whatever they may be and it's a very individual thing, are available to you.

Through sensitivity to the individual's functional abilities and to LRE, programs can be planned that are inclusive and meaningful. It is important to look at the physical, emotional, social and spiritual components of the individual to make the leisure experience enjoyable and beneficial.

Recreation programs need to include differently paced activities to ensure that persons with different functional abilities will be able to take part in inclusive leisure programs generally opened to non-disabled persons alone. For example, Ada referred to canoeing as one such activity: "It's really quite a smooth motion, like swimming or bicycling and you can rest when you want. And I love canoeing."

To spend more time in community activities, persons with disabilities must have physical access in and out of their homes (Zola, 1989). Along with this is the need for physical access to other homes and public environments. Public space requires prior planning by business people, recreational departments, organizations and city works departments so that obstacles (i.e., hydro poles or ice and snow on walkways) would not impede the women's ability to be mobile within the community.

Also, provincial or federal low-interest renovation loans or grants for private and public environments would ensure decreased isolation and increased social interactions for persons with different mobility needs. This can potentially be more economical because future structural adaptations due to changes in the functional ability of the population would be avoided.

Access to knowledge about available leisure options was important to the women in the study. Ada suggested that there needs to be sharing of resources between communities so that research information about transportation, equipment and other types of resources in larger cities would be available to smaller communities. This saves research dollars for smaller communities while increasing awareness of the needs of persons with disabilities.

What can persons with disabilities do especially when they are viewed as a silent minority by decision-makers. Bickenbach (1993) and Oliver (1990) suggest that it is important for persons with disabilities to become politically active in order to redefine and develop services that will accommodate their "own self-defined needs." This can be done by joining committees that have an effect on their leisure activities. This will help create a liaison between management and service providers and the people they serve. Since men in general still hold a valued social position, it is particularly important for men with disabilities to join in and support women with disabilities around their double objectification as women and as persons with disabilities.

SUMMARY

This research suggests that in order to make leisure activities more accessible and available to women with disabilities, attitudes associated with disability must be addressed. These attitudes reveal an "us" (i.e., healthy, strong, male, mind controlled body) and "them" (i.e., dependent, weak, asexual, feminized body) dichotomy that often exists between persons with and without disabilities and isolates the former; these attitudes are reflected in public policies.

In order to change these attitudes there needs to be more opportunities for persons with and without disabilities to spend time together. Inclusive leisure environments are one way to achieve this in a non-threatening way. Giving the experiential knowledge of living in a marginalized body the same value as expert and/or non-disabled knowledge provides opportunities for teaching and valuing each other's needs, learning to rely on each other, to give and take, to ask and receive help, to delegate responsibility and to respect each other's boundaries. Hillyer (1993) refers to this as a "model of reciprocity" where value is given to dependence upon others as well as being depended upon. People depending upon others happens in an ongoing way everyday, but it seems to be ignored as a reality by those of us who endeavour to be independent as a sign of strength and success. When value is given to dependence and independence, then the feminized body is valued as much as the male-defined body.

"WE ARE MAKING A DIFFERENCE": THE WOMEN'S WORKSITE ACTION GROUP: A PARTICIPATORY ACTION RESEARCH PROJECT

**Maroussia Hajdukowski-Ahmed, Myrna Pond, Isik Urla Zeytinoglu
Lori Chambers**

Le projet dont il est question dans ce chapitre a été mis sur pied par un petit groupe de femmes immigrantes qui avaient des inquiétudes au sujet de leur santé et de leur sécurité au travail dans une usine d'alimentation locale. Le but de ce groupe de femmes était d'obtenir que l'usine soit inspectée au niveau de la sécurité, de conscientiser les autres employées sur des sujets de santé et de normes d'emploi, et d'améliorer les conditions de travail dans cette usine. La voix des femmes constituait la source de savoir primordiale, et les femmes ont elles-mêmes identifié les facteurs qui rendaient l'environnement au travail malsain; elles ont élaboré elles-mêmes des stratégies d'action destinées à éliminer ces problèmes; enfin, elles ont vu leur pouvoir de résolution ('empowerment') augmenter au cours du processus de mise en vigueur de leur plan d'action.

Chacune des femmes du groupe était sur-éduquée pour le type de travail qu'elle faisait dans cette usine; chacune d'entre elles avait connu une mobilité d'emploi latérale depuis son arrivée au Canada, passant d'un emploi mal rémunéré à un autre; et toutes se plaignaient du peu de respect qui leur était accordé au travail. Ce groupe de femmes a organisé des groupes de consultation thématique ("Focus Groups") et a entrepris une action directe sur les lieux du travail et dans leur communauté. Elles ont obtenu la collaboration d'organismes communautaires, fait des recherches à la bibliothèque, pris connaissance de la législation au travail et des règlements relatifs à la santé et à la sécurité en milieu de travail. Les femmes du groupe ont créé un prospectus qui a été distribué aux employées de l'usine, et dans lequel elles les informaient de leurs droits et des règlements au niveau de l'emploi. Elles ont aidé des collègues de travail à formuler des plaintes dans le cadre de la Loi sur les Normes de l'Emploi. Elles ont augmenté leur savoir, leurs compétences et leur aisance verbale, leur estime de soi et leur leadership, qu'elles ont par la suite fait valoir dans d'autres projets. Les plus actives ont trouvé des emplois plus stimulants et plus satisfaisants. Il est important que ce type de projet dans lequel les femmes immigrantes elles-mêmes font entendre leurs voix et passent à l'action, dépasse le niveau local pour s'étendre à d'autres lieux de travail.

This project was initiated by a small group of immigrant women who experienced health and safety concerns regarding their work in a food processing plant. The project was defined, directed and controlled by the immigrant women themselves and academic involvement in the project was primarily facilitative (Lather, 1992; McDaniel, 1987). The women sought: to have a safety inspection of the company; to make other workers at the plant aware of issues in relation to health and labour standards; and to improve working conditions—in particular noise, overcrowding, ventilation, lunch space and parking lot security. The women aimed at the immediate correction of perceived problems in their workplace and they conducted intensive research on identified issues and worked with legal, employment, health and labour organizations to develop strategies to solve these problems. The fact that there was no union at the factory, as well as the new immigrant status of the women, prevented the extension of the project to other worksites. This limited the scope of the project, but not its efficacy.[1]

This project has important implications for the health promotion movement. The immigrant women were considered a primary source of knowledge and identified for themselves the issues that made their work environment unhealthy; they devised the action strategy to be employed in combatting these problems; and they were empowered by the process of carrying this plan into action. They also acquired knowledge and skills transferable to other projects, and their sense of accomplishment improved their self-esteem and self-confidence and was conducive to the development of individual leadership skills and upward occupational mobility. Their achievements illustrate that "the meaningful participation of people in the development and operationalization of policies and programs is essential for them to influence the decisions that affect their health" (Hamilton and Bhatti, 1996, 9). The immigrant women who initiated and sustained this project were motivated by a desire to create a more just and equitable work environment in which they would feel respected. Their achievements are important because optimal health is only possible in an "environment that is based on the principles of social justice and equity and where relationships are built on mutual respect and caring, rather than power and status" (Hamilton and Bhatti, 1996, 9). This paper will begin with a review of recent literature on immigrant women and health, discuss the origins of this project and the methods employed by the immigrant women and will conclude with a discussion of the outcomes of the project, the obstacles that the women faced in the workplace and recommendations for future research in the area of immigrant women, work and health at the conceptual, policy and occupational levels.

[1] This chapter is written based upon the report prepared by the women themselves with the assistance of the research coordinator, Myrna Pond. Maroussia Hajdukowski-Ahmed and Isik Zeytinoglu helped to initiate the project and acted as academic consultants on participatory action research and on labour relations. The chapter was written with the financial assistance of the McMaster Research Centre for the Promotion of Women's Health for which we are grateful.

IMMIGRANT WOMEN AND HEALTH

Health has traditionally been defined as the absence of illness or injury (Armstrong, Lippman and Sky, 1997; Doyal, 1996; MacIntyre, Hunt and Sweeting, 1996; Navarro, 1986; Rutten, 1995; Thurston, Scott and Crow, 1997). It is only in recent years that a new approach to health has emerged that takes into account the contribution of socially produced conditions in the process of health and well-being (Armstrong et al., 1997; Bolaria, 1994b; Doyal, 1996; MacIntyre et al., 1996; Rutten, 1995; Thurston et al., 1997). These conditions include factors such as social class, economic cycles, and socially produced stress (Hamilton and Bhatti, 1996; Navarro, 1986; Waitzkin, 1983). Health is now widely viewed as not merely the absence of disease, but as a "state of complete physical, mental and social well-being" (World Health Organization, 1994). In this context, feminist researchers have asserted that women's health is holistic and must be understood within the wider social and material contexts of their lives. Improvements in women's health will therefore require changes beyond the health-care system itself (Pugliesi, 1992; Spitzer, 1995; Walters, Lenton and McKeary, 1995). The health of women of colour and immigrant women has come to be viewed as linked to the conditions under which they live; the position of many such women in the lower economic strata of society as a result of job segregation, descaling and discrimination has important ramifications for their overall health and well-being (Canadian Advisory Council on the Status of Women, 1995; Das Gupta, 1996; Mullings, 1984).

The study of immigrant women[2] is a relatively new area of research in Canada; until recently, immigrant women have either been subsumed into the category of women or have been considered as undifferentiated from immigrant men in official statistics and reports (Boyd, 1984, 1986, 1992; Estable, 1986; Ng, 1993; Ng and Ramirez, 1981). Although immigration has always played an important role in the growth of the Canadian economy, government reports on immigration and employment have concentrated solely on the issues, needs and contributions of male immigrants, neglecting in particular the labour force partipation of married immigrant women who arrive as dependent, family class immigrants (Boyd, 1976; Das Gupta, 1996; Iacovetta, 1992; Ng and Ramirez, 1981). Not surprisingly, the labour force participation rate of immigrant women is strongly correlated with their educational attainments and their ability to converse in either English or French (Statistics Canada, 1996b). The problem of the recognition of non-Canadian educational credentials and professional training remains a serious barrier for immigrant women, ensuring that many women work at jobs totally unrelated to their areas of expertise and knowledge and below their capacity (Bolaria, 1994; Corrigan, 1994; Das Gupta, 1996; DeSilva, 1992; Djao and Ng, 1987; McDade, 1988; Ng, 1993;

[2] The legal definition of an immigrant in Canada ascribes a legal status to people who seek "lawful permission to come to Canada to establish permanent residence" (The Canadian Task Force on Mental Health Issues Affecting Immigrants and Refugees, 1988). The term 'immigrant women,' however, despite this precise legal meaning, is also a powerful socio-political construction of these women as 'other' (Arat-Koc, 1992; Ng, 1986). Although increasing numbers of immigrants since the 1960s are members of visible minority groups, visible minority women who are not immigrants can also suffer many of the disadvantages associated with the stereotype and social construction of 'immigrant women.'

Pandakur and Pandakur, 1996; Trovato and Grindstaff, 1986). Downward mobility is exacerbated by government policy. Women, as dependent class immigrants, have limited access to language training programs, a factor that not only increased their isolation in the community but limited their job prospects and potential independence (Adamson, Schindler and Sparling, 1990; Allevato, 1987; Das Gupta, 1996; Ng, 1993; Ng and Gupta, 1981; Paredes, 1987; Seward and McDade, 1988).

Immigrant women are at a significant disadvantage in Canada's sex-segregated labour force. Like most of their Canadian-born counterparts, they are concentrated in "female occupations," but immigrant women are proportionally over-represented in the lowest paid jobs in the service and clerical sectors of the economy (Das Gupta, 1996; Richmond, 1982). Non-English-speaking immigrants are particularly exploited, working in private service as office cleaners and domestic workers and in textile, garment, plastics and food processing factories. They are also employed in restaurants, hotels and other food industries (Ng and Gupta, 1981). In these positions, immigrant workers are generally non-unionized and have little or no job security (Estable, 1986). Visible minority and immigrant status increase the likelihood of being underemployed or unemployed, of being employed in marginal, unsafe and poorly remunerated workplaces, and of facing stress related to societal discrimination and racism in the workplace (Adamson et al., 1990; Beach and Worswick, 1993; Bolaria, 1994; Christofides, 1993; Das Gupta, 1996; Ng, 1993; Ng and Estable, 1987; Pandakur and Pandakur, 1996). Despite these problems, however, feminist researchers have been slow to incorporate the specific concerns of immigrant women into research on occupational health and safety in Canada (Messing, 1991).

As a consequence of the occupational segregation of immigrant women into low status jobs, they often have income rates below those of both Canadian-born women and immigrant men (Adamson et al., 1990; Beach and Worswick, 1993; Estable, 1986; Ng, 1993; Ng and Estable, 1987; Pandakur and Pandakur, 1996). While white, educated immigrant women from G7 countries are exempt from many of these disadvantages, visible minority immigrants, in particular, suffer what Herberg (1990, 218) has described as "brutal" income inequality. In spite of their high rates of labour force participation, the employment patterns and incomes of immigrant women clearly illustrate that they are, as suggested by Ng and Gupta (1981) a "captive labour force" with severely limited opportunities; regardless of their work and educational achievements, visible minority immigrant women continue to be among the most disadvantaged people in Canada, despite extensive occupational mobility.

The health concerns of immigrant women are unique and are often closely related to their linguistic, cultural, social and economic isolation and the existing gaps in services provided to the immigrant population in Canada (Beiser, 1988; Bolaria, 1994a; Ng, 1993; Satzevich, 1992). The low status work, hazardous working conditions, poor pay and frequent unemployment experienced by immigrant women have a direct impact on their health. Racism in the workplace compounds the problem and poses a direct threat to health (Das Gupta, 1996). Until recently, however, women's occupational health and safety concerns, particularly the concerns of immigrant women, were ignored by researchers (Mergler, Braband, Vezina and Messing, 1987). Many immigrant women often lack control over their employment conditions, a negative aspect of their work with consequences for their health (Bolaria, 1994; Das Gupta, 1996; Karasek and Theorell, 1990; Link and Phelan, 1994). Immigrant women

do the jobs no one else wants to do and are therefore particularly likely to suffer the effects of heavy workloads and night shift work (International Union of Food and Allied Workers Association, 1988). Specifically in the manufacturing sector, poor physical working conditions can include such things as inadequate lighting, poor ventilation and sanitary facilities, high levels of noise, excessive heat or cold, and exposure to potentially toxic chemicals. Immigrants are particularly at risk for work injuries. Being more specific is difficult; not enough is known" (Report on the Health of Canadians, 1996, 24). Women in such environments can suffer heat stress, headaches, fatigue and apathy, problems that are only exacerbated by shift work, bonus systems and job insecurity (Clark and Grey, 1991; Das Gupta, 1996; Drummond and Lee, 1981; Wortman, 1994). Immigrant women also suffer from stress related to their bleak employment prospects; without the opportunity to learn new skills, or to acquire language skills under government sponsored programs, these women find themselves stuck in job ghettos with limited chance of advancement. Their ability to combat this disadvantage through participation in labour unions is often constrained both by the non-unionized nature of much of women's work, particularly in workplaces with a high concentration of immigrant workers, and by the fear of losing one's job and of deportation (Das Gupta, 1996; Estable, 1986; Ng and Gupta, 1981). To summarize: "gender and race compound worker's disadvantages— minority workers and women are exposed to an ever more hazardous working environment" (Bolaria R., 1994, 164). These problems, and sometimes also the belief, on the part of both management and workers themselves, that working conditions in Canada are better than those in the old country, mitigate against the improvement of poor working conditions.

THE LOCAL CONTEXT: STARTING THE PROJECT

Hamilton is situated in the heart of the industrialized corridor of southern Ontario and thus attracts many immigrants; in 1991, immigrants comprised 24% of the population of this city (Iacovetta, 1995; Statistics Canada, 1991).[3] Jobs that attract immigrant women workers are often an extension of their unpaid labour as homemakers and require little knowledge of the English language. They are found in food processing, home-care services, fruit, vegetable and mushroom picking. It is difficult, however, to establish a clear picture of the socio-economic situation of immigrant women in Hamilton-Wentworth because census data do not break down the percentages of women of different ethnic backgrounds employed in various sectors of the local economy. It is clear, however, that immigrant women in the region earn less than both Canadian-born women and immigrant men. In 1986, for example, immigrant men in the city earned an average yearly wage of $25,307.00, while immigrant women earned a mere average of $12,337.00 per annum. Importantly, average income also varied significantly within the immigrant classification on the basis of country of origin, with Spanish-speaking women earning the lowest average annual income of $8,560.00 (DeSantis,

[3] This meant that Hamilton ranked third in the nation with regard to the proportion of the population comprised of immigrants. Toronto had an immigrant population of 38%, Vancouver 30% (Statistics Canada, 1991).

1990). These earnings reflect the disadvantaged position of immigrant women in the local workforce.

The women who initiated and directed this project had experienced this disadvantage and exploitation personally. They were working in a food processing factory in Hamilton that has consistently employed large numbers of immigrant women of diverse ethnic, racial and linguistic backgrounds. The work environment as described and experienced by the women was exploitative. At the time of the worksite action, in 1995, the company employed approximately 1000 women on three shifts in the winter months. In the summer months, lay-offs reduced the workforce to between 300 and 400 women; workers asserted that the employer deliberately laid off workers so as to "avoid termination pay" (field notes, July 1996). Seasonal workers have "no paid holidays, no benefits" (interview, December 1998, with current employee). The largest proportion of the women working in the factory were immigrants from Portugal. Spanish-speaking immigrants from South America constituted the second largest group of workers, and workers from the former Yugoslavia were the third largest group. The work was demanding, the working conditions difficult and unpleasant, with workers complaining that "ventilation is a big problem," and that "the line is too fast for me to take my breath" (interview, December 1998). These conditions, and the fact that the employment lacked basic security and decent remuneration, combined with the seasonal lay-off policy, ensured that the company had a high turnover rate amongst its employees of all ethnic groups. It was in this context that the worksite action project was initiated.[4]

The Women's Worksite Action Group formed because of a chance occurence. The principal investigator of the McMaster Research Centre for the Promotion of Women's Health (MRCPOWH), who chose to focus on issues related to immigrant women, by error dialled one of the women—an old friend—who would become an enduring member of the group. In the fall of 1994, MCRPOWH was developing projects related to women and health; this interested the woman whose sister, who was an employee of the plant, had her car vandalized in the company's parking lot during an evening shift. The lot, located beside a train track, was poorly lit, and the security guard did not seem to have been present at the time of the incident. The sister had to drive her car home at night with broken windows in the bitter cold. The company refused to accept any responsibility for the incident. The police indicated that the lot was private and therefore outside their jurisdiction, and legal aid would not intervene. Frustration with the employer's intransigence with regard to this incident and with regard to other unsafe conditions experienced by the victim at the plant provided the backdrop for this project. Start-up money available through a grant from MRCPOWH made it conceivable for the women to begin to combat these problems in the workplace. The two sisters contacted other workers and the worksite action project was born. The research, therefore, was triggered by and provided focus for the anger and frustration of workers, and feminist research acknowledges the inclusion of affect in the research process (Reinharz, 1992).

[4] This description of the company is compiled based upon information provided by the participants in the worksite action project. To date, the company has refused to answer even basis statistical questions with regard to workforce composition. They also resolutely refused to discuss employment conditions or the worksite action itself: phone calls, May 13, 1998; June 15, 1998.

The worksite action group consisted of six immigrant women and the academic facilitator/ researcher. Of the six women, two were from Chile, one was from the Dominican Republic, one was a Spanish-speaking woman from Latin America and two were from the former Yugoslavia.[5] The women shared the experience of exploitation at the worksite. They were also all young, one was pregnant and the others had small children, with a dual workload that exacerbated worksite stresses (Armstrong and Armstrong, 1993; Pugliesi, 1995; Ross and Bird, 1994). Not suprisingly, all of the women were over-educated for the work that they were performing (Bolaria, 1998; Ng, 1993; Pandakur and Pandakur, 1996). One of the Yugoslavian women had trained as a legal secretary in her own country. Another woman had trained as a secretary. Two were teachers with university degrees from their country, but they could not use their credentials in Canada. One of these teachers had worked for six years in Montreal in a garment factory before moving to Hamilton and finding employment in the food processing sector. With the pressing demands of work on the line, she had experienced difficulties in learning Canada's two official languages. Although she had only been working in this factory for two months, she was suffering from back strain and pins and needles in her right arm, a problem not uncommon among workers on the line (Neis, 1995; Stock, 1995; Vezina et al., 1995). The two sisters who initiated contact with other workers had emigrated from Chile in the mid 1980s when both were young adults. They too had worked in stereotypical immigrant employment ghettos, as private domestic workers, as nannies, in greenhouses, in night office cleaning and, most recently, at the food processing plant. These employment histories attest to the occupational mobility of the immigrant women workforce in Canada. All of the women complained about a deep lack of respect at the worksite.

ISSUES AND GOALS

On November 27, 1994, the principal investigator, Maroussia Hajdukowski-Ahmed, a research assistant from MRCPOWH, Myrna Pond, R.N., and community health practitioner met with the women to discuss issues that needed to be addressed at the worksite and to discuss the methods that might be employed to alleviate these problems. The women clearly expressed their resentment of worksite working conditions and exploitation and presented a long list of grievances against the company including: "noise, smells—people faint, no windows, fluorescent lighting, no space (two machines are so close), a small lunch room, low pay, really hard work, the speed of the line, long stretches of work (five-and-one-half hours) between breaks, the schedules (five twelve-hour shifts one after another), a widespread desire to retrain for other jobs, and mostly the lack of respect" (field notes, November 27, 1994). After this initial meeting, work began in earnest, with four planned group meetings in members' homes between December 1994 and March 1995. The purposes of the meetings were: to identify the worksite issues (in focus group style); to plan for direct action; and to support group members throughout the process of challenging company policy. Meetings were held

5 The women are identified throughout in accordance with their own wishes.

in members' homes to reduce the costs of day-care and to ensure an unthreatening setting. Despite attempts to make the meetings accessible, by the conclusion of the project only three women remained to work with the research assistant. The three women who saw the project through to completion were all Spanish-speaking and knew each other well, a factor that may have allowed them to support each other more fully throughout the process. Two of the women belonged to a family of activists; their father, a union organizer, had been jailed during a repressive regime in their home country. They expressed no fear of retributive actions on the part of management. One woman withdrew from the group after having a baby because the work was "too time consuming." Internal tensions based on ethnicity also emerged within the group; these seem to have reflected tensions exacerbated by company policy as workers and their supervisors were, the women asserted, never drawn from the same ethnic group. Other members of the workforce at the factory expressed interest in the project, but declined to participate because of fear of retribution at work, including the potential loss of jobs. Current workers at the plant remain intimidated and "keep quiet (despite poor work conditions) because it is better not to make waves. Most women are seasonal and they are afraid they can be laid off or have problems" (interview, December 1998).

The women's workplace action group identified and articulated their major goals by April of 1995. They described the factory "as a jail" and sought to change this environment (field notes, November 27, 1994). The women sought to increase awareness at the plant with regard to labour rights and job safety standards as set out by Ontario legislation. They also wanted healthier and safer working conditions in their workplace. In particular, it was clear that "noise, crowding, ventilation, lunch space and parking lot security were issues that people would like to see improved. Nevertheless, repetitive strain injuries of arms and hands, and back pain, were relevant" (Joint Written Report or JWR, July 1995). Although the initial concern of the women was to address these issues within their own workplace, their long-term goal also included "working for the same goals for other local companies in Hamilton" (Goals Statement of the Group, 1995). They invisioned their project as providing not only an example of worksite challenges to intransigent employers but also as a springboard for similar projects at other worksites. One of the partipants described the project succinctly:

> I am part of a group of women who are working and fighting for better conditions in the workplace.... Everybody is frustrated about the issue. We are happy to have a job because of the money and the independence that comes with it. But we are also having such a hard situation at work. Everybody feels frustrated—being overloaded with work, work and overwork ... kind of a slavery. We don't know if it is slavery or if we are being treated fairly. We don't know exactly how we are being made slaves. Our thoughts are how to make the situation better.... We got together and focused ourselves and set up our goals. We discussed health, employment standards, safety, pay equity There is a high concentration of immigrant women, many of them don't speak the language, many of them don't know what the law is. WE'RE NOT GOING TO TAKE IT ANYMORE!

METHODOLOGY

The women employed a radical version of participatory action research (PAR) by defining for themselves the problems at the workplace that needed correction and by devising their own strategies for change. PAR led to the creation of their own report, the use of field notes as a research methodology and the distribution of flyers at the workplace. Such an approach not only empowers the participants by viewing the women themselves as a source of knowledge but provides a more realistic and accurate assessment of the workplace than can be accomplished by outsiders. "To analyze with workers the work activity is the best way to identify what determines risk factors involved in the activity which will serve to inform the recommendations. To look at the multi-dimensional aspects of their work with the workers is not a difficult task since this is their daily reality" (Vezina et al., 1995, 762). Collegiality among the PAR group members brought and kept three women as key researchers/ activists in the project together. A $700 start-up grant from the MRCPOWH was utilized to cover group expenses, making the project possible as the women were economically disadvantaged. The women took specific roles in the group based on areas of interest and expertise. The group did outreach work to try to expand the membership and approached local employment, health, legal and labour organizations. One member kept track of the budget and expenses. Decisions about the use of finances were made entirely by the worksite action group, not by academic advisors. The women spent the money on: gas and parking expenses; refreshments for meetings; child care; and long distance phone calls, papers, slides and promotional materials for distribution at the worksite.

Although a central and immediate objective of the group was the improvement of unsafe and unpleasant working conditions at the plant, the women quickly realized that the company would not initiate change voluntarily and that knowledge about employment and labour standards was a necessary precursor to meaningful improvements at the worksite. To further this goal, the women initiated, scheduled and participated in 14 appointments with community agencies including a local legal aid clinic. They met with Occupational Health Clinics for Ontario Workers representatives, the Ontario Worker Co-op Federation developer and the United Food and Commercial Workers Union (UFCW) representative and developed partnerships with these organizations. They conducted library research, read labour laws and related occupational health and safety policies, and contacted a university expert on industrial relations, Isik Zeytinoglu, who acted as a consultant, in order to inform themselves with regard to labour issues. They participated in a citywide advocacy committee. All three women attended and participated in the "share and tell" evening at the district health council organized by the advisory committee of the immigrant women's health promotion projects, for immigrant women's groups in Hamilton. At this event, planners arranged to make a videotape recording the words of immigrant women participants so that the three women could share their experiences with over 50 other immigrant women. They also discussed their project and work concerns with a local newspaper reporter in May of 1995. However, they declined being interviewed when the reporter could not submit the article to the women for approval prior to going to press. The three women generated a written report of all activities undertaken by the group as a way to ensure that they maintained control of the process and information provided to academic investigators. Scepticism towards academia

and the media was conducive to the retention of control of the project by the participants themselves.

The women also undertook direct job action. Having increased their own knowledge and awareness of health and safety issues and provincial regulations, the women set out to increase the knowledge of their co-workers since they had learned that among workers "there was confusion regarding overtime, termination payment, job security and last minute layoffs" (JWR). At a meeting on January 10, 1995, they discussed the design of a flyer intended to provide information about employment standards for co-workers. The suggested title of the flyer was "Immigrant Women in the Factory Work for Health/A Wake-Up Call." The suggested wording of the flyer included: "All you get is—headache, hand and muscle pain, back pain, varicose veins, stress, no time to move your body and no time for bathroom breaks or friends. For information call" (field notes, January 10, 1995). In preparing the flyers that would be distributed at the worksite, the women worked with the professionals whom they had met at legal clinics, through community organizations, the UFCW and the Hamilton Workers' Advocacy Group. They designed the flyer, organized and scheduled its distribution, and handed the flyers out to workers at the end of a day shift. They were doing what they had set out to do: to facilitate health promotion in their worksite and to provide information to the other workers at the company. In the flyer, entitled "Are You Concerned About:", they gave information about health and safety standards, compensation rights and employment standards. They had researched this information themselves. They listed the resources that had proven helpful to them, and names, addresses and phone numbers were provided to facilitate contact with these resources. Five hundred flyers were distributed. With this flyer the women achieved their goal of improving awareness of issues and resources among workers in their factory.

OUTCOMES OF THE PROJECT

Using this knowledge, the women assisted several co-workers in presenting claims under the Employment Standards Act. Workers had been denied the termination pay owing to them. The claim led to an audit under the auspices of the Employment Standards Review Office. "The claim under the Employment Standards Act for termination pay was a resounding success, as 139 employees were found to be owed over $52,000 in unpaid wages. The employer has paid these amounts" (letter to Worksite Action Group from staff lawyer, Dundurn Community Legal Services, April 23, 1996). Although not all of the employees to whom wages were owed had been located, ongoing efforts were underway to track down these individuals in order to distribute monies collected on their behalf. The women felt that this was the high point of their efforts to redress labour justice issues. The company had, for many years, been evading labour and employment standards; by making themselves experts on the subject, the women were able to understand the mechanics of their exploitation and to challenge it. One participant, having received her small compensation cheque, articulated her belief that this cheque provided eloquent testimony that the employer had been confronted regarding labour standards infractions and thereby forced to acknowledge the exploitation of past employees. This experience was empowering.

This demystification of expert knowledge regarding health, safety and employment standards also helped the women to improve the worksite environment and to challenge the company's disregard for the welfare of employees. The women proved, to themselves and to the employer, that not only could they access and understand technical and legal knowledge but that they could use it directly and effectively. For example, one employee at the company complained to a member of the Women's Worksite Action Group that she was suffering from arm and hand pain related to her work. The incident was then referred to a legal aid clinic:

> A woman brought several doctor's letters to the company since she was having arm and hand pain related to her work. Despite the doctor's advice to put her on light duty, she was never relieved of her job of packing heavy boxes. It finally drove her to quit her job. Later, when asking for her separation papers she was told that first she had to sign a letter for the company agreeing that she would not claim compensation. Later she would find out that the same letter was sent to the Compensation Board without the company's letterhead and fixed as if she had sent it. Later on a claim was filed by the woman with the help of the Dundurn Community Legal Services of Hamilton. (JWR)

Concurrently with these challenges being presented to the employer, working conditions at the plant began to improve. No union representative could act as an official advocate for the women. And management never acknowledged the Women's Worksite Action Group. Therefore no cause-effect relationship between planned action and these changes can be claimed, but temporal "coincidences" were noticed. In particular, the company was ordered to make a $50,000 reparation for guarding equipment on the jobsite (communication at joint meeting, Occupational Health Clinics for Ontario Workers, April 13, 1995). The improvements may also be related to the fact that, towards the end of the project, the company was partially bought out. "We also have news that the company has been sold. Working conditions seem to be improving. The parking lots have been fenced and lighted, there are reports of better treatment by supervisors, bonuses were given to recalled temporary workers" (personal communication to the research assistant, Winter 1995). Frustrations and problems remain, however, and conditions need to be monitored constantly: "A Polish worker who has been there four years continues to be laid off for four weeks every year and is still called a 'seasonal worker'. This means no benefits" (personal communication, August, 1996).

The women wanted to continue to tell their story in a creative and sensitive manner, to make the information they have gathered accessible to other immigrant women: "we expressed our beliefs, concerns and views through *arpillera*[6] style aprons making statements on the themes of human rights and repetitive strain injuries" (JWR). Repetitive strain injuries are

[6] An *arpillera* is a form of popular art and looks like a painting made of pieces of cloth which depicts a situation and constitutes a recognized form of protest. The *arpillera* makes a statement and is culturally grounded in Latin America, particularly in Chile.

"disorders that affect the hands, wrists, elbows, neck and shoulders. The injured parts are the muscles, nerves and tendons. They occur when hand and arm movements are done continually and in a forceful manner. These injuries are often permanent" (Clark and Grey, 1991, 23). One illustrated apron read: "Repetitive Strain Injury. It Can Be Prevented." This apron was displayed at the National Conference on Multicultural Health in Montreal in 1995.

The women felt that the project had come to a successful completion because: changes in health and safety practices at the worksite had been implemented; they had generated a greater awareness among workers about their labour rights and resources to which they could turn for assistance; they had reported their initiatives to others so that women in similar workplaces might employ this model to improve working conditions at other factories.

EMPOWERMENT OF THE PARTICIPANTS

For all of these reasons, the achievements of the three women who saw the project through to completion are remarkable. They learned how to access useful resources in their community and in the process acquired a personal sense of confidence. They developed knowledge and skills transferable to other projects and employment, improved and enriched their language skills as they acquired legal knowledge. The demystification of professional knowledge reduced the gap between lay and expert knowledge and encouraged women to take initiative. In the process, the women improved their self-esteem and their leadership skills. As the participants themselves described it: "Working on this project gave us the opportunity to learn from a new experience and experience the satisfaction of self-growth.... We could voice our concerns" (JWR).

Knowing about useful community services gives immigrant women a sense of control and confidence. Information is power. A consistent problem documented in studies of the immigrant population is the lack of knowledge of resources to help in the settlement process (Allevato, 1987; Canadian Task Force on Mental Health Issues Affecting Immigrants and Refugees in Canada, 1988; Ng and Gupta, 1981; Ng, 1993; Paredes, 1987; Ramkhalawansingh, 1981; Seward and McDade, 1988). Working together to accumulate knowledge about government agencies helped the women to develop a sense of solidarity and power:

> We don't feel as alone. We do not feel as threatened as before by phoning individuals in government because we have contacted individuals behind the desk, the shell. We have found sensitive people in community agencies. The women found that working within a network could back up and support the goals of the individual women. (JWR)

By accumulating knowledge that allowed them to challenge their exploitative work environment, and by developing such supportive social networks, the women promoted their own health.

Control of the environment is also a key determinant of health. In the workplace, the lack of control over the speed of the line, over breaks and working conditions contributed to

women's illness (Das Gupta, 1996).[7] As one participant asserted, "they were giving me work that actually three people should be doing, making boxes, putting labels on boxes and I don't remember what else...they were complaining because I was taking too much time. We were new and they wanted us to be very fast" (field notes, April 3, 1995). In the Women's Worksite Action Group, however, women developed the tools and skills to make changes in their environment, enabling them to exercise more control over their own health (Hamilton and Bhatti, 1996; Ottawa Charter, 1986). They controlled and directed the project themselves:

> The opportunity of being able to make our own decisions regarding a budget, conducting a meeting, setting our own agendas, reporting to community partners and being responsible for our own actions, produced confidence and developed new skills. (JWR)

Moreover, their protest was concurrent with changes in management style and conditions at the plant that are now beneficial to the health of all employees, not just those involved in the action group.

When people have the ability to make changes in their environment, they feel stronger and healthier. This confidence builds self-esteem, and self-esteem fosters successful teamwork and wider support for change. The women who saw the project through to completion were justifiably proud of their efforts and achievements:

> The women who remained in the project to the last are proud of the results accomplished. A big effort was made by a few people to make women workers aware of their working conditions. We believe that women cannot see a way out of their unhealthy working conditions, although they acknowledge them. In our opinion women remain in unhealthy jobs because of many reasons, but the main reason is that they feel they are not able to find a better job. (JWR)

Perhaps the most important achievement of this project is that in developing skills and confidence, these women came to realize that they were able to find better jobs, to achieve the upward mobility that so often is denied to female immigrant workers. All three women have moved on to satisfying and challenging careers. For example, two of them completed a college program to become technicians in cardiology and they plan to start their own "lab on wheels." The academic consultants and the coordinator gave the honoraria they had received as members of the immigrant women's advisory committee to one of the participants for the purpose of participation in a self-awareness and writing workshop. The participant plans to use these skills to write the story of almost three generations of immigrant women in Canada:

7 Statistics Canada released a study reported in the *Globe and Mail* of January 13, 1999 (pp. 1 and 10) whereby worksite stress is linked to lack of control, and women suffer more becuase "men still have more decision-making power in their jobs." The report links job stress with high blood pressure, repetitive strain injuries and carpal tunnel syndrome and back problems (*Globe and Mail*, January 13, 1999, pp. 1 and 10).

her mother, herself and her much younger sister. She has also written children's stories in a community journal. The changes instituted in these women's lives illustrate that "when stigmatized groups shift from individualistic explanations to social, structural and political analyses, they find that personal as well as collective empowerment ensues" (Naples and Clark, 1996, 178).

OBSTACLES FACED BY THE WOMEN'S WORKSITE ACTION GROUP

Although the accomplishments of the group are significant, the women failed to achieve one of their central objectives; the Women's Worksite Action Group did not expand beyond the initial site of protest. The group lacked time, energy and resources because, despite verbal encouragement for the project from co-workers, few women at the original worksite were willing to be affiliated openly with the group. Immigrant women need their jobs and are often, as in this case, unprotected. This is a tremendous impediment to worksite protest: "Working conditions for immigrant women are poor. Women have little trust in the system and they are afraid to voice their concerns. Their fear of exposure is greater than their (perceived) need for change" (JWR). In this factory, the women worked under conditions that prevented socializing with other workers at coffee or lunch breaks, and schedules were heavily regimented and worksite visibility was intense: "The problem is that you never get to be friends with people, because they keep moving you every week" (field notes, April 25, 1995). This constant shifting also prevents contacts that could lead to unionization. Working conditions that include noise, crowding, smells and time pressures not only make women unwell but function to create a feeling of systematic oppression and isolation that mitigates against group action (Das Gupta, 1996). Before the initiation of the project not only did women employed at the factory know little about their rights as workers but they were so tired, isolated and afraid of retributive firings that they hesitated to express their concerns about company policies: "They are having the same problem in the company and they know about it, they just don't want to ask" (field notes, April 25, 1995).

Not only were women unaware that legal recourse was available against the employer but those who did have some knowledge of labour standards and workers' rights were acutely aware of the double dilemma they faced in reporting the experience of oppression. They were fearful with regard to their jobs because of the threat of being fired or deported, and describing your oppression is difficult when the oppressor, and the agencies addressing the problem, do not speak your language: "There is a perception that racial, cultural and language difference stimulate discriminatory responses from government workers. Not knowing how the system works, not knowing their rights in the worksite and fear of losing their jobs keeps workers from speaking out and making changes" (JWR). The fact that the workplace was non-unionized not only reduced the potential for support for the work action outside the initial workplace, since the union would have served as a legal spokesperson and an advocate, but exacerbated fears of retributive firings (Das Gupta, 1996).

The relationship between the academic community and the immigrant women was also strained, limiting the potential expansion of the project. The women distrusted the research focus of academia and sought instead to promote practical, immediate action. Although these goals are compatible with PAR, the distrust created tension. In particular, the women wanted

to see the company named explicitly not only in the flyer that they produced to inform co-workers about their legal rights but in any academic work that might be produced to disseminate the results of the project. Academic advisors, however, were deeply concerned about the potential legal liability of the university in releasing such information. The refusal to print the company name reinforced the perception of the workers that the university was removed from reality and of limited assistance in promoting worksite action and thereby the health of immigrant women.

RECOMMENDATIONS AND CONCLUSIONS

The evaluation of this project is limited to what the women themselves reported with regard to changes in the workplace and their own sense of empowerment. The project illustrates, however, that knowledge is not owned by academics alone, that determination and hard work, not large numbers, are central to the success of a health promotion project, and that control and respect are central to mental health. Moreover, the participants identified further necessary changes not only at the worksite but in the wider community in order to accommodate the needs of immigrant women. The voices of these women need to be heard and their concerns addressed.

The women want to see that the changes they initiated will continue in their former workplace and spread to other non-unionized worksites Hamilton. Their primary concern is that the voices of immigrant women are too often silenced; the oppressive conditions under which immigrant women work and live mitigate against group action and perpetuate a cycle of disenfranchisement. The women spoke clearly of the need for greater awareness of the existence of occupational health and safety standards among immigrant women workers. For immigrant women to improve their knowledge of workers' rights, government action will need to be undertaken to translate information and to distribute pamphlets, such as the one produced by this group, preferably in a variety of languages, at the diverse worksites of the immigrant communities. Strategies are also necessary to enforce health and safety standards in non-unionized plants and to prevent employers and administrators from discouraging unionization. The women's experience illustrated that employers will be less intransigent with regard to health and safety concerns when workers are informed about their rights and active in defending them. Once again, however, government must take a greater role in inspecting immigrant worksites and enforcing existing health and safety standards; currently inspectors are too few in number and worksites often remain exploitative and unsafe.

Although not initially concerned with this issue, over the process of the demystification of expert knowledge, the women also came to identify language as a central concern of immigrant women; they advocated standardized certification with regard to English language skills and access to information, at the worksite, with regard to testing requirements. Such information would facilitate job mobility, allowing women to escape from the most exploitative of work environments and forcing such employers to reform. They also asserted that English language training should be provided by the employer at the job site since shift work makes it difficult for women to take language courses offered by existing educational institutions.

These recommendations are important and have significant implications for the study of immigrant women and for the health promotion movement. This project suggests that

longitudinal studies of immigrant women and their employment are necessary; without longitudinal studies of immigrant women and their work, we are at risk of interpreting mobility as instability, whereas for the women in this group, occupational mobility represented upscaling and was reflective of their resourcefulness. Moreover, the results of the project illustrate that a small group of women can effect change if they are determined and motivated. Academic involvement in health promotion should be primarily facilitative, allowing women to determine for themselves the solutions to the particular problems they face. Advocacy is another important role academics could play. Creating links between the university and the community is important, but it also raises the problem of the "double bind of accountability" (Beattie, 1991; Cancian, 1996). How can academics both satisfy the needs of the participants in projects such as this one, participants who seek immediate goal-oriented results, and fulfil the requirements of granting agencies and research criteria necessary for funding? To whom does the academic facilitator owe primary loyalty? (Allegrante and Sloan, 1986; Pasmore and Friedlander, 1982). Participatory action research, as this project illustrates, works with small numbers of participants; the test of a health promotion project should not be statistics, but its efficacy for the participants who validate experiential knowledge (Walters et al., 1995a). Moreover, the urgency of needs as in this case is an important ethical consideration for researchers. This project also illustrates the difficulties inherent in the study of a workplace in which employers refuse to cooperate with researchers; it is important that academics not ignore the workplaces of immigrant women despite the difficulty of amassing data and creating partnerships under such conditions. The academic community needs to embrace models of research such as the radical participatory action undertaken at this worksite and to advocate on behalf of vulnerable populations. This project empowered the participants, helped to improve local working conditions for some immigrant women and was very cost effective. The many immigrant women who work for wages outside of the home enjoy greater financial security and greater personal satisfaction, thus enhanced self-worth and well-being. Their health would benefit from the improvement of their working conditions (Anderson and Lyman, 1987). Projects such as this are necessary so that the voices of immigrant women themselves can be heard and so that action specifically to address their concerns can be undertaken at a larger level than that of individual worksites.

ADOLESCENT SELF-CONCEPT AND MENTAL HEALTH PROMOTION IN A CROSS-CULTURAL CONTEXT

Nazilla Khanlou and Maroussia Hajdukowski-Ahmed

Dans ce chapitre, nous rendons compte d'un projet de recherche-action participante entrepris avec des étudiantes d'origine sud-asiatique dans une école secondaire.Les objectifs de cette recherche étaient d'identifier les questions relatives à la santé mentale des participantes et de déterminer les actions destinées à promouvoir leur santé mentale. En nous référant à ce qui a été ecrit dans ce domaine, nous nous attacherons à la notion de concept de soi en relation avec le développement de l'identité culturelle durant les années d'adolescence. Dans le cadre de cette recherche-action participante, nous avons organisé dix rencontres sous forme de groupes de consultation thématique avec un groupe d'étudiantes d'une école secondaire ontarienne. Le recueil de données incluait l'enregistrement des discussions, ainsi que des questionnaires et les journaux de bord tenus par les deux chercheures. Dans ce chapitre, nous considérons les trois thèmes qui ont émergé de notre analyse ainsi que leurs sous-thèmes, à savoir: le stress, le concept de soi et les transformations culturelles. Dans la conclusion, il sera question de la double transition psycho-sociale et transculturelle dont les adolescentes font l'expérience. Selon notre étude, qui différencie entre l'étape de développement que traversent les jeunes adolescentes et celle que traversent les plus âgées, la transition psycho-sociale se fait de façon plutôt positive. Dans le cas de la transition transculturelle, il sera question de l'aptitude des participantes à équilibrer les attentes d'ordre culturel de leurs familles et de leur communauté d'une part, et celles de leurs pairs, de l' école, et de la société en général d'autre part. Le conclusion de ce chapitre se concentre sur les considérations relatives à la pertinence de la recherche-action participante dans le domaine de la santé mentale chez les adolescents.

ଔ ଔ ଔ ଔ ଔ

This chapter describes a participatory action research study conducted with a group of South Asian Canadian female high school students. The study's objectives were to identify the participants' mental health issues and to identify actions that would promote their mental health.

Referring to the literature, we will pay particular attention to self-concept and its relation to cultural identity development during the adolescent years. In describing our findings, we will examine the influences on the self-concept of South Asian Canadian female adolescents. We will consider gender, age group, ethnicity and marginally race. We have set aside the class and cast factors, as there were no noticeable differences in the group. The study adhered to the Hamilton and Bhatti model of population health and health promotion (1996) as it aimed at creating supportive environments, developing personal skills and eventually contributing to culturally sensitive school environments and educational policies.

THEORY AND LITERATURE REVIEW

Adolescence is acknowledged to be a crucial time in human identity development. As a process, identity formation is a complex phenomenon that is often considered either from a universal perspective or from a contextual perspective. In this paper we assume that adolescents' development follows similar stages which manifest themselves differently in different contexts (Hart and Fegley, 1997). Our definition of self-concept parallels that of Neisser's (1997) conceptual self; it is "what we bring to mind when we think about ourselves," how we perceive ourselves, the self we evaluate, like or want to change, and it is not necessarily close to the "real self" (3).

Developmental, socio-cultural and economic factors are believed to influence the adolescent's self-concept (Cochran, 1988; Freire, 1993; Knoff, 1986; Muuss, 1975; Rosenberg, 1965). We will pay particular attention to the influence of a cross-cultural context on the participants' sense of self. The participants in our study were female, adolescents, South Asian Canadian, "visible minorities," thus sharing representations associated with these markers.

Culture and Self-concept

In belonging to a particular cultural group, the participants in the study had "shared ideas about 'how to be', who they are and where they belong, what is possible for them, what is not ... reflected in an array of culturally significant metaphors, images, stories, proverbs, icons and symbols, as well as in their foundational texts" (Markus, Mullally and Kityama, 1997, 16). A specific socio-cultural community can offer a distinct description and valuation of the self-concept. For example, early independence for adolescents can be valued in an individualistic culture whereas interdependency can be valued in a collectivist culture. However, we should be cautious of dichotomization and generalizations on cultures, as culture is not a monolith that is transmitted in one episode to the individual. Rather, it is a process that takes place over a lifespan. The consideration of adolescent development within a cross-cultural context points towards a greater complexity than the study of youth living in a monocultural context (see also Hart and Fegley, 1997).

For persons experiencing an intercultural context, the transition between cultures influences their sense of self (Zaharna, 1989). According to Marlinda Freire, "Children and youth are in an even more vulnerable position because they go through the process of cultural

translocation and identity transformations at a stage in their development when they have not yet consolidated a solid sense of self and cultural identity, including a linguistic identity" (1993, 81).

The literature on the influence of culture on self-concept development includes theory and research on the role of ethnicity. Ethnicity is an ambiguous term which in this paper refers to "an involuntary group of people who share the same culture and descendants of such people who identify themselves and/or are identified by others as belonging to the same involuntary group" (Isajiw, 1985, 16). Drawing from developmental theory, Phinney (1990) has proposed a three-stage ethnic identity development model. The stages have similarities to the four statuses of identity formation proposed by Marcia (1967, 1966). The first stage consists of unexamined ethnic identity and relates to "early adolescents and perhaps adults who have not been exposed to ethnic identity issues" (Phinney, 1990, 502). It is characterized by a lack of exploration of one's ethnicity. Those who are not interested in ethnicity are believed to have diffused ethnic identity. Those who base their views of ethnicity upon the views of others, such as their parents', are believed to have foreclosed ethnic identity. The second stage consists of ethnic identity search, during which an exploration of one's own ethnicity is undertaken. The final stage consists of achieved ethnic identity and entails an understanding of and confidence in one's ethnicity.

Rosenthal (1987) observes that the aspects of a culture an ethnic group will emphasize is dependent on "their cultural history or place in the broader society" (164). Both mainstream society and the ethnic group influence the individual's ethnic identity. In this sense, ethnic identity is "a product not only of the individual and his or her relation to the ethnic group but of the relation between that group and the wider social setting" (Rosenthal and Feldman, 1992, 215).

Setting the Context: Views on South Asian Family

According to the 1996 Census, close to 3.2% (342,375) of Ontario's population (10,642,790) identified their single ethnic origin as South Asian (Statistics Canada, 1998). Our study specifically considered youth from an East Indian background.

Several authors in Canada have described the attributes of what is commonly believed to be a traditional South Asian family (Assanand, Dias, Richardson and Waxler-Morrison, 1990). In a South Asian family women are the nurturers and are responsible for household, child-rearing and care-giving duties. The elderly enjoy a great deal of authority and respect, they advise the younger ones, arrange marriages and help raise children. A bride is expected to be a virgin, and girls are often prevented from dating. After marriage, the bride usually joins her husband's household and a girl is raised with the expectation that she should adapt to her new home. Separation and divorce are rare and discouraged as well as inter-cast, inter-religious or inter-racial marriages. Male children are favoured as they are responsible for the care of aging parents. The reputation of girls is very important and affects that of the family's. The eldest female sibling receives more household responsibility than the other siblings. However, there are variations to this basic framework and the conditions of emigration can also alter it drastically. For example, the extended family tends to disappear in favour of the nuclear family, and the family can experience a parents/children role reversal if children become more conversant in English than their parents.

Examining the socialization of South Asian immigrant youth in Canada, Kurian (1991) has referred to the "inevitable generation gap" between parents and their children. While parents "are not willing to give up their culture, which they often regard as being more meaningful for the cultural identity....the children, especially those who are born in modern societies, adapt relatively easily" (47, see also Beiser, 1988, Chapter 9: Children and Youth).

However, any description of cultural traits, such as those listed above, should not be considered as applicable to all South Asian families living in Canada but as a starting point to be validated or refuted by the study's findings.

STUDY OBJECTIVES, RESEARCH MODEL AND METHODOLOGY

Recognizing the interplay between life-stage, gender and the socio-cultural context, we wanted to understand how a group of female adolescents describe their experiences in relation to their identity development and general sense of well-being (Khanlou and Hajdukowski-Ahmed, 1997). The objectives of the study were to:

i. Determine the mental health issues faced by South Asian female students, as defined by adolescent women of East Indian origin in one high school;

ii. Determine their stated contextual experiences, both at home and at work (including school), and how they perceived these experiences to affect their mental health;

iii. Determine courses of action, as defined by the group, that would promote their mental health.

The research model applied in the study was that of participatory action research (PAR). Following a PAR model (Maguire, 1987; Hall, 1981; Denton, Hajdukowski-Ahmed, O'Connor, Williams and Zeytinoglu, 1994), the participants identified the issues that were of concern to them and controlled the process of action/research, the process also being a product (ie: empowering, knowledge generating).

Aside from the participatory and action components of PAR, we believed that its education component (Hall, 1993; Freire, 1989; Maguire, 1987; Smith, Pyrch and Lizardi, 1993), whereby participants research and create knowledge on their issue, disseminate it and enrich their own self in the process, made the choice of PAR particularly relevant. Furthermore, reports on PAR's relevance in culturally diverse or cross-cultural contexts (Dagenais and Piche, 1994; McTaggart, 1991) made it a logical choice for our study.

The data collection methods utilized in this project included audiotaping of and note-taking during the focus groups, self-administered questionnaires and ongoing entries into the study's field log. Qualitative analysis of the data for emerging themes was accompanied by quantitative findings whenever relevant.

A group of South Asian Canadian female high school students had organized themselves in order to prepare a cultural event at a high school and needed help for the event. Our contact with the group was facilitated through a school teacher who acted as the liaison person.

We met twice with the group prior to the focus groups. The first meeting took place with the female leaders of the South Asian student group and the school teacher. The purpose of the meeting was to explain the study and to seek the group's approval to participate in

the project. The authors shared their knowledge of the PAR methodology. During the second meeting we were told by the group that it wanted to participate in the study because the process would be interesting and possibly relevant to some of their issues such as school stress and sense of self-esteem. We discussed our roles, expectations and what we could offer to the group in terms of resources. We emphasized exchange of knowledge, confidentiality and group ownership of the process.

The first nine of the ten focus groups (FGs) were held from February to April of 1996 on an almost weekly basis with the same participants. The tenth focus group (FG10) was held in August. Most of the time there were five to seven participants present. One participant, who gradually emerged as the group leader, was present during all of the FGs. Each FG was approximately one hour in length. All of the meetings and FGs were held at the high school, except for the last FG, which the group decided to hold in a pizza restaurant.

Audiotapes. The FGs were audiotaped with the permission of the participants, except on three occasions (FG1, FG9, FG10). Summary notes were taken on these occasions and were later expanded. The taped meetings were transcribed verbatim.

Questionnaire. During FG1 we asked the participants to write down what their mental health interests were and what things they thought would promote their mental health. The subsequent questionnaire covered the areas of interest expressed by the participants and several items, such as demographics and work related information, that we were interested in. The questionnaire consisted of scale items, categorical and open-ended questions.

Field logs. The authors each kept an ongoing field log and made chronological entries, such as personal reflections, arising from the fieldwork experience.

Analysis

Themes and sub-themes. The qualitative analysis, based on the transcription notes from the focus groups, involved an iterative process in which each of the authors identified themes and sub-themes and placed these into a hierarchical format. The authors met several times until consensus was achieved on the themes, sub-themes and their hierarchical positions.

Descriptive statistics. The quantitative analysis, based on questionnaire data, consisted of descriptive statistics of nominal, Likert and visual analogue scale items.

FINDINGS

There was a total of eight participants (P1- P8) who attended the focus groups. However, one participant did not return after the first focus group. Of the seven participants, six responded to the questionnaire. Three of the respondents were in Grade 9 and the other three were in grades 12 and 13. The two Grade 9 respondents were 15 years old and one was 14 years old. Two of the respondents in the higher grades were 18 and 20 years old. Five respondents were Canadian-born and one was an immigrant. Two identified their parents' original ethnic or cultural background as Jatt Sikh from Punjab; one as East Indian, Punjabi, Sikh; one as East Indian; one as Hindu; and one as Muslim. Over the course of the study, the

group, for the most part, referred to itself as a South Asian group with an East Indian background.

Three main themes emerged from the analysis of data. These were stress, self-concept and cultural transformations. As depicted in Figure 1, "Emerging Themes from the Study," the main themes should not be considered as separate domains. They are experienced simultaneously by the adolescents and are affected by the gender factor in a cultural context. Each theme influences the others and, in turn, is influenced by them.

Stress

From the outset, stress was identified as an area of relevance by the participants. The emerging sub-themes for stress consisted of work as a source of stress (including school and home related work), age and perceived gender differences in stress levels experienced, and sources of stress reduction (including relationships with friends and with family).

In response to a questionnaire scale item ranging from one representing "feeling not stressful" to ten representing "feeling extremely stressful over the course of the past week," the average score for the group of respondents was six, which leaned towards the feeling stressed half of the scale. Sources of stress included school related work, home related work and friends. The type and amount of work done each day included homework related to school (average of 3.1 hours), housework (1.1 hour), volunteer work (0.9 hour) and other work such as preparing for the cultural event and babysitting (2 hours). Therefore, in addition to going to school, the respondents reported working an average of 7.1 hours per day. Their

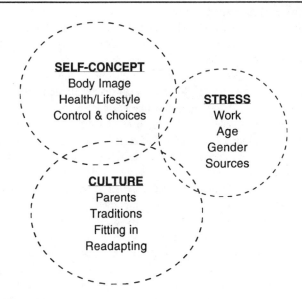

Figure 1
Emerging Themes from the Study

responses to three Likert scale items indicated that although they enjoyed their work and felt that they had enough time to do the things they wanted to do, the respondents also felt that they spent too much time working. As one participant summarized: "This week I am so stressed out. I have so many things to do, I have night school, the cultural event, I have work, I have volunteering," (P6, FG8). While the major source of stress was school related work, two participants also felt stress due to home related work. One of these two participants had the responsibility of looking after her recently bedridden grandmother for several hours during the day:

> She can't do anything by herself, she can't wash, eat. So I have to go home and come back for class for about an hour and then I have to go home and be with her and feed her. You have to do everything for her. Then my dad gets home. By then everything has to be done, because my mum is working until 7 or 8, she's self-employed but she still has to put her hours in. And so I have to go home and make a meal for the whole family, everything is done. And then on top of that I have night school classes every day.... So that's the pressure and there is homework. I wouldn't be surprised if I had white hairs by the end of this semester! (laughs) (P4, FG3)

There were age differences in the levels of stress experienced, with younger respondents reporting lower levels of stress or no stress compared to their older group members. This was attributed to the life-stage of the two groups. The younger group's age ranged from 14 to 15, they were all in Grade 9. The older group's age ranged from 18 to 20, one was in Grade 12, one in OAC (Ontario Academic Credit)/Grade 12 and the other in Grade 13. The older participants were making imminent post-secondary education plans. Their performance during the last year of high school had an instrumental effect on their university choices and, ultimately, their career plans. One participant also noted the influence of other people's changing expectations on her stress level. Now considered an adult, she was expected "to act like one." This clashed with her still feeling like a "kid inside" (P4, FG7).

Participants perceived that there were gender differences in the levels of stress experienced. Their responses to three Likert scale items suggested that while respondents felt that, as females, they experienced more stress, they had diverse perceptions on whether gender differences were to their advantage at school or at home.

Stress reducing sources included such activities as resting or entertainment and talking to friends. Relationships with friends were important for the respondents. In addition to being someone who was there to listen, friends were at times considered to be positive role models: "...she has been [pointing to another group member] a really good example, a role model for me, she's changed me a great deal" (P1, FG8). Relationships with family members were another supportive source. Most of the respondents felt they could talk to their families about important matters. The range for characterizing parents extended from "liberal" to "restrictive." Grandparents were often considered as a positive source of support, helping the parents to "understand" the participants' points of view. In this way, the extended family situation enhanced the link between one generation and the next. Three participants had a

grandmother living with them, and another participant had one set of her grandparents living with her family.

Self-concept

The main theme of self-concept manifested itself across a variety of discussions. Although not as explicitly referred to as stress, awareness of the self and its evolution emerged through diverse topics of discussion. The emerging sub-themes for self-concept consisted of the participants' views on their body image (including influences on self-image), on their health/ lifestyle (including nutrition, exercise, health and beauty and other), and the degree of perceived control and choices in their lives (including career and marriage plans, violence, racism and mystical beliefs).

In response to a questionnaire scale item ranging from one representing "didn't feel good about who I am" to ten representing "felt great about who I am" over the course of the past week, the average score for the group of respondents was 7.2, which was in the feeling good half of the scale. Sources of feeling good about the self included achievement at school, recognition of achievement by parents, helping others, making friends, exercising and controlling one's temper. Sources of feeling not very good about the self included parental disapproval, the self such as feeling lazy or stubborn, let down by friends and not having enough time. Among the things that could be done to feel good about the self were helping family more, taking care of and pampering oneself, going out with friends, managing time, achieving goals, relaxing and exercising.

Half of the respondents were satisfied with their body image. While several sources of influence on self-image, including fashion models, female family members and boys were identified, the participants seemed to fluctuate in the importance they gave to other's perceptions of them:

> I don't have any role models that are models, personally I don't like Cindy Crawford or Claudia Schiffer. I don't like them just because they're so so beautiful and I don't think they are. I think the reason why I look at models is the same way as you [another group member] said, because guys prefer someone with that kind of body, though I don't think they're beautiful. (P1, FG4)

Thus while recognizing the impact of the fashion model's image on females, some participants demonstrated independent judgment in showing their indifference towards them.

Half of the respondents were satisfied with their health. Their ideas of proper nutrition centred around reducing high fat food. Half of the respondents thought they were not getting enough exercise, mainly because of not having enough time and giving more priority to school work. Several participants thought that girls should be encouraged to enter team sports and that parents had an important role in doing so. Although being healthy was considered to be more important than beauty, some participants alluded to the societal "perks" that accompany beautiful people, including doing well in the job market.

The notion of control and choices manifested itself across various topics. Although all respondents felt that they had control over their lives, there were differences in the level of perceived control. While some thought that "you're in control of your whole life," others believed that it was a combination of fate, their choices and the actions of others. The lingering belief in fate among some of the participants could be culturally based. All respondents felt positive about their personal future. This optimism weakened when the group talked about culturally grounded prophesies on World War III that circulated in their community (described below).

Participants closer to graduation from high school had definite education and career plans. Most of them had decided that they would start their own families after completing their education and getting a job. The concept of establishing a self, one that is financially independent and has had the opportunity "to grow on your own" (P3, FG3) before entering marriage, was important to the older participants:

> Yeah, how could you give yourself to someone if you don't know who you are yourself? And how would they know what you are like? (P1, FG3)

> I am looking forward to going to university, to be on my own, to have no one look over my shoulder, to be independent. (P4, FG3, 223)

The importance of career among the group of participants may have been influenced by the presence of mothers who worked outside their homes. Of the six respondents to the questionnaire, five had mothers who worked on a full-time basis. The participants' desired sequence of starting a career and then marrying was not always in congruence with their parents' expectations.

While education, career and marriage were areas in which participants felt they had control, increasing violence in society was perceived to be something they had little or no control over. Violence was believed by some to inevitably lead to World War III (WW3) and the end of the world. During one of the focus groups the participants talked about their recently heightened fear following a video which was circulating in the community. The video showed a man in India who prophesied an imminent WW3.

During the same focus group on fear related to WW3, the discussion also involved ideas on mystical beliefs. One belief centred around a cultural narrative related to giant and little men, another had to do with fear of vampires and ghosts. Referring to the current Western preoccupation with describing all phenomena in scientific terms, group members attempted to rationalize their fears. As one participant noted "you don't believe in it till you see it" (P1, FG7). The adolescents appeared to be embarrassed at the prospect of holding such beliefs, as evidenced by nervous giggles during the narration, thus exposing a tension between logic and beliefs.

In facing and dealing with racism, five of the six respondents felt they faced racism. Some participants thought that they had no control over other people's racist comments but that they did have control over how they themselves reacted to such comments: "Verbally

you can't control them, you can't stop what they're saying, you can't put your hand over their mouth. But mentally you can have control over yourself" (P6, FG8). Several sources through which racism can be learned, including the media, school, parents, other youth and the environment, were identified.

The notion of self-concept was also tied to culture and traditions, a sub-theme under cultural transformations (discussed in the next section), and was present in the participants' written evaluation of the project during the last focus group (see section on evaluation of process).

Cultural Transformations

The cultural transformations theme revolves around the notion of transition, of the process that the participants were undergoing as South Asian Canadian adolescents living within two cultures. It was a thread that tied the past to the present and the present to the future throughout the discussions. The notion of transition was also present in the participants' views, at times their thoughts, beliefs and attitudes fluctuating from one focus group to another or changing within the same focus group.

The sub-themes which contained change included the participants' views on their relationships with parents, on their culture and traditions (including self-concept, grandparents, cultural practices and superstitions, gender differences, and community responsibilities), on fitting into Canadian culture (and preserving Indian culture), and on readapting to Indian culture.

Discussions regarding relationships with parents were often closely tied to discussions on culture and traditions. There was a sense that immigrant fathers had changed more than immigrant mothers, being more flexible in terms of letting their daughters do things that their mothers would not. However, one participant believed that mothers were the communicators of the fathers' expectations and, as a consequence, mothers may be perceived to be the stricter ones:

> ...if my dad has a point to get across to us and it's a negative point, like I
> don't like the fact that they go out so much and come home so late, he'll
> tell my mum to tell us, he won't say it, he doesn't want to look like the
> bad one. So we're all like, dad doesn't say much, dad doesn't mind. The
> thing is my mum is stuck in the middle, she has to give us the information.
> My dad won't yell at us. It's just the way he is....That's why I don't
> believe that dad is easier to get by than mum. Because dad is just as
> smart as mum. (P4, FG2)

All respondents to the questionnaire believed that following traditions was important for them. Their definition of tradition included past ideas, customs and rituals that are passed down. Five of the six respondents were Canadian-born and one had immigrated to Canada with her family when she was eight years old. Continuing traditions was important for most group members because it tied them to their culture and sense of their self, of "knowing who

you are." This was despite gender differences reported in the traditions and in the societal attitudes. "It's the satisfaction of knowing who you are, you have a confident feeling inside you that you're proud of who you are" (P4, FG5).

The participants intended on teaching the languages they spoke at home to their children when they became parents. They identified their grandmothers as the carriers of traditions over time in the family. Some of the practices were perceived by the participants to be superstitious (such as customs related to washing hair on certain days).

Gender differences were noted in traditions carried out for sons and daughters and in the societal attitudes towards marriage and divorce. Females were expected to marry at a younger age than males. Following a divorce, it was often the female and her family that were blamed. Several participants believed that such attitudes may be changing among East Indians living in Canada or that similar differences prevail in Canadian society as well. Society rather than religion was perceived as the cause for inequality:

> In this society now women are lower than men, but in our religion [Sikhism] it's stated that men are just as equal as women, and women are just as equal as men.... It's just that men don't want to acknowledge it. (P4, FG3)

> I was just going to say that same thing. In our religion [Islam] it says that men are equal to women. But it's not the way it is. People define it differently. (P5, FG3)

> Like if you look at a cashier that's female, the male will be paid more than the female [in Canada]. Like women say that we've reached a stage where we're equal but we're not. (P1, FG3)

The sense of having community responsibilities stemmed both from the feeling of a lack of privacy in a location where most people from the same background knew each other and from having to behave "according to good standards" (P4, FG5).

Several of the participants spoke with sarcasm about newcomers who rapidly changed their names and their appearance in order to fit in to Canadian culture. One participant believed that the rapid change was an attempt to "fit in" and "be just like everyone else" (P3, FG6).

Preserving Indian culture was important. The participants believed it was a "big advantage" to speak another language. They were resolute that when they had children of their own, they would teach them the languages they themselves spoke at home, to keep the culture alive:

> Some kids don't really know much about their background, India. They're not really connected to their homeland. If they speak the language they can know where they're from.... I think Canada is the most multicultural country. The US is more patriotic, once you come from another country there, even though you came from a different background, you're American, that's it. Here we're Indo-Canadian or whatever. We're proud

of our heritage, that's the big difference. I think that's why there's no real area differences of dialogues or accents here. (P3, FG6)

Participants also talked about people who returned to India after having lived in Canada. While some thought readaptation would be a difficult process, one participant believed that "the rich people in India have a better quality of life than here" (P4, FG3) and readjustment would be possible for such people.

ACTION: THE CULTURAL EVENT

From the beginning of our contact with the group, the participants wanted help in organizing a cultural event that would enhance knowledge of South Asian cultures in their high school and strengthen their own cultural pride. The event was also meant to be a fund-raiser for a Canadian charitable organization, thus demonstrating South Asian integration and community participation.

The event took the shape of a cultural fashion show. Female and male students from South Asian background alternatively displayed traditional attire and Western attire with corresponding music and accessories. The show aimed at conveying to the high school community glimpses of a rich cultural heritage from different regions of India as well as a representation of South Asian students in their Western context.

Two aspects of the show were particularly striking. First, the students strived to harmoniously include all regions, cultures and religions from India. For example, the entry ticket displayed four religious symbols (Christian, Hindu, Muslim and Sikh). Second, there was a complete dual structure to the presentation in which the display of Western fashion alternated with the display of South Asian fashion in a striking contrast of colour, body language and pace. The student models appeared to be comfortable in both contexts and in the presence of their parents, relatives, teachers and peers. The cultural event gave the students great pride as it was successful and highlighted the leadership qualities of several participants in the study.

EVALUATION OF PROCESS

During the last focus group (FG10) the participants were asked for their written feedback, which they eagerly provided. Their responses to a question on what they had learned about themselves through the focus groups indicate that the participants had gained a better understanding about themselves and their peers:

"I'm not the only one who seems to have overprotective parents."

"I have leadership skills. Very talkative. I try to include everyone in the groups."

This knowledge appeared to have practical repercussions as indicated in their answers to the question on the usefulness of the acquired knowledge:

"Try have an open mind about their [parents'] concerns."

"Apply towards a future career. Take charge of my life."

"I will be more strong and dependent on myself."

In reply to the question on the contribution of the focus groups to their sense of well-being, the participants expressed unanimous satisfaction:

"This sounds weird, but they seem to have improved how I feel about myself and it's also helped me deal with my fears and problems better."

"I have enjoyed being able to discuss my feelings throughout the sessions and feel that the sessions were therapeutic in a sense."

"They were really useful, because now I know what kind of a person I really am."

"They have been quite useful since it was a chance to talk and take a weight off my shoulders."

CONCLUSION

The adolescents participating in the study had an overall positive sense of self. The self-concept of the participants conveyed the picture of assertive, self-confident, independent young women, which belied the stereotypical perceptions of South Asian women (see also Bannerji, 1994a). The findings point towards the experience of a dual transition faced by the participants. In addition to going through psychosocial developmental changes, the adolescents experienced ongoing transitions between two cultures.

The psychosocial transition revealed that the participants were at two different stages of development. The older participants faced an imminent transition from one life-stage (completing high school) to another (such as starting post-secondary education, moving away from home, making future career plans and the possibility of marriage). This transition, along with its accompanying increased work, had led to higher levels of stress among the older participants. At school and at home the younger adolescents did not experience the same stressors as their older peers. The difference between the two age groups justifies studies that would consider the chronological distinction.

The cross-cultural transition revealed the participants' ability to balance the cultural expectations of their family and community with the cultural expectations of their peers, school and society. The participants demonstrated that identity and self-concept are multi-

faceted and multi-layered, which could function in different cultural contexts. The study consolidated the notion of culture as a shifting concept based on everyday practices that change with time.

As the more vocal group throughout the focus groups, the older participants relayed their deep respect for their culture and traditions, while at the same time describing their perceptions of gender differences directed towards them both from the majority culture and their own culture. Even as adolescents, this group had experienced Phinney's (1990) ethnic identity search stage and was well on its way to the achieved ethnic identity stage.

The participatory action research framework placed the participants' voices at the centre of the research process. It created a forum where the adolescents' voices were heard as sources of knowledge about themselves, affirming the identity and agency of the young women. As characterized in the Hamilton and Bhatti model (1996), the group achieved trust and mutual support at a crucial time in their studies and personal life. The PAR framework, thus, contributed simultaneously to mental health research and promotion with the participants.

Chapter 12

STRESS INDICATORS AND MANAGEMENT FOR IMMIGRANT, REFUGEE AND MINORITY WOMEN[1]

Basanti Majumdar, Sarah Ellis and Penny Dye

Les auteures ont mené une enquête antérieure et postérieure qui examine comment les services de soutien familial et de soutien au travail, ou leur absence, affectent l'aptitude des femmes immigrantes d'origines ethniques et ethno-culturelles diverses, à gérer leur stress dans la vie quotidienne. Les immigrantes se sont rassemblées en groupes de discussion thématique pour prendre part à des sessions dirigées par une immigrante préalablement formée. C'est le soutien familial qui s'est avéré le facteur le plus important dans la réduction du stress. Ces résultats ont été confirmés par l'information recueillie dans les journaux personnels des femmes et analysés selon la méthodologie fondée sur la théorie ancrée. Les résultats indiquent qu'un grand pourcentage d'immigrantes dans cette étude percevaient le revenu, les finances, la famille, les travaux domestiques et la discrimination comme des sources majeures de stress; le fait que les problèmes du revenu et des finances l'emportaient ne devrait pas surprendre puisque le niveau de vie de plus de 60% des femmes se situait au-dessous du niveau national de pauvreté (Majumdar et Ladak, 1998). Les femmes mentionnaient les maux de tête, la colère, la fatigue, et l'insomnie comme des signes et des symptômes de leur stress. Suite aux discussions de groupe thématique, la perception du stress a baissé, relativement aux finances, au revenu et à la discrimination; les femmes ont aussi remarqué qu'elles avaient plus souvent recours à la prière et à la musique. C'est à travers l'apprentissage de techniques d'efforts personnels que ces femmes pourraient être mieux à même d'aider leurs familles, leurs proches et leurs communautés respectives de manière positive; conformément aux objectifs des ateliers, il semblerait que les femmes aient commencé à aller chercher en elles-mêmes les forces nécessaires.

ርষ ርষ ርষ ርষ ርষ

Within the last decade, feminist research has expanded rapidly. The special and individualized stressors faced by women have become increasingly visible to society. This is especially true of female immigrants who face many stress-inducing challenges and situations

upon entering Canada. In addition to the stressors afflicting other Canadian women, they must also contend with ethnic minority status and culturally determined roles. There is considerable evidence of prejudice directed towards non-white groups in Canada, and immigrants must contend with language difficulties, unemployment and a lack of social support (Majumdar, Browne and Roberts, 1995).

The cultural diversity of the Canadian population is widely recognized; this must be considered in the delivery of health care in order to achieve a culturally sensitive approach (Majumdar et al., 1995). A study of immigrant, refugee and racial minority women by the Women's Health Bureau (1993), identified mental health and stress related issues as major health concerns for immigrant women. Key stressors identified by focus group interviews were attitudes toward lower wages, lack of support (child care, transportation, family), cultural differences, discrimination, lack of local training, language barriers and unemployment. The establishment of effective stress management programs was recommended to assist immigrant, refugee and racial minority women.

The strategy focused on personal health practices and coping skills, and the action strategy chosen was to develop personal skills. While it was hoped that each participating woman would develop her own stress management techniques or enhance pre-existing strategies, it was also seen as a way of impacting individual ethnic communities of women, making participants self-sustaining and therefore in a better position to empower others.

We examined the clinical manifestations and management of stress and aimed to increase coping strategies through small focus group discussion. Our study also contained a quantitative component to the research. It was hoped that these immigrant women with diverse ethno-cultural backgrounds would gain greater control over their reaction to stress and thus become empowered. These immigrant women hold different cultural values from that of the mainstream Canadian population. Those women with diverse ethno-cultural backgrounds, born in Canada or those who have resided in Canada for a long period of time, were not included in our study due to the process of assimilation. We viewed our research as a health promotion effort in that it aimed to enable people to take control over, and improve, their own health.

Women account for at least 45% of the paid labour force across Canada (Statistics Canada, 1992). Sixty-five to eighty hours of labour a week are necessary for a family to meet its basic needs: thus, the presence of women in the workforce is imperative (Statistics Canada, 1992). Although paid employment would appear to be a solution to both ethnic and mainstream women's poverty and associated ill health, this may have complicated the problem by creating new sources of stress (Mustard and Frank, 1991). This area has received little attention with regard to immigrant women (Canadian Mental Health Association Citizen's Survey Project Committee, 1984).

The disproportionate share of domestic chores women perform even while working outside the home may serve to increase women's distress (Statistics Canada, 1992; Canadian Mental Health Association, 1984). In addition to this stress, immigrant women may also experience difficult psychological adaptation due to cultural conflict as they adjust to resettlement conditions, occupational and financial difficulties, reduced social support and loss of status (Baker, Arseneault and Gallant, 1994; Lipson, 1991; Lipson, 1992). Increases

in mental illness and ill health have been connected to a lack of social support, placing these women at high risk for depression (Beiser, 1988; Sundquist, 1993; Sundquist, 1995).

Many sources have been identified for women's health problems including rigid schedules, feelings of worthlessness on the job or at home and a lack of support from employers and family (Franks and Faux, 1990). The competing demands of multiple roles as care-giver, housekeeper and breadwinner are taking a toll on the physical and mental health of women (Koch, Boose, Cohn, Mansfield, Vicary and Young, 1991).

These unique stressors make it very difficult for women to take control of those characteristics that determine their health. Women must feel in control of their lives in order to effectively deal with their stressors. Women need to feel an "internal locus of control" to, in turn, have control over their lives and to cope with the competing demands of work and family life. In a study concerning multiple roles and psychological well-being by Kopp and Ruzicka (1993) it was determined that internal locus of control was important to the prediction of both happiness and self-esteem. Landau (1995) conducted a study exploring internal locus of control and real resources and opportunities and personal coping abilities in which both locus of control and socio-economic status were found to be related to depression and life satisfaction independently. Spalding (1995) investigated the effect of perceived locus of control over health states and adjustment as measured by depression levels in minority and mainstream HIV patients. Minority subjects were more likely to believe their health status was in the hands of powerful others or chance (Spalding, 1995). Psychological adjustment was more likely to be problematic among those with an externalized health locus of control, particularly women of low socio-economic status (Spalding, 1995). Tobacyk and Tobacyk (1992) investigated the impact of socio-cultural and political situation on locus of control. In a study of belief-based personality constructs in Polish and American university students, it was discovered that individuals living in Poland between 1945-1985 had an externalized locus of control due to governmental pressure. Therefore, it is possible that immigrants from countries with a very strong government influence may have externalized locus of control due to previous life experience. It can be argued, therefore, that a low socio-economic status and an externalized locus of control place ethnic minority women at higher risk for depression and decreased life satisfaction.

As the number of women in the workforce increases, so does their exposure to these unique stressors (Gruber and Bjorn, 1982), which include open racial/sexual harassment; isolation/loneliness; and noisy, unclean, dangerous working environments. Although research in this area is limited, data show that women of high visible minority experience increased harassment on the job (Gruber and Bjorn, 1982; Meyer and Lee, 1978).

As stress management is culturally determined (Lee, 1996), those methods employed by immigrant minority women were of interest to the researchers. As the literature review revealed that women are under duress from many sources, it was apparent that further research was required. It was hoped that new methods of stress management might be accomplished by helping these women to identify their unique stressors and the subsequent clinical manifestations of their stress. In this manner, it was thought that participants could regain a feeling of control and become empowered. Both qualitative and quantitative research methods were utilized in this study.

METHODOLOGY

Focus Groups

A quantitative and journal method with pre-test/post-test design was carried out with 67 women of ethnic minority using focus group methodology. A focus group is composed of 6 to 12 individuals who are similar in some way and come together to discuss an issue of interest to research (Majumdar and Ladak, 1998). The ability to visualize and problem-solve are enhanced by the focus group atmosphere, which promotes exploration. Focus groups provide researchers with information on the needs of service and programs as they tap into perceptions and attitudes of human beings. The thinking and verbal contributions of participants are stimulated by the dynamics of focus group interactions giving the researcher valuable insight and information that could not be obtained through other methodological strategies (Asbury, 1995; Carey, 1995; Krueger, 1995; Smith, 1995; Stevens, 1996).

Participatory Action Research

A participatory action research (PAR) approach was utilized in our study. PAR is a combination of community participation, research and action that supports local insights and abilities regarding the resolution of community issues (Rains and Ray, 1995). The PAR method is a source of empowerment utilized to organize/mobilize self-sustaining community groups (Rains and Ray, 1995). Eng, Salmon and Mullen (1992) describe PAR as a critical base for primary community-based health promotion and education efforts. According to Eng, Salmon and Mullen (1992, 6), "A healthy, competent community is not a gift given by health care professionals; it is the accomplishment of a broad base of community members and others who are involved in the ongoing processes of empowerment."

PAR additionally reduces distinctions between the researcher and the researched. As active participants, community members join the research team to identify the problem and receive educational material to facilitate group communications (Rains and Ray, 1995). The group collectively decides how to cope with the problem. PAR becomes a strategy to empower people to think and value their collective understanding, promoting self-reliance and feelings of liberation among community members (Park, Brydon-Miller, Hall and Jackson, 1993).

Participatory action research (PAR) is a recommended research paradigm when health professionals are seeking to acknowledge local talent, develop lay leadership abilities and empower groups or communities to reach their full potential (Chesler, 1991). Communities are in the best position to identify untapped resources and priorities through the active involvement of community members. Group facilitators for this project were, therefore, recruited from community-based populations by advertising in the newspaper, on the radio and in multicultural organizations (Majumdar and Ladak, 1998).

Content

Community facilitators received 16 hours of training. Train-the-trainer technique was used to educate the facilitators in group process, stress and stress management techniques.

Facilitators used the Cycle of Stress Process (Figure 1) to guide group discussion allowing participants to start anywhere within the cycle (Majumdar et al., 1998).

Cycle of Stress Process

negative behaviour change	positive behaviour change ◄──────►	encounter stress
⬍		⬆⬇
loss of personal control and self-esteem	building self-esteem	recognition of stress
⬆	increase of social interaction	⬆⬇
⬆⬇		influence of stress on physical and mental health
decrease of social interaction constrained opportunities	reinforcement of stereotyped behaviour	⬆⬇ stereotyped expectations ⬆
OR developing positive behaviour ◄──────►		modified behaviour for stress management

From "Management of Family and Workplace Stress Experienced by Women of Colour from Various Backgrounds," by Majumdar, B. and Ladak, S., 1998, *Canadian Journal of Public Health*, 89(1), p. 49.

Each facilitator recruited volunteer participants, a maximum of ten per group, from their respective cultural/religious community and provided a culturally sensitive educational program in the mother tongue of the group (Majumdar and Ladak, 1998). Congruency existed among all group members regarding their beliefs, values, culture and language, promoting group cohesion and community partnership (Majumdar and Ladak, 1998). Women participating in the study included recent immigrant women of diverse cultural backgrounds. Those women born in Canada, or having resided in Canada for a long period of time, were not included due to the process of assimilation.

There was at least one month between the first and last meetings of the focus groups, which met for a total of 12 hours. Focus group discussion concentrated on: identification of stress in the workplace and family, methods of coping with stress, avenues for advocacy measures, the politics of power and the stages of change. Verbal expression of feelings and values relating to family and workplace stress was encouraged (Majumdar and Ladak, 1998).

Group members were also asked to keep a journal for the duration of the project. Qualitative data were obtained by analysing journal entries. This is considered to be within the category of semi-structured or unstructured self-report techniques of data collection (Polit and Hungler, 1997). Ideas and feelings in relation to a particular phenomenon are explored. This method of data collection has been used with success in research related to health. (Verbrugge, 1980).

Group members were given booklets (journals) in which to describe an event experienced by them at home or at work. The participants were asked to comment on: What particular problem was bothering them? How does that make them feel? What did they do about the problem? Did it work? and Why or why didn't it work? Those entries written in a language other than English were translated into English for the purposes of data analysis. Journals were given to participants at the beginning of the group sessions. The expression of thoughts, feelings and opinions regarding workplace and family stress was encouraged in both group sessions and in journal writing.

Grounded Theory

Grounded theory methodology was used to analyse the journals. This approach allows the researcher to identify concepts and the relationship between these concepts in an inductive manner. The goal is to conduct empirically grounded research on a particular topic that will lead to a theory about the topic of study based on the participant observations and interviews of the researcher and participants.

If women are to become equal and productive members of society, they must learn to manage their unique stressors. Liberal feminism seeks to eliminate oppression by seeking equal opportunity for women, not determining the factors leading to women's oppression (Wuest, 1994). If women as a whole are to achieve this ideal, then they must develop effective coping and stress management strategies.

DATA COLLECTION

Qualitative

A personal journal was used for the collection of qualitative data. In order to ensure the correct and accurate translation of the journals, the questions were translated into the language of the participants (Lao or Arabic). Community experts translated the journals from English to Lao and Arabic and then retranslated back into English to ensure content validity. The original journal was compared with the re-translated version for content reliability in Lao

and Arabic. A test of reliability and validity of the journal was conducted (Majumdar and Ladak, 1998).

Quantitative

An interview guide was developed for collection of quantitative data (Nakagawa-Kogan, 1976) and tested for use as only one had been developed and validated specifically for immigrant, refugee and racial minority women. Content validity of the questionnaire was established by testing it on 18 facilitators to ensure the appropriateness of expressions and terminology (Majumdar and Ladak, 1998). This was modified to accommodate women more accustomed to the verbal tradition (Majumdar and Ladak, 1998). The guide was then restructured and translated into the Lao and Arabic languages and subsequently retranslated back into English. Inter- and intra- reliability ($r=.82$ and $r=.72$ respectively) and the validity of the translated interview guide were established (Majumdar and Ladak, 1998).

RESULTS

Study Population

Sixty-seven focus group participants completed the interview guide at baseline (T_1) and after focus groups (T_2). Sixty-two percent of the women ranged in age from 30 to 49 years. Less than $500.00 monthly was earned by 13% of participants while 15% earned between $501.00-$1000.00 per month (Majumdar and Ladak, 1998). At T_1, 54% of participants were employed increasing to 52% at T_2. Sixty percent of participants earned below the nationally recognized poverty line (Majumdar and Ladak, 1998). The fact that many of these women experience financial difficulties was well documented in the literature (Baker, Arseneault and Gallant, 1994; Lipson, 1991; Lipson, 1992; Overholser, Norman, Miller, 1990).

The most prominent religion was Islamic as participants were from Africa (30%) and the Middle East (24%). Thirty-four percent identified English as the first language spoken (Majumdar and Ladak, 1998). The high level of stress was not surprising as language barriers often create conflict due to misunderstandings (Beiser, Turner and Ganesan, 1984).

What Problem is Bothering You?

The most common stressors identified at T_1 were finances (58%), income (57%), family (54%), housework (43%) and discrimination (40%). The fact that finances and income problems were prevalent was not surprising considering the fact that 60% of the sample were below the poverty line. Finances and income were frequently discussed in journal entries as illustrated in the following journal excerpts:

> "I have to work to help my husband but I can't find a job, and my husband works very hard but the income is very low and the work is not secured and if any one lost his job it is very hard to find another

one. For all this the person feels very stressed and for me I have always headache because I see my husband working all the day and what he gets is not enough to live on."

At T_2 the percentage of women experiencing stress related to finances, income and family remained high. Income as a source of stress decreased to a statistically significant level (p=0.01).

Family problems were also described in journal entries. Often these occurred due to conflict between parents and children. Those who gained employment during the time of the workshops (N=3) indicated that family increased as a source of stress while financial stress decreased although this was not statistically significant. Family as a source of stress may be noted in the following excerpts:

"My parents don't let me do anything or go anywhere...I really can't do anything because they won't listen. It's just the fact that I am in the prime year of and facing young adult (*sic*) and it doesn't help that I am a girl either."

"Problems with my parent/not enough freedom, trust...I try communicating with them to reach an understanding but neither side wants to compromise. It ends up in an argument and nothing is solved."

"I'm really excited about meeting these Arab women. I think I have so much more in common with them than with my American counterparts. Surely they'll understand my concerns about the children who've adapted fully to the lack of sexual values, etc. I sometimes feel as if my children are strangers to me."

Racial, cultural, linguistic, social and sexual areas were most frequently cited types of discrimination. These concerns were also voiced in journal entries as demonstrated by the following excerpts:

"I have been in Canada for three years. I had a job training at a poultry company. I wonder why working in Canada is like this?...Then I wondered why the foreman was not fair. There were many times that I worked overtime for him. Why didn't he regard me as a human and not as a machine. Why did he consider me to be a machine? However. I tried hard to do my job. Later on, I had a fever for three days, but I had worked till the end of my shift and planned to go to see the doctor. But it wasn't as I expected because the foreman told me, 'You have to stay, you cannot go home!' I replied, 'I have a fever and I am going to see the doctor.' He said, 'Everyday you can stay. Why can't you stay today?' He did not listen to what I said. If it was his people he would let them go, but for

me he wouldn't allow it. 'If you go home, don't come back to work,' he said.... I decided to quit the job. This is the best way for me."

"Employment is a big problem for me. Because I am a foreigner, I have no opportunity to raise myself to the same level as others. There is no work equity."

Perceived discrimination, as a whole, was reduced from 40% to 31% (p=.05). In addition, three areas of perceived discrimination decreased: racial (p=0.03), cultural (p=0.03) and family status (p=0.01) at T_2 (Majumdar and Ladak, 1998).

How Does It Make You Feel?

Headaches (68%), anger (53%), fatigue (52%) and insomnia (38%) were identified as signs and symptoms of stress at T_1 (Majumdar and Ladak, 1998). These were also noted in journal entries as demonstrated in the following excerpts:

"How does it make me feel? Frustrated because I do not know how long the situation will last or how bad it will get before it gets better."

"I found that I could not find a job, and that everything is different from back home. The language and custom is (*sic*) different and I feel very sad and disappointed. Life here is very difficult and it is the opposite of what I thought."

"It makes me feel so upset and uncomfortable to live like this. Sometimes, I get angry about my situation because it makes my life unsettled."

At T_2 a wider distribution of responses was evident as loss of appetite and anxiety were also realized as clinical manifestations of stress (Majumdar and Ladak, 1998). More participants were aware that fatigue was a stressor (p=0.04). This wider distribution of responses demonstrated participants' increased ability to identify signs and symptoms of stress. As the workshops focused on identification of stress factors, the workshop was seen to achieve its objectives in this area.

In general, it was found that participants who felt in control of their lives were happier and more satisfied. Those who viewed their lives and destiny as controlled by outer forces were less satisfied. This was seen in the following journal entry:

"Trying hard to meet other people from different cultures and backgrounds, hoping to find 'good friends.' I know I can and I know I will. It works for me—simply because I am at a stage where I know what I want and who I want to be with. I don't regret that I have burned the bridges with my past friends. I feel much stronger about myself. Now I make the choices not the society—who makes the rule...I rule me (*sic*)."

What Did You Do About It?

At T_1 and T_2 the five highest-ranking stress management strategies were prayer, listening to music, hot bath, exercise, reading and positive affirmations (Majumdar and Ladak, 1998). Prayer and exercise were frequently described as stress management techniques in the journals as demonstrated in the following excerpts:

> "I got over it because of the good friends who helped me at that time and also by listening to the Quaran."

> "The Bible teaches us to love each other, to be a good person, to love your friends or neighbours and not be jealous. This helps me to be patient to this day. This is one of the ways that helps my family to find happiness."

> "If someone believes and listens to the Lord's teaching, he will be happy—nothing bad will happen in his life. Everyday, even when something bad happens in my life, I am always happy because God abides in me."

> "By 1:30 I was exhausted, and didn't feel like going to my aerobics class but thinking about why I was so tired I realized that it was stress related. Knowing that exercise was an excellent stress-buster, I decided to force myself to go anyway."

Contemplation and meditation were found to increase at a statistically significant level at T_2 (Majumdar and Ladak, 1998). "Family support" was the most influential factor in decreasing stress levels at both T_1 and T_2 as identified by 76% of the participants. The percentage of participants with adequate child-care arrangements increased from 18% (T_1) to 26% (T_2) (p=0.01)(Majumdar and Ladak, 1998). As adequate child arrangements decreased workplace stress, this was thought to be a positive outcome (Freedman and Bisesi, 1988). Family was shown to be a major source of support and understanding for working women, possibly acting as a buffer to pressures experienced at work (Majumdar, 1998). There is still much research to be done in the area of stress-buffering mechanisms (Kong, Perucci and Perucci, 1993).

It would appear the women began looking inward for their own strength, which was congruent with workshop objectives. The women could incorporate this strength into their daily lives. These techniques of stress management have been used by other groups (Koch et al., 1991).

Did It Work?

At the onset of focus groups (T_1) participants were quiet and uncomfortable in expressing feelings and using non-verbal expressions such as smiling and head nodding. As they became

more verbal they supported one another's feelings and expressed dissatisfactions, realizing their lack of awareness of clinical manifestations and sources of stress (Majumdar and Ladak, 1998).

The physical and mental health of the participants remained constant during the study with over 70% rating their health as good (Majumdar and Ladak, 1998). Ninety-seven percent of participants believed they had adequate access to health care and did not find language, discrimination, fear or being unknowledgeable regarding accessibility to be barriers (Majumdar and Ladak, 1998). This is contrary to the literature (Overholser, Norman and Miller, 1990).

DISCUSSION

As women become an ever-present and powerful contribution to the Canadian workforce, the additional stressors of work life become a burden. Immigrant women must carefully balance the competing demands of culture, work and family life. Learning effective stress management techniques will help ethnic minority women to secure a valuable and prominent presence in Canadian society.

Participants realized the value of support groups and group process with women of their own ethnicity. The women gained an understanding of their daily stressors as caused by their multiple roles and conflict between Canadian and traditional cultural values. Some groups chose to continue meeting on an informal basis. Thus, this research was seen to reach beyond the level of the individual to impact upon the family and ultimately on the community.

Previous findings that immigrant women are of low income, lack support, are isolated and are discriminated against in the workplace were reconfirmed and supported (Majumdar and Ladak, 1998). Participants cited discrimination on the basis of culture and race as primary stressors in their lives (Majumdar and Ladak, 1998).

The conflict between parents and children was not unexpected as many immigrants feel alienated from their children (Canadian Task Force on Mental Health Issues Affecting Immigrants and Refugees, 1988). As children learn the local customs and culture more quickly than their parents, the resulting value differences cause conflict. This enhances a feeling of loneliness and isolation by immigrants and may cause the family to lose its authority.

Educational programs are imperative if societal conflict is to be decreased and healthy relationships among all races and cultures encouraged (Majumdar and Ladak, 1998). As ethnic minority women have low socio-economic status, social support and are isolated—factors contributing to mental and physical ill-health (Mustard and Frank, 1991; Beiser, Turner and Ganesan, 1989)—they may be considered a high risk population.

It is necessary that women work in collaboration with such programs in addressing these issues for themselves. Simply recognizing the sources of their stress is a first step in such a process. Recognizing and supporting other women faced with similar problems may also be useful for all involved. Mentoring and role modelling may reduce much of the stress faced by women in the future (Freedman and Bisesi, 1988). There are intrinsic and extrinsic connections between individual and community empowerment (Rappaport, 1984). In the process of becoming empowered, women, organizations and communities are gaining mastery over their own lives (Rappaport, 1984). Empowerment is associated with such concepts as

coping skills, mutual support, support systems, community organizations, neighbourhood participation, personal efficacy, competence, self-sufficiency and self-esteem. In response to the Ottawa Charter (1986), we acted to create supportive environments, develop personal skills in the participants and thereby empowered the women to gain control over their lives.

Allowing the ill health of immigrant women to continue unabated shall ultimately tax the Canadian health-care system. As health care is provided using the medical or curative model with its inherent views of health and illness, it is necessary that health-care providers are aware of, and have respect for, other health-illness concept paradigms. These paradigms are formed by the individual experience of culture, economics, environment and language. Just as different cultures have individual health-illness paradigms, so too do they have their own means of coping. To impose Western coping strategies on immigrant populations would be a disservice. Instead, health-care providers need to encourage existing healthy coping strategies (Majumdar and Ladak, 1998). It is in this manner that providers may capitalize on the strengths of ethnic minority women and strive to accomplish the goal of health for all as identified by the World Health Organization (World Health Organization, 1978).

YOUNG MOTHERS:
A POVERTY OF SUPPORT

Christine Walsh

A partir de perspectives qualitatives et quantitatives, cette étude se penche sur l'expérience de la maternité à un jeune âge. La première partie utilise des méthodes quantitatives afin d'examiner les facteurs inter-familiaux et inter-personnels qui précèdent la grossesse chez les adolescentes à haut risque. Les idéologies prépondérantes voient généralement la maternité chez les femmes de moins de 20 ans comme un problème, attribuant à la maternité une image socialement construite négative et stéréotypée. La seconde partie du chapitre examine l'expérience de la maternité et de la disponibilité de l'aide sociale du point de vue des jeunes mères à haut risque. L'étude a débuté avec un groupe de discussion thématique suivi d'une série d'entrevues individuelles avec 11 jeunes femmes. Après la tenue d'un atelier de groupe, les jeunes femmes se sont lancées dans une série d'activités visant à éduquer et à réduire l'opprobre social relié à la maternité à un jeune âge. Pour ce groupe de femmes, la maternité à un jeune âge survient dans un contexte de pauvreté sociale et socio-économique qui a des répercussions directes sur leur aptitude à donner des soins maternels. Malgré ces conditions plutôt regrettables, les jeunes femmes affirmaient leur compétence à être de bonnes mères capables de prendre soin de leurs familles. Un engagement vers des stratégies complètes, intégrées et libres de tout préjugé social doit être pris afin de répondre aux besoins des jeunes mères.

ঙ ঙ ঙ ঙ ঙ

Over the past two decades, changes in trends of sexual activity among teens, teenage pregnancy and motherhood have occurred in Canada. Recent studies have documented higher rates and earlier onset of sexual activity in adolescents (Gottlieb, 1988; Posterski and Bibby, 1988). Although a study of Canada's youth revealed that 85% of youth consider themselves to be knowledgeable about conception, 58% of the same youth did not use any form of contraception (Posterski and Bibby, 1988). This earlier onset of sexual activity and low use of contraception among teens, however, has not resulted in an increase in teenage pregnancy. In fact, the annual number and rate of teenage pregnancies declined by 2% from 1975 to

1987. The current rate of 44 pregnancies per 1000 women aged 15-19 remains 17% lower than the 1975 rate (Wadera and Strachan, 1991). Recent statistics reveal that Ontario has one of the lowest rates of teenage pregnancy in Canada (Orton and Rosenblatt, 1991); teenage fertility rates have declined consistently between 1971 and 1992 (44 per 1000 and 22 per 1000 respectively) and have since "levelled off" (Wong and McKilligin, 1994).

This reduction in teenage pregnancies and births is not reflected, however, in discussions about teenage motherhood. Teenage motherhood drew little attention prior to the 1960s but quickly escalated into an "urgent crisis" in the mid 1970s. Over the last two decades, a "veritable industry" has developed to deal with this "social problem" (Furstenberg, 1991). If there has been a substantial decrease in the number of births as well as in the birth rate for females aged 15 to 19 (Vinovskis, 1988), then why is it that there is an underlying moral panic (Phoenix, 1991) about teenage motherhood?

Since neither the rate nor the number of pregnant adolescents can account for the public concern regarding the "epidemic of teenage pregnancy" (Alan Guttmacher Institute, 1976), historian Maris Vinovskis (1988) suggests that social scientists and policy-makers have organized information in ways which created this epidemic. The socially identified problem may be that adolescent pregnancy is resulting in increasing out-of-wedlock births and single parenthood.

This suggestion is supported by recent studies. Greater changes have occurred, not in the number of pregnancies, but in the numbers of teenagers who become lone parents after giving birth. This rate has increased from 50.3% of pregnant adolescents in 1978 to 83.5% in 1991 (Statistics Canada, 1993). Although the trend for births and abortions for women under age 20 generally parallels those for women over 20 (Phoenix, 1991), and there is a dramatic increase in the rate of births to single women over twenty, "women under twenty have become the first age group in Britain, USA, and Canada in which it is normative for mothers to be single rather than married when they give birth" (Phoenix, 1991, 42).

Teenage mothers have become separated from the category of "mothers" by virtue of their age and perhaps their marital status. This "focus on reproductive trends" necessarily decontextualizes them by making them seem exotic and worthy of special note (Phoenix, 1991, 42). Once young mothers have been set apart, the way is paved to construct teenage motherhood as an urgent crisis driven by underlying moral panic (Phoenix, 1991). This panic has even escalated to the point that Schamess (1990) observes that teenage motherhood is not only receiving nationwide attention but is deemed to be the top social deviance problem in American history.

Teenage motherhood is like any other health problem. It does not exist as a problem until it is named as one. How it is named as a problem depends as much or more on cultural discourses about appropriate teenage sexual behaviour, the institution of marriage and the family, good mothers, and proper parenting as it depends on research statistics. Like many other social problems, once depoliticized, attention is redirected from structural and institutional aspects to a theory of social behaviour (Gusfield, 1989). The net result of this failure to account for structural and institutional considerations of young motherhood is to individualize the problem. Phoenix (1991) asserts that:

> Rather than being viewed as a phenomenon related to social factors, early
> motherhood has progressively come to be seen as the result of individual

> moral failing 'Blaming the victim' is not an uncommon phenomenon once a social problem has been identified. Early motherhood is merely one instance where a social problem is identified and it is then assumed that the individual is not only the culprit, but also the proper focus of social intervention. (34)

Much of the research on teenage motherhood has utilized this individualistic focus. The collection of race statistics in the United States that divides black teenage mothers from white teenage mothers (Vinovskis, 1988) and studies of dependence on welfare in both Britain and the United States (McRobbie, 1991) are two of the most inflammatory forms of individualistic research. In Canada, it is suggested that the issue of race is more muted with the discourse centring around teenage mothers' school failure (Geronimus, 1991), welfare dependency (Dooley, 1993) and questions about their parenting skills (Hardy et al., 1978). Because these research studies focus on individual deficiencies or negative consequences of teenage motherhood, the conclusions drawn from such studies create a rhetoric about teenage mothers associated with negative social constructions of young motherhood that perpetuate the pathologized stereotype of the unwed teenage mother.

Recent research studies have begun to dispel some of these myths. Two recent longitudinal studies (17- and 20-year follow-up) alter earlier perceptions because they reveal that 70% of young mothers, at follow-up, had received their high school diploma or equivalency, 68% were currently employed and 82% were self-supporting. Although 70% of the women had received welfare, only 29% had received welfare in the past year (Jaskiewicz and McAnarney, 1994). Researchers who set out to examine the common stereotype that teenage mothers become pregnant to receive social assistance found no evidence that women in Britain or the United States were so motivated (Phoenix, 1991). These studies demonstrate that a focus shift from an individualistic analysis to a contextual analysis of a person embedded in a historical, social and economic environment may provide a more beneficial and accurate picture of the determinants of health and the health promotion strategies that will provide positive results.

This study was an attempt to research the experience of teenage motherhood from an insider's perspective, with a focus on the person embedded in socio-economic realities, institutional policies and practices, and societal discourses. The purpose was twofold: a) to discover the determinants of health that the teenage mothers identify, and b) to propose health promotion strategies that address their concerns. A participatory methodological framework was chosen because of its guiding principles: a) the people who have the problem should define the problem, b) the people with the problem should benefit from its investigation, c) the investigation of the problem should be to eliminate the structural causes of a problem, and d) an investigation without resulting collective action is incomplete (Sohng 1996).

THE RESEARCHER

Qualitative techniques have been characterized as a less oppressive research methodology (Reinharz, 1992) which provides "a successful medium for collecting women's words reaching

a social group that does not often speak on the social stage—whose discourse is not perceived as legitimate" (Chanfrault-Duchet, 1991, 77). However, with that ideal in mind, I was cognizant of the difficulties intrinsic in hearing across differences. Feminist theory advocates the examination of the power inherent in differences between the narrator and the researcher's age, class, ethnic affiliation and education (Narayan, 1988; Minister, 1991). I identified a number of differences that impacted powerfully on my ability to hear and understand each woman's experience. I was almost two decades older than some of the women. Although I am a mother, I have not been a young mother. More relevant had been the difference in the privilege of academic education, which meant that the goals of my educational pursuits were juxtaposed with the challenging activities of the daily lives of the young women. The absence of poverty in my life prevented me from understanding the profound and chronic impact of poverty. The following is an example to illustrate my limited ability to understand:

> "During an interview with a woman with a three-year-old daughter, she explained to me how she had not been able to do their laundry for a few weeks because of difficulty with transportation, cold winter weather and lack of money. I offered to drive her to a laundromat and she agreed. I believed my offer had eliminated all three constraints since she had been paid a consulting fee of 30 dollars for her participation in the study and I was providing the transportation. When I arrived at the agreed upon time, there was a note taped to the door. The note explained that she was sorry she was unable to tell me she could not go to do their laundry since she was embarrassed because she needed money for menstrual pads and milk."

This incident reminded me that we cannot assume we can comprehend what the lives of young women are really like and how young women know we are limited in our ability to hear.

The women who participated in the research project were also removed from the researcher and perhaps doubly disadvantaged because of their prior experience as consumers of mental health services for emotional and/or behavioural issues. What the women have told me and what I have heard and have written will always be, to some extent, tainted by the differences that cannot be eliminated by even the most rigorous methodologies or the loftiest principles.

METHODS AND PARTICIPANTS

Initial Focus Group

The director of a local shelter that provides accommodation, aftercare and outreach for pregnant women and mothers agreed to contact clients and ask if they would be willing to participate in a focus group concerning young mothering. All the women agreed to participate save one who was studying for exams. Thus the membership consisted of six women, all of

whom were young mothers ranging from 16 to 24 years of age. Five were current residents and one was attending educational courses at the shelter. The group was facilitated by the author and an additional person audiotaped and kept process notes of the discussions. Focus group participants were invited to discuss their experiences of young mothering and identify those aspects that contributed to or hindered the task of mothering. The purpose of this focus group was to identify those common themes generated within conversation in order to develop the interview guide. I wanted to know which questions would be useful in eliciting their experience and how to word them in respectful ways. Participants talked about social support, families, boyfriends, friends and social discrimination. I organized interview questions around these themes.

Individual Interviews

Women who had participated in a longitudinal study investigating the emotional health of adolescents were mailed a letter asking permission to be contacted regarding their participation in the present study. All 65 women were contacted and asked if they had had a pregnancy. Thirteen women had become mothers as adolescents and were currently caring for their infants or young children. One woman was ineligible to participate in the study as she had moved out of the country and one woman chose not to participate.

Eleven women agreed to participate and completed one or two individual interviews in their homes. The women were initially difficult to locate; three of them were living in different cities and none was living in the homes where they had been contacted approximately six months previously. Most of the women had experienced several relocations over the previous two years. One woman, for example, who was in the process of moving at the time of the interview, had moved thirteen times since her three-year-old daughter had been born.

In the spirit of participatory research and respect for each woman's living situation, child care was made available to each woman and each participant was compensated for her time. After each interview, I made notes of the conversation and sent a draft summary to each participant for comment. I followed this up with a telephone call. This was my attempt to give each woman more voice in the creation of knowledge about her experience as well as some ownership over the project.

Group Workshop

During the individual interviews, women identified that they would be interested in meeting as a group to discuss their own experiences with other young mothers. In the interest of providing the opportunity for participant ownership of the research process and enriching the research study findings, I organized this group meeting. The session was held at an inner city day care with professional child-care provided. The meeting was co-facilitated by a member of the group and myself. Study participants reviewed the written summaries to see if they conformed to their stories and they had a conversation about their experiences. They related their individual stories of young mothering and I observed that they began to identify shared experiences. Although the participants had talked about some of this information in

the individual interviews, I noticed that, in the group forum, they discussed more contentious information including drug and alcohol use during and after their pregnancy.

RESULTS

Women identified areas of support or gaps in support across their social network in relationships with families of origin, birth fathers, partners, partner's or birth father's families, friends and health and social services institutions. These relationship categories will frame the discussion. Pseudonyms were used in the place of each woman's name to ensure her confidentiality.

Family

Family support, both instrumental and emotional, is essential for women who become mothers. When women were asked about their families, they initially replied that families were supportive of them, their pregnancy and their role as mothers. However, after further dialogue, non-supportive and conflictual elements in their family relationships were revealed.

Jennifer, who was 18 years old when she became pregnant, had been living with her father and younger brother. Her mother had died a few years previously. She was the only woman in the study who was living with her family of origin at the time of the interview. When asked what her feelings were when she first realized she was pregnant, Jennifer stated: "My first thought was my dad is going to kill me. And that's about it. I was happy, but I wasn't real happy because I was kind of upset too. I wasn't sure which one to be at all." Jennifer was unable to tell her father about her pregnancy until she was between four and five months pregnant. She waited until she and her partner had found an apartment before she could "tell him and then if he freaked out then I could leave right then because we were really worried about what my dad would do." Shona, who was the only mother with more than one child at the time of the interview, had two young girls. She became pregnant with her first child at age 19 and was living on her own at the time. Shona described her family as really supportive because they helped her out financially, lending her money for diapers when she ran out and assisting her with the cost of moving. She chose to live briefly with her mother after her daughter was born since her partner refused to live with her and being on her own with the baby "scared the heck out of me."

Some of the women reported renewed relationships with their families during their pregnancy and with the birth of their infants. Nicole portrayed her relationship with her mother:

> "I moved back home and we went to prenatal classes together and I watched her cry when we watched a movie about giving birth. And that's probably the closest I've ever been to my mom—I think she was excited and she was my best friend during that time. You know—we're not like that anymore. I don't know if it was the baby or—I don't know."

Although her mother had planned to be Nicole's labour coach, she did not attend the birth because the birth father was present. Nicole related feeling scared and horrified during her son's birth. She stated that she was angry with her mom for not being there, "I missed my mom, you know. I wanted her." Her son was placed in the neonatal ward for about a month due to medical difficulties. Nicole recounted her family's reaction: "While Kevin was in the neonatal [ward] and she [mother] came in with my dad and my sister and brother and just looked and they left." Although Nicole moved in with her family after her son's birth, her father refused to address the infant by name, and when he was angry would call the infant "a bastard."

Nicole had recently left an in-patient psychiatric facility, was evicted from an apartment and had been living with friends when she learned she was pregnant. Nicole, who was 16 years of age, described feeling humiliated when she told her mother about the pregnancy: "My mother said, 'I knew it.' I think it's because she had been waiting for it—and she decided I would just keep going down. Trash."

Prior to becoming pregnant, Mary had, over the past couple of years, moved several times between her mother's home, different foster homes, group homes and living on the street. When she became pregnant, she was 16 years of age and primarily living on the streets. Her own motherhood had brought back memories of childhood sexual abuse. As a child, she had been abused for two years from the age of nine to eleven. When she revealed the abuse to her mother, her mother began to experience flashbacks of her own childhood abuse and was too overwhelmed to care for Mary and her younger brother. Mary was subsequently removed from her home and placed into foster care. In describing this, Mary stated: "It was all kind of taken away so abruptly. I didn't have a chance of finishing my growing up—we lost a lot of mother-daughter things."

Wendy, who describes herself as a drug and alcohol addict since age 13, was living in a group home for teenage girls when she became pregnant at age 15. When asked what family meant to her she recounted that: "All my life I had to live with people who adopted me. And they were like a family too, but like my dad used to beat me up and stuff. I always felt that I was not loved and no one cared." Wendy believed her parents would hate her because she was pregnant. Nevertheless, she said, her mother was not angry, she just said she would not support her. According to Wendy her mother stated: "If you are going to keep the baby you are on your own." Wendy asked her mother to relay the news of the pregnancy to her father because, she said, "I figured my dad was going to beat the crap out of me if he found out that I was pregnant."

Alex had been in a relationship with her boyfriend for approximately four years and had wanted a baby. She was 16 years of age and had lived with a roommate for about a year before giving birth to her son. Alex, who had been worried about telling her mother about the pregnancy, thought her mother would be angry and would think Alex had messed up her life in the same way her mother had. Alex's mother had given birth to Alex when she was also 16 years of age. Alex reported relying on her mother who "comes over and helps me out all the time—about twice a week."

Shannon had just turned 19 when she gave birth to her child. She had been living with friends since leaving foster care. Although she characterized her family as supportive, they were unable to provide much care due to her mother's psychiatric illness and her father's

drug and alcohol addiction. Shannon, as well as many of the woman in the study, expressed feelings that the conception or birth of her child had a dramatic impact on her own life. Shannon, who believed her very life was at risk due to her lifestyle prior to becoming pregnant, recounted her relationship with her daughter in the following way: "If I hadn't had her, I wouldn't be around."

Rachael became pregnant at 18 years of age and was living independently at the time she became pregnant. She had left foster care where she had been placed as a young child because of physical and sexual abuse. Rachael talked about seeing her mother and grandmother daily, she nevertheless stated that she only felt real love for her son and her former boyfriend, the father of her son.

Samantha, who was 16 when her son was born, had moved in and out of her mother's home since age 12. She parallelled her pregnancy experience with that of her mother's who was pregnant with her two-year-old sister while Samantha was pregnant with her child. Samantha described her family as supportive even though she had to move out of her mother's home to "get away from the stresses, my mother was always freaking on everybody when she had no sleep 'cause she was raising her own baby." Samantha moved back home for a few months after her son was born but had to leave in the middle of the night. She said: "I had to up and move because my mom was threatening to kill me and my baby." In the past year, Samantha's grandmother has allowed her to stay rent free in a small home she owns. Samantha said she "can have a lot more food than most people and can afford a social life" because of her grandmother's contribution.

Women in this study all felt they received some support from their family members or others who took on the role of family members. However, in their stories, gaps existed in family support for their role as young mothers. All but one woman had been living apart from their families and many had been in protective care as children. This absence of familial support predates their pregnancy by several years and had played an integral role in their childhood lives. In some of their families, young mothers were subjected to continued threats of physical violence and/or verbal and emotional abuse. Parents of some of the young women were unable to be supportive because they were struggling with serious personal problems of their own. This sample of young women reflected the double disadvantage experienced by some young women; they had recently accessed mental health services and they received constrained and limited family support from their families of origin. However, health promotion strategies aimed at the family level of society cannot be based on the assumption that the families are able and willing to provide such support. For these young women, the first level of support above themselves is in many ways lacking or inadequate. Intervention at the family level at this stage would likely be ineffective given the historical nature of the problems and needs. Family support is often assumed, and individual mothers are erroneously judged on this assumption. Mary illustrates this point quite well:

> "I think that some young mothers do exceptionally well. It may not look like it when you look directly at them, but if you look at the whole picture and then just the fact that they don't have any support, like some people don't take that into consideration—some people slip down to the bottom and never come back up. And some people, some people make it out and some people keep fighting."

Birth Fathers and Paternal Families

Many of the fathers had left the relationship during the pregnancy or shortly after the birth of their children. For the most part, they have made little contribution to the care of their children and do not provide financially for these young mothers or their offspring. Jennifer was married to the father of her child and was, in part, financially supported by her partner. However, she stated that he dismissed her role as mother: "He doesn't think [she] does anything all day." She reported that the child's father would not care for his son since he was "scared to be alone with him."

Susan was the only other woman who had a relationship with her partner, the father of her child at the time of the interview. He was unable to provide financially for either Susan or her son, but Susan felt he was emotionally caring of her by "talking with her." Interestingly, Susan and Jennifer, who had the two youngest children in the study and were the only women with partners, also had the most difficulty attending to the interview due to fatigue associated with being in effect sole care-givers of their young infants.

Women expressed a great deal of affect in describing the father of their child and the loss of their idealized view of family. Rachael felt that her "heart isn't complete, I try for the baby but at night time I just cry, not even a phone call and I'd been with him six years." Alex's partner did not allow her to leave the house or spend any money when they lived together. She reported that her boyfriend was gone most of the day and would not care for their son since he felt that child care was her responsibility. Shona acknowledged that she had married her abusive partner to cling to her notion of a two-parent family and dreams of the "white picket fence."

The traditional family ideal was a common theme in these conversations. Lynn, for example, outlined her ideal home life with a father and mother and "the mother stays home raises the child—not single parent, not on welfare." Many of the young women talked about looking for partners who could fulfil husband and father roles in their family. Wendy talked about this as wanting her new partner and her daughter and herself to "get together and make a family-type thing" with her new partner in the "daddy's role."

The paternal families were almost exclusively absent from the lives of their grandchildren. The women related that, often, paternal families actively removed and kept fathers hidden, eluding any responsibility they might have had for their children. Lynn suggested that her partner's mother "kept trying to push me down the stairs to abort the baby." One mother talked about receiving care from the father's family, but related the unwillingness of the birth father to care for his child as a result of his immaturity.

Although the young women expected the birth fathers to participate in their children's lives, the fathers and their families generally mirrored society's acceptance of teenage pregnancy as a 'teenage mother' problem. Dominant ideology is replete with the concept of the single teenage mother while social comment on teenage fathers remains mute. This mother-blaming emphasis and exclusion of the father is a form of gender bias that must be addressed at all levels of health promotion planning.

In addition to the lack of support from birth fathers and paternal grandparents, the young women's words mirrored many of the societal discourses on the traditional family. They, like the larger culture, defined a 'proper' family as one that has a father and a mother.

They longed for an idealized notion of family typified by the white picket fence as portrayed in many family television shows. They judged themselves and their families as failures because they have not achieved this family ideal. Jennifer, the woman in this group who may have achieved the closest to the idealized concept of the two-parent family, openly criticized her life, "I did it backwards, should have married and then had babies." Young mothers share this stigmatization with single mothers. Health promotion strategies, at the policy and service level, must address the psychological risk factors inherent in attempting to fulfil a culturally supported mythical ideal.

Community and Friends

Women characterized their friendships as sources of both sustenance and frustration. Few of the women had friends who were supportive during pregnancy. All of the women reported feeling anxious that they would lose the relationship of their friends as a result of becoming pregnant. Jennifer felt that "it was important to me that they were going to stand by—they weren't going to leave because I got pregnant." Alex talked about a girlfriend who came over to her house to care for her son for two days. She says, "there is always someone that I could call."

Most of the women expressed more ambivalent feelings about their relationships. Some women lost friends due to their decision to continue with their pregnancy. One of Nicole's friends who had terminated her own pregnancy refused to speak with her for more than a year when Nicole advised her that she would not have an abortion. Mary lost friends as a consequence of eluding an abusive partner.

Other women talked about losing relationships with their peers because of their change in lifestyle resulting from their mothering role. They felt they had different lives than their peers. They could not have a comparable social life because of the high cost and limited availability of child care. Alex talked about how she was unable to go out socially with her friends because her son had to be in bed by eight o'clock in the evening. Women found it difficult to connect with other mothers who were usually older, had different routines, experiences and life chances than they had. In addition to these differences between their age-matched peers or other mothers, the women in the study talked about difficulties that they experienced maintaining friendships due to geographical distance, frequency of relocation, lack of telephone and transportation facilities, and limited financial resources for social activities.

Social support systems exist in many community forms. One of these forms is the social support provided by peers. The creation of supportive environments in the form of support groups or neighbourhood groups is an important health promotion strategy. However, for these young women, they are more likely to become severed from social support systems at this time when they most need them. This lack of peer support or support from other mothers creates a gap in their support network and creates a further risk condition.

The group session was a vibrant example of the need for these young women to find a peer group and have the opportunity to talk with other mothers of their age who share commonalities. In the group session they began to talk with each other in different ways than they had spoken in the individual interviews. It became a safe place to talk about what

they had earlier feared to discuss. They could talk about drugs and alcohol, boyfriends and families. The difference in their involvement in this group made it clear to me that this kind of support group would be especially beneficial. The mothers were able to talk about shared experiences and exchange knowledge about motherhood. Nevertheless, this strategy poses some risk for young mothers who have incorporated the negative stereotypic image of teenage motherhood and have difficulty becoming part of a group characterized by social stigma. Health promotion strategies that focus on creating supportive environments for young mothers with an emphasis on non-stigmatizing peer support may begin to address their needs. Finding a way to link young mothers with experienced mothers in a nonjudgmental mentoring role might also be a helpful health promotion strategy.

Institutional Support

Many of the women relied on a number of institutional supports while they were pregnant and during the subsequent care of their young children. All of the women, except one, depended on social assistance for financial support at the time of the interview. Although most women reduced the welfare payment through paid employment, none were able solely to support their families.

Women reported difficulties contacting their income maintenance workers and feeling diminished during these interactions. Shona recounted that she was unable to cope given the amount of financial assistance she was receiving and, as a result, was losing weight while pregnant. She recounted being unable to contact her worker for three months stating: "It's very tiring. It makes you feel like you're begging all the time. They are not really helping you—they are helping, but they make you feel really bad for helping you." The women in the study overwhelmingly agreed that they felt stigmatized by their use of welfare and identified becoming self-sufficient as a fundamental goal. Trisha's wish for her future is "to make something of myself, I don't want to be a fat, lazy, welfare bum." Some of the women had resided at or used resources provided by a local shelter for pregnant women. Most of the women interviewed depicted their experience with shelters as beneficial and supportive. Mary perceived that "once you had your child, the support or anything they had to offer was cut off." She believed the shelter was promoting the option of adoption and made their support conditional on making this choice. Other women required the services of shelters for women because they were homeless or terminating abusive relationships. All of the women described these types of shelters as positive experiences.

Only one of the women was still attending an educational institution when she became pregnant. Jennifer talked about her experience as a pregnant high school student. She stated that the principal of her school advised her: "We don't have no problem with you staying here, but for your own safety I don't think you should." Jennifer felt that the principal "doesn't want it [somebody being pregnant] in her school—I think she thought that [the school] would look worse, that it wouldn't look good anymore."

Some of the women in the study utilized subsidized day care to facilitate the completion of their secondary or post-secondary education. Other mothers enrolled their children in therapeutic day care to enable them to cope with the task of parenting and to provide an enriched environment for their children. Trisha talked about the benefits of this help: "I

knew if I did not have help I would probably lose my cool and I would end up hurting her and I did not want to do that." Many of the young women expressed fears that they would lose their subsidized placement in day care due to cutbacks or changes in rules which would make them ineligible.

All of the mothers had been involved with child protection services during the lifetime of their young children and many of them had been identified as at risk for child maltreatment during their hospital stay for the birth of their children. Although research evidence remains inconclusive, the common sense knowledge of social workers, nurses, and other health-care workers is that young age is an important determinant of child maltreatment. Mary said she "wasn't allowed to leave the hospital until [she] had a meeting with the CAS [Children's Aid Society]." Some of the women were thought to be at risk because of their own childhood involvement with the CAS. Wendy talked about this: "Because of the fact that I had just got out of the CAS, they did not think I was emotionally ready ... I wanted to prove it to them so that they couldn't come back to me and say I was a bad mother." Not all of the young women experienced the involvement as negative. For example, Trisha suggested the child protective agency was "very helpful and very beneficial." She placed her daughter in the care of the CAS under a voluntary agreement while she went for in-patient treatment for her drug and alcohol addiction. Some of the other women chose to remain involved with their child protection workers even after their cases were closed because they found the relationships to be supportive.

When young women do not find institutional supports helpful, it is often because they feel discriminated against. They encounter myths and assumptions about their ability to mother simply because of their age. Samantha experienced the health-care system at the hospital as discriminatory: "The nurses wouldn't do anything, they were really mean. I just couldn't put up with listening to them, they were just treating me like real crap." Shona talked about her experience with a physician during a visit to emergency for symptoms she believed were related to miscarriage:

> "She asked me all the usual questions about my health, whether I smoked, drank, or did drugs and I did not do any of them. I was in good health as it was. And she made this comment, 'Well you probably will miscarry.' I don't think it was appropriate because there was no reason she would say that the risk should not have been higher because I was young and not married."

Women who become teenage mothers are open to criticism by virtue of their age, vulnerability, membership in a group with low social support and their reliance on social assistance. It would appear that institutional supports designed to be health-promoting are failing at their task because of cultural stereotypes and myths about young mothers. If young women feel ostracized by educational, health and social service institutions because of these cultural myths, one must question how accessible these services really are. Health promotion strategies must focus on reorienting health and social services away from these negative stereotypes based on pathologizing, moralistic and individualistic notions of social problems. We cannot expect young women to develop the personal skills and knowledge needed to

succeed in parenting if the institutions that are designed to support them offer instead discrimination and ostracization.

ACTION RESULTS

Feminist and participatory research bears with it the responsibility of providing the knower with techniques to act upon their circumstances. Given the burden of their complex lives, I did not expect that they would choose to work towards education designed to alleviate the social stigma associated with young motherhood. Through conversations during the group meetings the young women initiated discussions about what actions to take, and we began to focus on the task as a research team. I wanted to support the young women to take on activities of their choice and to take the leading roles. I affirmed that their knowledge was valuable and I made a commitment to support their compensation for any educational or advocacy activities in which they took part. My time was not recompensed because I considered these activities to be an integral part of the research project, and my involvement was a repayment of the debt I incurred upon entering into a relationship with the women.

The action component continued over one year and focused on education for three different groups: professionals who provide therapeutic care to young mothers; academics and researchers; and the general public. For the first group, the young women felt it was important to present their stories to members of the community who work therapeutically with adolescents or young mothers. To that end, a presentation was made at grand rounds of the Chedoke Child and Family Centre, a local child and adolescent psychiatric outpatient unit. In that presentation, women talked about helpful ways to intervene with young women. A seminar was conducted for the Women's Health Office at McMaster University about the stigmatization of young mothers. Finally, two training sessions were offered for nurse practitioners who work with young women in remote areas.

In order to educate academics and researchers, a workshop was conducted for the McMaster Research Centre for the Promotion of Women's Health; an information session was presented at the staff rounds for the Centre for Studies of Children at Risk; and seminars were conducted for undergraduate students in social work and women's studies.

The final aim was to provide more general public education. This was accomplished through a workshop presented for a local group of secondary school students entitled, Students on Sexuality. An article by one of the research team members was published in a local newspaper in Oakville, Ontario. Finally, a discussion group was held on local television and one woman's story is in the process of being published in a collection of women's experiences.

These actions not only served the purpose of educating and perhaps alleviating some of the negative stereotypes associated with young motherhood but they also provided a forum for an ongoing relationship and support for members of the research team of young mothers. The action component helped address some of the need for social support. An example of this was a Christmas dinner held for the young mothers and their families by a church-affiliated local women's group. The gifts were donated to the mothers and children by staff of the McMaster Research Centre for the Promotion of Women's Health.

Through the process of ongoing dialogue and the opportunity of engaging in fora which challenged individualized explanations of young motherhood the young women in the study began to adopt a contextual analysis which embedded the issue of early mothering within a historical, social, and economic environment. In the relationship that developed from working together I think the young women began to question their earlier ways of seeing themselves as the problem.

CONCLUSION

This study is just a beginning towards examining the health determinants in the lives of young mothers. Young mothers have identified problems in assuming that family supports are always intact. They have identified the gender bias in family responsibility that blames young mothers and makes the role of teenage fathers and their families accepted as invisible. They have pointed to problems in peer social support systems and access to shared experiences with other mothers. They have identified both the possibilities of institutional supports and the social discrimination that interferes with the effectiveness of these services.

A societal analysis of teenage pregnancy would reveal even further the ways in which teenage parents are put at risk by health promotion inaction and health and social services based on stereotypic notions. This 'big picture' focus would reveal the structural risk factors that are still in place. Young mothers are one of the most socially (Cooley and Unger, 1991) and economically disadvantaged groups in Canada (National Council of Welfare, 1993; Schamess, 1990; Statistics Canada, 1995b). Teen unemployment is high, and employment opportunities are based on minimum wage salaries and generally part-time hours. In Ontario, recent reductions in social assistance of 21.6% (Schuster, 1995a), subsidized day care (Schuster, 1995a and b) and subsidized housing have had a profound impact on the well-being of young mothers and their children. Governments are reducing services for sole support mothers and seem to be emphasizing the prevention of early parenthood with punitive, regressive measures (Phoenix, 1991).

For too long, researchers and service providers have simply focused on the ways in which individual adolescent parents (primarily mothers) are inadequate, on the negative consequences of early parenthood, and strategies designed to eliminate early parenthood. This has resulted in a stereotypic, moralistic, framework that has not only failed to achieved the goal of health promotion but has systematically isolated and targeted young mothers for harsh treatment. Health promotion strategists should listen to the voices of young mothers who have experienced the big picture—who have intimate knowledge about the ways in which institutional attitudes, practices and services keep them trapped in a variety of health risk factors.

PROMOTING HEALTH THROUGH INTERGENERATIONAL VOLUNTEERING

Margaret Denton, Lili Dolina, Allison Cummings and Sharon Webb

Ce chapitre résume l'évaluation du programme de bénévolat inter-générationnel dans les écoles élémentaires du département de la santé publique de la région de Hamilton-Wentworth. Ce programme a été mis sur pied pour répondre aux recommandations du sondage de personnes âgées considérées comme informateurs-clés, et pour répondre à un forum communautaire de personnes âgées qui avaient identifié des problèmes de nature inquiétante chez les personnes âgées, soit l'isolement et la solitude. La participation aux activités bénévoles offre aux personnes âgées des opportunités d'interaction sociale et de maintien de leur estime de soi tout en leur permettant de bénéficier des programmes inter-générationnels dans lesquels ils peuvent enrichir la vie des jeunes. Les études démontrent aussi que le contact inter-générationnel peut changer les dispositions négatives des enfants envers les personnes âgées. Le programme de bénévolat inter-générationnel inclut présentement quatre écoles élémentaires de Hamilton-Wentworth. En permettant aux personnes âgées d'aider les enfants dans leurs travaux scolaires, dans la lecture et la conversation dans la salle de classe au niveau élémentaire, le programme comble le fossé des générations. On s'attendait certes à ce que le programme ait des bénéfices positifs pour les enfants, mais les objectifs du programme visaient spécifiquement à prévenir l'isolement et la solitude des personnes âgées, à augmenter leur participation dans la communauté de manière constructive, à augmenter leur niveau d'activités, et à réduire les préjugés entourant la vieillesse. L'évaluation des résultats de ces objectifs est basée sur des informations recueillies de sources diverses (personnes âgées bénévoles, enseignants et enfants) et de façons différentes (entrevues avec les bénévoles, analyses des journaux de bord, rapports de groupe, entrevues avec enseignants et groupes de discussion thématique composés d'enfants). Les résultats indiquent que le bénévolat était perçu par les bénévoles comme ayant eu des effets positifs sur leur bien-être et leur santé mentale, et que les enfants leur avaient apporté du plaisir et les avaient amusés. Les personnes âgées avaient le sentiment d'être un modèle à suivre pour les enfants et les résultats suggèrent que le programme permet aux enfants de voir les personnes âgées sous un aspect positif. On a aussi remarqué que le programme avait amélioré la

performance scolaire chez plusieurs enfants parce que les bénévoles pouvaient accorder une attention individuelle à chaque enfant. Les bénévoles ont aussi amélioré la qualité de vie au travail pour les enseignants.

₡₿ ₡₿ ₡₿ ₡₿ ₡₿

Health promotion is an important objective for the Hamilton-Wentworth Regional Public Health Department. A seniors' key informant survey (1991) and a senior's community forum (1993) identified isolation and loneliness as key areas of concern for seniors. This is a particular problem for older women, many of whom live alone. Evidence suggested that one way to combat the problems of isolation and loneliness is through intergenerational contact. A number of health promotion recommendations were implemented as a result of these studies including the introduction of the Intergenerational Volunteer Program in elementary schools (IVP).

Health-care providers are beginning to recognize that strategies to promote health should involve consumer participation in the planning and evaluation process (MacMillan, Harmer and Long, 1994). This means that the role of the traditional health provider is changing as health promotion and population health strategies are better understood by health professionals. Health providers acknowledge that older adults are an "integral part of the solutions to the problem, requiring health providers to relinquish power, prestige, and sole responsibility and recognition" (MacMillan, 1994, 29). An advisory group composed of six older women was formed to assist in the planning, implementation and evaluation of the IVP. This chapter summarizes a participatory action research evaluation of Intergenerational Volunteer Program in elementary schools.

INTERGENERATIONAL PROGRAMS: A LITERATURE REVIEW

Benefits

For seniors, evidence suggests that intergenerational contact combats the problems of loneliness and isolation (Hutchison and Webb, 1988; Abrahams, Wallach and Divens, 1979; Hill and Northwood, 1996), provides seniors with a sense of being part of an ongoing society, increases self-esteem and makes up for role losses that occur with aging (Peacock and Talley, 1984). Through intergenerational programs, seniors can renew their sense of purpose by acting as mentors (McGowan, 1994). Seniors benefit from intergenerational programs through the reciprocal element of intergenerational contact where seniors contribute to the lives of youth, and youth in turn contribute to the lives of the elders (Cherry, Benest, Gates and White,1985). Intergenerational involvement can also have a positive effect on the health of older individuals (Newman, Lyons and Onawola, 1985).

Intergenerational contact can have benefits for the institutionalized elderly by reconnecting the elderly with others (Hutchinson and Webb, 1988), increasing social interaction, increasing mobility, decreasing confinement, reducing daytime sleeping (Abrahams, 1979), increasing alertness and having a positive effect on social behaviour among Alzheimer's patients (Newman and Ward, 1993).

There are also several benefits of volunteering for older adults. Kuehne and Sears (1993) conclude that there is a positive relationship between social activity and well-being among older adults. In addition, it has been demonstrated that those who volunteer later in life experience high levels of life satisfaction (Kuehne and Sears, 1993; Stevens, 1991). Participation in volunteer activities provides seniors with opportunities for social approval and self-esteem. Stevens (1991) suggests that for the older adult, satisfaction with the volunteer role is related to a sense of belonging, feeling needed, meeting others, sense of self-worth and recognition and appreciation. Volunteering may even be considered as an indicator of successful resolution of crises in the last stage of the life cycle (Monk and Cyrns, 1974).

Studies show that intergenerational contact can alter negative attitudes of children towards the elderly (Glass, Conrad and Trent, 1980; Corbin, Kagan and Metal-Corbin, 1987). This is important in light of evidence that suggests children harbour negative attitudes about getting old (Miller, Blalock and Ginsburg, 1984), which may result from limited contact with the elderly (Corbin and Strauss,1987). Other benefits of intergenerational programs for children include: increased feelings of comfort with older individuals (Peacock and Talley, 1984); the potential to learn from older adults "whose historical sense of economic and societal development of the last few decades is first hand" (Peacock and Talley, 1984, 18); enjoyment through helping seniors; and acquiring an appreciation for a different generation.

Barriers

A number of structural barriers and socio-cultural factors in our society serve to prevent or inhibit intergenerational contact. Peacock and Talley (1984) highlight six areas in modern Western society where age groups are strictly separated: the school system; recreational activities; family structure (it is not as static as it once was with increased mobility and less interaction with grandparents); institutions and age-segregated housing for the aged; suburbanization (suburbs become areas wherein children grow up and leave in maturity); and the economic structure of our society. Peacock and Talley point to possible tensions between generations and propose that without some form of intervention, generations will move further apart.

In addition to structural barriers, Peacock and Talley (1984) outline prevailing attitudes that prevent contact between the different generations. First, there is the general assumption that different age groups do not wish to interact with one another, that this interaction would be in no way beneficial and that their needs, values and interests are so different that they have nothing to offer one another. Other barriers outlined by Peacock and Talley are: a strong age bias among youth that starts very early in life; attitudes held by educators and other professionals who appear to favour youth over the aged; the way in which many older adults have "bought" the stereotype of the older person; and misunderstandings of the motivation behind certain behaviours of members of other age groups. These instances of both structural and attitudinal barriers illustrate the need for intervention as intergenerational contact does not occur freely and naturally within the structure of our society. Therefore, programs are needed to facilitate interaction between the generations.

THE INTERGENERATIONAL VOLUNTEER PROGRAM

An intergenerational program is a "planned, intentional interaction of different age groups, infants to elderly, in a variety of situations at a level that provides close communications, sharing of feelings and ideas, and cooperative activity in meaningful tasks" (Peacock and Talley, 1984). The Intergenerational Volunteer Program in elementary schools (IVP) is one component of a larger intergenerational program developed as part of the seniors program in the nursing division of the Hamilton-Wentworth Department of Public Health Services. The larger intergenerational program is three pronged. It involves the network, the community-based programs and the advisory group. The network involves interagency collaboration with interested agencies in which members act as resources to the community.

The IVP is one of many community-based programs established in 1994 as part of the Public Health Nurses' (PHN) Seniors Program. The IVP at present involves four elementary schools in the Hamilton-Wentworth region. Senior participants help bridge the gap between young and old by helping children with school work and reading and by conversing with children in an elementary school classroom. The program focuses on establishing relationships between the seniors and children. Volunteers in the program are older adults, working with the Hamilton Department of Public Health. Senior volunteers chose classes ranging from pre-kindergarten to Grade 7 according to the age group with which they preferred to work.

The third component to the IVP is the Intergenerational Advisory Group. Interested seniors formed the advisory group in 1995 to guide the Intergenerational Volunteer Program and generally promote intergenerational activities. Its members were six older women, aged 63-86. The advisory group was started in response to the department of public health's recognition of the healthful effects of community involvement in the decision-making process and the value of community participation in designing and implementing the program.

The purpose of the advisory group is twofold: to promote intergenerational programs and to plan and evaluate programs in the community. The advisory group consists of approximately six senior volunteers and a PHN. Later, MRCPOWH co-investigator Dr. Margaret Denton attended advisory group meetings in order to facilitate the evaluation of the IVP. The group meets monthly to: share their experiences, achievements and delights with the program; voice concerns; and to plan for the promotion of intergenerational activities. The group was also involved in the planning of program evaluation by assisting in the development of an evaluation methodology and research tools utilized in the study.

Advisory group members were involved in program development, promotion and evaluation. From the onset of the program, the advisory group has worked to establish more programs and recruit senior volunteers and children for intergenerational programs. Advisory group members made presentations to senior's residences, churches, schools, universities, the Salvation Army, Rotary clubs and a volunteer centre; recruited schools for the program; and were involved in a community intergenerational display. Throughout this project, links were developed in the community between the advisory group members, public health nurses, schools, university students and numerous community agencies.

The goal of the program is to improve and/or maintain the health and well-being of seniors through participation in intergenerational activities in elementary schools. The objectives of the program are to:

1) prevent and/or reduce isolation and loneliness for seniors;
2) increase seniors' meaningful involvement in the community;
3) increase the activity level of seniors; and
4) decrease the myths of aging.

Benefits of the program are also expected for children, teachers and the community.

THE STUDY

The purpose of the study was to evaluate the overall effectiveness of the IVP in elementary schools in achieving its goal and objectives. It was anticipated that an evaluation would demonstrate the benefits of the project to policy-makers and groups interested in the project.

In applying principles of participatory action research, the community advisory group was actively involved in the planning and evaluation of this project: determining the program objectives; making suggestions for the evaluation of the program during group meetings; and by developing, reviewing and revising research instruments. As the community group determines the issue and the type of research, the role of MRCPOWH was to facilitate the research initiatives of the group, to facilitate documentation and presentation to larger audiences and to provide resources to the group.

DATA COLLECTION METHODS

Research methods utilized in the evaluation were triangulated. Sidell (1993) defines triangulating data as a "multi-dimensional approach to collecting and analyzing data" (108). Methodological triangulation involves the mixing of methods including the use of both quantitative and qualitative data in understanding the same subject matter. This multi-dimensional approach to collecting and analyzing data is particularly conducive to the evaluation of a community health promotion program. These programs are often not suited to the more traditional program evaluation design involving an experimental pre-post test design such as a randomized clinical control trial. Using the triangulated method, findings are considered valid if replicated through different data collection methodologies. To give voice to the program participants, data were collected from a variety of sources (senior volunteers, teachers and children) and in a variety of ways (interviews with volunteers, log book analysis, advisory group reports, interviews with teachers and focus groups with children).

Personal interviews were conducted with senior volunteers in January 1997.[1] The sample consisted of all of the volunteers in the IVP: two men and nine women.[2] Volunteer ages

[1] This section of the evaluation was conducted by Allison Cummings, as part of an Honours BA thesis.

[2] In order to conceal individual volunteer identities in this report, all volunteers will be referred to as female.

ranged from 63 to 86, five volunteers were married, three volunteers had some college or more education and two volunteers identified themselves as members of ethnic groups. In order to assist volunteers with questions with five answer options, the possible responses were given to volunteers on a card.

Questionnaire construction involved a review of existing volunteer satisfaction questionnaires and input from the advisory group.[3] The questionnaire is comprised of six sections, containing both qualitative and quantitative measures, with open-ended and choice questions. The questionnaire addresses: volunteer expectations and concerns prior to their experience; volunteer satisfaction and direct benefits to the seniors; other activities that seniors do to remain active in their daily lives; the effects of intergenerational experience on the health and well-being of the volunteer; social support; and volunteer background and demographic characteristics.[4]

A second source of data used in this evaluation is obtained from log books in which the older volunteers recorded their experiences after each day of volunteering. Instructions were given in the book for volunteers to record the date, length of time, volunteer activity and any additional comments for each day at the school. The journals were collected from volunteers at the time of their interviews, at which time most of the volunteers had been in the schools for at least four months. A third source of data is obtained from reports of the advisory group meetings, which began in September, 1995.

A fourth source of data was a questionnaire used to conduct personal interviews with 12 teachers who had senior volunteers in their classrooms. Interviews were conducted in April, 1997. Respondents taught classes ranging from pre-kindergarten to Grade 8 with the number of students in their classrooms ranging from approximately 17 to 30. Teachers were asked questions pertaining to issues regarding the class in general (in terms of grade, size and special needs) and the senior volunteer (in terms of volunteer assignment, why teachers wanted a volunteer, expectations of the volunteer, the volunteer's activities, the helpfulness of the volunteer, likes, dislikes, etc.). Teachers were also asked about the general effect senior volunteers have on the schools.

A fifth source of data was collected from focus groups conducted with 28 children from grades 1 to 7.[5] This part of the evaluation was conducted in four Hamilton-Wentworth elementary schools over a period of three months, from late September 1995 to early January 1996. Children were asked questions developed by the advisory group about their attitudes and perceptions regarding older people. Unfortunately, focus group results were vague, lacked clarity and were not particularly useful in this study. On reflection, this was due to the inappropriateness of using focus groups with young children. The open and abstract forum

[3] This section of the evaluation was conducted by Allison Cummings, as part of an Honours BA thesis.

[4] Using SPSS/PC, frequencies were run on the quantitative data obtained in the questionnaire. All responses were coded, with most answers labelled according to scales ranging from one to five, with one representing very dissatisfied and five representing very satisfied.

[5] These focus groups were conducted by McMaster University nursing students as part of a research course study.

of focus groups was ill suited to children who appeared to have difficulty answering abstract questions such as "What does old mean to you?" and "What do you think about old people?".

RESULTS

Findings from the evaluation of the IVP clearly indicate that the program was successful in achieving its overall goal to maintain and/or improve the health and well-being of seniors through participation in intergenerational activities in elementary schools. Volunteer questionnaire results indicate that 5 out of 11 volunteers felt that volunteering had positively affected their mental health and well-being. Volunteers described their improved sense of well-being as getting personal pleasure and amusement from the children and receiving satisfaction in knowing others are benefiting from their help. One volunteer explains that she feels happier, contented, never feels upset at home and has constant good feelings. Another volunteer states that mentally, volunteering with children keeps her "on her toes;" another states "just being around young people is inspiring;" and another reports feeling needed and wanted and that her mental attitude toward life in general has been positively affected. Log book results also provide strong evidence of positive feelings associated with the volunteer experience. Comments include: "I enjoy it very much;" "Another great day;" "This week was fun for the pupils and me;" "It is so heartwarming to see their enthusiasm;" "Feeling more comfortable with the children;" and "Had hugs from two children." Advisory group reports provide further evidence of the relationship between positive feelings and well-being. One member says "You leave feeling ten feet high." Another volunteer describes her feelings after receiving cards from the children: "I felt so loved—the depression lifted." Although the program has achieved its overall goal, it must be noted that a direct relationship between health and well-being and intergenerational activities is difficult to discern as it is possible that healthy seniors are more prone to volunteering. A more accurate interpretation is that volunteering may not necessarily improve health, but instead helps volunteers maintain their health and well-being. The achievement of the objectives of the program will be examined next.

OBJECTIVES

Prevent and/or Reduce Isolation and Loneliness for Seniors

As noted the seniors' key informant survey and the senior's forum (1993) identified loneliness and isolation as primary concerns for seniors. A key recommendation made as a result of these studies was to develop programs pairing children with seniors. In providing seniors with opportunities to develop relationships with others, the IVP has achieved its objective to prevent/and or reduce isolation and loneliness for seniors. While only 4 of the 11 volunteers reported feeling less isolated since the beginning of their volunteering, it is possible that most of the volunteers were not isolated prior to volunteering or were uncomfortable stating they were feeling isolated. Evidence that volunteers were not isolated

prior to volunteering is found in questionnaire results indicating a relatively high participation rate in other volunteer organizations (N=6) and recreational activities (N=10). Furthermore, all 11 volunteers interviewed reported having someone to count on in a crisis, someone to count on for advice and someone who makes them feel loved.

While the volunteers may not have been isolated prior to the experience, results do indicate that by allowing seniors to form relationships with children and with others, there was a reduction in isolation and loneliness for senior participants. For example, interviews with the senior volunteers revealed the most frequent reason for the older adults' decision to volunteer was the desire to be with children (N=9). Furthermore, when asked what they liked about volunteering, all 11 seniors responded that they enjoyed being with children. Log books also indicated that seniors enjoyed being with the children. Excerpts from the log books emphasize the concern they show for children: one volunteer was concerned about a student who has no concentration and seems to be troubled; and another reports concern about a "difficult" child who does not appear to get enough sleep. Advisory group reports also provide further evidence of the positive relationships formed between seniors and children. As well, through advisory group activities, seniors were able to meet new people and develop new relationships.

Increase Seniors' Meaningful Involvement in the Community

Results of this study indicate that the program has successfully increased seniors' meaningful involvement in the community. Through participation in this program seniors feel a sense of purpose, feel needed and appreciated and are able to learn. Most volunteers interviewed responded that volunteering gives them a sense of purpose, a reason to get up in the morning (N=8). Furthermore, most volunteers responded that when they go home they feel that they have made a difference (N=10), they are a positive role model for children (N=9) and volunteering allows them to care for/about others (N=10). Log books provide numerous examples of situations in which volunteers help the children. In one example, a volunteer put a child at ease when the child, who was ill, had soiled her underwear. Another child shared with a volunteer that her mother had been in the hospital two weeks before Christmas, and she came home wearing a wig. The volunteer was able to share a similar experience and helped the child to feel better. After, the volunteer reported, "I don't like being older at times, but when you can call on past experiences in your life, it helps those who ask us to have hope and carry on, as we have been there too." In another example, a volunteer describes assisting students with a class project: "What a feeling I got with their thanks and enthusiasm." Advisory group reports indicate that the volunteers find their experiences helping children and teachers rewarding. Advisory group reports also provide examples of how seniors help the children: "I read to one boy because his mom said she didn't have time to read with him." Interviews with teachers demonstrated the helpfulness of volunteers in the classroom. All 12 teachers reported that the senior volunteers were helpful. One teacher even commented that she would be lost without the volunteer. Seniors are also provided with a sense of purpose outside of the classroom as they were active participants in the planning and evaluation of the program.

In volunteer interviews, most volunteers reported feeling needed (N=10) and appreciated by the teacher (N=9). One story described by a volunteer in the log book particularly demonstrates the feeling of being needed. In this story, the volunteer had helped the teacher by cleaning up a sick child. After the incident, the teacher said, "Do you ever think you're not needed? What I would have done today without you and 25 kids to look after?—you're needed, wanted and loved." Advisory group reports are also indicative of volunteers generally feeling that they are much appreciated. "He put both of his arms around me and said thank you." "I received a package of cards from the school when I was ill."

The IVP also increases seniors' meaningful involvement in the community by providing them with opportunities to learn. Most senior volunteers interviewed reported that they were able to gain knowledge and learn from the children (N=9), they get a sense of accomplishment and competence from their jobs as volunteers (N=10) and volunteering is a challenging and stimulating experience (N=10). In log book accounts, volunteers described their experience as challenging and stimulating. One volunteer comments, "I've learned so much more about children, little habits, quirks, and fears they have, how to discipline them etc." In an advisory group meeting, a volunteer describes a learning experience when she notes how she handled the children when the teacher left her in charge. She asked them to tell their phone numbers one after the other and "it worked." Another volunteer jokes that she needs to take a course in child psychology. Involvement in the advisory group is also a learning experience for seniors as they take part in the planning and evaluation of the project.

Increase the Activity Level of Seniors

It is difficult to determine if this program increased the activity level of seniors since activity levels of the seniors were very high prior to the volunteer experience. It seems more likely that this program helped seniors to maintain their activity level and enhance their quality of life. The IVP helps these seniors to maintain their already high level of activity by providing them with the opportunity to participate in numerous activities both within and outside of elementary schools. Within schools, seniors participate in activities ranging from helping children with school work to playing with children and helping the teacher prepare lessons. Activities outside of the schools also helped to increase the activity levels of seniors. For example, the advisory group made several presentations to the public and a variety of community agencies.

Decrease the Myths of Aging

Evidence in this study suggests that the IVP enables children to view the elderly in a positive light. In interviews with the volunteers, most seniors felt that they were positive role models for the children (N=9). Of all data collected in this study, teachers best illustrated how the IVP decreases the myths of aging. Teachers reported that volunteers allowed children to see that "the elderly are people too" and that old people can be useful. One teacher also noted the interaction as having the effect of omitting the stereotypes about older people. The relationship between older adults and children in itself decreases the myths of aging as noted in one of the teachers' comments: "The kids seem to be very attracted to seniors

because the seniors accept them as they are." Unfortunately, the focus groups conducted with the children were not able to provide evidence in this area.

SECONDARY EFFECTS OF THE PROGRAM

Although the primary focus of the study was on the effects of the program on seniors, there were also several benefits of the program for children. Through the IVP, children were provided with the opportunity to receive extra help with their school work. This resulted in improvements in academic performance. Log books and advisory group reports provide evidence of situations in which seniors were able to help students with school work. Seniors help students in areas ranging from reading, writing and class projects to craft making. Volunteers were also able to provide direct academic help in the form of tutoring. One senior volunteer is an active French tutor. Although the influence of senior volunteers was not directly discussed in the focus groups with children, it is important to mention that after one of the focus groups, a child commented on how the senior volunteer had helped him improve his grades significantly. This child commented, "Before I joined (the volunteer), I got a D-. Now I get A pluses on French now. I wish (the volunteer) can teach math. If she does she could make my card turn into a straight A card."

As teachers often do not have adequate time to devote to students who need additional help or students with special needs, seniors can provide students with one-to-one attention. Teachers reported that students benefit from the extra attention of the senior volunteers. Seniors made note of how they help weaker students. For example, in a log book entry, a volunteer describes how a child responded positively to extra attention from the volunteer: "Up till now she was reluctant to leave her desk—didn't feel she needed help. The teacher was amazed also. She wrote her story with little help."

Children also benefit from the relationships they develop with seniors. Seniors seem to truly enjoy being with children. Warm feelings toward children on the part of the volunteers are documented in data collected from the volunteer questionnaire, log books and advisory group reports. In advisory group reports, volunteers noted: " A shy little girl hugged me when I came and all the other children stampeded to hug me too;" "I guess it reminds them of their grandparents and they really respond to that (re: children);" and "A little girl asked if she could kiss me because her grandmother was up north." Children and seniors were able to share their life experiences with one another. Interviews conducted with teachers also provide evidence of the relationships formed between the volunteers and children. Teachers made reference to the "grandparent" bond in relation to the senior volunteers and children. These connections provide additional emotional and social support to the children and increase their sense of security.

Another notable impact of the IVP was an improvement in the quality of work life for teachers. Numerous comments, stories and reports by the seniors demonstrated the valuable help they provide to teachers. Volunteers generally felt appreciated and needed by teachers. The reports of seniors are supported by data collected from the interviews with teachers showing that all of the teachers felt that the volunteers were helpful (N=12). Specific comments from teachers were that the volunteer is very good at playing with the children, the volunteer

is willing to do anything, it is good to have an extra person, weak students benefit from the extra person, the volunteer instinctually notices when things need to be done, students need extra stimulation and that the volunteer is a good influence on the children in relation to the children's views of older people. Having an extra person to help out was appreciated by teachers. Most teachers also reported being satisfied with their volunteer. Only one teacher was dissatisfied.

One of the most important effects of the program was the integration of the community through the formation of numerous links made by the IVP. First, the generation gap in the community was bridged as seniors were linked with children. Reciprocity between the generations occurred as seniors and children developed relationships and shared experiences with one another. Seniors and children were able to learn from one another. Second, seniors and children from different backgrounds were linked together in this program. One of the schools participating in this program has children from a diverse variety of ethnic and cultural backgrounds. As such, children from multi-ethnic backgrounds were linked with seniors who were not members of their ethnic groups (only two seniors reported belonging to an ethnic group). Third, links were made between a variety of community agencies, the senior volunteers, the public health nurses, elementary schools and university students and faculty. These links were mainly created through the work of the advisory group in the development, promotion, planning and evaluation of the program. The larger intergenerational program network also involves collaboration with several community agencies.

In general, satisfaction with the program was high for seniors and teachers. In interviews conducted with the senior volunteers it was found that no volunteers were dissatisfied with their experiences. Descriptive comments from interviews, log books and advisory group meetings describe the experience as very positive. Most teachers were also satisfied with the program (N=9). All but one teacher would consider having a senior volunteer back next year.

DISCUSSION: PROMOTING HEALTH THROUGH INTERGENERATIONAL VOLUNTEERING

The strategy of involving the older adults in all aspects of program decision-making ensured its relevance and fulfilment of several population health promotion principles. The IVP fulfilled health promotion principles to enable/advocate/mediate by supporting senior women to increase their control over and improve their health through decision making in the advisory group. As such, these women were able to enhance their life skills and take action according to their own beliefs and levels of expertise. Through the IVP program, public health nurses helped create supportive environments by supporting seniors in the expansion of their social networks and by addressing the myths of aging. The IVP has also strengthened community action through advisory group activities which educate the community regarding intergenerational activities and the meaningful involvement of older adults in the community. As well, community action was enhanced through involving seniors, teachers and children in the evaluation research. Throughout this program, the PHNs worked with seniors in developing personal skills. Advisory group members learned new skills by making presentations to community groups and agencies, sharing their experiences and participating in the planning

and implementation of the program. Seniors also learned about children in the classrooms. Lastly, this program is consistent with the health promotion strategy to reorient health services. PHNs have changed their traditional management of programs based on agency defined needs of the community to management of programs based on community defined needs. This shift has been accomplished by developing a partnership with community members who actively influence program development and implementation. The active participation of seniors in this program is an indication of the reorientation of health services. This program also represents a shift away in focus from disease-oriented interventions to the broader determinants of health.

FUTURE CONSIDERATIONS

A few negative experiences reported by some volunteers must be addressed in order to improve the program. When asked what they disliked about the program, one volunteer expressed that she was not informed of her duties. Log books also contain at least three incidents in which the volunteer showed up to an empty classroom or the students did not show up for tutoring. These incidents could be avoided with enhanced communication between the schools, teachers and the senior volunteers.

Communication must also be enhanced with respect to information regarding the expectations of volunteers. In this respect, a concern was raised in the advisory group that the volunteer was "copying" for the teacher instead of working with the children, which she preferred. Other seniors also reported grading assignments and helping teachers with class preparation. These types of tasks should only be performed if it is the preference of the volunteer. Those involved with the program should also be informed that the emphasis of the IVP is on the relationships between the children and volunteers.

Another recommendation is for an initial interview and further follow-up to be conducted with the volunteers. One volunteer reports that she was never asked about her capabilities. This is an important issue as seniors should be assessed regarding their interests and capabilities to assure that an appropriate match is made between volunteers and the students. Follow-up should be conducted with volunteers to determine if the experience is suitable and enjoyable for the older adult. The volunteers could get together on a regular basis with the public health nurse and/or teacher to debrief, share and problem solve together.

Evidence from this study spurs research interest in a variety of areas. In particular, it would be useful to study the extent to which an intergenerational program could change societal attitudes. This could be done by investigating attitudes both before and after the inception of the program. Future studies would also benefit from conducting unstructured interviews with children, to ask them directly about their experiences with a senior volunteer. This program, and others like it, should be explored as an avenue to resolve intergenerational tensions. This is especially crucial as with increasing divorce rates and geographic mobility, generations have become more and more isolated from one another.

Another area of interest would be to examine the role of seniors as resources in the school system in this era of financial restraints and government cutbacks. O'Connor (1995) points out the danger of government policies that shift the responsibility for health onto

individuals, without providing them with adequate resources. Similar dangers exist in the IVP where we must caution against the possibility of shifting responsibility for teachers' work onto volunteers. In an era of cutbacks, the possibility of increasing the use of volunteers instead of hiring more teachers and/or providing schools with adequate resources for the classroom is very real. The role of seniors should not be to replace teachers, but instead to provide children with extra or additional individual attention. Using volunteers as replacements for teachers translates into the exploitation of volunteers as a sources of cost-savings. And, by performing teachers' tasks, not only will volunteers be exploited but paid workers may fear that volunteers will take over their positions. This fear has been documented by Fischer and Banister-Schaffer (1993).

After the IVP evaluation was completed, the program continued to operate but with greater awareness from the community and public health nurses. In addition, several new initiatives have been followed to expand the IVP program. However, it is still too early to determine what effects this evaluation will have in terms of program expansion. As results from this study indicate a number of positive effects of the IVP, it is recommended that the program be expanded to involve more schools. This program should also be expanded within schools. This has already happened to some extent, as some schools are encouraging and inviting grandparents to participate in school activities. This could have the effect of not only strengthening community bonds but family bonds as well.

COUNTING ON DESIRE: SUPPORTING A LESBIAN WITH BREAST CANCER[1]

Chris Sinding

Au cours des quinze dernières années, la littérature féministe sur la prestation des soins a illustré comment l'état approuve et même requiert ce service "informel". Cette littérature concerne la façon dont les politiques sociales, qui reflètent et renforcent les iniquités basées sur le sexe, forcent les femmes à donner des soins sur une base non rémunérée. Tout en constituant une critique importante des politiques gouvernementales, cette littérature s'est confinée aux prestations de soins dans un contexte de liens de parenté selon une définition traditionnelle. Ce chapitre remet en question la focalisation des soins sur la 'famille' en examinant la façon dont les femmes, spécifiquement les lesbiennes, s'entraident les unes et les autres à l'intérieur d'une communauté. En tant que femmes situées symboliquement et matériellement en-dehors de la famille, les lesbiennes sont peut-être placées dans une dynamique unique dans le domaine de la prestation des soins. Il nous faut—et nous avons l'opportunité de le faire—forger nos propres stratégies de prestations des soins. Nous avons porté attention sur un exemple d'aide informelle au milieu d' un groupe de femmes à Hamilton en Ontario qui ont répondu au diagnostic de cancer du sein annoncé à l'une d'entre elles. Les thèmes émergeant des entrevues des cinq lesbiennes qui font partie du réseau d'entraide ont été reliés aux questions soulevées dans la littérature féministe sur la prestation des soins, à savoir les obligations, le manque de droit d'intervention, le sentiment de dette envers l'autre et le "fardeau" que représentent les soins à donner. Nous avons mis en évidence la façon dont nous avons réussi à redéfinir, à réencadrer et à contrecarrer quelques-uns des aspects des soins informels qui sont des contraintes et mettent mal à l'aise. Si on situe les réseaux de soutien dans le contexte de débats politiques au sujet de l'équilibre entre les soins à donner sur une base formelle et ceux sur une base informelle, nous les percevons comme prometteurs, mais en même temps nous

[1] Many thanks to the women who gave so generously to the Web and to this research project: Jane Aronson, Debbie Jones, Lynn Kearney, Ruth Patefield and Lesley Roberts. Thanks also to the McMaster Research Centre for the Promotion of Women's Health for the grant that supported this initiative.

conseillerions la prudence dans la façon dont ils pourraient être utilisés dans un climat politique qui cherche à réduire la responsabilité gouvernementale et à offrir des "solutions" aux problèmes sociaux aux dépens des femmes.

ଓଃ ଓଃ ଓଃ ଓଃ ଓଃ

Over the past fifteen years, feminist scholarship in the area of caring has focused on the experiences and politics of women providing unpaid, home-based caring labour for their family members. Hilary Graham, reviewing developments in feminist research on caring in Britain, suggests that feminists have attended to this particular configuration of caring with good reason. She outlines a shift in both Labour and Conservative policy emphasis from residential care by the state towards informal care in families and communities (Graham, 1993, 462). This shift is also evident in Canada, where parties from left to right enthusiastically endorse deinstitutionalization and the ascension of community-based social and health services. Feminist researchers have examined these shifts, mindful that rhetoric decrying institutional care and promoting informal services coincides with pressures to reduce government health-care expenditures and with women's socialization to caring. Attentive to the possibilities of women's coercion and exploitation, feminist academics have drawn attention to the ways that community-based care serves as a euphemism for unpaid caring labour by women in families, reflecting and reinforcing women's oppression (Graham, 1993; Opie, 1992; Stoller, 1993).

Women's descriptions and analyses of their care-giving work in families provide a foundation from which feminists continue to challenge government policy. Yet researchers' focus on women caring for their own families in their own homes has left other forms and manifestations of caring undocumented and unconsidered in the caring literature.

> Like the policies they critique, feminist analyses have yet to explore the conceptual distinction between the location and social relations of care... the result is a mode of analysis which obscures forms of home-based care that are not based on marriage and kinship. (Graham, 1991, 65)

Graham cites the work of black and anti-racist feminists such as Carby, who point out that focusing exclusively on the work women do for their own families in their own homes effaces the work and understandings of black women caring for the families and in the homes of white women (Carby in Graham, 1991, 69). Similarly, analyses located in the family eclipse the experiences and analyses of lesbians caring for and supporting one another in the community. It is to this latter exclusion that this paper is directed.

In many ways, symbolically and materially, lesbians find ourselves on the margins of family.

> While lesbians and gay men are located within the family/household system, their relation to it is not the same as that of heterosexual people due to the stigmatization of same-gender sex by families, the law, the state, and popular culture. (O'Brien and Weir, in press, 111)

Lobby efforts which assert the existence and rights of same-sex families, such as the 1994 Ontario Campaign for Equal Families, are greeted with indignation; lesbians and gay men are perceived by mainstream culture as both outside of, and a threat to, 'real' families. Heterosexism also manifests in strained, sometimes non-existent relationships between lesbians and our biological families.

Marginalization from kinship systems has been linked to the reliance of lesbians and gay men on non-familial intimate relations (O'Brien and Weir, in press, 111). As a community of choice, we support one another through traumas. Yet neither mainstream observers nor social researchers seem to have taken account of the ways and means by which lesbians respond to the crises in each other's lives.

A particular crisis to which all Canadian women are increasingly called to react—and to which the support network this paper describes responded—is breast cancer. Breast cancer is the leading cause of potential years of life lost for women in Canada (Statistics Canada, 1995c). The Canadian Cancer Society estimated that 16,300 new cases of breast cancer would be diagnosed in 1993 and that 5400 women would die of the disease. Currently one Canadian woman in nine can expect to develop breast cancer over her lifetime, and one in 23 will die of it. Lesbians, for a variety of reasons, may be at higher risk than heterosexual women for developing breast cancer (Ramsay, 1994, 27).

Numerous studies have identified a relationship between social support and a woman's quality of life when she is living with breast cancer (see, for instance, Johnson and Lane, 1993; Neuling, 1988; Primono and Yates, 1990; Spiegel, Bloom and Kraemer, 1989). Other studies suggest that social support may be linked to delayed disease spread or recurrence (Levy, Herberman and Whiteside, 1990) and longer survival (Johnson and Lane, 1993; Maunsell, 1993; Spiegel et al., 1989; Waxler-Morrison and Hislop, 1991).

In a prospective study of the effect of social relationships on survival for 133 women with breast cancer, the extent to which a woman felt that she could call upon three or more friends for support or help was most strongly associated with survival. Speculating about the meaning of these findings, Waxler-Morrison and Hislop noted that in open-guided interviews women spoke of the importance of being able to choose their friends. She suggests that "women who are linked into a large social network of choice rather than of family obligation may be able to be more selective about, or in control of, the kinds of relationships they have" (1991, 181).

That social networks of choice may be an important facilitative factor in the well-being of women with breast cancer suggests thoughtful attention to these networks. Such attention, however, is scant in the literature on social support and breast cancer. In one of the few articles in the area, Winnow (1992) compares the community-social-response model developed by AIDS activists to the dearth of resources and services for women with cancer, and particularly highlights the isolation and struggles of lesbians living with cancer. Lesbians are virtually invisible in the literature on social support and breast cancer. In a review of the literature on breast cancer support groups, McLean (1995) notes that "married women made up the majority of the women studied, and although widowed, divorced, single and unmarried women living with men were studied, lesbians were unidentified in any of the studies."

This article will consider an instance of informal, semi-organized support among a particular group of women who responded to one woman's breast cancer diagnosis. Using

the lens of the Hamilton and Bhatti model of population health promotion (1996), the paper addresses social support networks as a health determinant, attending primarily to lesbian community as the level of action. In a health promotion framework, our collective effort is in keeping with the Ottawa Charter's emphasis on creating supportive environments, considered critical to health promotion in *Achieving Health for All* (1986). Our initiative also served to strengthen and refine lesbian community action in the caring arena. While the social support network we created is consistent with visions for population health promotion, several cautions about this kind of caring initiative are necessary, and I outline these towards the end of the paper.

On November 25, 1993, Lesley Roberts was told she had inflammatory breast cancer. News of her diagnosis spread quickly, generating waves of shock and sadness among friends and colleagues. In the days and weeks following the diagnosis, each of the 35 or so women who first formed 'the Web'—a support network for Lesley and her partner Ruth—made some gesture of empathy and solidarity. Women called or wrote or dropped by, asking questions, wanting to help out.

Lesley has a particularly virulent form of breast cancer. During their first meeting with the oncologist, Lesley and Ruth were told that, with treatment, Lesley would live for just 18 months. As both Lesley and Ruth said many times in the weeks following that, "all the cliches are true," such a prognosis rearranges priorities. Time with one another and their son James became critical. Daily tasks receded into triviality. The house deteriorated, ironing piled up. Lesley continued to work outside the home until February, struggling for herself and with Ruth and James to come to terms with it all. She wanted time to write in her journal, time for herself, time to meditate. As chemotherapy progressed, she became fatigued and unwell. For her part, Ruth struggled to accommodate all the emotion of the diasnosis, full-time employment, the majority of the housework and time with Lesley (she claims, actually, that chemotherapy fatigue travels osmotically; the partner gets it too). She thought other people's support would be valuable, and our desire to help out was certainly apparent to her.

In mid-January, Ruth asked if I would organize and 'concretize' the offers of support and assistance she and Lesley had received since Lesley's diagnosis. We held a gathering at which about 30 would-be supporters signed up for a variety of practical and caring tasks—making meals, driving, cleaning the house, arranging and conducting 'excursions' with the two of them, lunching with Ruth and so on. A 'commitment jar' was set aside for people to identify the unique things they felt they could offer Lesley and Ruth.

From February until May women appeared almost every weekend to drop off meals and clean their home. A myriad of clever and thoughtful gifts was given and received. We initiated a newsletter to keep everyone updated about Lesley's health and to celebrate some of the workings of the Web. On May 28, Ruth and Lesley hosted an end-of-chemotherapy party. Lesley had a mastectomy in June. The house-cleaning crews fell off over the summer, but meals were delivered to coincide with Lesley's arrival home from the hospital (they missed the mark slightly, Lesley was out before most of her visitors made it in). Lesley was accompanied by a 'Webster' for virtually all of her 25 radiation treatments.

The response of friends, colleagues and other lesbians to Ruth's clear request for a support network, and our day-to-day presence and activities in the Web, were and are at some level

completely natural, unconsidered, virtually automatic. At another level, the process of creating and sustaining a supportive environment at the community level was and continues to be complicated, laden and full of interesting potential.

In attempting to surface and sift through some of these complications and potentials, I conducted semi-structured interviews with Ruth and Lesley and three women in the Web—Jane, Lynn and Debbie. The particular constellation of Ruth and Lesley's supporters whom I asked for interviews do not, of course, represent the diversity of life circumstances and perspectives of the women in the Web. Yet within the scope of this paper and the small number of women interviewed I have, in keeping with qualitative research goals, attempted to surface a range of experiences (Lincoln and Guba, 1985). The women I interviewed have some age span between them; their relationships with Lesley and Ruth before Lesley's diagnosis were of different natures and strengths; they have been differently and to different extents engaged in the lesbian community in Hamilton; and they are variably involved in Ruth and Lesley's day-to-day lives right now.

Grounding the observations of the women who were interviewed in the literature both necessitated and allowed a threading together of academic work not generally combined: on social support, on caring, on communities of choice, on breast cancer. It also suggested a particular analytic approach. In discussing qualitative research, Opie recommends a reading and analysis which is

> constituted by attention to the paradoxical, the contradictory, the marginal, and by the foregrounding (not suppression) of these elements. Its focus on difference and on marginality within a text means that it specifically attends to what may be quantifiably insignificant but whose (remarked) presence may question a more conventional interpretation. (1992, 59)

This is the stance I have attempted to adopt in relation to the interviews I conducted and the literature, particularly the literature about women and caring. In certain sections, I have juxtaposed quotations to highlight the apparently contradictory analyses the women I interviewed hold of a particular situation or subject. In other places, I have given weight to a particular experience because it seemed to me to challenge the ways feminist research has tended to construct that experience.

The Web, and participatory action research about it, inhabits a place at the edges of ideas and debates in the literature on women and caring. Riessman contends that "because qualitative approaches offer the potential for representing human agency—initiative, language, emotion," they provide support for "liberatory" projects (1994, xv). Qualitative examination of experiences and perspectives about the Web provide insight into what social support among friends might mean and allow for; it may also challenge or disrupt mainstream understandings of women's relationship to caring, both as providers and recipients. The Web and our achievements in it contain implications for social policy in the area of community-based care.

In our particular situation, the structure of the Web also enabled caring relationships among people who are not related to each other.

Debbie: I remember feeling at the time that I wanted to do something, and I wasn't sure how I'd be able to integrate myself into doing that because I didn't at that time feel very close to them.... So this was a great opportunity for me to be involved.

In some ways, the Web set up roles and relationships parallel to the normative expectations which guide a family though 'what to do' in a crisis. At the same time, our (relative) freedom from kinship expectations has been regarded as one of the key elements in the Web's innovative possibilities. As Jane put it, one "aspect of the Web that differs—positively—from my experience of family ties [is that] its inevitably not so rule-bound... we've had to make some of it up as it's gone along." That the relationships we might develop with Ruth and Lesley around supporting them in this crisis were voluntary—could be chosen or refused—was affirmed over and over as the Web started to form. The concerns and assurances that surfaced reflected a desire to detach the Web and the women in it from images and practices, the rule-bound nature of duty. In one sense, we were engaged in an effort to avoid replicating women's exploitation in kinship-patterned caring relationships. Seeking to dissipate womanly injunctions to unconditional, unlimited giving, we exhorted one another to achieve clarity about our own needs and set parameters around our involvement. The directions in the Web wo-manual, distributed at our first Web gathering, were explicit:

It is important that we each be clear about how "in" this network we want and are able to be, clear about our capacities and availabilities, and our limits, over the next few months. This is not about guilt, obligation or vague offers of help: its about setting up a sustainable, consistent network of support, something Lesley and Ruth and James can come to trust and rely on.

Though not nearly as emphasized, some of the ways we talked about the Web suggested limits around Ruth and Lesley's responsibilities: we encouraged supporters not to take offence if one or both of them were unable or chose not to go on excursions with us, or if they didn't return our phone calls.

That the Web was against obligation was a theme that appeared even from the first moments of its formation. Ruth describes how she felt about asking me to coordinate a support network:

Quite nervous really... because it was a big thing that I was asking you. You might have said no, although I guess I assumed you wouldn't otherwise I wouldn't have been asking you, but you could have said no.... I wanted to make it very clear that you could have said no. I didn't want it to feel obligatory to you or anything.

As Ruth very poignantly suggests, "you could have said no," affirms both the risks and the promises of support among friends. On the one hand, it confirms the possibility of our

refusing and denying one another, our potential for non-responsiveness to the risk we might take in asking. At the same time, "you could have said no" confirms the possibility of our escape—as both recipients and providers—from the burdens of caring. It suggests that we are not bound to give and that we need not feel indebted for receiving. It speaks to the potential for environments supportive of both recipients and providers of care; assured of mutual regard; free to speak and enact our own needs and capacities without fear of hurting or burdening one another.

Certainly many of us were and are quite acutely aware of the consequences of dutiful caring. Lesley highlights the patterns of obligation that stem from ascribed status in families:

> I think if you look at mainstream non-lesbian support, people can end
> up being in a situation, doing things out of a sense of duty. They do
> things because, 'this is my mother, this is my sister.' And that's not to
> say that, in fact, somebody may also do that not just out of a sense of
> duty, but yeah, because they love them. But there is that obligation.

She contends that our motivations for helping one another are considerably less ambivalent or complicated. Among lesbians, in the Web, "You're freed from that. So you kind of cut the crap, and you get down to the crux of it, and its done out of genuine love and concern." In a similar vein, Waxler-Morrison and Hislop (1991, 181) points to the often ambivalent or conflictual nature of family relationships, suggesting that friends or members of a more distant support network, while frequently providing less support, may be able to provide support which is more satisfactory and meaningful.

Yet as Lesley also notes, despite all the possibilities in the Web for less dutiful relationships, and all our claims and attempts at resisting obligation, we are terribly well socialized in patterns of proper behaviour. She talks about the difficulty she and Ruth have had in cancelling plans with people in the Web that they don't feel up to:

> Where, part of you says, 'course you can call' [and tell someone not to
> come by]. We are dealing with exceptional circumstances here, and if you
> can't do it now, when can you do it? [But] that part of our upbringing
> creeps back in and says, no you can't possibly do that to people. So
> you just, you go ahead and do it.... Which is, in some ways is linked to
> ... duty, you don't let people down. We're all conditioned, aren't we?

As women in this society, we are certainly conditioned: we are socialized in ways which inhibit our saying 'no' in virtually any circumstance to anyone who asks anything of us. In the situation of women friends caring for one another, this conditioning becomes particularly relevant. Aware of each other's general sense of disentitlement to care, and aware that the bonds between us are in some sense more tenuous than those of kinship, do we feel compelled to be especially consistent in our presences and availability, to swallow even more frequently our own hesitations and refusals? Not having had the opportunity or the freedom to develop our capacities to enact no-saying, how far can we carry our promises to do it here and now?

Jane points to the patterns of extending self which she, like many of us, finds herself in: "Actually, I'm much more likely to say 'I'll do this or I'll do that' or just to let happen whatever/ do whatever's needed, rather than deciding that I'm not ready to do it...." Lynn suggests that her perception of Ruth and Lesley's openness in having asked for the Web would move her to want to buffer them from the possibility of people not 'signing up' to help out:

> I felt dreadful when I was at the party, when I saw how sparsely that
> part [to do cleaning] was filled in. I really did. And I worry then about
> their hurt feelings.... I would cheerfully have signed up every one of those,
> I mean that sounds so Pollyannaish I can hardly stand it... [but] my
> instincts would be to do that so they wouldn't have / so that their feelings
> wouldn't be hurt.

In light of the ways we have been conditioned, as Lesley says, Jane suggests that the 'Web difference' may not lie so much in the complete repudiation of kinship-fashioned caring patterns, but in the possibility of our each examining and modifying these patterns in our own lives, in circumstances where that may be more feasible than it generally has been for women: "I think the possibility of my getting better tuned about 'I'm able to, I'm not able to,' that's much higher here [than in relation to family]."

Beyond the ways that women's socialization shapes our interactions as lesbians, there may be other patterns of commitment or obligation between us. Jane is explicit about her aversion to certain aspects of kinship ties, but acknowledges the possibility that the attitudes and behaviour we cherish as a community might also make caring for one another seem required:

> I don't like the sense of obligation that most of us could have or have
> known from our biological families ... those kinds of scripted obligations.
> But we do attach some value to caring about each other or looking out
> for each other or something.

Considering whether support from other lesbians is something we should be able to count on, Deb speaks to the many layers and reasons we might have for being in supporting relationships with other lesbians:

> C: Do you have a sense that this is something that we should be able to
> expect from one another? D: Yes. And for many reasons... I think that
> because many of us are so disenfranchised and so disconnected from our
> biological families, many of us may not have other families, other than
> our friends, and that, I think that not obligated, but I think there should
> be a real strong *wanting* to take care of one another.... The best example I
> have is the death of my brother. And the support that came around that,
> and that just moved me through that in ways that I just I could never ...
> but I just know that I was able to get through that because of it. And it's
> made such a huge difference in my life. And um, knowing that there's

that ongoing underlying support if I need it, that its there. And I'm not sure I'd call it obligation, um, more about real wanting ... for us to come together in those kinds of ways.

Deb's 'real strong wanting' emerges in part from her sense that we do not have viable alternatives for caring, and thus touches on one of the ways that our caring can be seen as coerced, without options. Yet she also speaks of her own deep appreciation for social support as a determinant of health and well-being, both in specific hard times and in an ongoing way, 'knowing it's there.' Her shift from saying 'yes, we should be able to expect this,' to talking about how much she *wants* us to want to take care of one another, is poignant. Somehow, our own experience of the conditions of our lives, our losses and disconnection in relation to family, our own experiences of pain and need and what support has meant then, should move us to want this; certainly it has in her own life, and she speaks of it as a choice fully made. And, at some level, we should be able to expect it—we should be able, in some way, to count on one another's desire to be present for us in caring ways.

Considering some of the reasons that the Web works, Debbie reveals two themes common in feminist literature on caring—the burdens of care and how those burdens are distributed:

> One of the reassuring things for me is knowing that there's so many other women involved.... I know it's not falling just on four or five different people to carry it. And then you get really burnt out, and maybe a bit resentful, just because of the burden. Not that Ruth and Lesley are a burden whatsoever, and I know that of course you carry a lot of that with yourself, but at least you know that there's always other people that are carrying it too.

The way I read this, Deb says that supporting Ruth and Lesley both is and could be a burden, and that it is, but they are not. In discussing ways of looking at an interview text, Opie (1992) suggests that making sense of the contradictory moment—the simultaneous support for and denial of an issue—is often important to our understanding of it.

One way of 'making sense' here is to consider the duality contained in the term—and the practice of—caring. Caring is both about feelings and about work: "the word effectively elides the twin ideas of 'labour' and 'love'" (Ungerson, 1991,11). And, it seems that one part of the duality often obscures or negates the other: someone we love cannot be work, cannot be a burden; those whose formal sector work is care-giving cannot love the people they care for. Debbie clearly does not want to use the word burden in relation to people she cares about, but at the same time wants to acknowledge the work involved in supporting them.

In this paper I want, like Debbie, to acknowledge the work involved in caring; I also want to avoid constructing our/my support for Ruth and Lesley as burdensome to me/us. Mostly I want to highlight the parts of the interviews and our caring for one another which throw our traditional understandings of burden and the burden of caring into disarray and which challenge the ways that feminist literature has traditionally understood these things.

Focused on identifying, describing and developing policies to alleviate the burden of caring on the woman carer, feminist research has obscured many aspects of caring. It has veiled the ways that providing care is experienced as choice, as privilege, as gift. Drawing respondents largely from formal care-giving organizations, research has attended to caring relationships wherein one person is clearly the carer, the other cared for. It has thus concealed more mutual and reciprocal caring relationships, in which joys, burdens and challenges are more easily shared (Morris, 1995, 162). It has particularly obscured the ways that women receiving care support and care for the people around them, including their carers.

Recounting parts of her engagement in the Web, Deb describes a situation in which a Web activity for Ruth and Lesley clearly required thoughtful, planned work on her part, and was for various reasons quite difficult—even burdensome—for her:

> The hardest thing I did was the excursion. Because that took/ you had to
> be creative, and you know what if you pick something they don't want
> to do, and then they have to be polite and do it anyway, you know.
> Those are just my personal things that I have a lot of difficulty with.
> But still wanting to do that, you know?

Even further than still wanting to do it, Deb later notes that she didn't particularly want the activity to require less effort. She expects supporting friends to be burdensome in some senses; extending oneself and putting significant personal energy into caring for other lesbians is entirely appropriate. In a similar vein, talking about getting to know Ruth and Lesley better, Deb identifies the sadness that comes from caring more and more about someone so ill. But rather than suggesting that the sadness detracts from the relationship, or even that it is part of a package she has to live with, she has a certain appreciation for it because it confirms the relationship she has with Ruth and Lesley:

> [Being closer] brings a lot of sadness with it too, because you can't
> distance yourself as much from it. Which is good, I'm glad, you know,
> because its so easy, its so easy to know that something's happening with
> somebody, and to say, oh, that's too bad, and then set up that distance
> thing, you know?

Constructing women in the Web as (only) supporters and Ruth and Lesley as (only) supported also obscures the many, many ways that Ruth and Lesley have supported and cared for women in the Web over the last several months. Certainly they attend, as they always have, to the bumps and joys and sadnesses in other women's lives. Many of the gifts given and received over the last months have been from them to us. Still experiencing many of the debilitating effects of chemotherapy, they hosted a large gathering, made quantities of beer and received and entertained with their habitual aplomb. Deb also makes it clear that she thinks Ruth and Lesley have done something significant for their supporters in asking for the Web, because the Web offers the people in it "the ability to feel ... that we can do something for them, we're not feeling ... isolated in our feelings for what's happening. But to

actually feel like you can do something... that is *hugely* important." In some sense, their request for a Web confirms to us that Ruth and Lesley believe we can make a difference in their lives—not an unwelcome affirmation in the face of a life-threatening illness.

In the tradition of socialist feminism, Stoller advocates for a feminist gerontology "which understands family caregiving as an experience of obligation, structured by the gender-based division of domestic labour, the invisibility and devaluing of unpaid work, occupational segregation in the workforce, and an implicitly gendered workforce" (Stoller, 1993, 166). This understanding is structured around only one side in the care-giving equation. It thoroughly obscures the perspective of the person being cared for. It allows no space for us to consider the ways that receiving care may itself require considerable invisible and unpaid work, exact a significant cost and, in some aspects, be itself an experience of obligation.

Around the time of Lesley's diagnosis, Ruth identified the difficulty she had dealing with the volume of calls from people asking what we could do: "People needing to do things for her, for us, 'cause we're moving into a time of great difficulty in our lives, and I couldn't handle it on an individual basis. I mean, I already couldn't handle the phone calls." Here, the 'it' that Ruth was handling was not only the disease, not only the trauma, but the supporters; the "great difficulty" was theirs, but the "needing" was also ours. While we spoke mainly of the Web alleviating some of the tensions and day-to-day tasks Ruth and Lesley had to deal with, it was also a way for them to respond to and alleviate us—our concern, our calls—as a burden to them. For however comforting the calls were as evidence of support, responding to them has clearly required a great deal of time and effort. Along with the illness, our expressions of concern have intruded on and detracted from their time together—a bit ironic, considering that the Web was intended to do just the opposite.

Ruth, not without regret, understands the invasion of privacy, the intrusions, the demands for sociability, as necessary corollaries—as the obligations—of being supported in the community:

> Your evening was not your own necessarily because the phone rings all night and there's some, there's some obligation to respond to all people who are phoning for all those perfectly wonderful reasons and intruding on our space. But we gave them license to intrude in upon that space by inviting them to be a part of this whole thing with us. So you can't complain, shut them out, say, 'bugger off,' really, even though we did have that option, you can't really. You're going to do it on your own, well, do it on your own. We chose not to do it on our own.

She clearly expresses the conviction that people can't have it both ways—we cannot simply receive support from friends without a significant commitment to responsiveness and reciprocity. If we are not to be on our own in times of need, we must, it seems, be prepared to give up our privacy and solitude, our calm times alone. Again, this may be particularly true among friends: the license to intrude—like the work Ruth and Lesley have done responding to questions, keeping people updated, composing sections of the newsletter, thanking and acknowledging support, arranging and hosting Web gatherings—may be particularly required when we are not 'family' to one another.

Despite its occassional challenges, we took pride in the Web working, and we have talked about the possibility and wisdom of duplicating it. Clearly there are many things about Ruth and Lesley and the women in the Web that have made this particular configuration of caring possible and likely. There are also ways that we would hope and believe something like the Web could happen again. But aspects of social and health policy in Ontario and elsewhere make lesbians caring for one another virtually compulsory, and this suggests a certain caution around promoting more Webs.

Stoller notes that women who become care-givers "seldom feel that they had a choice... their decision is overdetermined" emerging in part from the limited availability of public services (1993, 159). Debbie's analysis of the formal care options available to lesbians suggests that our choice of community care—as either providers or recipients—may be particularly overdetermined:

> A lot of the things that are available we don't really have access to. So you think sort of health care, and you think sort of support, some of that support that you get through, you know, social services... you don't have the same access and we can't be the same people and our lives aren't seen the same way.

Heterosexism and homophobia delimit our informal care options as well. Our relationships with our biological families are often strained or compromised, sometimes thoroughly antagonistic. In the end we support one another because we want to, because we get something out of it, because we often believe we can do it better than any formal service or institution could, but also because there few viable options for lesbians in this community.

Regardless of how positive the experience of the Web has been for each of us in it, its promotion at a formal policy level could certainly undermine the collective interests of women. Even though the support we are sustaining is not among family members, some of the consequences and cautions that feminist researchers have identified with respect to the state and home-based care still apply. Walker notes that

> the state occupies a dual role in relationship to community care: it can provide direct support when this is absolutely necessary, but its main concern is to ensure the continuance of the primary responsibility of the family for the support and care of its own members. (Stoller, 1993, 160)

The Web can be seen to reinforce the tacit expectation on the part of state apparatuses that women will continue to care for people in need on an unpaid basis in the community. Thurston and O'Connor (1996) note that while women's participation in community-based efforts to promote health is consistent with the Ottawa Charter's vision, "it can also be manipulated for economic costgoals on the part of governments at a time of fiscal restraint." It may also further allow the smooth progression of prevailing policy trends, in which health and social services are provided at the expense of women rather than the state.

In the long term and over the scope of community need, the viable and responsive scenario is one in which lesbian-positive formal service options are readily available. Initiatives

like the Web could still exist, with much uniqueness preserved, but the fear of overburdening informal resources would be reduced; if and when informal caring became difficult for either givers or recipients, alternative sources of care would be available. This way, too, some of the compulsory strains in responsiveness and reciprocity would be substantively reduced, rather than us having to tinker with our individual patterns of behaviour in relation to need. The choice of the Web—and the choice to learn different ways to support one another—would then be even more genuine. Our most substantive resistance to obligation and indebtedness among lesbians supporting one another, then, is to advocate for lesbian-positive alternatives to informal community care.

THE BRONZED AESTHETIC: THE SOCIAL CONSTRUCTION OF WOMEN'S TANNING[1]

Kathleen Wilson, Theresa Garvin and Colin McMullan

Les cas de cancer de la peau sont à la hausse à travers le monde. Les messages de promotion de la santé traditionnels ont encouragé les femmes à prendre leurs propres responsabilités pour réduire l'exposition au soleil et de ce fait diminuer le risque de contracter cette maladie quelquefois mortelle. Ces messages visent surtout le contrôle individuel qui demande qu'on évite le soleil, qu'on se couvre, et qu'on utilise des écrans solaires puissants. De tels messages supposent qu'une plus grande connaissance des dangers du soleil conduit les gens à modifier leur attitudes et leurs croyances, et par conséquent à changer leurs propres habitudes d'exposition au soleil. Cependant, les recherches les plus récentes prouvent que l'exposition au soleil—et plus particulièrement le bronzage- est une habitude bien ancrée dans le contexte social. Chez les femmes en particulier, les concepts socialement construits de beauté et de santé sont étroitement liés au bronzage. Des entrevues avec des jeunes femmes considérées comme informatrices clés (moins de 30 ans) ont exploré le degré auquel elles associent une peau bronzée à la santé et à l'attrait chez les autres femmes et pour elles-mêmes. Une méthodologie ayant recours à un petit scénario en images fut utilisée pour obtenir des réponses sous forme de narrations de la part des femmes qui pratiquent le bronzage et celles qui ne le pratiquent pas au milieu de l'été. Ces réponses incluaient des descriptions générales du contexte social et identifiaient beaucoup de présupposés cachés derrière les critères de statut social et de beauté associés à une peau bronzée, comparativement à ceux qui sont associés à une peau non bronzée. Les résultats de l'étude ont démontré que les jeunes femmes associaient une peau bronzée à un style de vie actif, à un statut social élevé et à une haute opinion de l'image personnelle. Par contre, les femmes

[1] The following key funders have provided financial assistance for this project: the McMaster Research Centre for the Promotion of Women's Health (MRCPOWH) and its funding agencies Health Canada and the Social Sciences and Humanities Research Council (SSHRC); the Eco-Research Chair's Program in Environmental Health at McMaster University; and the Social Sciences and Humanities Research Council (SSHRC) through doctoral fellowships for all authors.

à la peau non bronzée étaient perçues comme étant calmes, tranquilles et travailleuses. Ces résultats confirment que les motivations du bronzage sont reliées au contexte social de la vie des jeunes femmes et que c'est aux critères de beauté et de santé socialement construits que les messages de promotion de la santé doivent s'adresser pour encourager des habitudes d'exposition au soleil qui ne présentent pas de dangers. Les résultats de ce projet sont en concordance avec la littérature qui circule de plus en plus et nous vient d'Australie; celle-ci montre que la meilleure méthode pour changer les habitudes d'exposition au soleil est de reconstruire la norme sociale qui associe le bronzage à la beauté.

C3 C3 C3 C3 C3

Incidence rates of skin cancer have been on the rise worldwide over the past several decades. In Canada, incidence rates for melanoma (the most deadly form of skin cancer) have doubled among women while mortality rates have increased marginally between 1969 and 1997 (NCIC, 1997). At first glance, this could be interpreted as a minor public heath promotion success: though more women are contracting the disease, fewer are dying from it. The assumption is that the lower mortality rates reflect changes in women's perceptions and an increase in individual preventive behaviour (for an example of this see O'Brien 1995). Others, however, argue that current trends reflect changes in historical and lifestyle factors and that decreasing mortality rates, coupled with increased incidence rates, reflect changes in detection and treatment rather than increased avoidance (Marks, 1992).

The following pages present the findings from a small-scale, community-based qualitative research study on women and tanning. Using the population health promotion model, the discussion suggests that increased theorization of the body in health promotion can help us better understand the role that social construction plays in motivating and encouraging risky health behaviours. Traditional health promotion messages encourage women to take individual responsibility for reducing sun exposure thereby reducing the risk of contracting skin cancer. These messages centre on individual control and responsibility by recommending that women avoid the sun, cover up and use sunscreens. Such messages implicitly assume that individuals will apply greater knowledge of the dangers of the sun to engage in less "voluntary" sun exposure. We argue, however, that sun exposure—and specifically tanning—is a behaviour embedded in a social context and that social constructions of health and beauty are inextricably linked to motivations to tan, particularly among women. Public health programs must therefore do much more than simply exhort individual women to protect themselves. In accordance with the population health promotion model, public health programs must address the societal and cultural influences that encourage sun exposure: the social standards that link tanned skin to health, status and beauty.

BACKGROUND

The population health promotion model (Hamilton and Bhatti, 1996) reminds us that health status is the result of a complex set of factors including behaviour, genetic endowment,

physical environment and more—all of which are mediated by one's socio-economic environment (Evans, Barer and Marmor, 1994; Hayes and Dunn, 1998). From this perspective, health and well-being are less a function of the medical care system and more strongly related to social status to the extent that position in the social hierarchy (socio-economic status) is argued to be a major indicator of population health (Wilkinson, 1996).

Implicit within the population health promotion model is a move away from the behavioural/lifestyle (micro-level) hypothesis to explain social and spatial disparities in health status and a move toward a more structural (macro) perspective where society itself is seen as exerting an important influence on the health of its inhabitants. Within this framework, health threatening and health promoting activities and behaviours cannot be divorced from the social context in which they are situated (Taylor, 1993). The individual's ability to "choose" a healthy behaviour is constrained by the milieu (see Link and Phelan, 1994), and the model argues for the need to incorporate broader social, economic and political strategies into decision-making about health with the ultimate aim of improving the health of the entire population.

One of the benefits of the population health promotion model is that it recognizes the importance that social constructions play in motivating and limiting individual behaviours through the social labelling of risk and illness. Past research has shown the importance of social construction in health. Smith (1981) shows how the community definition of black lung disease changed in Appalachian coal mining towns as the social, political and economic situation of miners evolved. She provides concrete historical examples of how community norms are key in identifying "safe exposure" and in defining and validating (or not) illness. Likewise, Linder's (1995) discussion of risk perceptions around electromagnetic fields (EMFs) shows that scientific definitions of safe exposure hold little weight when communities label something "risky." These and other studies show that community level social constructions of danger, illness and risk are all pivotal for resultant individual behaviours.

THE RESEARCH PROJECT

In order to explore Canadian women's motivations to tan, this research project attempted to move beyond traditional epidemiologic studies to uncover women's assumptions about the influence of tanned skin on health, beauty and social status. Two main research questions were addressed:

- What qualities and characteristics do young women ascribe to women with tanned and untanned skin?
- How might those reflect underlying assumptions equate tanned skin with health, beauty and social status?

Skin cancer is a disease with a long latency period (up to 40 years) that primarily affects Caucasian populations. It often poses a challenge for public health personnel faced with the task of convincing young people that activities undertaken early in life (such as tanning) can have detrimental effects later in life. As a result of these characteristics this research project limited participants to white women under the age of 40. All participants were selected by

purposive sampling and drawn from three public parks in Hamilton, Ontario, Canada. The first was a large, urban park in the centre of the city and the second was a suburban park with an outdoor community swimming pool. The third public park had two distinct areas: a public beach bordering Lake Ontario and a publicly owned and operated water park.

Participants were selected based on whether or not they were identified as practicing two or more of the standard sun safety messages promoted by Health Canada (seek the shade, wear sunscreen, wear protective clothing, wear a hat). At the pre-test stage "tanners" were identified as individuals practicing two or fewer behaviours; "avoiders" were women practicing three or more behaviours. At this stage, however, many of the protective behaviours were found to be mutually exclusive. For example, a woman might remove a long-sleeved blouse or hat when moving to the shade. Likewise, a woman might not apply sunscreen if she knew that she would be wearing a hat and protective clothing. As a result, the criteria were changed for the final stage of the study and women engaging in two or more sun protective behaviours were identified as avoiders while those exhibiting just one or no protective behaviours were identified as tanners.

Prospective participants were approached by a female researcher and asked to participate in the study. Interviews were conducted within 15 minutes by a second female researcher. Nineteen participants took part in the study, ranging in age from 17 to 40 years. The response rate was just over 80%. Of the 19 participants, 11 were categorized as tanners and eight as avoiders.

The personal interview consisted of two parts. The first section used a picture-elicited storytelling method whereby participants were shown photos and asked to develop life stories about the women they saw. The two photos showed head and shoulder shots of younger women wearing bathing suits with a neutral aquatic background. One photo showed a deeply tanned woman with long, dark hair and the other showed an untanned woman with very fair skin and blond hair. The pictures were shown consecutively: women looked at the first picture and developed a story, then were shown the second and another story was constructed. Throughout the interviews the order of the photos was alternated so that some respondents saw the tanned photo first and some saw the untanned photo first. The interviewer generated discussion by asking, "For each picture I would like you to make up a story about the woman... where she comes from, who her friends are... whatever you think is important in her life." Respondents were asked to develop scenarios about work, family, friends and activities. The interviews lasted between ten and thirty-five minutes and all were tape-recorded, transcribed and theme-coded using NUD-IST, an electronic data analysis software program.

The second component of the interview consisted of a short survey questionnaire designed to measure women's perceptions and attitudes towards tanning and having tanned skin. The perception and attitude statements used in this questionnaire were drawn from previous studies on sun exposure and tanning that examined the knowledge, attitudes and beliefs (KABs) of students in Arizona (see Buller, Loescher and Buller, 1994). The questionnaire also collected information regarding socio-economic and socio-demographic characteristics.

PROJECT FINDINGS

The results from the survey questionnaire show that knowledge about the risk of skin cancer may not necessarily result in changes to tanning attitudes and behaviours. As expected, women practicing avoidance behaviours were less likely to associate tanned skin with physical attractiveness than their tanning counterparts (see Table 1). For example, 91% and 73% of tanners felt that men and women, respectively, look better with tans. Responses from avoiders were 12.5% and 25%. Admittedly, these numbers are low, but the trend seems to continue with tanners agreeing that having a tan makes a person look and feel better and reporting that they like to have tans. Avoiders were more likely to report that it is stylish not to have a tan and less likely to agree that they personally like to tan. While tanners and avoiders were in disagreement over whether tanned skin is associated with beauty, both groups strongly agreed that a tan does not necessarily mean that a person is healthy. In addition, in relation to external judgments of beauty and attractiveness, the majority of both tanners and avoiders disagreed with the statement that beautiful women have tanned skin and very few agreed with the statement that men prefer women with tanned skin.

A number of interesting points emerged from the survey. For instance, most respondents (tanners and avoiders) did not see the lack of a tan as associated with poor health, a less active lifestyle or an indoor occupation. Nor is tanned skin a prerequisite for beauty despite the fact that most see tanned skin as always having been popular. But it is here that the similarities end. In general, the majority of the tanning respondents felt that tans make people—both men and women—look and feel better, that tans have always been popular, and that tans are more stylish. Their avoider counterparts disagreed that a tan makes one look and feel better and were more likely to believe that it is stylish not to sport a tan. From this survey we conclude that while the respondents did not equate tanned skin with health, they still indicated that tanned skin is related to looking and feeling better. Most interesting is that almost all of the tanners (91%) and some of the avoiders (50%) reported that, in the end, as individuals, they like to have a tan.

It is the interview results, however, that shed the most revealing light on women's assumptions about tanning, health, beauty and status. Despite some methodological concerns regarding the use of the picture-elicited storytelling method (see Garvin and Wilson, 1999 for a discussion of these issues), this procedure was effective at revealing underlying assumptions because, as Polanyi (1981) notes, stories tell a great deal about the storyteller and her world. The stories generated by women during the interviews demonstrated that women, both tanners and avoiders, implicitly associate tanned skin with beauty and higher social status. In fact, the women in this study ascribed very different attributes to women with and without suntans. The specific social contexts developed by both tanners and avoiders in the 'life stories' indicated that higher social status, in terms of beauty, social life, employment and health, is associated with tanned skin.

Beauty

Many of the women, both tanners and avoiders, felt that the tanned woman was more beautiful and physically attractive than the untanned woman.

Table 1:
Knowledge, Attitudes and Beliefs of Respondents

Statement	Percentage of Tanners (n=11)			Percentage of Avoiders (n=8)		
	Agree	Disagree	Don't Know	Agree	Disagree	Don't Know
Not having a tan means a person has a less active lifestyle.	0	100	0	0	87.5	12.5
Not having a tan means a person works inside a great deal.	27	64	9	25	62.5	12.5
Not having a tan means a person is unhealthy.	0	100	0	0	100	0
Suntans have alway been popular.	82	9	9	75	25	0
Men look better with a tan.	91	9	0	12.5	62.5	25
Women look better with a tan.	82	9	9	25	50	25
Beautiful women have tanned skin.	9	91	0	0	100	0
Men prefer women with tanned skin.	36	36	27	0	25	75
Not having a tan is in style today.	45	36	18	62.5	25	12.5
Sunscreen is too messy.	9	91	0	0	100	0
It takes too long to put on sunscreen.	9	91	0	0	100	0
Wide-brimmed hats are out of style.	45	36	18	25	75	0
Having a tan makes a person look better.	73	18	9	12.5	87.5	0
Having a tan makes a person feel better.	73	27	0	12.5	87.5	0
Having a tan means a person is healthy.	0	100	0	0	100	0
I like having a tan.	91	0	9	37.5	50	12.5

"She seems, I don't know, she's an attractive woman, she seems like she really takes care of herself, she's really conscious about her looks." (Lynn, avoider)

Similar statements of beauty and physical attractiveness were noticeably lacking in comments about the untanned woman. In fact, one woman commented that the untanned woman did not "appear to care about her appearance" (Linda, tanner).

Social Life

Differences between the tanned and untanned women were also translated into assumptions about their social lives and that their social lives were validated, primarily, by their relationships with men. Both tanners and avoiders perceived the tanned woman to be more socially active and attractive to men than her untanned counterpart. One woman upon seeing the picture of the tanned woman commented that "her day would go fine but at night she'll probably have a lot of guys staring at her" (Anne, tanner). This was reiterated by other respondents who felt that the tanned woman would socialize with people who were popular and equally attractive. One commented that the tanned woman would probably date "good looking, tanned guys, like professionals, you know, like a guy with a suit, that's what I picture her with" (Jessica, tanner). Several respondents, both tanners and avoiders, reiterated the importance of the male gaze.

"This type of girl seems more outgoing in terms of dating a lot, a lot of boyfriends [who are] more rebellious in terms of taking risks ... business man, high up and that ... this girl seems to be not quite sure of what she wants." (Katrina, avoider)

In contrast, the untanned woman was perceived to socialize with individuals of a much lower social status. In fact, some women felt that her friends were "low key, very easy to get along with for any group, you know, they're not high society or anything like that" (Alanna, tanner).

In addition to associating with different social groups, the interviews revealed that the tanned and untanned women also led very different lifestyles. For example, the tanned woman was described as being much more socially active (in terms of a night-life) with a more exciting life than the untanned woman.

"I'd say [tanned woman is] outgoing, like fun to be around, hanging with a big crowd. Active, likes her personal appearance to look good." (Alicia, tanner)

The tanned woman was also more often thought to be a single woman who dated considerably.

"I think she seems like a partier, yeah, very easy going, free going." (Joyce, avoider)

Not only was the tanned woman seen to occupy a higher social status but was also thought to be more sophisticated than the untanned woman.

> "Definitely a city person she looks like the city type, old sophistication ... trendy dress and even though the hair's a little straggly you can see that there is a style, there's a style to it as well...there's an air of sophistication." (Rose, avoider)

In comparison, the untanned woman was perceived as being married, more stable, responsible and having a less active social life.

> "She looks like she's a mom, she looks married, she might look like she has an occupation either with the government or something that has to do with children ... she looks like also sports minded and oriented and on her spare time doing the same thing, riding bikes, swimming, or roller blading." (Morgan, tanner)

> "Maybe she enjoys some types of crafts, social activities in groups studies, and maybe she's part of her community activity or board." (Carol, avoider)

Employment

The differences in characteristics ascribed to the tanned and untanned women in the photos were not limited to physical attractiveness and social networks. In fact, the higher social status thought to be enjoyed by the tanned woman also applied to her career. While most of the respondents saw both women as professionals, many felt that the tanned woman enjoyed a more exciting career.

> "Young, attractive, probably very much into her looks ... I would say not married, occupation, probably a secretary, an important secretary, probably like a large company." (Joyce, avoider)

> "A journalist who travels a lot, meets a whole lot of people, she has a very interesting job ... worldly, well read, well educated and very outgoing.... Her friends live in different place s... some of them are doctors, some of them are lawyers, they're kind of well-to-do people." (Tess, avoider).

In contrast, the untanned woman was characterized as having a more mundane job with some respondents indicating that it might also be of lower social status. "I think she's more blue collarish type, kind of on the high end of blue collar" (Tess, avoider).

Health

For the women in this study, seeking tanned skin was primarily related to concerns with beauty and social status, with only one woman associating tanned skin with health.

> "Yeah, I would like to have some bronzeness but not...I don't like it when people are like so dark that you can't even tell that it's them, you know. I just like some colour, I think everybody looks healthy with some amount of colour. She [untanned woman] looks white." (Jessica, tanner)

THE BRONZED AESTHETIC

Overall, the interviews show that many of the women tend to associate tanned skin with physical attractiveness, popularity, style and prestigious, exciting careers. These findings held for both tanners and avoiders and regardless of the order in which the photos were shown. In fact, two of the women interviewed explicitly referred to the colour of each woman's skin when ascribing characteristics. One respondent drew a direct association between the colour of the untanned woman's skin and her lack of physical attractiveness.

> "She [untanned woman] doesn't have much colour to her ... maybe she looks better with makeup on or whatever." (Marie, tanner)

Meanwhile another respondent drew a direct link between the colour of the tanned woman's skin and her higher social status.

> "She [tanned woman] probably tans, spends her day at the beach, she has a good body, she's probably into physical appearance, has colour...she could be a professional woman." (Sarah, tanner)

Throughout our analysis of the interview data, it became increasingly clear that women respondents saw tanned skin as being directly related to beauty, style and social status. We have termed this socially constructed relationship the bronzed aesthetic because it assimilates deeply tanned skin into the idealized female body form. Those respondents who wished to be seen as attractive, popular and outgoing seemed to be the same women more likely to seek this bronzed aesthetic. Other research has shown that social constructions of health and beauty are important factors influencing the decision to tan (Keesling and Friedman, 1994; Miller et al., 1990). Our results suggest that the tanners in our study (and perhaps tanners in general) are engaged in a form of adaptive behaviour in that they alter the appearance of their body to more closely resemble that of the bronzed aesthetic in an effort to become more attractive to themselves, their peers and the world at large. Through tanning, these women's bodies become a reflection of the broader social definitions of beauty and social status. It is these social constructions of beauty and status that we suggest continue to encourage the risky behaviour of suntanning. As Miller et al. (1990) argue, suntanning thus becomes an

individual activity that represents a conflict between one's personal health and the social values of physical attractiveness.

Both the tanners and avoiders generally acknowledged the fact that suntanning posed a risk to their health, but this acknowledgment did not always translate into sun safe behaviours. In particular, a number of avoiders indicated that they practiced sun safety measures either by wearing sunscreen, hats or staying out of the sun during peak hours of the day. However there was one avoider who, much like her tanning counterparts, sometimes consciously elected riskier behaviours despite the known dangers associated with tanned skin:

> "I don't tan very often so...like this is very seldom... that I do, be out in the sun and enjoy, like not very often because of the sun rays and how we're all at high risk of cancer and stuff like that ... I know I should [wear sunscreen] but I don't burn so I don't put any suntan oil or anything, when I do sit in the sun, which is very seldom. I put oil on if I want to get some kind of a colour but that's about it." (Katrina, avoider)

Similarly, very few tanners admitted to practicing sun safety measures. In fact, one tanner indicated that while she did practice one sun safety measure, wearing a hat while in the sun, it was not due to the risk of skin cancer but out of concern for her physical appearance: "but that's not really to do with my skin, it's more because my hair keeps lightening" (Nicole, tanner). From these and other responses it seems that even the avoidance behaviours exhibited by women during the study may be prompted by concerns over style and physical appearance rather than by the known health dangers of tanning.

In general, the results show that for tanners the benefits of tanned skin (beauty, popularity, higher social status) far outweigh the associated future costs of extensive sun exposure. Despite the fact that these women were aware of the risk of skin cancer, tanners still chose to tan in an attempt to become more beautiful and physically attractive. One woman in particular voiced the struggle she faced in wanting to achieve a dark tan while avoiding skin cancer:

> "I'm more cautious of it [skin cancer] ... I notice all kinds of spots all over me now so I'm going 'oh oh' ... I'm thinking not so much wrinkles but you know cancers and I don't know. I'm more safe, not even safe, I don't know...I know that suntanning is not healthy. I think it's attractive, but I don't think that being black is attractive, I just think being a little bit coloured is attractive like I think I'm albino right now and I don't think that's attractive." (Jessica, tanner)

THE SOCIAL CONSTRUCTIONS OF TANNED SKIN: IMPLICATIONS FOR PUBLIC HEALTH POLICY

The findings from this project suggest that public health messages encouraging individual women to limit sun exposure will likely have little long-term effect until the social benefits

of tanned skin are addressed. According to the population health promotion model, biological risk and individual behaviour form only part of the explanation for risky activity. In Canada, skin cancer prevention programs (often called sun safety programs) have primarily focused on individual behaviours rather than on the community and societal influences identified in the population health promotion model. This is not the case in other parts of the world.

In Australia, sun safety programs have been moderately successful at changing family, community and societal definitions of what is considered safe sun exposure (Marks, 1992). For example, in Australia hats are a mandatory part of most children's school uniforms and many communities employ a "no hat—play in the shade" policy on school property. Shade structures have been made a mandatory design component of public outdoor facilities to encourage avoidance behaviours. New fabrics and clothing styles have recently been developed that both cover more skin and block more ultraviolet (UV) rays.

As a result of these and other initiatives, attitude surveys suggest that Australians no longer consider tanned skin to be "healthy," and fashion magazines are reflecting this trend by showing models with untanned skin and beach-wear bodysuits reminiscent of the 1920s (Chapman et al., 1992). In these ways, the population health promotion model has been shown to be effective in addressing the broad spectrum of motivations that encourage Australians to tan (Marks, 1992). The results of our study in Canada suggest that, as in Australia, future public health messages would be more successful if they targeted the social support networks, community standards and broad social and structural imperatives that equate tanned skin with women's health, social status and beauty. However, in doing so, public health promoters face a number of challenges.

One public health challenge lies in trying to change decades of media messages that present deeply tanned skin as both beautiful and socially appealing. Historically, the cultural arenas of medicine and fashion have been very powerful forces in dictating the form of the beautiful body (see Bordo, 1993; Grosz, 1994; Hahn, 1989), and both have been successful at using the media as a conduit of these standards. More recently, the medical community has tried to redefine tanned skin as unhealthy, but its success in Canada seems to have been limited. The fashion industry, reflective of other social trends, has begun to use imagery of untanned women over the past several years. Yet these new images—dubbed "the heroin look" because the models are young, wan and "sickly"—are themselves laden with indicators of the ideal female body and the social values underlying such a form. Given the strong influence of medicine and fashion, as recast and reflected in the media, the challenge to public health practitioners is to support the new message of denying deeply tanned skin without embracing the unhealthy connotations associated with the heroin look.

A second challenge for public health is to recognize that the body—and the female body in particular—is a contested site embedded within a complex social milieu. Recent feminist writing contends that the body is a site where women can contest and challenge dominant social and cultural constructions of the natural body. However, our research suggests that rather than using their bodies as sites of resistance (Watson et al., 1996), many of these women seem to be using their bodies as sites of acceptance and inscription. In other words, rather than sites of resistance to social norms (through tattooing or body-piercing for example), these women (tanners especially) appear to be using their bodies as palettes on which to paint the social ideal of the bronzed aesthetic.

Relatively easy access to a variety of technologies has recently enabled women to alter their bodies, sometimes permanently, to reflect the dominant social norms. Over time, technology, especially cosmetic surgery, has allowed individuals to free themselves from what Bordo (1993) terms bodily determination. Tanning technology such as indoor tanning salons and sun lamps is simply one more kind of physical alteration parallelled by procedures such as rib removal, liposuction, face lifts, collagen injections and breast enlargements. These are all ways that technology (medical technology in particular) has attempted to usurp the aging process and redefine women's bodies according to current social conceptions of beauty. As a result, the twentieth-century female body has become a mould that is continually broken, shaped and altered to reflect the changing social norms by which women are judged to be beautiful.

There will never be a shortage of technology or medical personnel who are willing to help women change the appearance of their bodies. This is a serious concern for public health promoters because, like other body altering behaviours, many women today seek the bronzed aesthetic despite known health risks: skin cancer, vision problems and the potential reduction of immune system efficiency. Due to the implicit power of social pressures to tan as well as the strong desire for social conformity, public health promotion must begin to change those social constructions that equate tanned skin with health, status and beauty.

Finally, public health promoters must recognize that public health messages directed at reducing the desire for tanned skin (the bronzed aesthetic) have important implications in a multicultural society such as Canada. Data on race and the implied skin colour have only recently begun to be collected (in the 1996 census) so there is little or no data on the skin types of Canadians. We do not know, therefore, how many people have characteristics that put them at high risk for skin cancer: fair skin, red or blond hair, blue eyes and a propensity to freckle (Dubin et al., 1989). As such, developing a public health message that advocates light or untanned or not dark skin for this unknown proportion of the Canadian population may not only be a questionable use of public use funds but could also have racist implications. Health practitioners, therefore, are faced with the difficult task of demonstrating that pale (white) skin is more attractive than tanned skin without implying that the black or non-white skin of people of colour is somehow less attractive. The Australians have got around this potentially conflicting message by advocating that individuals accept that natural skin colour is healthy skin colour. Individuals are encouraged to "love the skin you're in," whether it be light or dark.

While unquestionably difficult, there is a need to move the discussion of sun exposure and tanning beyond the level of the individual. At present, public health sees the production of one's health as an individual moral endeavour (Lupton, 1995). Tanning is therefore a morally wrong choice to engage in a behaviour that will endanger one's health. The population health promotion model, however, reminds us of the need to recognize that health-related behaviour is fundamentally and inextricably bound within a social context. Women may feel little choice when their only options are to tan and be considered attractive/successful or to not tan and be considered unattractive/unsuccessful.

CONCLUSIONS

The findings from this project support the growing literature from Australia showing that sun exposure behaviours are most effectively changed by reconstructing the social milieu that equates tanned skin with beauty, health and social status. Once motivations to tan are removed from the context of an aberrant individual behaviour and placed in the context of a response to social demands, tanning takes on a new and more complex meaning: it becomes an adaptive behaviour women use in response to social and structural pressures. Thus, concerns about women's self-image, body-image and personal control become central to understanding why women tan.

Using the population health promotion model, sun safety in the study community is now widening to include a broad range of health determinants. Most importantly, sun safety is now being incorporated in a wide variety of programs related to self-image and young women's development including public health programs on healthy lifestyles, food and nutrition, eating disorders and self-image. Broad links are also being established between community groups and organizations to encourage a re-evaluation of public health messages in attempts to counter the social constructions equating tanned skin with women's health, status and well-being.

Chapter 17

OUTSIDERS WITHIN: WOMEN'S EXPERIENCES IN THE FAMILY LAW SYSTEM

Karen Bridgman-Acker

Le processus de négociations de la garde des enfants, la question de l'accès et du soutien d'un parent, peuvent avoir des répercussions à long terme négatives sur le bien-être physique, émotionnel et financier des enfants, lorsqu'ils se déroulent à l'intérieur d'un système institutionnel qui, souvent, n'apporte aucun appui aux femmes et aux enfants. Le processus d'application de la loi sur la famille a un grand impact sur les conditions nécessaires à la santé des femmes, au niveau de l'abri, du revenu, des ressources durables, de la justice sociale, de l'équité et de la paix de l'esprit. Ce chapitre présente un rapport sur un projet de recherche—action participante, mis sur pied pour explorer les expériences, les besoins et les préoccupations des mères par rapport au système de la loi sur la famille, et pour solliciter leurs recommandations destinées à changer la situation. Trop souvent, les femmes les plus affectées par la législation et par les décisions de la cour ne sont pas consultées au cours du processus de recherches. Si on choisit de ne pas faire participer les intéressées aux décisions relatives à la politique et aux programmes qui les affectent, il nous est impossible de répondre à leurs besoins adéquatement. Des idées ont été sollicitées au cours de sessions organisées à l'intérieur de groupes de discussion thématique. Les 50 participantes consultées étaient des mères sans partenaire et des professionnelles du service de soutien. Le sentiment d'être exclues et marginalisées durant le processus de négociation avec le système légal revenait sans cesse. Les sentiments de perte de contrôle et de dévalorisation entraînaient des effets négatifs sur elles-mêmes et sur leurs enfants. Les femmes se sentaient manipulées et dévalorisées non seulement par les pères de leurs enfants, mais aussi par les avocats et les juges qui les rabaissaient et les humiliaient. Les femmes rapportèrent des exemples selon lesquels le processus provoquait des symptômes physiques et émotionnels allant de sentiments de culpabilité, de colère, de frustration, d'incompétence et d'isolement à ceux de peur, d'anxiété, de panique et de dépression. La plupart des femmes vivaient dans la pauvreté, résultat de structures et de systèmes qui maintiennent le déséquilibre du pouvoir et des doubles standards entre les hommes et les femmes. Les femmes sont convaincues que la toute première étape pour améliorer ce système serait d'inclure les mères qui ont déjà connu l'expérience judiciaire et de les inviter à prendre part

à la planification, au développement et à l'usage de tous les services et de tous les programmes.

<div align="center">

& & & & &

</div>

Negotiating child custody, support and parental access in an institutional system that is often unsupportive of women and children can have long-term negative implications for their physical, emotional and financial well-being. The family law process impacts on their fundamental prerequisites for health, directly and indirectly, in the areas of peace, shelter, income, sustainable resources, social justice and equity (World Health Organization, 1986). Societal inequities experienced by women and children generally, and more specifically in the current family law system, undermine women's health, as optimal health is only possible in an "environment that is based on the principles of social justice and equity and where relationships are built on mutual respect and caring, rather than power and status" (Hamilton and Bhatti, 1996, 9).

This chapter reports on the findings of a participatory research project carried out in Hamilton, Ontario in 1995-96. A community consultation was undertaken to a) explore mothers' experiences, needs and concerns in relation to the family law system and b) to solicit their recommendations for change. To set the context for the research, an historical overview of the family law system in Canada is presented, and I, as the researcher, describe my personal approach and interest as they relate to these issues. Information about the methodology and the participants is offered, followed by the project findings, presented in two sections. Voices of Experience includes women's voices, in the form of excerpts from focus group transcripts; Voices for Change contains a summarized account of the participants' recommendations for change. The paper concludes with my personal reflections on the process and current initiatives in Hamilton that are attempting to make a difference in the lives of women and their children in the family law process.

HISTORICAL CONTEXT

Historically, the law has responded to social change, and there have been corresponding shifts in child custody patterns, from a belief in the absolute authority of the father to the ideal of nurturant motherhood, and finally, to a supposedly gender-neutral standard in which the best interest of the child is to be the sole consideration in custody decisions. Social changes related to the roles of motherhood, fatherhood and parental rights have factored into these shifts. Legislation and case law have been influenced by the social construction of parental roles, the media, social science research and the lobbying of special interest groups and advocates (Bertoia, 1996).

The 1980s saw fathers' rights groups begin to organize to demand equal rights in the private sphere of home and family as women had organized to demand equality in the public sphere of labour. While non-custodial fathers complain that mothers and the court deny them custody and access to their children and control over their children and their money, custodial mothers are concerned about fathers who use threats of joint custody and withhold child

support and visitation to maintain power and control over their lives (Crean, 1988; Bridgman-Acker 1995; Taylor, Bransley, and Goldsmith, 1996).

The average woman appears to have been excluded from much of this ongoing political activity and often ends up on the receiving end of decisions and discussions which have a serious impact on her ability to adequately parent and support her children. Her reality is often in contrast to and far removed from the political process. "Women are losing their livelihoods, their savings, their health, their self esteem, their children, and sometimes their lives, in custody battles with men" (Crean, 1988, 6). The present family law system is failing to protect the best interests of the children (Department of Justice, 1993) and failing to enable mothers to do the work of mothering (Landsberg, 1988) in healthful situations for themselves and their children. Children of single mothers are five times more likely to live in poverty than other children (Dhooma, 1994) and the family law system contributes to this poverty by ordering low child support payments and by failing to adequately address the 70-80% non-compliance rate for child support orders (Lindsay, 1992). Women, when abused by their male spouses, enter courts which some say consider woman abuse irrelevant to custody and access and which demand higher standards of parenting from mothers than from fathers (Department of Justice, 1993; Hester and Radford, 1996). In 1997, new federal child support guidelines were implemented, but only after amendments proposed by father's rights groups and sympathetic senators were adopted.

Historical and current literature supports what too many mothers already know from their own experience. Legislation, policy, professionals and their opponents in this adversarial system of family law make their ability to mother their children a continuous and long-term uphill battle. The cost to them and their children is far greater than many people know. Their stories remain untold, and their energy to fight for change is often depleted by their day-to-day struggles.

While community consultations and support groups have started in various parts of the country, no coordinated effort exists in Hamilton to document or address the needs of women as they go through this legal process. Many women struggle alone to raise children and to survive, financially and emotionally, upon the break-up of a relationship with little support or information available to them. Taylor, Barnsley and Goldsmith (1996) argue that gender bias against women in the family court system has created a crisis and allows men to continue exercising power and control over women and children in disputes over custody, access and support.

APPROACH TO THIS STUDY

The effect of these issues has been a long-time concern of mine, both as a custodial mother and as a social worker whose primary practice has been with sole-support mothers struggling through this difficult process. My interest in the impact of the family law system on mothers and children has developed over years of listening to the stories of women I have come in contact with through my work and in my friendships with other custodial mothers. Several years ago, I experienced the trials and tribulations of navigating the family law system to sort out custody, access and child support for my two children. In the process of sharing

this experience with other women, I was initially surprised to discover many similarities in our stories. As my career developed and I began working with single mothers on social assistance, I heard repeatedly about women's emotional and financial struggles in relation to the family law system. The stories involved interactions with ex-partners, judges, lawyers and other social service professionals while making arrangements for custody, access and child support. In increasing numbers, women told me about the damage done to themselves and their children and the ongoing effects of this trauma on their ability to get on with their lives.

At some point, after I began writing papers and researching this issue, a newspaper reporter suggested that I could now be considered an expert in these matters. Upon reflection, I had to agree that I and all women with first-hand knowledge of this process share an expertise which we do not wish for others. My "expertness" in this area does not come from any level of education or objective way of knowing but from the large volume of stories I have in my collection, including my own. Smith (1987) argues that each of us is "an expert practitioner of our everyday world," and in order to enhance our understanding of our experience as women, we need research strategies which start where women are, "as subjects and as knowers" (153-154). An idea was brewing for a project that involved talking to the "experts" about these issues from their standpoint, so that other women might not have similar stories to tell in years to come. The goal would be to foster women's empowerment through their participation in generating knowledge, identifying problems and offering solutions in a participatory action research project which could potentially use this experiential knowledge to influence practice and policy-making (Whitmore and Kerans, 1988; Hamilton and Bhatti, 1996).

PARTICIPATORY METHODOLOGY

It is with this background and these commitments that I embarked on a participatory action research project to explore the experience and needs of mothers as they access the family law system. A group of five other experts, all custodial mothers living in Hamilton, met with me at the home of one of the women to brainstorm ideas on the best way to approach the project. It was decided that I, through my university involvement, would act as the community researcher and the others would form an advisory group to recruit women to participate in focus group interviews and to assist in recording and transcribing the discussions. The research question was designed by this advisory group, and we named ourselves the Mothers' Family Law Advocacy Project. We wanted to explore local women's experiences within the system and determine what practice interventions, if any, could assist them as they navigate the family court process. A proposal was submitted to, and funding provided by, the McMaster Research Centre for the Promotion of Women's Health to help defer administrative costs and to cover the expenses of participants. It was agreed that an important aspect of the study was to value and recognize women's involvement and sharing of experiences as modestly paid labour by providing an honorarium for their participation. The work of this project could not have been carried out without the assistance of Dr. Jane Aronson, Associate Professor in the School of Social Work at McMaster University, who graciously acted as our research advisor throughout the entire process.

The approach used in this project and in my own practice is a combination of knowledge, skills and values drawn from social work, feminism and participatory action research methods.

For too long, decisions in social welfare policy and legislation have been made with little consideration for those most affected. Needs have been assumed and programs developed without seeking input or feedback from participants. People have had little, if any, control over decisions that impact their lives, resulting in feelings of powerlessness and helplessness. Participation and inclusion are key to empowerment, defined by Whitmore and Kerans (1988) as: "an interactive process through which people experience personal and social change, enabling them to take action to achieve influence over the organizations and institutions which affect their lives and the communities in which they live" (51). We all have strengths, resources and experiences which can help us to cope and make changes within our environments. By not involving people in decisions about policies and programs that affect them, we are not able to adequately meet their needs. An empowerment approach in research includes being aware of "power relations, cultural context, and social action...building knowledge that seeks to change the conditions of people's lives, both individually and collectively" (Ristock and Pennell, 1996, 2).

Our research project involved an extensive community consultation which asked participants to 'tell their stories' and then to 'paint a picture' of the ideal program for women and children in similar circumstances. Participants for this study were contacted using a purposive, snowball sampling technique. We recruited women by posting flyers in local women's organizations (shelters, women's centres, counselling agencies, YWCAs, day cares, etc.) and through mothers and service providers already known to us. As a coordinator of a program for single mothers, most of whom had been through the family law process, I was able to seek interested participants from my caseload. Each member of the Mothers' Family Law Advocacy Project advisory group took responsibility for coordinating at least one focus group from her circle of acquaintances. Once the initial contacts were made, women were asked to refer other interested participants to the study who shared a common concern or experience with the issue of inequities in family law.

Various women's organizations in Hamilton, such as shelters for abused women, services for single parents, the Women's Centre and counselling agencies, were approached for support in promoting and hosting focus groups for the purpose of this research study. Their co-operation was anticipated due to the relevance of this topic to their mandates of assisting women in crisis and with problems of daily living. Focus groups were the chosen approach because they can encourage women to engage with each other and discuss previously unspoken thoughts and feelings about a particular shared experience (Kitzinger, 1994). Ideas were solicited through open-ended questions in a semi-structured group setting allowing participants to influence and be influenced by each other, while at the same time being free to express personal insights and opinions.

Focus groups were scheduled at various times during the day and evening at different locations in order to be accessible to a larger number of women with varying schedules and commitments. In an attempt to limit as many barriers as possible to women's participation, a volunteer was recruited to provide child care for those families who required it, and sites that are wheelchair accessible were utilized. A total of nine focus groups of six to ten

participants were held, seven with mothers and two with service providers within local women's organizations.

The discussions were facilitated by me as the moderator/researcher whose role was to keep the conversation focused and to observe and to listen to the respondents, while notes were taken by an advisory group member of the Mothers' Family Law Advocacy Project. Data were gathered in the focus groups using an interview guide consisting of a series of open-ended questions with a few general probes to elicit views on different aspects of the topic. The discussion revolved around the following three questions:

1) What has your experience been in the family law system?
2) What kind of support do you wish you (or your clients) had when going through this process?
3) If a program or service was developed to help meet the needs of women and children in this situation, what would it need to look like?

Service providers were asked an additional two part question:

4) Are you aware of any support available within your agency or this community for such a program? What resources could you or your agency offer to such a service?

At the end of each focus group, a debriefing process took place, the discussion was summarized and the themes noted. The group discussions provided a wealth of descriptive material about these women's experiences. Analysis involved looking for patterns and sorting the information gathered into categories and themes (Coffey and Atkinson, 1986). The notes and tapes were transcribed in detail and copies were sent to all participants requesting additional comments or feedback prior to the preparation of the final report.

THE PARTICIPANTS

Fifty women participated in nine focus groups during the spring of 1995 in Hamilton; thirty-seven mothers with personal experience in the family law system in seven focus groups, and thirteen service providers from a variety of settings, in two groups. For a demographic view of the mothers who participated, see the table below.

While attempts were made to promote and make groups accessible to a diverse population of women by sending flyers to agencies serving culturally diverse communities and holding focus groups in physically accessible locations, the vast majority of women were white, heterosexual and able-bodied. Three of the women were Native Canadians and three were newcomers to Canada.

On the confidential information sheet, the women were asked if they identified with any group generally considered to be disadvantaged, other than female. Twenty-four women answered "no," however, other responses included: "poor," "unemployed," "mental health patient," "permanent physical disabilities," "visible minority" and "single mother" (see table below for breakdown of responses). While some women had more than one response to this question, the majority did not identify themselves as belonging to any disadvantaged group. It is not clear if this is due their personal perspectives or to some confusion about the meaning of the question. In any event, a more varied sample might have shed some light on the particular concerns, barriers and experiences faced by women from diverse backgrounds. It is, however,

apparent that many of these women and their children live with risk conditions in their social, physical and economic environments that impact negatively on their health status.

DEMOGRAPHICS OF PARTICIPANTS

Age		Marital Status		Number of Children		Source of Income		Support Ordered		Support Received	
\</=25	1	Single	2	0	3	FBA	22	Yes	32	Yes	16
26-35	17	Married	1	1-2	28	GWA	3	No	5	No	17
36-45	17	Separated	11	3-4	6	Employed	5			Unknown	4
46-55	2	Divorced	23			Other	7				
N=	37		37		37		37		37		37

SELF IDENTIFICATION AS "DISADVANTAGED"

Self Identified Category	Number of Responses
Poor	7
Unemployed	2
Mental Health Patient	2
Permanent Physical Disabilities	1
Visible Minority	2
Single Mother	3
N=	17

After the series of focus groups had been completed, and word travelled about the project, several more women in the community contacted me by phone to give their input and to tell their stories. With their permission, notes from our conversations were recorded, and the feedback and experiences of 12 of these women were incorporated into the analysis. Three years later, women still call me to share details of their situations and to seek information and encouragement around these issues. These calls and ongoing contacts reflect the degree of concern that women feel about the family law system and, likely, the paucity of supports and resources available to sustain them through the system. It should be noted that the mothers in this study did not assume they spoke on behalf of all women's experiences. Occasionally, a woman would point out that she knew of situations where parents settled these matters amicably. I, and other authors (Mothers on Trial, 1993; Wilson, 1997), agree that the collecting of women's stories about their family law experiences is not about father-bashing. It is recognized and appreciated that many fathers accept and take seriously the

rights and responsibilities of child-rearing. Most of these mothers would have liked their children to have healthy and positive relationships with their fathers. The majority would prefer to share the responsibility with an ex-partner who is responsible, reliable, nurturing and committed. While many fathers fit this role, the reality is that many others do not.

The 13 female service providers had various backgrounds and years of experience working in women's services such as shelters, women's centres and family service agencies. Vocational backgrounds included child-care workers, social workers, group workers, shelter workers and one nurse. Years of service ranged from one year to twenty years and both part-time and full-time employees were represented. These service providers, through their combined experiences, shared an awareness and sensitivity to the plight of women and children caught in the middle of family law matters. They were excited about contributing to the potential development of programs and policies designed to meet the needs of the population they serve based on the principles of a health promotion model such as social justice, equity and mutual respect.

FINDINGS

Participants' contributions to the focus group discussions have been divided into two main categories: Voices of Experience includes excerpts from the women's stories outlining the effects of the family law system on mothers and their children, and Voices for Change presents their suggestions and ideas for a service or program model to address the needs of women who access the family law system. Although the service providers talked about the experiences of women they come into contact with in their work, the focal point of their input was on the needs and gaps apparent to them as they support and advocate for women within the family law system. For this reason, their observations are included in the Voices for Change section.

VOICES OF EXPERIENCE

The women discussed in great detail and with ranging emotions their own stories of accessing the family law system, covering all aspects of the legal process and their personal and professional relationships with the people key to this process. Three central themes were discernible in their descriptions: their sense of exclusion and marginality; their sense of dis-empowerment and devaluation; and the negative impacts of these realities on themselves and their children.

Sense of Exclusion and Marginality

Women, collectively and historically, have been excluded from the structures and institutions constructed by the powerful (usually men). Exclusion includes being silenced, ignored and being absent from the circles in which men "attend to and treat as significant

only what men say...and carry forward the interests and perspectives of men" (Smith, 1987, 18). Collins (1991) defines marginality as being the outsider within. Women in this study spoke of continually being excluded from, and feeling like outsiders within, the process of decision-making regarding custody, access and child support, part of a system which they expected to be operating on their behalf and in the best interests of their children. For example, mothers said they often were not informed of court dates, upcoming actions and proposals offered by the other party. When they expressed opinions about amounts of child support or suggested arrangements for visitation, many women were told to leave these worries to the lawyers. Several women on social assistance were advised by lawyers to forgo child support because the government would only deduct the amount from their monthly cheques, even though they knew that returning to court at a later date would be difficult and expensive. Not only did this increase their sense of dependence on the state, but often these women had to deal with parental support workers who later admonished them for not pursuing the fathers of their children for payment of support. One mother explained:

> My ex doesn't pay support and when I asked my lawyer to pursue it, he said not to worry right now because I'm being supported by Mothers' Allowance and they'll only deduct it anyway. My ex has a lot of debt and the lawyer says it's not in my best interest to fight for it. Sometimes it feels like he's working for my husband. Now, I have Mothers' Allowance on my case....

Several women discussed how their lawyers had kept them in the dark about what was happening with their cases.

> My lawyer withheld from me an offer to settle submitted to her by my ex and his lawyer. She withheld specific access dates requested by my ex's lawyer which made me look unreasonable. She failed to produce the names of any assessors, leaving little choice but for me to agree to the name suggested by the other side. Unsurprisingly, this assessor decided in favour of my son's father.

While some women in this project felt excluded due to overt actions by someone within the system, others complained of exclusion due to the lack of accurate information available to them. One woman told us:

> Having no experience with the court system, I didn't know what I was allowed to do and not. There was nothing in the separation papers to say I couldn't move. I learned the hard way that because he had visitation rights, whether he used them or not, I can't move. I went to P.E.I. because my whole family was there. I was there two weeks when my husband found out. He went to a lawyer and to court and I was given one week to get back. I had no money, but I was told that if I wasn't back, the

> judge would issue a Canada wide search for my children and award
> temporary custody to their father and I'd be locked up. I'm stuck here
> with no family support and have to live within a 25 mile radius of their
> father.

And another said:

> I have since found out about several things that should have been in my
> court order, but it's too late to change it. I wouldn't get legal aid and
> can't afford to hire a lawyer to go back and fight for changes. Things like
> adjustments for tax—I didn't realize I had to pay tax on this support,
> and life insurance, cost of living.

Sense of Disempowerment and Devaluation

Unsurprisingly, women's sense of marginality in legal processes, ostensibly about them,
generated feelings of disempowerment. Being involved in a system in which those in authority
make decisions about one's life creates feelings of powerlessness and helplessness.

The women in the focus groups talked about encounters with professionals and ex-
partners in which they were manipulated, emotionally, verbally and financially abused and
given little control over the outcomes of their cases. Some mothers identified parallels between
their personal and professional relationships and how they were left feeling victimized and
hopeless in both. At times, women felt so vulnerable and lacking in power that they refrained
from speaking up or gave up the fight for custody or support. Women recognized that the
men in their lives who were controlling during relationships continued to control and intimidate
them during the family law process. For example:

> My ex kept bringing our 11-year-old son to court to intimidate me because
> he knew I wouldn't say too much in front of him.

> Our court order says free and liberal access...he takes my daughter every
> second week supposedly, but he usually backs out at the last minute. I
> can't make plans because he has me tied up not knowing whether he's
> coming or not.

Fathers are not the only offenders in the mistreatment and devaluation of women during
the family law process. Many mothers had anecdotes to tell about assessors, lawyers and
other professionals who degraded and humiliated them. One woman offered this reflection:

> When the final report was submitted by the assessor (whom I later
> discovered was the wife of one of my ex's law partners) my character
> and self-worth were in shreds. She wrote about how I reminded her of a
> Barbie doll! I think she was referring to my appearance, the relevance of
> which escapes me.

Kahn (1990) suggests, while there are many fine divorce attorneys, some resort to destructive strategies when representing women. Females end up feeling intimidated and manipulated by lawyers who direct them to act or not act in certain ways. They are told to "stay calm...not be difficult or demanding." She states: "With the husband and his lawyer in a position of power, the implicit goal during the divorce trial becomes to break the woman's spirit" (16). Women described incidents in which they were demeaned by lawyers who were being paid to represent them. For example:

> My lawyer stalled, lied and finally refused to file my affidavit despite my very clear instructions that I wanted it submitted. She rewrote my affidavit, without my permission, destroying the content, feeling and accuracy of the document.

The Negative Impacts of These Realities on Women and Children

When women spoke of the toll these encounters and this process had on themselves and their children, it was obvious that there were both physiological and material consequences for their families. Many women felt that their control over their well-being and their economic status had been undermined in a system they had expected to support and safeguard them. Women told stories of the family law process creating physical and emotional symptoms for them ranging from feelings of guilt, anger, frustration, inadequacy and isolation to fear, anxiety, panic and depression. Some women required medical treatment and psychological counselling to get them through stress-related sickness such as ulcers, headaches, panic attacks, depression and exhaustion. One woman described her day in court like this:

> I went through Hell; mentally and physically, I was sick. During recess, [the court officers] would laugh, joke, talk about their upcoming vacations... while I'm dying, running to the washroom to throw up from nerves. The stress was horrible. My ex kept dragging me back to court fighting for custody. Eventually I let him have my son because the fight was killing me.

Prolonged and repeated attendance at court and related appointments take time and energy away from women's ability to parent, to nurture and care for themselves and their children. Women's emotional and physical health and their ability to economically survive suffer from their involvement with the family law system (Mothers on Trial, 1993).

Taylor, Barnsley and Goldsmith (1996) note that mothers' primary concerns in custody and access disputes tend to revolve around the rights and needs of their children, particularly their right to love and protection. Mothers typically want their children safe and happy first, often placing the needs of their children ahead of their own in a society that considers women and children last in its hierarchy of concerns. The mothers in this study talked emotionally about the effects of this process on their children, ultimately their greatest concern. Noticeable signs ranged from low self-esteem, feelings of rejection, sadness, confusion, inability to trust and withdrawal to misbehaviour, bedwetting, running away, violent aggression and

suicide attempts. While the majority of mothers thought separation from the fathers was partially responsible for children's problems, most agreed that extreme reactions occurred when fathers were abusive, controlling and were inconsistent with their access visits. Women described the effects of sporadic visits:

> My daughter is terrified to go on her visits because she hardly knows her father. He comes so sporadically. He is loud, not very comfortable with a three-year-old girl and she knows it. Every time he shows up, she makes strange and cries, screams and clings to me.

> My daughters wait on the step every other week, faithfully. Sometimes he comes, sometimes he doesn't. I usually get the brunt of their frustration and anger when he doesn't show. They are sometimes unconsolable. They act up and kick and scream and cry. They ask why their Daddy doesn't love them anymore. I have to bite my tongue and defend him and make excuses to ease their pain. It's hard.

One woman told us how her son had attempted suicide because he was so tired of the back and forth nature of his relationship with both parents. He told her how he felt torn and constantly placed in the middle of his parents' custody battle. The confusion had finally overwhelmed him. She reported that he was currently okay and finally in therapy.

Taylor (1993) argues that abusive men continue to exercise control over women by using custody and access visits to maintain contact and express hostility. She states: "Many threaten to ruin the woman's reputation, turn her kids against her, kidnap her children or kill her" (4). Woman abuse can escalate and be transferred onto the children as anti-mother conditioning whereby children are taught to blame, hate and even hurt their mothers. Children can become confused and develop a need to nurture and protect these fathers. They often act out in the care of their mothers, and can behave aggressively or withdraw and become depressed. At times, when reports of abuse are disclosed to the mother, she is accused of lying or being manipulative. Women are frustrated and angry about not being believed when acting in what they see as the best interest of their children.

Factors associated with poverty in the lives of women and children are well documented (Belle, 1990; Fraser, 1992; Kitchen, 1992; Swigonski, 1996). Low wages, low levels of social assistance and inadequate amounts and enforcement of child support payments are the major contributors to the poverty of single mothers, and they are more likely to face discrimination and exploitation. Carey (1997) cites research by Christopher McAll, a sociologist at the University of Montreal, which reveals that welfare mothers are "kept out of society" by the majority of people not on welfare. He found they are excluded, discriminated against and blamed for their own poverty, while the incidence of fathers who do not pay child support is de-emphasized. Canadian women continue to see at least a 23% reduction in income after divorce, while men's income rises a minimum of 10% (Bagnall, 1997). According to Statistics Canada (1995c) women's income levels vary greatly depending on marital status, with single mothers having the lowest income of all family types. Support payments represent a significant portion of these families' incomes, however in 1994, in Ontario, only 24% of family support orders were in full compliance without arrears.

Financially, most of the women who participated in the focus groups were in poor shape. Twenty-five of the thirty-seven women were living on social assistance. Only 50% of the mothers in this project reported receiving child support as it had been ordered. Some of the others were employed, however most were also dependent on ex-partners for support. Most of the women who discussed their financial dilemmas would agree with Swigonski (1996) who argues that mothers confronted with the reality of poverty and its stigma "continue to survive and to make lives for themselves and their children, for the sake of the children" (101). Poverty for women and children is seldom the result of poor personal choices, but of the structures and systems that create and maintain power imbalances and double standards for men and women.

VOICES FOR CHANGE

Participants were asked to reflect on what changes could counter the negative effects for them and their children and which positive interactions could be transferred to ensure a more equitable and comfortable experience for others. The 13 women's services providers also contributed their experience and opinions to the hypothetical design of such a program and proposed some solutions for financing and donations of time and resources. Generally the discussions focused on the provision of support and information within a service that could offer inclusion, give them a sense of control and lessen the negative impacts the family law system has on women and children.

While the women were attracted to the notion of autonomy, they recognized that areas of expertise existed across the community in areas such as advocacy, political and social action, counselling and legal issues, which could be utilized to the benefit of all women. They proposed a model which would be consumer-driven, have some affiliation with a trusted women's organization and include a role for sensitive professionals in the provision of support and resources. It was deemed imperative that women with personal experience within the family law system offer self-help, support and information to users of the service. Their own practical experience could be used to ease women's struggles through the bureaucratic process by offering empathy, sensitivity and emotional connections with other women (see below).

The Proposed Service

Mothers' Roles
- co-facilitating groups
- individual support
- court accompaniment
- advisory committee membership
- awareness/sensitivity training to staff, volunteers and community
- provision of information
- "staffing" phone line

Professionals' Roles
- provision of legal and financial information
- training and professional support to women volunteers and consumers
- referrals
- advocacy
- counselling for women and children
- funding, space and resources

Priorities to Consider:
- safety
- accessibility
- comfortable, welcoming environment
- open and available to a diverse population of women and children
- printed and visual resources in various languages
- availability of child care
- transportation/parking
- interpreters
- training for all staff and volunteers on awareness of woman and child abuse issues
- cultural sensitivity
- effects on children of divorce and witnessing abuse

It would seem, then, that the first step to empowerment for these women would be to include them at all levels of planning, development and delivery of any service or program. Breton (1994) summarizes the necessary components of empowerment as social action, political awareness, having a voice, being recognized as competent and being able to use power to influence outcomes. Professionals must abandon the role of "expert" and relinquish power to recognize the knowledge and skills that clients possess in order to establish collaborative and participatory relationships. Lord and Farlow (1990) found the answer to personal empowerment does not always lie in the creation of additional professional services. While certain resources and supports are sometimes needed to help people gain personal control and participate in the community, the process of empowerment is accelerated when people are independent and encouraged to develop self-help systems. Participants in this study noted the critical role filled by self-help groups, peers, colleagues and mentors in their journey to personal empowerment by building confidence and acting as resources and role models.

When the discussion came around to funding, various ideas were considered including government grants, donations from service clubs, professional associations and private businesses, fund-raising activities and flexible fees for service. The service providers suggested that agencies such as shelters, women's centres and family service agencies could possibly provide donations in kind such as space, sharing of resources and materials, volunteer speakers, education and training, and could help with referrals, program promotion and community awareness.

In reviewing recent literature which documents the experience of other women in North America and Britain going through the family law system (The Women's Research Centre, 1990; Hester and Radford, 1996; Taylor, Barnsley and Goldsmith, 1996; Wilson, 1997), I was struck by the familiarity of their stories and the consistent nature of their proposals for change. Taylor, Barnsley and Goldsmith (1996) suggest that women need a safe space with a trusting atmosphere where they can share stories, be supported and have their feelings validated. They need accurate information about the system and an awareness that others will work with them in advocating, educating and lobbying to change systems and institutions that perpetuate the problems.

REFLECTIONS AND CONCLUDING THOUGHTS

In concluding, some reflections about the transferability (Lincoln and Guba, 1985) of this study's findings are in order as well as some discussion of the ongoing character of the change-oriented work of which this project has been just a part. Similar experiences and program proposals have been echoed in other large centres such as Vancouver and Toronto (Taylor, Barnsley and Goldsmith, 1996; Mothers on Trial, 1993). The literature from the United States and Britain suggests parallel reactions and conclusions from mothers who access family law systems in those countries (Chesler, 1986; Hester and Radford, 1996; Wilson, 1997). While no two people's experience is the same, I would anticipate comparable patterns of women's stories across other populations. I expect that women in rural centres, or those with multiple disadvantages, would have multiple issues to report, so I suspect their experiences, while varied, could be even more complex than the ones presented in this project. Their access to services and support would likely be more limited and difficult.

The benefits of this research are considerable. The women who participated in this study have increased our awareness and understanding of the scope and impact of women's negative experiences within the family law process. This can enhance our ability as social workers and health professionals to support and advocate on behalf of women as they maneuver this system. The results of this study can assist in the development of healthy public policy and the creation of supportive environments for women and children. Participants and members of the advisory group developed personal skills and strategies in community action. Their voices for change have the potential to create systems which focus on the needs of women and children in a partnership between service providers and community members (Hamilton and Bhatti, 1996).

We designed and conducted a participatory research study based on the ideals and values of feminist social work practice (Gregg, 1994). The approach reflects the belief that participants, if given the opportunity and resources, are able to define and solve their own problems. Target populations have the capacity and the right to take part in the development of policies and programs which affect them. We are more informed about what needs to be in place for women to feel included, respected and empowered. While those of us who originally came together to form the Mothers' Family Law Advocacy Project knew of our own experience, it was validating and encouraging to learn none of us is truly alone. The research was in some ways representative of the process of support and networking proposed by the women who participated. They discussed how their inclusion in the focus groups was both empowering and therapeutic to their own healing. When people have little control over decisions that impact their lives, they report feeling powerless and helpless (Whitmore and Kerans, 1988). It is apparent that women's physical, emotional and financial well-being are at risk when they are discriminated against and mistreated while attempting to sort out custody, access and child support. This risk inhibits their ability, as mothers, to provide for and protect their children (Mothers on Trial, 1993).

The project was designed to explore women's experience and perceptions of the family law system with the goal of having them develop plans for a service that would offer an improved response to the needs of mothers and children. Although at this time the actual service as proposed has not materialized, several new initiatives, for which this project was

partly the impetus, have started in Hamilton leading toward some progressive change. For example, for the past two years I, with other women's services providers and family law lawyers, have been meeting as a sub-committee of the Hamilton Family Law Association with the objectives of improving women's access to information and enhancing lawyers' awareness and sensitivity to issues of abuse and diversity through training workshops. A support group called Women and Children First has been developed by a small group of women, some of whom were participants in this project, and they continue to meet informally and support other mothers as they struggle through the issues of custody, access and support. Others have signed on as volunteers for a court observer program operated by the local women's centre in which women are accompanied to family court and offered support. A few of the members of the Mothers' Family Law Advocacy Project advisory group have written letters to the editor about the concerns we share, and on four occasions articles have been published in *The Hamilton Spectator* regarding the results of this research project.

Impatience and frustration at the slowness of change are perhaps inevitable, however Ristock and Pennell (1996) remind us that for feminists "the primary means of empowerment has been the telling of women's stories...women are encouraged to come forward and give voice to their realities as a way of beginning to change the oppressive and constraining conditions that still exist" (3). So far, and to that end, I think we have made some important beginnings.

STOP THE VIOLENCE: A COMMUNITY-BASED VIOLENCE PREVENTION PROJECT

Ronald Bayne

La violence contre les femmes et les enfants est une réalité quotidienne au Canada. Cette violence est implicitement approuvée. Ce chapitre trace les grandes lignes d'un projet développé à Hamilton par une coalition d'agences travaillant avec les victimes de la violence, afin d'augmenter l'efficacité de ces agences par des efforts communs de coopération et de collaboration. La coalition était composée d'écoles, d'organisations sportives, d'associations de quartier, de groupes de femmes, de médias, de la police, d'étudiants et de chercheurs universitaires, d'agences de services sociaux et de santé et de personnes intéressées par ce problème. La conviction profonde de la coalition était que la violence est un grave problème social, et parce que le pouvoir et le contrôle sont inscrits dans nos valeurs sociales, seuls d'importants changements apportés à ces valeurs pourraient réduire et prévenir une telle violence. Les participants de cette étude informelle contactèrent plus de 80 organisations et furent impressionnés par l'éventail des services en place. Cependant, peu de travail de prévention se faisait et très peu de communication ou de coopération existait parmi les groupes en question. Les représentants des organisations les plus intéressées formèrent un comité de planification. Les chercheurs se sont penchés sur les agences préoccupées par la violence dans les écoles, dans les sports, dans les médias et dans la communauté. Une conférence intitulée Arrêtez la violence, *une conférence de travail sur la prévention de la violence dans* Hamilton-Wentworth, *eut lieu du 31 octobre au 1er novembre 1996 au Centre des congrès de Hamilton. Les participants formèrent des groupes de discussions sur la prévention de la violence et l'information fut ensuite recueillie pour être analysée. Deux conférences suivirent pour répondre aux recommandations proposées à la conférence* Arrêtez la violence. *Ce fut d'abord* La conférence sur l'esprit sportif, *qui eut lieu le 25 octobre 1997, suivie de* La conférence des étudiants contre la violence *qui eut lieu le 2 mars 1998. La Coalition pour la prévention de la violence dans Hamilton-Wentworth et les conférences de travail qu'elle a parrainées sont des exemples de la détermination de la communauté à agir contre la violence et à améliorer la santé de la communauté et de chacun de ses citoyens.*

Canada has the reputation of being a peaceful country, but violence is hidden and endemic within our society. Violence in Canada is carried out by individuals, rarely by organized groups, and the victims tend to be women and children. Violence against women and children has enormous implications for their health and well-being. A recent report by the Federal Department of the Secretary of State indicates that one million Canadian women are abused by their husbands or live-in partners annually. As well, one in four Canadian women can expect to be sexually assaulted at some time in their lives. Assault has been estimated to be the cause of injuries in 6% of women who visit emergency rooms. In addition to the physical injuries caused by the violence against women, women often also suffer psychological complications (Canadian Panel on Violence Against Women, 1993). Violence represents, therefore, a fundamental health risk for women in Canada. Such violations of women's basic human rights are possible in part because violence is socially condoned and or denied. In a culture in which violence is acceptable in any forum, violence against women and children will continue. Violence in sports, violence as portrayed by the media, implicitly make such behaviour acceptable, and often these images also portray women as appropriate targets of violent behaviour. For this reason, all images of violence must be challenged and sports and the media must be particularly monitored. It is with this belief in mind that an initiative was taken by a diverse group of concerned citizens in Hamilton-Wentworth to stop the violence.

Hamilton is a highly industrial city at the west end of Lake Ontario with a poputlation of 318,000 and is a component of Wentworth County with a population of 458,000. Violence prevention in Hamilton-Wentworth is an initiative taken by a coalition of local agencies and persons with a concern about violence. Although these agencies and people have already been involved in various ways in combatting violence or with providing services to the victims of violence, the aim of the coalition is to explore ways of increasing their effectiveness in combatting violence through cooperation and collaborative action. The coalition includes schools, sports organizations, neighbourhood associations, women's groups, the media, police, university students and researchers, health and social agencies and concerned individuals. Described here are the processes, challenges, accomplishments and limitations of consensus building and action on violence prevention.

Underlying this action is the belief that violence is an abnormal, abhorrent behaviour. Violence causes physical and psychological harm to its victims. It is a major public health problem. Because power and control are embedded in our social values, only a major change in values will reduce or prevent violence. In this light, violence prevention is concerned with the health of the entire population and is a health promoting activity; by combatting violence, we help to build healthy public policy, to create supportive social environments and to strengthen community action.

Preparation for this initiative began in 1995 when the author explored the possibility of action against violence by interviewing local agencies regarding their involvement in anti-violence work, particularly in light of continuing cutbacks in financial support from the government. It was apparent that many agencies were involved chiefly in dealing with the victims of violence but that little was being done to prevent the violence from occurring. It is evident that violence prevention must target not only changing the behaviour of those who are already violent but at teaching children alternative methods of conflict resolution and helping them to develop positive, non-violent methods of interaction.

Interestingly, at the outset of the project the only community institution working from this perspective was the schools, where the zero tolerance policy of the ministry of education was being implemented. By September of 1995 every school board was required to have a zero tolerance policy, but each school was allowed to implement the policy in any way that it wished.[1] Children learn behaviour not only in the schools but in their homes and through other activities. Recreation programs have been shown to reduce vandalism, and such programs were found in several housing projects in the city, but there was no formal relationship between the schools and social workers. A big brother-big sister mentoring program was helping children by providing role models for behaviour development, but was subject to reduced funding. The city's culture and recreation department provided facilities for a large number of amateur sports groups. Their policies required that coaches should have level 1 (four hours) training, but this did not include education in ethical and non-violent sport. *Fair Play* educational material was available from Sports Canada but was not widely distributed or used, and reports were given of shouting and abuse of both children and officials, particularly in amateur hockey. Representatives of all these organizations expressed interest in a stop the violence campaign.

Also involved in this coalition were neighbourhood associations that had worked for the development of sport facilities, associations that had worked to combat prostitution and drug dealing in the inner city, the Hamilton-Wentworth Regional Police, women's groups, organizations concerned with media violence and pornography, and researchers from McMaster with an interest in violence. It should be noted, however, that the academic researchers were viewed with suspicion by community activists who saw academics as using research to serve their need for data, not to assist with the needs of community agencies or the people they aimed to help. Altogether, this informal study contacted over 80 organizations, but it was readily apparent that there was little cooperation or communication between the various agencies involved in combatting violence. There was, however, interest in a project that would bring these groups together. It was agreed to form a coalition and to plan for a consensus conference to identify practical and feasible actions for violence prevention, actions that would involve as many people in the local community as possible. As these agencies were already involved in dealing with violence in various ways, we wanted them to share their experiences and benefit from mutual support. Such cooperation was seen as especially necessary when government support and funding were dwindling. The fundamental belief guiding the formation of this coalition was that it is important for all people—teachers, professionals, care-givers, students, coaches, media personalities—to think about the subtle and not-so-subtle ways in which their own thinking, attitudes and practices contribute to the perpetuation of violence or the abuse of power in society; preventing violence in all sectors of society and teaching values that celebrate egalitarian, respectful and non-violent

[1] This also created a problem for community agencies as severe offenders could be disbarred from school even though the child might be violent due to witnessing violence in the home or on the street. However, an experimental project had been started by the Hamilton-Wentworth Regional Police in which a police officer worked informally in several schools. His role was to offer information and support to any student who requested it.

behaviour will create a society in which violence against women and children is less prevalent and in which, therefore, women and children will be more healthy.

Representatives of the most interested organizations formed a planning committee. The first step was to formalize the survey of the local agencies. With the support of the McMaster Research Centre for the Promotion of Women's Health, we employed three doctoral students in sociology and kineseology who had some experience researching issues of violence. They worked under the supervision of a research committee of health and social science faculty and during six weeks, between July and August of 1996, they met with representatives of over 100 community agencies. They asked two open-ended questions of those interviewed: What are the major local issues in violence? and What are you doing, or what would you wish to do, in cooperation with others, towards violence prevention (given that no additional resources will be available)?

Each of the researchers dealt with agencies in one area of concern: violence in schools; violence in sports; violence in the media; or violence in the community. They communicated regularly with one another to avoid redundancy or gaps. The information collected was printed in *Stop the Violence: A Working Paper*. The purpose of this document was to list the agencies and their actions, to inform agencies about one another and to therefore allow them to prepare for the upcoming conference on violence prevention. Participants were asked to come to the conference prepared to commit their agencies to participating in some of the practical and feasible violence prevention actions recommended in this working paper.

RESEARCH FINDINGS

Violence in the Schools

The researcher in this area was informed of an apparent increase in aggressive behaviour in female students and in pre-school children, in the use of weapons and in harassment and racial discrimination. There was also a reported increase in the number of depressed and despondent children. In response to the estimated 1-5% of students who manifest violent behaviour, the schools of Hamilton-Wentworth have developed 60 to 70 different programs aimed at: reducing and eliminating violence; enabling students and staff to develp skills for handling violent situations; and helping students to manage their lives and relationships in non-violent ways. The methods used to achieve these aims included: early identification for prevention; codes of behaviour; guidelines for dealing with the aftermath of violent incidents; mentoring; social skills training; peer mediation; anger management training; social work involvement; tutoring; behavioural teaching; parent representation on safe schools task forces; peacemaker associations; parent and community member mediation; support groups; and safe school committees and policies. The respondents also had specific recommendations for improving existing programs. These were:

- provide ongoing training opportunities and support for teachers, front-line staff and principals;
- provide more programs that involve parents and community members;

- encourage parent and community representation on school councils and decision-making bodies;
- find ways to engage or target resistant parents (it was noted that the parents who are involved are generally those who have less need for training and support);
- use consistent recording and assessment tools as a way of evaluating the various prevention programs currently in use;
- encourage communication between schools and school boards about these programs;
- allow full access to student's records of previous violence so as to have the opportunity for better planning to meet the child's needs;
- increase the efforts to incorporate violence free issues into the general curriculum;
- incorporate parenting classes into the curriculum to teach children how to be good parents;
- continue to set clear expectations of non-violence and to disseminate this information to parents;
- improve the physical layout of some schools, which at present have small playgrounds and lack park spaces and areas for children to interact.

Some respondents also recommended a centre for children at risk where they could receive intensive support and guidance before they were returned to the formal school setting. Preventative and social skills programs should focus on social isolation, lack of empathy, lack of impulse control, lack of decision-making skills, lack of anger management and lack of self-esteem in order to improve the prospects of such children. Respondents also emphasized that the entire community needs to be involved in designing and implementing such programs. For the student, the school is microcosm of the world, and it is of great importance that non-violent attitudes be incorporated into all aspects of daily life at school.

Violence in Sports

The researcher on violence in sports in Hamilton-Wentworth was told that in both high school sport and minor sport some coaches and some parents put too much emphasis on winning. There is a lack of training among amateur coaches, and although most leagues have a code of ethics addressing violence in sports, they have difficulty enforcing such codes. The leagues react to violence rather than preventing it. The respondents recommended, as preventative action, that league executives should be strengthened and that these executives should screen coaches, enforce policies against violence and make these policies clear to parents before the season begins. Also recommended were training for coaches and the education of both coaches and parents with regard to the connection between violence and the pressure to win. Emphasis should instead be placed on skill development, team spirit and fun. It was also asserted that male athletes should be specifically educated on issues of violence against women. Participation in athletics must also be encouraged among disadvantaged youth; the cost of registration in sports, transportation problems and lack of information about sports can prevent those children most in need of role models and anti-violence education from participating in sporting events. The respondents believed that youth should be included in the planning process; that there should be specific programs focused on youth at risk; and that agencies should combine their resources and seek private funding to replace waning government support.

Violence in the Media

The researcher on violence in the media noted a common concern among respondents about the negative influence of media violence. Some respondents quoted research showing that children and adults who watch violent programs tend to support the use of aggression to resolve conflict, and that adults respond to sex-related violence by becoming callous towards women. But critics point out that while the media may be a factor influencing violent behaviour, it is not the primary cause of such behaviour.

Regulation of material, it was noted by participants, is increasingly difficult because of the availability of home video cassettes and increasing numbers of television channels. The guidelines of the Canadian Radio-television and Telecommunications Commission (CRTC) and the Voluntary Code Regarding Violence in Television Programming of the Canadian Association of Broadcasters (CAB), prohibit gratuitous violence that provides unnecessary detail and programming that sanctions, promotes or glamorizes violence and the depiction of violence in children's programming that is so realistic as to threaten young children. Scenes of violence intended for adult audiences must not be shown before the late evening (9pm) and must have an advisory warning. Also, sporting programs must not promote violent action outside the sanctioned activity of the sport.

Respondents recommended media literacy programs for students and the general public, public education against violence, increased government regulation, a campaign against products that advertise on violent programs, locks that can prevent children from watching violent programs and research on the local media as a basis for action.

Violence in the Community

The researcher in this area remarked on the considerable experience of the staff of community agencies. It was evident, however, that their resources were chiefly devoted to secondary and tertiary prevention, not to primary prevention. Because these agencies often respond in crisis situations, they have focused, by necessity—particularly with large demand on their services and dwindling government resources—on providing for the immediate needs of victims of violence. The respondents emphasized to the researcher the need for a whole community approach and for cooperation between agencies. Action is needed against poverty and racism and the other underlying structural forces that make violence so pervasive. Respondents stressed the need to promote partnerships between agencies, to share information and to provide mutual support for education and research in cooperation with the university. However, respondents in this area remained somewhat pessimistic; without a significant investment of community resources, responses to violence in the community will remain reactive rather than preventative.

THE CONFERENCE

Stop the Violence, a working conference on violence prevention in Hamilton-Wentworth, was held at the Hamilton Convention Centre on October 31 and November 1, 1996. It was

funded by the Hamilton Community Foundation and several other organizations. One hundred and eighteen registrants participated. Registrants included high school students, teachers, representatives of unions, of racial and cultural minorities, of women's groups, the police, sports and recreation groups, the family court, neighbourhood associations, health and social service agencies, McMaster University and the media. Recognizing that agency staffers were already overextended because of the reductions in funding, and had already attended numerous conferences on violence, we adopted a highly structured approach that would be conducive to a pragmatic outcome.

It was assumed that registrants would have read the working paper. Therefore, after a plenary session to outline the procedure, registrants broke into small, ten-person groups, each with a volunteer facilitator. The facilitators had been prepared with training and registrants had been asked to indicate if they wanted to discuss: violence in schools, violence in sports or safety and security (violence in the community). Violence in the media was considered so pervasive that it was covered in the other three topic areas. This resulted in the formation of two violence in sports groups, three violence in schools groups and five safety and security groups.

In their first small group session in day one, every group reviewed the issues relevant to their topic as identified in the working paper. They could expand on these issues or modify them as they wished. The information was collected for later analysis. This was followed by the second session of their small group that morning in which each group was asked to identify which of the issues might be dealt with by a feasible action. Those for which no action was evident were recorded for later analysis. Those issues for which there appeared to be a feasible action were carried forward to the afternoon.

After lunch the same small groups met to review the issues they had identified in the morning and to discuss which actions could and should be implemented. The groups then met together at a plenary session at which each group reported formally on the actions it had identified.

The second day of the conference began with a brief plenary session at which the collated action lists were presented. The groups combined to form three large groups, each focussing either on violence in schools, violence in sports or safety and security. The task for each large group was to identify which agency and persons would commit themselves to carry out each action and who would be the catalyst person responsible for continuity. No one was allowed to commit anyone else, or another agency, to carry out an action. If no one volunteered to sponsor an action it was relegated to the archive for later analysis.

The final plenary session brought everyone together to hear what actions had been adopted. The lists constitute the conference report. The recommended actions were:

- (schools) violence prevention newsletter
- (schools) cataloguing financially accessible recreation
- (schools) literature search and bibliography of existing violence prevention programs
- (schools) evaluation of two existing programs
- (schools) public service announcements
- (schools) community council parent involvement
- (schools) conflict resolution/peer mediation programs

- (schools) nutrition programs for schools
- (schools) workshops and PD programs on racism and other isms
- (schools) family support groups
- (schools) conflict resolution programs in schools
- (schools) awareness of secondary school reform
- (schools) media literacy programs
- (schools) violence in the media program with police
- (schools) media advisory group
- (schools) student wellness centre
- (sports) community development project (Hess School)
- (sports) access to recreation for at risk youth
- (sports) information package for youth, parents and coaches
- (safety and security) education of the judiciary
- (safety and security) central clearing-house for information on violence and available services
- (safety and security) anti-violence spokespersons
- (safety and security) anti-oppression coalition
- (safety and security) community based media advisory committee
- (safety and security) accountability and next year's conference
- (safety and security) skill exchange bank
- (safety and security) anti-violence policies and practices
- (safety and security) faces of violence video
- (safety and security) shaping public policy for schools
- (safety and security) personal power for kids/adolescents
- (safety and security) public awareness campaign
- (safety and security) public education for children experiencing and witnessing violence

The conference committee did not see the conference as a goal but as a step in a process. It was successful in bringing together a very diverse group of people who normally do not meet.

EVALUATION

We wanted to know not only if the conference achieved its objective of developing an action plan but also whether or not the process worked in enabling discussion. We had been warned that the conference could release hostility and end in rancour, precisely because of the diversity of the beliefs and experiences of the registrants. Some hostile remarks did emerge during the small group discussions, but no serious disruptions occurred. Two evaluation forms were developed with assistance from the McMaster Health Priorities Analysis Unit and from the Hamilton Social Planning and Research Council. One form was for the facilitators. There were seven responses out of a possible eleven. One facilitator would have favoured a less structured approach but abided by the plan adopted. Another found that the conference

worked well specifically because of its clear focus. All facilitators believed that the process worked well but some noted scepticism in their groups that any action would be forthcoming.

A different evaluation form was given to registrants. It asked whether the process was successful in identifying the major issues and feasible actions and whether the action plan would be a good basis for continuing violence prevention action. Registrants were asked if any segment of the population was absent and whether they anticipated opposition to the plan from any group.

There were 44 responses out of a possible 107. A five-point Likert scale was used for scoring. The majority of evaluations were positive. The largest number of less favourable forms (scoring three or less) came from the safety and security groups. Of these, fourteen persons scored three or less on whether the issues identified for action were the most important ones. In contrast, the responses of the violence in schools groups and of the violence in sports groups were mostly positive with only three persons in the schools groups scoring three or less on the question of whether the conference was useful and with all respondents from the sports groups scoring four or above.

The registrants were also asked for their general comments. Some believed that the focus of the conference was too narrow, others believed it was too broad. Several felt that the discussion was amiable only because it did not focus on specifics. One person stated that violence was not defined, another that the conference was too gender neutral with 20 years of feminist work invisible in the proceedings. One person believed that it was naive to think that neighbourhoods could reduce violence. Although scepticism was frequently expressed, a number of evaluations expressed satisfaction that something could be done and urged a follow-up conference. All but one of the respondents expressed interest in attending such a follow-up conference.

FOLLOW-UP PROCEDURES

The planning committee for the conference decided to continue to meet after the conference. Given the enthusiasm generated by the conference, anyone who wished to join the committee was invited to do so. This new coordinating committee developed a mission statement emphasizing that its role was not to implement the action plan, but to assist agencies in carrying out those actions. The committee accepted responsibility for two actions identified at the conference: to survey the literature on violence prevention programs in schools and make this available to local schools; and to develop a follow-up conference for 1997. The coordinating committee also formed two sub-committees and developed a conference on violence in sports and a conference on violence in schools.

The Spirit of Sport Conference was held at the Hamilton Convention Centre on October 25, 1997 and was sponsored by the Hamilton Amateur Sports Council. It brought together amateur coaches and officials to identify the information they needed to manage violence and abuse in any of the sports in Hamilton-Wentworth, whether among players, spectators or coaches, and what policies the associations and the city government should adopt to implement these requirements. Sixty coaches and officials attended. Their concerns and recommendations were embodied in a conference report. A Spirit of Sport Task Force was

established to develop a new vision for amateur sport in this community; it is expected that their recommendations will be adopted by the major non-profit recreational organizations.

The Students Against Violence Conference was held on March 2, 1998. High school students were invited to meet in small groups with a student as a facilitator to discuss their concerns about violence. Eighty-five students and fifteen teachers from seventeen different high schools attended. The registrants were asked to identify their particular concerns and were able to choose two of five topics for discussion: violence in schools, violence in sports, violence in personal relationships, violence in the media and violence in the community. The students were to identify what actions they were willing to undertake as individuals and with others. They participated enthusiastically and produced a final conference report.

The coordinating committee also distributed a survey regarding the action plan to all participants in the original conference in February of 1997. They asked for information regarding progress on the actions. In most cases, some activity had already started, particularly in the area of sports, which is perhaps less inhibited by organizational protocol. The coordinating committee was able to assist agencies in promoting some of the actions, for example, in producing a newsletter and in the development of an information clearing-house with a site on the internet.

CONCLUSION

Research is illustrating that the quality of social life is an important determinant of health. As such, the elimination of violence in society is an important objective for health promotion. This is particularly true for women who are disproportionately the victims of violence. The Coalition for Violence Prevention in Hamilton-Wentworth, and the working conferences that it sponsored, are examples of the determination of a community to take action against violence and to improve the health of the public and of individual citizens. Through these conferences, awareness has been raised about the issue of violence in the community and significant steps have been taken to address, in particular, violence in the schools and violence in sports. Although some might argue that the schools and amateur sports are removed from women's health, it is the fundamental belief of those involved in this coalition that violence begets violence, that violence against women and children, with its detrimental effects on physical and psychological health, will not be eliminated until power imbalances within the community are corrected, until individuals learn to resolve disputes through non-violent means, until violence, in all forums within the community, is viewed as abhorrent behaviour. Enacting changes in schools and in sports, insisting that children in the classroom and in their recreational environments behave with zero tolerance for violence is integral to creating a violence free society for the next generations of women and children and thereby ensuring their health and well-being.

PROMOTING WOMEN'S HEALTH THROUGH VOLUNTEERING

Margaret Denton, Isik Urla Zeytinoglu, Sharon Webb, Jason Lian and Karen Barber

L'objectif de cette étude est d'examiner la santé et la vie de bénévole des personnes qui font du bénévolat dans les agences de services sociaux et de santé. Les résultats sont basés sur des groupes de discussion thématique de 22 bénévoles et sur un sondage de 335 bénévoles au sein de deux agences communautaires à but non lucratif. Les bénévoles de ces agences ont participé à diverses activités qui incluent les visites amicales, la livraison de repas, le transport des clients à la visite médicale, le travail de bureau et le travail dans une boutique de cadeaux. Les bénévoles qui participaient à cette étude ont identifié plusieurs aspects du bénévolat perçus comme positifs du point de vue de la promotion de la santé: le travail est stimulant, flexible et apprécié des clients. D'autres aspects mentionnés sont: le plaisir d'aider leurs clients et l'interaction avec les gens, le sentiment d'être utile, l'influence sur les clients et le sentiment de se réaliser; mais ils éprouvaient du stress lorsque le manque de temps ne leur permettait pas d'apporter un soutien émotionnel à leurs clients et aux familles de ceux-ci. Ils ressentaient aussi un sentiment d'impuissance devant la souffrance et la douleur d'un client lorsque la mort frappait l'un d'entre eux. Une autre préoccupation des bénévoles était celle de leur sécurité en rapport avec le travail de bénévolat, comme le transport chez les clients par mauvais temps, les habitations surchauffées, l'exposition à la fumée et aux dangers dans la maison des clients.

❧ ❧ ❧ ❧ ❧

Volunteering is defined as "an activity intended to help others, it is not done primarily for monetary compensation or material gain, and it is not based on obligation (Fischer and Banister-Schaffer, 1993, 13). There is often a distinction made between formal and informal volunteering services where formal volunteer services are referred to as services arranged through organizations and informal services are referred to as help given by neighbours, friends or relatives (Fischer and Banister-Schaffer, 1993). In this chapter we are referring to formal volunteer work. Typically volunteers are "altruistically motivated" individuals who feel that "helping others" and "doing good" are their social responsibility. Volunteering is an important

activity for Canadians. For instance, during the period between November 1986 and October 1987, 3 million women and 2.3 million men over the age of 15 volunteered formally with an organization/agency. In addition, more than 13 million Canadians (7 million women and 6.2 million men) reported that they were involved in informal volunteering during the same period (Duchesne, 1989). Volunteering is receiving increased attention lately as governments' fiscal restraints, restructuring and downsizing make public funds less available and non-paid sectors of society such as volunteers are being asked to fill the gaps (Chappell and Prince, 1997).

This chapter describes a participatory action research project (PAR) designed to promote the health of those who volunteer in community based health and social service agencies. Results are based on 3 focus groups with 22 volunteers and a survey of 335 volunteers from 2 non-profit community based health and social services agencies. Volunteers within these agencies participate in a variety of activities including: friendly visiting, delivering meals, driving others to medical appointments, working in an office and working in a charitable gift shop. This study is relevant to health promotion in several ways. First, this study focuses on work environment as a determinant of health. Second, this study utilizes health promotion strategies as articulated in the Ottawa Charter for Health Promotion (1986).

BACKGROUND

This study is one component of a larger PAR project entitled Healthy Work Environments in Community Based Health and Social Service Agencies. The larger project involves a study of paid home-care workers in three non-profit community based health and social service agencies. The volunteer study has three stages. The first stage involved an extensive literature review and focus groups with 22 volunteers. The second stage entailed a survey of volunteers. The third stage will involve implementation of recommendations by agencies initiated by results of this study.

The agencies involved in the study are two non-profit community based health and social service agencies. The volunteer programs are an integral part of these agencies and provide important services to clients and organizations. From 1996-1997, one agency had approximately 185 volunteers, and the other had approximately 1599 volunteers. These agencies use volunteers in a wide range of volunteer services: meals to wheels; wheels to meals; adult day-care centre; friendly volunteer visiting; palliative care; gift shops; making/supplying crafts to the gift shops; special steps (affiliated with the Alzheimer's Association); respite/care-giver relief; foot care clinics; Arthritis Society volunteers; and community home-care centre. Volunteers act as drivers for medical appointments, companions for shopping by bus, and office, committee and community volunteers. Some of these services require special course/training for volunteers (i.e., palliative, foot care, arthritis, community home-care centre).

Based on principles of participatory action research, McMaster Research Centre for the Promotion of Women's Health researchers worked in partnership with the volunteer agencies in all aspects of the research. Volunteer coordinators, along with upper level managers of the three agencies involved with the larger study, and MRCPOWH investigators worked in partnership in a Community Agencies' Steering Committee (CASC). The role of the CASC is to define and guide research. The CASC was involved in defining the research, developing focus group questions, developing the volunteer survey and providing comments on the focus

group report (Denton and Zeytinoglu, 1996) and the volunteer questionnaire report. Volunteer coordinators were interested in collecting information about volunteers' perspectives regarding their roles, the volunteer experience and the environment in which they participate. Coordinators were seeking to promote and support healthy volunteer environments.

LITERATURE REVIEW

Although volunteers make substantial contributions, little is known about how the challenges and opportunities of the work performed by volunteers affects their health and life satisfaction. As such, a brief review of literature will examine some issues regarding volunteers' socio-demographic characteristics, their roles, their activities and the positive and negative aspects of volunteering.

Research shows that volunteers share some common socio-demographic characteristics. Statistics Canada (1987) shows that almost 6 out of every 10 volunteers in Canada in 1986/87 were female. In addition, findings from the National Survey of Volunteer Activity (1987) showed that women contribute a greater number of total hours to volunteering than do men. For instance, of the 1.016 billion hours devoted to formal volunteer work in the period between November 1986 to October 1987, women contributed 54.5% of the total. Male and female volunteers are also involved in different volunteer activities. Male volunteers are more likely to assist voluntary associations indirectly by offering monetary support, while women are more likely to be directly involved in the personal care of clients. These differences "largely conform to gender-role expectations" (Fischer and Banister-Schaffer, 1993, 21).

Social class is a significant factor associated with volunteering. People with "higher income, more education and with professional types of occupations are more likely to volunteer" (Fischer and Banister-Schaffer, 1993, 21). Married people and those who are religiously affiliated are also more likely to volunteer than non-married persons and non-church members. In addition, poor health acts as a barrier to volunteer participation (Fisher et al., 1993).

The National Survey of Volunteer Activity (1987) provides information on the age of volunteers. Among formal volunteers, the rate of volunteering peaks between ages 35 and 44 and then declines. Canadians between 15 and 19 years had a participation rate of 20%, compared to those aged 35 to 44 who had a 36% participation rate (Rice, 1990). Participation then declines with advancing age to a 22% rate for persons aged 65 and older (Duchesne, 1989). However, volunteering as an activity has been increasing for older Canadians. In 1980 approximately 10% of persons aged 65 and older volunteered (Government of Canada, 1983) as compared to 22% in 1987 (Duchesne, 1989). In addition, Ross (1990) found that the amount of time spent volunteering rose with age. He noted that volunteers 65 years of age and older spend a greater number of hours, on average, at their volunteer activities than volunteers in other age groups.

The literature reveals both positive and negative aspects of volunteering (Fischer and Banister-Schaffer, 1993; Chichin, 1992; Bartoldus, Gillery and Sturgess, 1989; Berger and Anderson, 1989; James, 1989; Gidron, 1986; Cherniss 1980). Among the most positive features of volunteering is the formation of interpersonal relationships with clients and their families (James, 1989). Neysmith and Nichols (1994) found that relationships with clients,

giving, helping and reciprocating are sources of motivation for volunteers. Companionship and closeness are two other positive features of volunteering. Volunteers argue that their roles as volunteers are personally rewarding (Gidron, 1986). Volunteers in a Neysmith and Nichols (1994) study noted: "By helping others, by helping them stay at home, I get self worth for me" (180). In general, the literature reveals that the positive aspects of volunteering enhance quality of life, increase self-esteem and improve the overall health of the volunteer.

There are negative features related to volunteering identified in the literature. Travelling in inclement weather, relying on slow public transportation and clients' complaints when they are inadvertently late have been identified as sources of stress (Bartoldus et al., 1989). Excessive demands by clients placed on volunteers are extremely stressful (Bartoldus et al., 1989; Cherniss, 1980). Other negative aspects of volunteering have also been identified in literature and will be discussed next. These include: emotional labour, "burnout," conflicting views of care between professionals and volunteers, and reimbursement of out-of-pocket expenses.

Much of what volunteers do is emotional labour, defined as "the labour involved in dealing with other people's feelings" (James, 1989, 15). Caring for clients' emotional needs and dealing with clients and other family members' grief are important but often unrecognized aspects of volunteers' work. The emotional labour and attachment to isolated, chronically ill and/or dying clients by volunteers can place a great burden on volunteers and may lead to depression, stress and burnout.

Burnout is "a syndrome of emotional exhaustion, depersonalization, and diminished personal accomplishment, which occurs among individuals who work with people in some capacity" (Leiter, 1988, 118). Burnout undermines the personal relationship between the volunteer and the client. Fischer and Banister-Schaffer (1993) identified four separate forms of burnout having specific relevance to volunteers: 1) grief with a client who is dying or terminally ill; 2) frustration when volunteers feel incompetent or cannot change the clients' circumstances; 3) personal intrusion when volunteers' own lives are invaded through their "helping;" and 4) time demands and balancing between volunteer giving and receiving. Burnout results not from a lack of commitment on the volunteers' part, but rather because of overcommitment (Fischer and Banister-Schaffer, 1993).

A major source of strain revealed by the literature stems from the conflicting views of care between professionals and volunteers. Strain may occur when: 1) the role of the volunteer within the agency is not clearly defined or is ambiguous; 2) professionals "worry about volunteers intruding on their own position;" 3) there is a lack of volunteer involvement as part of the home care "team" /or lack of involvement in organizational decision-making; and 4) there exist negative attitudes on the part of paid staff members towards volunteers as "only volunteers" (Fischer and Banister-Schaffer, 1993; Isley, 1990). Fischer and Banister-Schaffer (1993) also reveal that some volunteers feel that they should be reimbursed for out-of-pocket expenses.

METHODS

The methodology used comprised 3 focus groups with 22 volunteers and a survey of 335 volunteers. Focus group participants were asked up to nine open-ended questions which

were developed by the CASC. The purpose of the questions was to elicit a general discussion about volunteers' work and health. Focus group discussions were approximately 120 minutes in length. Discussions were recorded, transcribed and analyzed using NUD*IST (non-numeric unstructured data indexing searching and theorizing), a software package for the analysis of qualitative data. Findings were presented in Denton and Zeytinoglu (1996).

Health and volunteer questionnaires were mailed to a random sample of 510 volunteers from the two agencies. One volunteer organization completed the mailout for their own volunteers whereas MRCPOWH completed the mailout for the other. This report presents findings from 335 returned questionnaires representing a 66% response rate.

The health and volunteer questionnaire was constructed utilizing results from focus groups with volunteers (n=22), an extensive literature review and a larger home-care employee questionnaire—the Health and Work Life Questionnaire. The Health and Work Life Questionnaire was administered to paid employees from three non-profit organizations in November 1996. It was constructed using results from 19 focus groups with 99 paid workers and 22 volunteers, an extensive literature review and a conceptual model. The conceptual model identifies five types of factors that influence work-related health and well-being: external/social structural factors; organizational/managerial factors; client factors; occupational characteristics; and individual/personal characteristics. (See chapter four in this volume.)

The 20-page self-administered health and volunteer questionnaire consisted of questions regarding: volunteer activities for the agencies; volunteering directly in clients' homes; volunteering for other organizations/people; volunteers' health; volunteers' family and friends; and socio-demographic background information. Some health questions replicated those found in the general social survey (1990) and the National Population Health Survey (NPHS) (1994-95). Volunteers were also invited to make comments about their volunteer work.

Questionnaire results were analyzed by calculating response frequencies with SPSS software package. Data are presented in grouped format. Volunteer responses are compared with the entire sample of the NPHS in the areas of socio-demographic characteristics, subjective health and long-term health conditions. The purpose of this comparison is to highlight the unique qualities of volunteers. Standard questions from large surveys also add validity and reliability to the measures.

RESULTS

Socio-demographic Characteristics

A number of characteristics seem to distinguish volunteers. First, volunteers seem to fall in two age groups: in their early 20s or in older age groups (55+). Younger volunteers concentrated in the 20-24 age group because many people in this age group volunteer as part of the requirements for courses within the gerontology program at McMaster University. Another large portion of the volunteers fell in older age groups. This explains why volunteers and their spouses were most likely to be retired. Volunteers were also likely to be concentrated in two income groups: those with relatively high levels of income and those with low levels of income.

Most volunteers were female and married or living with a partner. In addition, volunteers reported relatively high levels of education. Volunteers are more likely to be Canadian born, but of those foreign born, they were most likely born in the United Kingdom. One-quarter of volunteers were members of ethnic groups, the most common groups being British, Irish, Welsh and Canadian (Native). Almost two-fifths had children under 13 living with them and 3.5% reported having dependent adults living with them. One-quarter of the respondents had a special needs person living with them, most likely to be their parents or friends.

When comparisons were made between the volunteers and the sample from the NPHS, volunteers were more likely than the NPHS sample to be female, aged 20-24, in older age groups (55+), retired and a student. Volunteers were also more likely than the NPHS sample to be widowed, divorced or separated, to have some university education and to have an annual household income of less than $20 000.

Most volunteers began volunteering in the 1990s, averaging roughly 6.1 years of volunteer service. Most volunteers became volunteers as a result of approaching the organization themselves or being asked by the organization. The majority of volunteers are satisfied with their volunteering. Few volunteers reported attending any training or palliative courses. Results from this study indicate that volunteers are active people, with one-half of respondents being active in other organizations. In addition, volunteers are likely to have given help to others not living in their household in a variety of activities.

Benefits of Volunteering

Volunteers indicated numerous benefits of their volunteering including: challenge, flexibility and appreciation from clients. One volunteer explains the appreciation from clients:

> "I get a lot of joy giving things to people and knowing that they're happy...that whatever I give to them makes them happy and when I volunteer I know that they appreciate me. A lot of them, you know, give you hugs and kisses and thank you and I love you."

They also reported: enjoying helping clients and meeting people, feeling needed, having an impact on clients and having a sense of accomplishment from volunteering.

Respondents indicated that volunteering is interesting, builds self-esteem, allows them to make use of their skills and gives them a sense of purpose. Volunteers also seemed to feel supported by the organization and coordinator. Most respondents agreed that volunteering allows them to develop close personal relationships with clients. One volunteer speaks of a client with MS whom she takes grocery shopping:

> "I really enjoy going out with her because we talk about anything we want to between each other we are really close that way."

Challenges of Volunteering

Results from this study suggest that volunteers invest a great deal of emotional labour in their volunteering. They said:

> "So you get involved and it just drains you emotionally, there's no doubt about it, you know, you get exhausted. And I think 'why am I so tired I haven't done anything,' but your brain is going and you're thinking for them."

Most develop close personal relationships with clients. Volunteers displayed concern for their clients. In fact, many agreed that they worry about clients who are lonely, that they volunteer with clients whose needs are not being met and that they are not able to do enough to improve the clients' physical environment. One volunteer speaks of an elderly male client, unkempt, with a drinking problem, who lives alone; his apartment is in terrible disarray:

> "I was so concerned because he lived alone and he was lonely you know and I felt bad about it."

A substantial proportion of volunteers also reported that they did not have enough time to provide emotional support to either their clients or clients' families. One volunteer tells about a 90-year-old client:

> "This is the saddest thing. She's all by herself, she says will you stay, well you can't stay to talk to her cause you have to go."

Related to emotional labour, volunteers reported difficultly dealing with a clients' declining health and death. Approximately two-thirds of volunteers agreed that they find the death of some clients to be upsetting, they feel helpless in watching a client suffer pain and they mourn or grieve the death of a client who has passed away. Two-thirds of volunteers also agreed that they feel supported by their organization for the grief they may feel when one of their clients dies. After the death of a client, volunteers often ask for and are given time off before accepting another client. A small group of volunteers reported taking their volunteering related problems home with them and feeling overcommitted to volunteering. Clients posed problems for some volunteers who reported fearing making a mistake in dealing with clients, volunteering with some clients whose needs are not being met and not being able to do enough to improve clients' physical environment. Some volunteers also responded that they deal with difficult clients and that some clients make unreasonable demands.

Additional concerns of a small, but important, proportion of volunteers were related to organizational issues. For example, 8% of volunteers reported lacking the opportunity to attend meetings and 11% reported lacking the opportunity to share experiences with other volunteers. In addition, only 78% of volunteers agreed that they receive adequate information from their coordinator. One volunteer expressed it this way:

> "I got into a fight with the social worker and everybody else that was connected to it cause ... I had promised that I would be with him when he died.... If they would have notified me, he would have died happy, ah and peaceful. Instead I found out he died by himself and that really upset me and really made me angry."

Government policy is also a concern for some volunteers. One-quarter of volunteers were worried that legislation and government policies will affect their volunteering for the organization. But, in light of changes in the long-term care policy that sought to reorganize the volunteer agencies, it is not surprising that some volunteers were concerned. At the time of the study, staff at the agencies were concerned with legislative changes such as Bill 173, which sought to reorganize the delivery of home-care services. Bill 173 proposed the inception of multi-service agencies (MSAs), which were to serve as a single point of access into the long-term care system, including home-care services. Employees at the agencies in this study were uncertain of their role within this new delivery system (Denton and Zeytinoglu, 1996).

VOLUNTEER HEALTH AND SAFETY

Volunteers tended to be in relatively good mental health. They discuss how volunteer work is beneficial for their health and well-being:

> "I started to do volunteer work and by doing this volunteer work that made me stronger, happier, able to accept the loss of living completely alone for the first time in my life and I was 66 so really volunteer work has given me a purpose of doing things of living that made me feel happy."

Similar to the NPHS sample, most respondents described their health as good to excellent. Volunteers also tended to have high levels of control or sense of coherence. Stress was not a major problem for volunteers, with few volunteers describing their lives as stressful and no volunteers describing their volunteer activities as stressful. Exhaustion and depression were also not major health concerns for volunteers.

The major health conditions reported by volunteers were arthritis or rheumatism, back problems excluding arthritis, allergies and high blood pressure. Two-fifths of respondents reported that they were limited in activities due to long-term health conditions. In comparison with the NPHS, volunteers were more likely to report arthritis or rheumatism, back problems excluding arthritis, high blood pressure, heart disease and stomach or intestinal ulcers. However, when interpreting these results, one must take into account the fact that volunteers were more likely than the NPHS sample to be seniors. In terms of musculoskeletal problems, the most commonly reported were back pain and pain or discomfort in the neck or shoulder. With the exception of colds or flu, volunteers reported relatively few infections. Few also reported respiratory problems. Few respondents had allergies, although allergic reactions or sensitivity to smoke was a problem for a substantial proportion of volunteers. Only seven volunteers reported experiencing an injury while volunteering.

Although volunteers do not report a large number of safety concerns, substantial proportions of volunteers agreed that they travel to clients' homes in bad weather (53%), clients homes are excessively hot (28%), they are exposed to second-hand smoke in clients' homes (23%), they are exposed to poor physical conditions in clients' homes (i.e., uncleanliness, cockroaches) and that they are exposed to hazards in clients' homes and neighbourhoods (i.e., ice, dim lighting, dogs, scattermats, etc.) (16%).

HEALTH PROMOTION STRATEGIES

In accordance with the action strategies outlined by the Ottawa Charter for Health Promotion (1986), this study recommended strategies to build healthy public policy, create supportive environments, strengthen community action, develop personal skills and reorient health services.

Build Healthy Public Policy

This project helped to build healthy public policy by making a number of recommendations at both the organizational and policy level. As results of this study indicate that the agencies are very supportive toward the volunteers, one recommendation is for agencies to continue what they have been doing. Second, agencies should continue to address the needs of volunteers as identified in this study. The two participant agencies already take these needs into account when planning their volunteering activities. For example, one agency helps and encourages volunteers to apply their skills and cope with the stresses of their volunteer work by using a detailed selection process, orientation, on-the-job training, continuing education and volunteer recognition. The other agency also undertakes similar initiatives and conducts monthly meetings with volunteers to addresses their ongoing need for training, social interchange and support.

A third recommendation is to recruit volunteers so that others can benefit from volunteering as a health promoting activity. Results from this study could help facilitate volunteer recruitment by identifying the socio-demographic characteristics of volunteers. Also, as results show that almost one-half of volunteers also volunteer in other organizations, the two agencies could pool their resources by developing volunteer networks with other agencies.

Results suggest that volunteers enjoy healthy volunteer environments and that volunteering may be related to good health. Thus, the chief recommendation arising from this study is for governments to continue and/or increase funding to support volunteer activities. But an increase support for volunteer activities should not occur at the expense of paid home-care workers. This means that volunteers should not be used as a replacement for paid home-care workers, but instead should act as a supplement to them. This is important as health-care reform that emphasizes de-institutionalization often shifts caring onto unpaid family members and community health agencies' employees who are not provided with adequate resources to care (O'Connor, 1995).

Create Supportive Environments

Overall, volunteers reported healthy volunteer environments. They said their health was good to excellent, they identified several benefits of volunteering and they felt supported by their agency and volunteer coordinator. They also described their relationships with clients as very positive. However, while most volunteers work in supportive environments, results from this study indicate that a small, but important, group of volunteers are facing challenges in their volunteer work.

Agencies would benefit from continuing and/or increasing their training in addressing some of the difficulties expressed by some volunteers in this study. Training should address several concerns over organizational issues identified by volunteers. This includes concerns about lacking opportunities to attend meetings and to share experiences with other volunteers and about government policy changes. Training should also address emotional labour, taking volunteer work home, overcommitment to volunteer work and concerns about clients and their needs. Dealing with death could also be addressed through enhanced palliative training. Lastly, although relatively few volunteers reported problems with respect to safety, agencies should, nevertheless, address safety concerns in training sessions. Agencies could teach volunteers how to prevent falls, how to deal with difficult clients, how to deal with inappropriate sexual, racial and ethnic comments and behaviours, and how to better prepare themselves for travelling in bad weather and hazards in clients' homes and neighbourhoods.

Strengthen Community Action

Community action was strengthened as MRCPOWH investigators worked in partnership with the Community Agencies' Steering Committee throughout this project. Members of the two agencies formed valuable ties that can be used in future endeavours to help facilitate volunteer recruitment for both agencies. In addition, volunteers were provided with a voice through which to express their perceptions of their volunteer experiences.

Develop Personal Skills

This study helped to develop personal skills by providing agencies with the necessary tools to carry out research they perceived as important. Volunteer coordinators were able to define their own problems and solve them accordingly, remaining in control of the entire process. These coordinators developed personal skills by participating in research activities along with MRCPOWH investigators. These activities included: the development of focus group questions, questionnaire construction and providing feedback on both of the volunteer reports.

Reorient Health Services

The implication of this study is that volunteering is a health promoting activity. Volunteers in this study report good health and benefits from their volunteer work including self-esteem and a sense of purpose. As such, health-care services should be reoriented to

provide persons with enhanced opportunities to participate in volunteer work. Governments and agencies should not only provide volunteer opportunities but they must ensure that the opportunities are rewarding. Suggestions from this study help highlight how this is possible. As this study indicates that substantial proportions of volunteers are over the age of 55, volunteering will become increasingly important as the population ages.

Work-Related Health Issues for Managerial Women and Men: The Case of Chartered Accountants[1]

Janet Romaine and Isik Urla Zeytinoglu

Ce chapitre examine une recherche qualitative avec des cadres des entreprises publiques de comptabilité. Par définition, un professionnel investit beaucoup de temps et d'énergie émotionnelle dans son travail et beaucoup de cadres aujourd'hui font partie d'une famille où les deux parents ont une carrière. Un sondage a exploré les répercussions de cette tendance à partir de questions non structurées. La pression sur les comptables agréés et les exigences qui leur sont imposées peuvent avoir des conséquences physiques et émotionnelles. Hommes et femmes ont cité l'insomnie et la fatigue aussi bien que la fatigue des yeux, la tendinite et les migraines. Bien que ces formes de stress affectent tout aussi bien les hommes que les femmes, les femmes mariées, et plus spécifiquement les mères de famille, connaissent le potentiel de stress additionnel apporté par le soin des jeunes enfants. Ces résultats ont prouvé que ce sont les mères de jeunes enfants qui subissent les plus grandes pressions dans la tentative d'équilibrer le travail et la famille. Bien que le besoin d'un horaire flexible et l'acceptabilité du travail à domicile de la part de la direction soient souvent considérés comme des "problèmes de femmes", les résultats de ce sondage démontrent que les hommes ont identifié les mêmes besoins. Ce désir d'un meilleur équilibre entre le travail et la maison a créé une crise identitaire dans l'organisation des entreprises de comptabilité privées où la culture de bourreau de travail est remise en question. Les stratégies individuelles pour faire face au stress prenaient deux formes: diminuer les attentes dans la carrière et viser à rendre les entreprises plus flexibles. Il y a un avantage vital à essayer de rendre une entreprise plus ouverte aux besoins de la famille, qui réside dans l'atout que représente la valeur de l'expérience de ses employés. En ce moment, il n'y a pas assez de comptables agréés expérimentés, ce qui augmente le pouvoir de négociation des intéressés. Toutefois, le changement dans l'organisation est contesté et incomplet. Les plus

[1] The research on which this chapter is based was funded in part by the McMaster Research Centre for the Promotion of Women's Health and by a grant from the labour studies program of McMaster University.

voués au changement reconnaissent le pouvoir de leur propre socialisation en tant que professionnels et leur difficulté à sortir du modus opérandi selon lequel "le client passe avant tout".

○ॐ ○ॐ ○ॐ ○ॐ ○ॐ

This paper is concerned with the issue of how working conditions in professional firms affect managers who are in their prime child-rearing years. The specific focus is on chartered accountants (CAs) working in public accounting firms, which are work environments notorious for long hours and high stress, particularly during tax season. While these workplace conditions have not changed, the proportions both of female managers and of employees in dual-career marriages have increased over the past few decades (Hayes and Hollman, 1996). As a result, the issue of how to balance a successful career and responsible parenting has become a major concern for individual employees, while employers struggle with the question of how to hire and retain talented personnel in the face of competition from well-paying, less demanding jobs "in industry" (CA terminology for a position with a business firm).

We believe that this study is important for several reasons. First, while accounting firms are not usually considered unhealthy workplaces, they do in fact create some health problems, both mental and physical, for their managerial workforce. In keeping with the Ottawa Charter, which highlighted the need to create supportive environments (including the organization of work as a determinant of such an environment), and with Hamilton and Bhatti's (1996) model of population health promotion, we are examining how the voices of women and men employed in these workplaces are stimulating positive change. Second, the question of how dual career parents who are also professionals handle the competing demands of home and workplace is an interesting and timely one. A recent opinion survey shows that many Canadians believe working mothers may be detrimental to healthy child development (Mitchell, 1997). Healthy child development is one of the determinants of population health identified by Hamilton and Bhatti (1996), who do not link it to mothers' working arrangements. At the same time, economic conditions make it imperative for both partners to contribute to family income (Smith, 1998), and many women prefer to work outside the home in jobs that enable them to utilize their education and talents. Thus, the work/family balancing act has become a crucial issue in contemporary Canadian society. How precarious the balance is, and how it is maintained, particularly by women professionals, are themes that emerge in the stories told by our sample participants. Finally, this study shows the importance of voice as a means of changing detrimental work environments. In this case, both male and female employees shared concerns about the tug-of-war between responsibility to clients and to family members; their voices have produced incremental change in the definition of professional identity—a process which is by no means finished at present.

This chapter is organized as follows: first, we briefly review relevant literature on work/family issues and on the nature of professional work in public accounting firms. Next, we explain the methodology and results of the study. The chapter concludes with a discussion of suggested directions for future research and policy.

WORK/FAMILY ISSUES IN CANADA AND THE US

The second half of the twentieth century has been characterized, in both the US and Canada, by profound shifts in the character of the labour force and women's expectations about work and career. Between 1950 and 1988, the proportion of US women in the labour force increased from 34 to 56.4%. In Canada, women were 37% of the paid labour force in 1976, and 45% in 1994 (Almey, 1995). Although occupations continued (and continue) to be highly segregated by sex, these women were also moving into managerial positions at a steady pace. In 1992, 39% of US managers were women (Gutek, 1993), while in Canada in 1994, 43% of managers and administrators were women (Almey, 1995).

Interestingly, however, these changes in the nature of the workforce have not, by and large, been accompanied by major changes in expectations about how work gets done in the home. Compared with their husbands, married women still assume the larger share of responsibility for housework and child care, regardless of whether or not they work full-time outside the home (Gutek, 1993; Hochschild, 1989). As a result, "Women...have had to cope with a major new role without abdicating any of the responsibilities of the 'old' ones" (Gutek, 1993, 17). According to Lorber (1994), the major reason why this is so has to do with status: housework and child care have become low-status work in industrialized societies, so the burden of doing this work falls on those who "have fewer economic resources" (Lorber, 1994, 173). This explanation is consistent with a relatively recent pattern in which the spouse who earns less money stays home with sick children (Colwill, 1993).

The degree to which the double burden of paid and domestic work has resulted in increased stress for women is a matter of some dispute, partly because women's self-reports are inconsistent (Colwill, 1993). In 1985, a report on dual-career households showed that while women still were responsible for virtually all household chores, only 56% of them said that household responsibilities were a source of stress (Basset, cited in Colwill, 1993). To what extent these findings suffer from a social desirability bias, with women buying into the "supermom" image, is unclear. However, even the least sceptical interpreter of these findings has to face the fact that over half the women in Basset's sample did experience some stress resulting from the unequal distribution of household responsibilities, and other studies suggest that when this stress is present, it creates ongoing tension for the families involved (Hochschild, 1989).

For professional and managerial women, the issues involved may be somewhat different because their paid work is well-remunerated, enabling them, if they wish, to pay others (probably women) to do at least some of the household tasks. What increases the pressure of dual roles for a professional couple is the birth of one or more children, since cultural expectations in the US and Canada call for heavy parental involvement in the child's upbringing. Even if the couple hires a nanny or other child-care provider, there are firm societal mores on how much responsibility for the child's welfare can be delegated (Tom, 1993).

The issue of how to fulfil a dual set of responsibilities—as a career-oriented professional and a wife/mother/homemaker—is sometimes discussed in terms of coping skills (Long and Kahn, 1993). This perspective is a person-centred one, which ultimately leaves the onus for finding a workable balance with the individual, or possibly the couple. An institutional perspective, on the other hand, suggests that organizations have a role as active and responsible

partners in helping to create balanced lives for their employees (Mawson, 1993). Our findings will address this perspective in some detail. However, in order to understand why this has become a crucial issue for some organizations, it is necessary to examine the nature of professional work and training in the context of public accounting.

THE VALUED EMPLOYEE: PROFESSIONAL WORK IN PUBLIC ACCOUNTING

In order to understand the methods adopted by these managers to create more balance in their work/family situations, it is helpful to know something about the organizational structure and culture of public accounting firms in the US and Canada. They are usually partnership arrangements, meaning that those at the top are not employees, but owners. They are generally highly decentralized, with a group of partners in a given geographic location having a high degree of discretion over matters internal to that office. On the other hand, globalization and computerization (which tends to commoditize information) have favoured the strategy of amalgamation over the past few decades, resulting in the formation of the big six: the world's six largest accounting and management consulting firms, all based in the US and with a substantial Canadian presence (Ministry of Industry, Science and Technology, 1991). Partnerships in the big six are overwhelmingly male: although all the firms have made what they consider strenuous efforts to bring more women into the higher echelons over recent years, in 1992 less than 5% of senior partners in the US big six offices were women (Hayes and Hollman, 1996). Comparable figures were not obtainable for Canada as a whole. However, in Ontario in 1993, 4% of all women CAs were in partnership positions, as opposed to around 19% of all male CAs (McKeen and Bujaki, 1994).

Career paths in public accounting, along with a pyramid structure where the number of employees decreases as one climbs the career ladder, virtually ensure that partners will be older than most of the firm's employees. A typical accounting graduate from a four-year university program will begin his/her career at around 22, and take several years to obtain the CA designation, which requires a combination of further coursework and on-the-job training. Most accountants begin their work experience in the audit department, where they are assigned to teams that go out to client locations to perform the audits. After a few years, depending on performance and the firm's needs, the employee is likely to be promoted to senior accountant status, which means he or she will now be in charge of audits in the field. Further promotions to manager and senior manager may follow in due course. It is unusual for an individual to "make partner" before the age of 30, and in times of economic downturn, when it is harder for firms to support growth at the partner level, the time spent at the managerial levels lengthens (Wescott and Seiler, 1986).

In the past, personnel policies in major accounting firms favoured an "up or out" approach, whereby someone who had been with the firm for a certain number of years as a senior manager was either invited into the partnership or invited to leave. More recently, this policy has undergone some modification in response both to shortages of skilled personnel and to some employees' preference for a lower-profile role in exchange for more private time (Flynn, Leeth and Levy, 1997), and this new trend was reflected in many of our respondents' comments about their own perceptions in terms of a future career in public accounting.

Accounting firms at present are facing the combined challenge of shortages of qualified entry-level people, a workforce which is about 50% female and in its prime childbearing and child-rearing years, and a marketplace imperative which suggests that growth is key to survival and market dominance (Greenwood, Hinings, Cooper and Suddaby, 1997). The struggle on the part of individual employees to balance work and family responsibilities is reflected on the organizational side by firms' attempts to come to terms with the needs of dual-career employees without sacrificing a reputation for client service.

METHODOLOGY OF THE STUDY

We designed the study to reflect certain principles of participatory action research (PAR). Assumptions of PAR include the understanding that organizational members are in a position to know what needs to be changed and to play an active role in creating both knowledge and change (Whyte, 1991). The goal of the qualitative part of this study was to understand, by listening to the voices of organizational members, what issues in their lives were creating a need for positive organizational change, and to help further that change, where possible, by providing information and perhaps a larger perspective to those organizational members. In fact, as mentioned above, the process we discovered was one that we have termed "spontaneous action research," because organizational members were in the process of articulating and creating organizational initiatives designed to address the work/family balance issue.

As part of a larger study of gender and decision-making, we gathered qualitative data on how male and female accounting managers believed their work affected their overall well-being. Several open-ended questions elicited relevant information:

- Do you feel that there is a good fit between the organizational culture here and your personal style?
- If there was one thing you could change about [your workplace], what would it be?
- Do you feel that work affects your overall well-being?

Data collection took place in two phases. Phase one gathered quantitative data having to do with decision-making and organizational culture from 54 individuals who agreed to be part of the study. All had some managerial responsibilities and most were CAs; the majority were senior associates, managers and senior managers. There was some attrition between the phases. Phase two involved semi-structured interviews designed to elicit further information on the issues mentioned above, as well as data on how these individuals perceived the relationship between work and health (defined as overall well-being, physical, mental and emotional). In all, 46 managers (28 men and 26 women) from five different firms were interviewed. The age range was from 25 to 42, with a mean age of 31 for the women and 32 for the men. Most of the interviews were tape-recorded, but in some instances notes were taken immediately following the interview. The tapes were transcribed and the first author made up a coding protocol and did the initial coding. A subset of the transcripts was independently coded by a second person to ensure internal validity.

RESULTS OF THE STUDY

When asked about the relationship between work and well-being, a large proportion (78%) of the sample cited a concern for balance between work and private life. For most of these individuals, work was the dominant activity of their waking hours. Here is the voice of one woman:

> [M]y career is very important and so I want the challenge. And the challenge often means the hours and the volume of work, and I get very frustrated when I'm not busy. And yet I can also get very frustrated because there is so much of it, it takes away from other things that I want to do. And I think, over time, as a group we have gotten more cognizant of trying to consciously help balance that. (#40)

These remarks (by a single woman, aged 32) sound a number of themes that recurred across a number of interviews: the importance of career and enjoyment of its challenges, the stress built into chronic overwork based on client demands, the need to consciously find a balance in one's personal life between work and other important areas, and the advent of recognition "as a group" that this balance is something desired by and healthy for employees. Each of these themes will be discussed in more detail below.

Well-being and Professional Identity

One theme that sounded clearly in a number of interviews was the pride and satisfaction that these individuals felt in their choice of career. Nor was this simply rationalizing an unpleasant situation from which they were powerless to escape; part of the context in which the interviews took place was a very tight labour market in which they could easily find less demanding, and possibly equally lucrative, jobs. The choice to stay in public accounting, at least for the time being, was made on the grounds of the intrinsic interest of the work, variety and enjoyment of the work environment and co-workers. As one married, childless woman said:

> I like the variety, change, not knowing what I'll do next week. And I don't know what industry I'll get some exposure to this year. Those things are stressful in themselves, but also part of the thrill, so it keeps it really interesting. So ... that's another of those personal sacrifice things: do I like it enough that it's still worth the level of stress you have to cope with to be here? That's a question I think all of us ask ourselves, probably once a week, at least. Because there's lots of job opportunities, so if you're not up to the challenge, there's lots of other things you could try to do. (#2)

This woman's decision that staying with public accounting was "worth the level of stress you have to cope with to be here" was echoed by many individuals. In the voice of one manager:

[H]aving been through two maternity leaves, and having the pleasure of being able to spend six months home with my children, and also having the pleasure of looking forward to coming back to work and not being able to get back to work fast enough—it's crucial to me. I couldn't survive without it, you know, if I thought I had to stay home every day with the kids—no matter how much I love my kids, I just couldn't do it. (#29)

On the other hand, the stress that accompanied long hours and an unrelenting pace of work was not a negligible matter.

Stress and the Need for Balance

In discussing the relationship between work and well-being, individuals generally emphasized both pros and cons to their work situation. Some of the advantages have been mentioned above as reasons to remain in public accounting; on the other hand, most people admitted that there could be physical and emotional costs associated with the time commitment. On the physical side, many managers cited insomnia and fatigue (particularly during the busy season for auditors, when both business and personal tax returns are due). Here is an auditor's voice:

This is a very, very stressful job, and it's very, very long hours in the winter, and I get sick all winter long. And I totally think it's because of work....some people seem to be able to live on no sleep ... but if I work until ten o'clock one night, I'm so tired the next day ... and then I end up getting sick.

She was asked:

And when you're sick, do you feel sort of pressured to come in even though you're sick?

The response:

Definitely, yeah. Especially if you're in the audit department...you have a deadline, and it doesn't matter what you have to do to get it done by that deadline, but it has to be done. (#5)

Eyestrain and tendinitis, a result of long hours working on a computer, were mentioned. One senior manager spoke of migraines, which she linked to the stress of the work environment:

I'm a migraine sufferer, and I know sometimes that's just a combination of things including work; and the stress at work will set off one ... during some times of the year when we have a lot of client commitments, you

> can stress yourself to the point where you need to take a couple days
> because you're so exhausted or you've gotten yourself sick; I've done
> that to myself a million times. (#6)

This speaker had two young children and a husband who was currently seconded to the New York office of his accounting firm. It seems likely that the "combination of things" creating migraine-related stress had to do with a cumulative overload of both work and family responsibilities.

As the preceding quotations make clear, the separation between physical and emotional reactions to the workload is not always a clear one. Stress is both a psychological and a physiological phenomenon, and these employees commonly experience it in both ways. However, as professionals CAs have realized that they can use their voices, both individually and as a group, to negotiate certain types of change internal to the work environment. How they have begun to do so will be addressed in the next section.

Personal Responses to Stress: The Individual Balancing Act

As discussed above in the description of public accounting work, partners tend to be older than employees, and in the more prestigious (e.g., big six) firms, they also tend to be male. Four of the five firms represented in my sample were from the big six; hence, a number of partners in these firms were older men without personal experience of dual-career marital situations. As one respondent told me:

> Yeah, dinner's on the table, they put their feet up and read the paper,
> and the laundry's done. They don't have to worry about any of those
> things, in the old school. But I say to them all the time, 'I'm that wife,
> so I have to go, because (laughs) I still have to do laundry,' or whatever.
> Because homes aren't the same as they were then either—you know,
> husbands do laundry and cook and clean and everything else...But still,
> both partners are stretched. (#2)

The tradition of the firms was founded in the assumption that everyone in the firm could be called on to meet client demands, virtually at any time. One of the ways in which employees in dual-career families dealt with the pressure of partner expectations was to acknowledge somewhat explicitly that they would prefer not to enter the race for partnership. One woman and one man in my sample said that they had done this. The woman was a manager, aged 37; she had been with the same firm for 15 years and had been a manager for 10 of those years. She had three children; the oldest was eight. When I asked her whether the partnership track involved significant sacrifices, she responded, with a laugh:

> You're asking the wrong person. Yeah, I think so. Just the way my career
> has sort of developed—I think the [firm] culture's a lot different now
> than it was back then. In terms of the formative years, that was where I
> would have formally made a decision whether or not [partnership] was
> something I wanted to do, that happened to be the time when we were

having children, so it was difficult to sort of get that [i.e., a partnership initiative] going. And I don't think there was ever a time that I consciously made a decision that that's not something I wanted to do, but it sort of worked out that way. (#45)

The man who made a similar career choice was a senior manager, aged 34, with 9 years' experience in his firm. His two children were five and seven years old:

I told [the partners] a couple of years ago...I made a decision that partnership is not for me. I like my job, but...my family, and just having a life is more important than getting a higher paycheck and spending more hours in the office. And I think if I had told them that six years ago, I would have been sayonara, whereas I told them a couple of years ago, and that's fine. (#86)

This man's comments illustrate the changes that are taking place in how accounting firms are beginning to alter the traditional understanding about careers. The remark that "six years ago I would have been sayonara" springs from the old, up-or-out approach to promotion and retention in these firms; with new recruits becoming scarce, the firms have begun to realize that they cannot necessarily afford to let go of senior managers who do not choose to make the leap of commitment required by partnership.

Other individuals, without explicitly removing themselves from the possibility of partnership, chose to work part-time for at least some of the years that their children were small. One man and two women in the sample had negotiated part-time (three-fifths or four-fifths) work arrangements in their firms, but a number of others referred to the part-time option as a possibility. Only one firm of the five in our sample seemed unwilling to accommodate such "alternate work arrangements" (AWAs). In the firms that allowed them, it was generally acknowledged that such an arrangement would mean taking more time to make partner, but there seemed to be no penalty attached and no sense that people were less serious about their careers for making this choice. However, the most popular approach to achieving balance within our sample seemed to be one of alternate accommodation of, and negotiation with, the demands of work. Many parents did at least some of their work at home, often late at night after children were in bed. All knew that they could take time off when necessary, as long as client demands and deadlines were met, and this flexibility, valued by everyone, was seen by parents as indispensable to their balancing act. One mother commented:

I'm pretty flexible...if I have something at school, I go ... I think I've just not let it be a problem for me ... you're supposed to meet these, the filing deadlines—without input from me—is, can I meet that?... Thursday morning I have to go to a parent-teacher interview, so I won't come in until after that. (#81)

This quotation illustrates the classic dilemma faced by many of these managers and their firms: because the work is client-driven, even partners have relatively little control over

deadlines, which may be set by the client or by Revenue Canada. Since partner profits depend on keeping overhead down, they have an incentive to run as lean a ship as possible, virtually guaranteeing a lack of slack resources to meet emergencies. While employees value the flexibility that enables them to set their own hours to some extent, they also acknowledge that they work very long hours:

> We had approximately ninety hours a week in our busy time, for four weeks straight, which is too much time. So you're putting two months' work into one, and that's not what I want in life. It's not healthy.... (#85)

To sum up, then, from the point of view of individual employees, especially those in dual-career marriages with young children, the firm's demands were at once inescapable and at times inhumane. They at once identified with the sources of their dilemma ("we always have to put client service first, no matter what"—#68) and at the same time believed things both had to change and were changing. Some of the change was initiated on a more collective basis.

Group Responses to Stress: Changing the Organization's Mindset

While examples of collective "voice" were not as prevalent in our sample, there were several illustrations of how firms used task forces and policy initiatives to address issues raised (more commonly in my sample, at least) at the individual level. One woman discussed how this worked at her firm:

> We've had two surveys done regarding [this firm] as a workplace, and now the follow-up is being done as far as identifying where people see the problems are, and then what can we do to improve....I was on a group to come up with recommendations ... they set up focus groups, which I was part of, and went through what the firm could do. (#4)

Another woman from a different firm talked about how her organization had responded to the perception that many women left before the stage of partnership:

> [W]e had an initiative, I think it started two years ago, balancing your workload.... So now they want to recognize that yes, you have a life too. So maybe between 1990 and 1997...your family life is more important, and you want to contribute less.... I mean, not everybody buys into it, but at least it's the firm's initiative. (#68)

Another woman, a senior manager, had been specifically recruited on a part-time basis after a deliberate shift in organizational policy:

> I think it's something that five years ago the firm wouldn't have done, but I think it's a reflection—boy, she's got some skills that we really

need, she's really marketable, and we can either have 60% of her or we can have nothing—and that's where it's a business decision that the partners have to make. (#70)

It is important to realize, however, that "part-time" in this context is about a 40-hour work week. As another woman commented:

It's hard to go 60%. I think Jane tried to go sixty; before she was pregnant, she was sick.... At that time, I think even though she was 60% she was still working around 90%.... But at least she wasn't working at 150%. (#65)

LESSONS FROM A WORKAHOLIC CULTURE: CAN WORKPLACE INITIATIVES BE CONTAGIOUS?

Contemporary professional firms provide an interesting laboratory in which the effects of broad social change can be observed and to some extent addressed. The reason why this is so is that these firms make a large upfront investment in their employees, many of whom are part of dual-career marriages. These men and women face different pressures and priorities than did a largely male workforce with stay-at-home wives 30 years ago. It can be reasonably inferred that all organizations have experienced this type of change, but it is more crucial when the firm takes on a large burden of training initially (Schwartz, 1992).

It is clear that accounting firms have begun to be more proactive than in the past in their attempts to help employees with the work/family dilemma. Of the five firms in my sample, four were either promoting or at least allowing AWAs, including "part-time" work. A long-prevalent norm that associated productivity and commitment with visibility in the office was being eroded as technology and parental scheduling made flexibility on this issue both possible and desirable. A mother of two said:

[B]ecause of my situation, I'll do a lot of work at home, maybe after the kids are asleep....And you will get comments regarding someone who stayed and worked in the office....well, I don't have the choice and so I have to make it work for me, or it won't get done. (#6)

And meetings were perforce scheduled around the child-care arrangements of managers, whether senior male partners liked it or not.

The firm has over the past few years become very adaptable in that some people would prefer to get here at seven a.m. and leave at four, versus others stroll in at ten and stay through dinner. And basically I think if you can prove you can get the job done on time and you're making a decent dollar for the firm, then the client's happy, and how you do it isn't as much of an issue. (#6)

Despite some positive changes, however, the fact that a privileged segment of the professional workforce still experiences so much stress, and such detrimental effects to physical well-being, as did the women and men in our sample, provides much food for thought. What about employees with less leverage? How do they manage the balancing act? Is it, and should it be, entirely the responsibility of the dual-career couple, or do organizations (and possibly society) bear some share of accountability for the burdens imposed by child-rearing, in particular?[2]

The Hamilton and Bhatti model of population health promotion provides a tool to begin addressing questions such as these. On what should we take action, how, and with whom? The answers to the first question comprise the full range of health determinants (Hamilton and Bhatti, 1996) which include working conditions and healthy child development. "With whom" is answered at the various levels at which action can be taken: in this case, by the individual, the group (such as a task force or an individual group of partners) or the organization as a whole. The "how" question is answered by a series of comprehensive action strategies; the most relevant in this case seems to be creating supportive environments in which work and family responsibilities can be balanced, leading to the outcomes: more humane working conditions and better opportunities for healthy child development (for the children of employees). In other words, the outcomes are the determinants which have undergone positive changes in a health-promoting direction.

Another facet of the model addresses the role of research. The present research has had only a modest role in stimulating change because, for reasons addressed above, the changes are already occurring in response to the spontaneous action research strategies employed by professionals whose skills are valuable to their employers. However, the researcher may have helped to stimulate further change by disseminating information about what the respective organizations are doing to keep abreast of their competitors in order to attract and retain talented younger women and men as employees. The findings may also help policy-makers in the firms evaluate their own and others' change strategies as reflected by the voices of current employees.

For organizations whose employees are more expendable than professional CAs are to CA firms, what are the incentives that will drive organizational change in the desired direction? Current initiatives in health-care policy, such as research on work-related health threats, may help to make organizations aware of the link between dual-career family demands, employment norms that increase stress on employees (such as absence of flexible scheduling arrangements) and reduced quality and quantity of work from stressed employees. Certainly at present there are indications that widespread social change (the persistence of women in the workforce even after their children are born) has not yet been assimilated in public understanding. A recent Statistics Canada survey revealed that while most Canadians believe that women should work, they also believe that it is not good for preschool children to have two working parents (Mitchell, 1997). It is clear that we need new models of family, social arrangements and the place of a career in the adult life cycle in order to fulfil our collective responsibilities to the

[2] Due probably to the age of our sample, elder care did not arise as an issue. However, with a slightly older cohort, I suspect that this would also have been a concern for individuals with demanding careers (Schor, 1991).

next generation. Organizations, and issues of how they allocate work and perceive employee commitment, have a crucial role to play in this process.

CONCLUSION

The research described here represents an attempt to broaden the discussion of what is meant by a healthy workplace, along the lines laid out by the Ottawa Charter. While professionals occupy a privileged position, with challenging and fulfilling jobs in safe and pleasant surroundings, the downside of their career commitment has become increasingly apparent as societal norms change. Employees, male and female, who are able to use their voices to effect workplace change may provide benchmarks that can be used in the future by organizations that hope to create healthier work environments.

REFERENCES

Abdo, N. (1997). Critical issues in immigrant research: Gender issues. In B. Abu-Laban and T. Derwing (Eds.) *Responding to diversity in the metropolis: Building an inclusive research agenda* (pp. 95-99). Edmonton: Prairie Centre of Excellence.

Abrahams, J.P., Wallach, H.F., and Divens, S. (1979). Behavioral improvement in long-term geriatric patients during an age-integrated psychosocial rehabilitation program. *Journal of the American Geriatrics Society*, 27, (5), 218-221.

Acker, J., Barry, K., and Esseveld, J. (1996). Objectivity and truth: Problems in doing feminist research. In H. Gottfried (Ed.) *Feminism and Social Change: Bridging Theory and Practice* (pp. 60-88). Chicago: University of Illinois Press.

Adamson, S., Schindeler, J., Sparling, L. (1990). *Working paper on immigrant women: Education, training, employment.* COSTI—IIAS.

Aday, R., Sims, C.R., and Evans, E. (1991). Youth's attitudes toward the elderly: The impact of intergenerational partners. *Journal of Applied Gerontology*, 10, (1), 372-383.

Affergan, F. (1987). *Exotisme et alterite*. Paris: PUF.

Agnew ,V. (1996). *Resisting discrimination. Women from Asia, Africa, and the Carribbean and the women's movement in Canada.* Toronto: University of Toronto Press.

Ahlberg-Hulten, G.K., Theorell, T., and Sigala, F. (1995). Social support, job strain and musculoskeletal pain among female health care personnel. *Scandinavian Journal of Work, Environment and Health*, 21, 435-439.

Aird, V. (1986). *Whiteway health project annual report*. Bath: Whiteway Health Project.

Alan Guttmacher Institute. (1976). 11 million teenagers: what can be done about the epidemic of adolescent pregnancies in the United States.

Alcoff, L. (1991). The problem of speaking for others. *Cultural critique*, 20, 5-32.

Allegrante, J.P. and Sloan, R.P. (1986). Ethical dilemmas in workplace health promotion. *Preventative Medicine* 15, 313-320.

Allevato, C. (1987). The status of Italian immigrant women in Canada. *Canadian Women's Studies*, 8, (1), 12-13.

Almey, M. (1995). *Labour force characeristics. Women in Canada: A statistical report.* Ottawa: Minister of Industry.

Altman, B.M. (1985). Disabled women and the social structure. In S.E. Browne, D. Connors, and N. Stern (Eds.) *With the power of each breath: A disabled women's anthology.* Pittsburgh, Pa: Cleis Press, A Women's Publishing Company.

Amick, B.C., Levine, S., Tarlov, A.R., and Walsh, D.C. (Eds.) (1995). *Society and health.* New York: Oxford University Press.

Anderson, J. and Lyman, J. (1987). The meaning of work for immigrant women in the work echelons of the Canadian labour force. *Canadian Ethnic Studies,* 19, (2), 67-90.

Anzaldua, G. (1989). *Borderlands/La frontera.* San Francisco: Aunt Lute Foundation Books.

Anzaldua, G. (Ed.) (1990). *Making face, making soul.* San Francisco: Aunt Lute Foundation Books.

Arat-Koc, S. (1995). Immigration policies, migrant domestic workers and the definition of citizenship in Canada. In V. Satzewich (Ed.) *Deconstructing a nation. Immigration, multiculturalism and racism in 90s Canada* (pp. 229-243). Halifax: Fernwood Publishing.

Archibald, L. and Cirnkovich, M. (1995). Intimate outsiders: Feminist research in a cross-cultural environment. In S. Burt, and L. Code (Eds.) *Changing methods* (pp. 110-123). Peterborough: Broadview Press.

Armstrong, H., Armstrong, P., Choiniere, J., Feldberg, G., and White, J. (1994). *Take care: Warning signals for Canada's health system.* Toronto: Garamond Press.

Armstrong, P. and Armstrong, H. (1993). *The double ghetto: Canadian women and their segregated work.* Toronto: McClelland and Stewart.

Armstrong, P., Lippman, A., and Sky, L. (1997). Women's health, social change and policy development. Presented at the Fifth National Health Promotion Research Conference, Dalhousie University.

Arnopoulos, S.M. (1979). *The problems of immigrant women in the Canadian labour force.* Ottawa: Canadian Advisory Council on the Status of Women.

Aronson, J. (1990). Women's perspectives on informal care of the elderly: Public ideology and personal experience of giving and receiving care. *Ageing and Society,* 10, 651-84.

Aronson, J. (1991). Dutiful daughters and undemanding mothers: Constraining images of giving and receiving care in middle and later life. In C. Baines, P. Evans, and S. Neysmith (Eds.) *Women's caring: Feminist perspectives on social welfare* (pp.138-168). Toronto: McClelland and Stewart.

Aronson J. and Neysmith, S.M. (1996a). You are not just in there to do the work: Depersonalizing policies and the exploitation of home care worker's labour. *Gender and Society Journal,* 10, (1),59-77.

Aronson, J. and Neysmith, S.M. (1996b). Home care workers discuss their work: The skills required to use your common sense. *Journal of Aging Studies,* 10, (1),1-14.

Aronson, J. and Neysmith, S. (1997). The retreat of the state and long-term care provision: Implications for frail elderly people, unpaid family carers and paid home care workers. *Studies in Political Economy,* 53, Summer, 37-66.

Asbury, J. (1995). Overview of focus group research. *Qualitative Health Research,* 5 (4), 414-420.

Assanand, S., Dias, M., Richardson, E., and Waxler-Morrison, N. (1990). The South Asians. In N. Waxler-Morrison, J. Anderson, and E. Richardson (Eds.) *Cross-cultural caring* (pp. 141-180). Vancouver: University of British Columbia Press.

Attridge, C. and Callahan, M. (1989). Women In women's work: Nurses, stress and power. *Recent Advances in Nursing*, 25, 41-69.

Bachmann, M. and Myers, J. (1995). Influences on sick building syndrome symptoms in three buildings. *Social Science and Medicine*, 40, (2), 245-251.

Bagnall, J. (1997). Divorce: Women still big losers. *The Hamilton Spectator*. 10 April:B1

Baines, C., Evans, P., and Neysmith, S. (Eds.) (1991). *Women's caring: Feminist perspectives on social welfare*. Toronto: McClelland and Stewart.

Baker, C., Arseneault, A. M., and Gallant, G. (1994). Resettlement without the support of an ethnocultural community. *Journal of Advanced Nursing*, 20, 1064-1072.

Baker, M., Sidoruk, N., and Pennock, M. (1994). *Work able survey report*. Mimeo. Social Planning and Research Council of Hamilton-Wentworth. Study funded by the Secretary of State.

Bakhtin, M. (1981). *The dialogic imagination*. Austin: University of Texas Press.

Bakhtin, M. (1986). *Speechgenres and other late essays*. Austin: University of Texas Press.

Baldwin, S. and Glendinning, C. (1983). Employment, women and their disabled child. In J. Finch, D. Groves (Eds.) *A labour of love: Women, work and caring* (pp. 53-71). London: Routledge and Kegan Paul.

Balka, E. (1995). Technology as a factor in women's occupational stress: The case of telephone operators. In K. Messing, B. Neis, L. Dumais, (Eds.) *Issues in women's occupational health: Invisible, la sante des travailleuses* (pp. 75-103). Charlottetown, PEI: Gynergy.

Bannerji, H. (1991). But who speaks for us? Experience and agency in conventional feminist paradigms. In H. Bannerji, L. Carty, K. Delhi, S. Heald, and K. McKenna (Eds.) *Unsettling relations* (pp. 67-109). Toronto: Women's Press.

Bannerji, H. (Ed.) (1994a). *Returning the gaze*. Toronto: Sister Vision Press.

Bannerji, H. (1994b). The sound barrier. Translating ourselves in language and experience. In W. Waring (Ed.) *By, For and About. Feminist Cultural Politics* (pp. 33-52). Toronto: Women's Press.

Barrett, J. (1995). Multiple sclerosis: The experience of a disease. *Women's Studies International Forum*, 18, (2), 159-171.

Barsky, A. (1988). The paradox of health. *New England Journal of Medicine*, 318, 414-418.

Bartoldus, E., Gillery, B., and Sturges, P. (1989). Job related stress and coping among home care workers with elderly people. *Health and Social Work*, August, 204-210.

Beach, C. and Worswick, C. (1993). Is there a double-negative effect of the earnings of immigrant women? *Canadian Public Policy*, 20, (1), 36-53.

Beattie, A. (1991). Knowledge and control in health promotion: A test case for social policy and social theory. In J. Gabe, M. Calman, and M. Bury (Eds.) *The sociology of health service* (pp. 162-202). London: Routledge.

Begum, N. (1992). Disabled women and the feminist agenda. *Feminist Review*, 40, Spring, 8-24.

Beiser, M. (1988). The mental health of immigrants and refugees in Canada. *Sante Culture Health*, 5, (2), 197-213.

Beiser, M., Dion, R., Gotewiech, A., Hiamm, I., and Vu, N. (1995). Immigrant and refugee children in Canada. *Canadian Journal of Psychiatry*, 40, 65-72.

Beiser, M., Turner, R. J., and Ganesan, S. (1989). Catastrophic stress and factors affecting its consequences among Southeast Asian refugees. *Social Science and Medicine*, 28, (3), 183-195.

Belenky, M. (1986). *Women's ways of knowing: The development of self, voice and mind.* New York: Basic Books.

Bell, E.L., Denton, T.C., and Nkomo, S. (1993). Women of color in management: Toward an inclusive analysis. In T. Fagenson (Ed.) *Women in management: Trends, issues and challenges in managerial diversity* (pp. 105-130). Newbury Park, CA: Sage Publ.

Belle, D. (1990). Poverty and women's mental health. *American Psychologist*, 454, (3), 385-389.

Berger, R.M. and Anderson, S. (1984). The in-home worker: Serving the frail elderly. *Social Work*, 29, 456-461.

Berry, J.O. and Zimmerman, W.W. (1993). The stage model revisited. *Rehabilitation Literature*, 44, (9-10), 275-277.

Bertoia, C.E. (1996). *Identities under siege: The fathers' rights movement.* Ph.D. dissertation., McMaster University. Hamilton, Ontario.

Bertolini, R. and Drewczynski, A. (1990). *Repetitive motion injuries (RMI).* Hamilton: Canadian Centre for Occupational Health and Safety.

Bertsche, A.V. (1982). Worker burnout in child welfare and its effects on biological parents. In P.A. Sinanoglu and A.N. Maluccio. (Eds.) *Parents of children in placement: Perspectives and programmes.* (pp. 445-459). Connecticut: University of Connecticut School of Social Work and Child Welfare League of America.

Bhayana, B. (1991). Health shock. *Healthsharing*, 12, (3), 28-31.

Bickenbach, J.E. (1993). *Physical disability and social policy.* Toronto: University of Toronto Press.

Bisanti, L., Osen, J., Basso, O., Thonneau, P., and Karmaus, W. (1996). Shift work and subfecundity: A European multicenter study. *Journal of Occupational and Environmental Health*, 38, (4), 352-358.

Blackford, K. (1993). Feminizing the MSS of Canada. *Canadian Woman Studies*, 13, (4), 124-128.

Blatter, B., Roeleveld, N., and Zielhuis, G. (1996). Maternal occupational exposure during pregnancy and the risk of spina bifida. *Occupational and Environmental Medicine*, 53, (2), 80-86.

Blaxter, M. (1990). *Health and lifestyles.* London: Routledge.

Bolaria, B.S. (1988). The health effects of powerlessness: Women and racial minority immigrant workers. In B.S. Bolaria (Ed.) *Sociology of health care in Canada.* (pp.439-459). Toronto: Harcourt Brace.

Bolaria, B.S. (1994a). *Racial minorities, medicine and health.* Halifax: Fernwood.

Bolaria, B.S. (1994b). Sociology, medicine, health and illness: An overview. In B.S. Bolaria and H. Dickinson (Eds.) *Health, illness and health care in Canada* (pp. 1-18). Toronto: Harcourt, Brace, Jovanovich.

Bolaria, B.S. and Dickinson, H. (1994). *Health, illness and health care in Canada.* Toronto: Harcourt Brace.

Bordo, S. (1988). Anorexia nervosa: Psychopathology as the crystallization of culture. In I. Diamond and L. Quinby (Eds.) *Feminism and Foucault: Reflections on resistance* (pp. 87-117). Boston: Northeastern University Press.

Bordo, S. (1992). Feminist scepticism and the 'maleness' of philosophy. In E. Harvey and K. Oruhlik (Eds.) *Women and reason*. Ann Arbor: University of Michigan Press.

Bordo, S. (1993). *Unbearable weight: Feminism, western culture, and the body*. Los Angeles: University of California Press.

Borland, K. (1991). 'That's not what I said': Interpretive conflict in oral narrative research. In S.B. Gluck and D. Patai (Eds.) *Women's words: The feminist practice of oral history* (pp. 63-75). New York: Routledge, Chapman and Hall.

Bowes, A.M. and Domokos, T.M. (1996). Pakistani women and maternity care: Raising muted voices. *Sociology of Health and Illness*, 8, (1), 45-65.

Boyd, M. (1975). The status of immigrant women in Canada. *Canadian Review of Sociology and Anthropology*, 12, (4), 406-416.

Boyd, M. (1976). Occupations of female immigrants and North American immigration statistics. *International Migration Review*, 10, 73-79.

Boyd, M. (1984). At a disadvantage: The occupational attainments of foreign born women in Canada. *International Migration Review*, 18, (4), 1091-1119.

Boyd, M. (1986). Immigrant women in Canada. In R.J. Simon, C.B. Brettell (Eds.) *International migration: The female experience*. Ottawa: Rowman and Allanheld.

Boyd, M. (1992). Gender, visible minority and immigrant earnings inequality. In V. Satzevich (Ed.) *Deconstructing a nation: Immigration, multiculturalism and racism in the 90s* (pp. 279-321). Halifax: Fernwood.

Bradbury, B. (Ed.) (1992). *Canadian family history*. Toronto: Copp Clark Pitman.

Breton, M. (1994). On the meaning of empowerment and empowerment-oriented practice. *Social Work with Groups*, 17, (3), 23-35.

Bridgman-Acker, K. (1995). *Custody and access public response paper: The standpoint of single mothers*. McMaster University. Hamilton, Ontario (unpublished paper).

Brown, L.D. and Tandon, R. (1983). Ideology and political economy in inquiry: Action research and participatory research. *The Journal of Applied Behavioral Science*, 19, (3), 277-294.

Brown, R. (1989). *The search for well-being. Fine balances. Symposium report: Women and well-being*. Canadian Advisory Council on the Status of Women, Ottawa.

Brydon-Miller, M. (1993). Breaking down barriers: Accessibility, self advocacy in the disabled community. In P. Park et al. (Eds.) *Voices of Change* (pp. 125-143). Westport, Connecticut: Bergin and Garvey.

Buffalo, Y. (1990). Seeds of thought, arrows of change: Native story telling as metaphor. In T. Ladlaw and C. Malmo (Eds.) *Healing voices: Feminist approaches to therapy with women* (pp. 118-142). San Francisco: Jossey-Bass.

Buker, E. (1987). Story telling power: Personal narratives and political analysis. *Women and Politics*, 7, (3), 29-46.

Buller, M.K., Loescher, L.J., and Buller, D.B. (1994). Sunshine and skin health: A curriculum for skin cancer prevention education. *Journal of Cancer Education*, 9, 155-162.

Burt, S. (1995). The several worlds of policy analysis: Traditional approaches and feminist critiques. In S. Burt and L. Code (Eds.) *Changing methods. Feminist transforming practice* (pp. 357-379). Peterborough: Broadview Press.

Burt, S. and Code, L. (1995). *Changing methods. Feminist transforming practice.* Peterborough: Broadview Press.

Butler, J. (1992). Response to Bordo's feminist scepticism and the 'maleness' of philosophy. *Hypatia,* 7, (3), 163-166.

Butler, J. (1997). *Excitable speech. A politics of the performative.* New York: Routledge.

Callahan, M. (1985). Public apathy and government parsimony: A review of child welfare in Canada. In K. Levitt and B. Wharf (Eds.) *The challenge of child welfare* (pp.1-27). Vancouver: University of British Columbia Press.

Callahan, M. (1993a). The administrative and practice context: perspectives from the front line. In B. Wharf (Ed.) *Rethinking child welfare in Canada* (pp.64-97). Toronto: McClelland and Stewart.

Callahan, M. (1993b). Feminist approaches: Women recreate child welfare. In B.Wharf (Ed.) *Rethinking child welfare in Canada* (pp. 172-209). Toronto: McClelland and Stewart.

Callahan, M. and Attridge, C. (1990). Women in women's work: Social workers talk about their work in child welfare. *Research monograph #3.* Victoria: University of Victoria.

Campbell, N. (1997). Consumer relations coordinator (home care program). Action plan in response to study "Support needs for women with multiple sclerosis." *Memorandum.*

Canada. Department of Justice. (1993). *Custody and access: Public response paper.* Ottawa.

Canadian Advisory Council on the Status of Women. (1995). *What women prescribe: Report and recommendations from the national symposium "Women in partnership: Working towards inclusive, gender-sensitive health policies."* Ottawa.

Canadian Council on Rehabilitation and Work. (1993). *Perspectives on the journey: The qualifications and experiences of Canadian job seekers with disabilities.* Winnipeg.

Canadian Labour Market and Productivity Centre. (1994). *Women and economic restructuring.* Ottawa.

Canadian Mental Health Association Citizen's Survey Project Committee. (1984). *Work and well-being: The changing realities of employment. A popular summary.*

Canadian Mental Health Association. (1989). *Women and mental health.* CMHA social action series. Toronto.

Canadian National Council of Welfare. (1990). *Women and poverty revisited.* Ottawa.

Canadian Panel on Violence Against Women. (1993). *Changing the landscape, ending violence, achieving equality: Final report of the Canadian Panel on Violence Against Women.* Ottawa: The Panel.

Canadian Public Health Association. (1997). *Health impacts of social and economic conditions: Implications for public policy.* Ottawa.

Canadian Task Force on Mental Health Issues Affecting Immigrants and Refugees in Canada. (1988). *After the door has been opened: Mental health issues affecting immigrants and refugees in Canada.* Ottawa: Department of the Secretary of State of Canada. Multiculturalism Sector.

Cancian, F. (1996). Participatory research and alternative strategies for activist sociology. In H. Gottfried (Ed.) *Feminism and social change* (pp.187-206). Chicago: University of Illinois Press.

Carey, E. (1997). Welfare moms exploited by society, study finds. *The Toronto Star.* 12 Aug: A8.

Carey, J. W. (1993). Linking qualitative and quantitative methods: Integration of cultural factors into pubic health. *Qualitative Health Research*, 3 (3), 298-318.

Carey, M. A. (1995). Comment: Concerns in the analysis of focus group data. *Qualitative Health Research*, 5 (4), 487-495.

Carty, L. and Brand, D. (1993). Visible minority women: A creation of the Canadian state. In H. Bannerji (Ed.) *Returning the gaze*. Toronto: Sister Vision Press.

Carver, V. and Ponce, C. (1989). *Women, work and wellness*. New York: ARF Books.

Cassidy, B., Robina, L., and Mandell, N. (1995). Silenced and forgotten women: Race, poverty, and disability. In N. Mandell (Ed.) *Feminist issues: Race, class and sexuality* (pp. 32-66). Scarborough, ON: Prentice-Hall Canada Inc.

Chambers, L. and Montigny, E.A. (Eds.) (1998). *Family matters: Papers in post-confederation Canadian family history*. Toronto: Canadian Scholars' Press.

Chanfrault-Duchet, M.F. (1991) Narrative structures, social models, and symbolic representation in the life story. In S. Berger Gluck and D. Patai (Eds.) *Woman's words* (pp. 77-92). New York: Routledge, Champman and Hall, Inc..

Chappell, N.L. and Prince, M.J. (1997). Reasons why Canadian seniors volunteer. *Canadian Journal on Aging*, 16, (2), 336-353.

Chapman, S., Marks, R., and King, M. (1992). Trends in tans and skin protection in Australian fashion magazines, 1982 through 1991. *American Journal of Public Health*, 82, 1677-1680.

Charles, N. and Walters, V. (1994). Women's health: Women's voices. *Journal of Health and Social Care in the Community*, 2, 329-339.

Chelser, M.A. (1991). Participatory action research with self-help groups: An alternative paradigm for inquiry and action. *American Journal of Community Psychology*, 19, (5), 757-768.

Cherniss, C. (1980). *Professional burnout in human service organizations*. New York: Praegar Publishers.

Cherry, D.L., Benest, F.R., Gates, B., and White, J.I. (1985). Intergenerational service programs: Meeting shared needs of young and old. *The Gerontologist*, 25, 126-129.

Chesler, P. (1986). *Mothers on trial: The battle for child custody*. New York: McGraw-Hill.

Chichin, E. (1992). Home care is where the heart is: The role of interpersonal relationships in paraprofessional home care. *Home Health Care Quarterly*, 13, (12), 161-177.

Christofides, S. (1993). Wage determination by gender and visible minority status: Evidence from the 1989 LMAS. *Canadian Public Policy*, 20, (1), 34-51.

Clark, B. and Grey, S. (1991). *Double burden: Women's experience of workplace injury and disease in Ontario*. Ontario Worker's Health Centre.

Clarke, J. N. (1983). Sexism, feminism and medicalism: A decade review of literature on gender and illness. *Sociology of Health and Illness*, 5, 62-82.

Clarke, J.N. (1992). Feminist methods in health promotion research. *Canadian Journal of Public Health*, 83, (Suppl. 1), S54-S57.

Cnaan, R. and Cwikel, J. (1992). Elderly volunteers: Assessing their potential as an untapped resource. *Journal of Aging and Social Policy*, 4, (1/2), 125-147.

Cochran, M. (1988). Addressing youth and family vulnerability: Empowerment in an ecological context. *Canadian Journal of Public Health Supplement*, 2, 79, S10-S16.

Coffey, A. and Atkinson, P. (1986). *Making sense of qualitative data.* Thousand Oaks: Sage.

Cohen, M. (1991). Gender issues in family medical research. *Canadian Family Physician*, 37, 1399-1405.

Colin, C., Ouellet F., Boyer, G., and Martin, C. (1992). *Extrême pauvreté, maternité et santé.* Montréal: Éditions St.-Martin.

Collins, B.S., Hollander, R.B., Koffman, D.M., Reeve, R., and Seidler, S. (1997). Women, work and health: Issues and implications of worksite health promotion. *Women and Health*, 25, (4), 3-38.

Collins, P.H. (1991). *Black feminist thought: Knowledge, consciousness, and the politics of empowerment.* Boston: Routledge and Kegan Paul.

Colwill, N. (1993). Women in management: Power and powerlessness. In B. Long and S. Kahn (Eds.) *Women, work and coping: A multidisciplinary approach to workplace stress* (pp. 73-89). Montreal: McGill-Queen's University Press.

Conn, M. and Fox, R. (1994). Undoing medical conditioning. In E. Dua, M. Fitzgerald, L. Gardner, D. Taylor, and L. Wyndels (Eds.) *On women's health sharing* (pp.307-314). Toronto: Women's Press.

Cooley, M.L. and Unger, D.G. (1991). The role of family support in determining developmental outcomes in children of teen mothers. *Child Psychiatry and Human Development*, 21, (3), 217-233.

Corbin, D.E., Kagan, D.M., and Metal-Corbin, J. (1987). Content analysis of an intergenerational unit on aging in a sixth-grade classroom. *Educational Gerontology*, 13, 403-410.

Corbin, J.M. and Strauss, A.L. (1990). Grounded theory research: Procedures, canons, and evaluative criteria. *Qualitative Sociology*, 13, (1), 3-21.

Corin, E. (1994). The social and cultural matrix of health and disease. In R.G. Evans, M.L. Barer and T.R. Marmor (Eds.) *Why are some people healthy and others not? The determinants of health of populations* (pp. 93-132). New York: Aldine de Gruyter.

Corin, E. (1995). The cultural frame: Context and meaning in the construction of health. In B.C. Amick, S. Levine, A.R. Tarlov and D.C. Walsh (Eds.) *Society and health* (pp. 272-304). New York: Oxford University Press.

Corrigan, M. (1994). Burnout: How to spot it and protect yourself against it. *Journal of Volunteer Administration*, Spring, 24-31.

Cottone, L.P. and Cottone, R.R. (1992). Women with disabilities: On the paradox of empowerment and the need for a trans-systemic and feminist perspective. *Journal of Applied Rehabilitation Counseling*, 23, (4), 20-25.

Crean, S. (1988). *In the name of the fathers: The story behind child custody.* Toronto: Amanita Enterprises.

Creese, G. and Stasiulis, D. (1996). Introduction: Intersections of gender, race, class and sexuality. *Studies in Political Economy*, 51, fall, 5-14.

Crown, W., Ahlburg, D., and McAdam, M. (1995). The demographic and employment characteristics of home care aides: A comparison with nursing home aides, hospital aides, and other workers. *The Gerontologist*, 35, (2), 162-170.

Cruishank, J. (1994). Claiming legitimacy: Prophecy narratives from northern aboriginal women. *American Indian Quarterly*, 18, (2), 147-167.

Daenzer, P. (1993). *Regulating class privilege: Immigrant servants in Canada: 1940s to 1990s*. Toronto: Canadian Scholars' Press.

Dagenais, H. (1994). Quand la réalité fait éclater les concepts: réflection methodologique sur les femmes et le développement dans la région Caraïbe. In H. Dagenais and D. Piché (Eds.) *Women, feminism and development/femmes, feminisme et developpement. Canadian Research Institute for the Advancement of Women/ L'Institut canadien de recherches sur les femmes* (pp.111-158). Montreal: McGill/Queen's University Press.

Dagenais, H. and Piché, D. (Eds.) (1994). *Women, feminism and development/femmes, feminisme et developpement. Canadian Research Institute for the Advancement of Women/ L'Institute Canadien de recherches sur les femmes*. Montreal: McGill/Queen's University Press.

Dalley, G. (1988). *Ideologies of caring: Rethinking community and collectivism*. New York: Macmillan.

Das Gupta, T. (1996). *Racism and paid work*. Toronto: Garamond Press.

Datillo, J. (1994). *Inclusive leisure services*. Pennsylvania State College: Venture Publishing Inc.

Davidson, D.A. (1991). Facilitating balance between career and family: A crucial challenge. *American Journal of Occupational Therapy*, 45, (1), 84-85.

Davidson, K., Holderby, A., Stewart, M., van Roosmalen, E., Poirier, L., Bentley, S., and Kirkland, S. (1997). *Considering gender as a modifiable health determinant*. Synthesis paper, 5th National Health Promotion Research Conference: Gender and Health. Dalhousie University. Halifax: Atlantic Health Promotion Research Centre.

Davison, C., Macintyre, S., and Davey Smith, C. (1994). The potential social impact of predictive genetic testing for susceptibility to common chronic diseases: A review and proposed research agenda. *Sociology of Health and Illness*, 16, (3), 340-71.

Daykin, N. and Naidoo, J. (1995). Feminist critiques of health promotion. In R. Bunton, S. Nettleton and R. Burrows (Eds.) *The sociology of health promotion: Critical analyses of consumption, lifestyle and risk* (pp. 59-69). London: Routledge.

de Certeau, M. (1968). *La prise de parole. Pour une nouvelle culture*. Bruges: Desclee de Brouwer, 1968 . English translation: *The capture of speech and other political writings*. Translated and with an introduction by Luce Giard. Minneapolis: University of Minnesota Press, 1997.

de Certeau, M. (1997). *Culture in the plural*. Introduction by Luce Giard, Translated and with an afterword by Tom Conley. Minneaplis: University of Minnesota Press.

Deardorf, N., Brown, E., Baker, M., Meyer, H., Brandwein, R., Giibelman, M., and Schervish, P.H. (1995). Some thoughts on the status of women in social work. *Journal of Progressive Human Services*, 6, (1), 95-102.

Deber, R.B. and Williams, P.A. (1995). Policy, payment, and participation: Long-term care reform in Ontario. *Canadian Journal on Aging*, 14, (2), 294-318.

DeMyer, M.K. (1979). *Parents and children in autism*. New York: John Wiley and Sons.

Dennerstein, L. (1995). Mental health, work and gender. *International Journal of Health Services*, 25, (3), 503-509.

Denny, E. (1994). Liberation or oppression? Radical feminism and in vitro fertilization. *Sociology of Health and Illness*, 16, (1), 62-80.

Denton, M., Hajdukowski-Ahmed, M., O'Connor, M., and Zeytinoglu, I.U. (1994). *A theoretical and methodological framework for research on women, work and health.* Hamilton: McMaster Research Centre for the Promotion of Women's Health, Working Paper #1.

Denton, M., Hajdukowski-Ahmed, M., O'Connor, M., Williams, K. and Zeytinoglu, I.U. (1994). *Framework for research in the community*, MRCPOWH, unpublished document.

Denton, M. and Walters, V. (1997). *Gender differences in structural and behavioural determinants of health: An analysis of the social production of health.* MRCPOWH Working Paper Series #8. Hamilton: McMaster Research Centre for the Promotion of Women's Health. Forthcoming in *Social Science and Medicine*, 1999.

Denton, M. and Zeytinoglu, I.U. (1993). Perceived participation in decision-making in a university setting: The impact of gender. *Industrial and Labor Relations Review*, 46, (2), 320-331.

Denton, M. and Zeytinoglu, I. U. (1996). *Healthy work environments in community based health and social service agencies*. MCRPOWH Technical Report Series #1. Hamilton, Ontario: McMaster University.

Denton, M.A., Zeytinoglu, I.U. Webb, S., and Lian, J. (1998). *Healthy work enviroments in community based health and social service agencies stage two report: Employee questionnaire findings*. MRCPOWH Technical Report Series #7, April.

Department of Justice (1993). *Custody and access: Public response paper*. Ottawa

DeSantis, G. (1990). *Diverse racial and cultural groups' access to the social service system.* Social Planning and Research Council of Hamilton and District.

DeSilva, A. (1992). *The earnings of immigrants: A comparative analysis*. Catalogue no. EC 22-179/199E. Ottawa: Supply and Services Canada.

Dhooma, R. (1994). Poverty fells single moms. *The Toronto Sun*. 21 February: E7.

DisAbled Women's Network Toronto (DAWN Toronto). (1994). *Disabled Women's Network (DAWN) Toronto*. Information sheet.

Djao, A.W. and Ng, R. (1987). Structured isolation: Immigrant women in Saskatchewan. In K. Storrie (Ed.) *Women—isolation and bonding: Readings in the ecology of gender* (pp. 141-158). Toronto: Metheuen.

Donovan, R. (1989). Work stress and job satisfaction: A study of homecare workers in New York City. *Home Health Care Services Quarterly*, 10, (1/2), 97-114.

Donovan, R., Kurzman, P., and Rotman, C. (1993). Improving the lives of homecare workers: A partnership of social work and labor. *Social Work*, 38, (5), 505-648.

Dooley, M. (1993). Recent changes in economic welfare of lone-mother families in Canada: The roles of market work, earnings and transfers. In J. Hudson and B. Galaway (Eds.) *Single parent families. Perspectives on research and policy*. Toronto: Thompson Educational Publishing.

Douglas, J. (1995). Developing anti-racist health promotion strategies. In R. Burrows and S. Nettelton (Eds.) *The sociology of HP: Critical analysis of consumption, lifestyle and risk* (pp. 70-77). London: Routledge.

Douglas, J. (1996). Developing with black and minority ethnic communities, health promotion strategies which address social inequalities and their impact on health. In P. Bywaters and E. McLeod (Eds.) *Working for equality in health* (pp.179-196). London: Routledge.

Doyal, L. (1991). Promoting women's health. In B. Badura and I. Kickbusch (Eds.) *Health promotion research: Towards a new social epidemiology* (pp.283-311). Copenhagen: World Health Organization.

Doyal, L. (1995). *What makes women sick? Gender and the political economy of health*. Basingstoke: Macmillan.

Doyal, L. (1996). The politics of women's health: Setting a global agenda. *International Journal of Health Services*, 26, (1), 47-65.

Driedger, D., Fieka, I., and Batres, E.G. (1996). *Across borders: Women with disabilities working together*. Halifax: Gynergy Books.

Drummond, N. and Lee, M. (1981). *Working paper on the immigrant woman in the workplace*. Discussion paper: Social environment group of the health advocacy unit.

Dubin, N., Moseson, M., and Pasternack, B.S. (1989). Sun exposure and malignant melanoma among susceptible individuals. *Environmental Health Perspectives*, 81, 139-51.

Duchesne, D. (1989). *Giving freely: Volunteers in Canada*. Statistics Canada, Labour and Household Surveys Analysis Division.

Duffy, A., Mandell, N., and Pupo, N. (1991). *Few choices: Women, work and family*. Toronto: Garamond Press.

Dupuy, J.R. and Thibault, M. (1993). *Communications and information technologies and persons with disabilities*. Submitted to the advisory committee to the Minister of Communications on the national strategy for the integration of persons with disabilities. Ottawa.

Duras, M. and Gauthier, X. (1974). *Les parleuses*. Paris: Les Editions de Minuit.

Dyck, I. (1995). Hidden geographies: The changing lifeworlds of women with multiple sclerosis. *Social Science and Medicine*, 40, (3), 307-320.

Eagleton, M. (1996). *Working with feminist criticism*. Cambridge, Massachusetts: Basil Blackwell.

Edwards, P. (1997). HP in the 21st century. *Past Present and Future*, 1, 8-11

Eng, E., Salmon, M.E. and Mullen, R. (1992). Community empowerment: The critical base for primary health care. *Family and Community Health*, (1), 1-12.

Epp, J. (1986). *Achieving health for all: A framework for health promotion*. Ottawa: Health and Welfare Canada. Reprinted in *Canadian Journal of Public Health*, 77, (6), 425-450.

Esposito, G. and Fine, M. (1985). The field of child welfare as a world of work. In J. Laird and A. Hartman (Eds.) *A Handbook of child welfare: Context, knowledge and practice* (pp.727-740). New York: The Free Press.

Estable, A. (1986). *Immigrant women in Canada. Current issues*. A background paper for the Canadian Advisory Council on the Status of Women. Ottawa: Minister of Supply and Services Canada.

Eustis, N., Fischer, L., and Kane, R. (1994). The homecare worker: On the front-line of quality. *Generations*, Fall, 43-49.

Evans, P. (1995). Women and social welfare: Exploring the connections. In J.C.Turner and F.J. Turner (Eds.) *Canadian Social Welfare*, 3rd edition. Scarborough: Allyn and Bacon.

Evans, R.G., Barer, M.L., and Marmor, T.R. (1994). *Why are some people healthy and others not?: The determinants of health of populations*. New York: Aldine De Gruyter.

Falk, A. (1993). Immigrant settlement: Health and social supports. In R. Masi, L. Mensah and K. Macleod (Eds.) *Health and Culture* (pp. 307-329). Oakville: Mosaic Press.

Fals-Borda, O. and Rahman, M.A. (1991). *Action and knowledge: Breaking the monopoly with participatory action-research*. New York: The Apex Press.

Falvo, D.R., Allen, H., and Maki, D. (1982). Psychosocial aspects of invisible disability. *Rehabilitation Literature*, 43, (1-2), 2-6.

Farber, B. (1959). Effects of a severely mentally retarded child on family integration. *Monographs of the Society for Research in Child Development*, 24, 71-88.

Featherstone, H. (1982). *A difference in the family: Living with a disabled child*. Markham, Ontario: Penguin Books.

Federal/Provincial/Territorial Working Group on Home Care. (1990). *Report on home care*. Canada: Health Services and Promotion Branch, Health and Welfare Canada.

Feldman, P., Spienza, A., and Kane, N. (1994). On the home front: The job of the home aide. *Generations*, Fall, 16-19.

Ferguson, E. (1991). The child-care crisis: Realities of women's caring. In C. Baines, P. Evans and S. Neysmith (Eds.) *Women's caring: Feminist perspectives on social welfare* (pp.73-105). Toronto: McClelland and Stewart.

Finch J. (1984). 'It's great to have someone to talk to': The ethics and politics of interviewing women. In C. Bells and H. Roberts (Eds.) *Social Researching: Politics, problems, practice* (pp. 70-87). London: Routledge and Kegan Paul.

Finch, J. and Groves, D. (Eds.) (1983). *A labour of love: Women, work and caring*. London: Routledge and Kegan Paul.

Finch, J. and Mason, J. (1993). Filial obligations and kin support for elderly people. In J. Bornat, C. Pereira, D. Pilgrim and F. Williams (Eds.) *Community care: A reader*. (pp. 96-106). London: Macmillan.

Fine, M. and Asch, A. (Eds.) (1988). *Women with disabilities: Essays in psychology, culture and politics*. Philadelphia: Temple University Press.

Finn, J. (1994). The promise of participatory research. *Journal of Progressive Human Services*, 5, (2), 25-42.

Fischer, L. and Banister-Schaffer, K. (1993). *Older volunteers: A guide to research and practice*. Newbury Park, CA: Sage.

Fisman, S. (1988). *Parental stress*. Paper presented at conference on issues in autism across the lifespan, Chedoke-McMaster Hospitals, Hamilton, Ontario.

Flynn, P., Leeth, J., and Levy, E. (1997). The accounting profession in transition. *The CPA Journal*, 42-45, 56.

Fonow, M. and Cook, J. (1991). *Beyond methodology: Feminist scholarship as lived research*. Bloomington: Indiana University Press.

Fowler, C.A. and Wadsworth, J.S. (1991). Individualism and equality: Critical values in North American culture and the impact on disability. *Journal of Applied Rehabilitation Counseling*, 22, (4), 19-23.

Franks, F. and Faux, S.A. (1990). Depression, stress and mastery and social resources in four ethnocultural women's groups. *Research in Nursing and Health*, 15, (5), 283-292.

Fraser, K. (1992). Trading abuse for poverty. *Canadian Woman Studies*, 12, (4), 41-42.

Freedman, S. M. and Bisesi, M. (1988). Women and workplace stress. *AAOHN Journal*, 36 (6), 271-275.

Freire, M. (1993). Mental health, culture, children and youth. In L. Mensah and K. McLeod (Eds.), *Health and cultures* (pp. 79-121). Oakville: Mosaic Press.

Freire, P. (1970). *Pedagogy of the oppressed*. New York: The Seabury Press.

Freire, P. (1989). *Learning to question*. New York: Continuum.

Friedman, M. (1993). Feminism and modern friendship: Dislocating the community (ch 9). *What are friends for? Feminist perspectives on personal relationships and moral theory.* Ithaca: Cornel University Press.

Furstenberg, F. (1991) As the pendulum swings: Teenage childbearing and social concern. *Family Relations*, 40, (April),127-138.

Furstenberg, F.F. Jr., Brooks-Gunn, J., and Morgan, S.P. (1987) Adolescent mothers and their children in later life. *Family Planning Perspectives*, 19, (4), 142-151.

Gal, S. (1994). Between speech and silence: The problematics of research on language and gender. In G. Roman, S. Juhasz, and C. Miller (Eds.) *The women and language debate* (pp. 407-432). New York: Rutgers University Press.

Gardiner, M. (1992). *The dialogics of critique*. New York: Routledge.

Garvin, T. and Wilson, K. (1999). The use of storytelling in women's health research: Lessons from the field. *The Professional Geographer*, 5, (12), 296-306.

Gaventa, J. (1993). The powerful, the powerless, and the experts. In Park, P., et al. (Eds.) *Voices of change. Participatory research in the U.S. and Canada* (pp. 24-40). Toronto: The Ontario Institute for Studies in Education.

Geronemus, D. (1987). Available services. In L.C. Scheinberg and N.J. Holland (Eds.) *Multiple sclerosis: A guide for patients and their families* (pp.247-260). New York: Raven Press.

Geronimus, A. (1991) Teenage childbearing and social and reproductive disadvantage: The evolution of complex questions and the demise of simple answers. *Family Relations*, 40, (October), 463-472.

Gidron, B. (1986). Sources of job satisfaction among service volunteers. *Journal of Voluntary Action Research*, 15, 19-31.

Gijsbers Van Wijk, C., Van Vliet, K.P., and Kolk, A.M. (1996). Gender perspectives and quality of care: Towards appropriate and adequate health care for women. *Social Science and Medicine*, 43, (5), 707-720.

Gilligan, C. (1982). *In a different voice*. Cambridge: Harvard University Press.

Giroux, H. (1992). *Border crossings: Cultural workers and the politics of education*. New York: Routledge.

Giroux, L. (1995). *Recycled: A story of hope*. Sudbury, Ontario: Fenix Rysing Associates.

Glass, R. (1982). Meeting the program needs of women: Mainstream child care. *Rehabilitation Literature*, 43, (7-8), 220-221.

Glass, J., Conrad, J., and Trent, C. (1980). Changing ninth-graders' attitudes toward older persons. *Research on Aging*, 2, 499-512.

Glass, J. and Fujimoto, T. (1994). Housework, paid work, and depression among husbands and wives. *Journal of Health and Social Behavior*, 35, (June), 179-191.

Glazer, N. (1988). Overlooked, over worked: Women's unpaid and paid work in the health services: Cost crisis. *International Journal of Health Services*, 18, (1),119-137.

Glendinning, C. (1992). 'Community care': The financial consequences for women. In C. Glendinning and J. Millar (Eds.) *Women and poverty in Britain: The 1990s* (pp.162-175). Hemel Hempstead: Harvester Wheatsheaf.

Gold, N. (1990). *A gender analysis of families of autistic boys: Social adjustment and depression*. Unpublished doctoral dissertation. University of Toronto.

Goldberg, S., Marcovitch, S., MacGregor, D., and Lojkasek, M. (1985). *Family responses to a developmentally delayed preschooler: Etiology and the father's role*. Toronto: Psychiatric Research Unit, the Hospital for Sick Children.

Gordon, L. (1985). Child abuse, gender and the myth of family independence: A historical critique. *Child Welfare*, 54, (3), 213-224.

Gorelick, S. (1996). Contradictions of feminist methodology. In H. Gottfried (Ed.) *Feminism and social change: Bridging theory and practice* (pp. 23-45). Chicago, Illinois: University of Illinois Press.

Gottfried, H. (1996). (Ed.) *Feminism and social change: Bridging theory and practice*. Chicago, Illinois: Univeristy of Illinois Press.

Gottlieb, B.H. (1988). Support interventions: a typology and agenda for research. In S.W. Druck (Ed.) *Handbook of Personal Relationships* (pp. 519-541). New York: John Wiley and Sons Ltd.

Government of Canada. (1983). *Fact book on aging in Canada*. Ottawa: DDS.

Graham, H. (1983). Caring: A labour of love. In J. Finch and D. Groves (Eds.) *A labour of love: Women, work and caring* (pp.13-30). London: Routledge and Kegan Paul.

Graham, H. (1985). Providers, negotiators and mediators: Women as the hidden carers. In E. Lewin and V. Olesen (Eds.) *Women, health and healing*. New York: Tavistock.

Graham, H. (1990). Behaving well: Women's health behaviour in context. In H. Roberts (Ed.) *Women's health counts* (pp. 195-219). London: Routledge.

Graham, H. (1991). The concept of caring in feminist research: The case of domestic service. *Sociology*, 25, (1), 61-78.

Graham, H. (1993). Social divisions in caring. *Women's Studies International Forum*, 16, (5), 461-470.

Greaves, L. (1993). *Background paper on women and tobacco*. Ottawa: Minister of Supply and Services.

Greaves, L. (1994). Women and health: A feminist perspective on tobacco control. In Burt, S. and Code, L. (Eds.) *Changing methods: feminists transforming practice* (pp. 195-217). Peterborough: Broadview Press.

Green, K.L. (1994). Promoting women's health: Insights from recent research. In B.S. Bolaria and R. Bolaria (Eds.) *Women medicine and health* (pp. 375-388). Halifax: Fernwood; Saskatoon: Social Research Unit, Department of Sociology, University of Saskatchewan.

Green, L.W., George, M.A., Daniel, M., Frankish, C.J., Herbert, C.J., Bowie, W.R., and O'Neill, M. (1995). *The Royal Society of Canada study of participatory research in health promotion: Review and recommendations for the development of participatory research in health promotion in Canada*. Ottawa: The Royal Society of Canada.

Greenwood, R., Hinings, B., Cooper, C., and Suddaby, R. (1997). Do accounting mergers add up? *Globe and Mail*. Nov. 19: B11.

Gregg, R. (1994). Explorations of pregnancy and choice in a high-tech age. In C.K. Riessman (Ed.) *Qualitative studies in social work research* (pp. 49-66). California: Sage.

Grosz, E. (1994). *Volatile bodies: Toward a corporeal feminism.* Bloomington: Indiana University Press.

Gruber, J.E. and Bjorn, L. (1982). Blue-collar blues: The sexual harassment of women autoworkers. *Work and Occupations,* 9, (3), 271-298.

Gulick, E.E. (1994). Social support among persons with multiple sclerosis. *Research in Nursing and Health,* 17, 195-206.

Gusfield, J.R., (1989). Constructing the ownership of social problems: Fun and profit in the welfare state. *Social Problems,* 36, (50), 431-440.

Gutek, B. (1993). Asymmetric changes in men's and women's roles. In B. Long and S. Kahn. (Eds.) *Women, work and coping: A multidisciplinary approach to workplace stress* (pp.11-31). Montreal: McGill-Queen's University Press.

Guterman, N.B. and Jayaratne, S. (1994). "Responsibility at risk": Perceptions of stress, control and professional effectiveness in child welfare practitioners. *Journal of Social Service Research,* 20, (1/2), 99-120.

Hahn, H. (1989). Disability and the reproduction of bodily images: The dynamics of human appearances. In J. Wolch and M. Dear (Eds.) *The Power of geography: How territory shapes social life* (pp.370-387). Boston: Unwin and Hyman.

Hajdukowski-Ahmed, M. (1990). Ethnique de l'alterite, éthique de la différence sexuelle: Bahktine et les theories feministes. In R. Barsky (Ed.) *Discours social/ Social Discourse,* 3, (1 and 2), Special issue on Bahktin and otherness (pp.251-270). Montreal: McGill University Press.

Hajdukowski-Ahmed, M. (1992). The framing of the shrew: Discourses on hysteria and its resisting voices. Special issue on Bahktin, Carnival and other subjects, D. Shepherd (Ed.) *Critical Studies,* 3, (2), 177-195.

Hajdukowski-Ahmed, M. (forthcoming, 1999). *Immigrant/women/work and health.* MRCPOWH Technical Report Series #10. Hamilton: McMaster Research Centre for the Promotion of Women's Health.

Hall, B. (1975). Participatory research: An approach for change. *Convergence,* 8, (2), 24-32.

Hall, B. (1981). Participatory research, popular knowledge and power: A personal reflection. *Convergence,* 14, (3), 6-19.

Hall, B. (1993). Introduction. In P. Park, M. Brydon-Miller, B. Hall, and T. Jackson (Eds.), *Voices of change: Participatory research in the United States and Canada* (pp. i-xxi). Toronto: Ontario Institute for Studies in Education.

Hamilton, N. and Bhatti, T. (1996). *Population health promotion: An integrated model of population health and health promotion.* Ottawa: Health Promotion Development Division, Health Canada.

Hamilton, R. (1996). *Gendering the vertical mosaic.* Toronto: Copp Clark Ltd.

Harding, S. (1991). Thinking from the perspective of lesbian lives (ch 10). *Whose Science? Whose Knowledge?* Milton Keynes: Oxford UP.

Harding, S. (1998). *Is science multicultural? Postcolonialisms, feminisms and epistemologies.* Bloomington: Indiana University Press.

Hardy, J.D., Welcher, D.W., Stanley, J., and Dallas, J.R. (1978) Long range outcome of adolescent pregnancy. *Clinical Obstetric and Gynaecology,* 21, (4), 1215-1232.

Harrison, D. (1980). Role strain and burnout in child-protective service workers. *Social Service Review,* 31-44.

Hart, D. and Fegley, S. (1997). Children's self-awareness and self-understanding in cultural context. In U. Neisser and D. A. Jopling (Eds.) *The conceptual self in context: Culture, experience, self-understanding* (pp. 128-153). Cambridge: Cambridge University Press.

Hartrick, G. and Hills, M. (1993). Staff nurse perceptions of stressors and support needs in their workplace. *The Canadian Journal of Nursing Research*, 25, (1), 23-31.

Hartman, A. and Vinokur-Kaplan, D. (1985). Women and men working in child welfare: Different voices. *Child Welfare*, 54, (3), 307-314.

Harvey, E.B. and Tepperman, L. (1990). *Selected socio-economic consequences of disability for women in Canada.* Ottawa: Statistics Canada.

Havens, B. (1995). Long-term care diversity within the care continuum. *Canadian Journal on Aging*, 14, (2), 245-262.

Hawkins, F. (1972). *Women immigrants in Canada: A study prepared for the Royal Commission on the Status of Women.* Ottawa: Ministry of Supply and Services.

Hayes, M.V. and Dunn, J.R. (1998). *Population health in Canada: A systematic review.* CPRN Study No. H01. Ottawa: Canadian Policy Research Networks.

Hayes, R. and Hollman, K. (1996). Managing diversity: Accounting firms and female employees. *The CPA Journal*, May, 36-39.

Hayward, S., Ciliska, D., Mitchell, A., Thomas, H., Underwood, J., and Rafael, A. (1993). *Public health nursing and health promotion*, Working Paper N1, Hamilton.

Heng, C. L. (1988). Talking pain: Educational work with factory women in Malaysia. In S. Walters and L. Manicom (Eds.) *Gender in popular education* (pp. 202-229). London: Zeol.

Henderson, K.A., Bedini, L.A., Hecht, L., and Schuler, R. (1995). Women with physical disabilities and negotiation of leisure constraints. *Leisure Studies*, 14, (1), 17-31.

Henley, N.M. and Kramarae, C. (1994). Gender, power and miscommunication. In C. Roman, S. Juhasz and C. Miller (Eds.) *The women and language debate* (pp. 383-407). Rutgers University Press.

Herberg, E. (1990). The ethno-racial socioeconomic hierarchy in Canada: Theory and analysis of the new vertical mosaic. *International Journal of Comparative Sociology*, 31, (3-4), 206-221.

Herbert, M.D. and Mould, J.W. (1992). The advocacy role in public child welfare. *Child Welfare*, 71, (2), 114-130.

Hester, M. and Radford, L. (1996). Contradictions and compromises: The impact of the children's act on women and children's safety. In M. Hester, L. Kelly, and J. Radford (Eds.) *Women, violence and male power* (pp.81-98). Buckingham: Open University Press.

Hill, N. and Northwood, M. (1996). Effects of intergenerational programs on older adults: A literature review (unpublished).

Hillyer, B. (1993). *Feminism and disability.* Norman: University of Oklahoma Press.

Hitchcock, P. (1993). *Dialogics of the oppressed.* Minneapolis: University of Minnesota Press.

Hohne, K. and Wusow, H. (1994). *A dialogue of voices: Feminist literary theory and Bakhtine.* Minneapolis: University of Minnesota Press.

Hondagneu-Sotelo, P. (1993). Why advocacy research? Reflections on research and activism with immigrant women. *The American Sociologist*, Spring, 56-68.

Holland, N., Murray, T.J., and Reingold, S.C. (1996). *Multiple sclerosis: A guide for the newly diagnosed.* New York: Demos Vermande.

hooks, b. (1989). *Talking back: Thinking feminism, thinking black.* Toronto: Between The Lines.

hooks b. (1994). Moving into and beyond feminism. *Outlaw Culture* (pp. 207-242). New York: Routledge.

Hopwood, C. (1994). *Women and multiple sclerosis: Models, needs and (support) services.* McMaster Research Centre for the Promotion of Women's Health, Working Paper Series. No. 2.

Hochschild, A. (1989). *The second shift: Working parents and the revolution at home.* New York: Viking Penguin, Inc.

Hunt, H.A. and Berkowitz, M. (1990). *New technologies and the employment of disabled persons.* Geneva: ILO.

Hutchison, E.D. (1992). Child welfare as a woman's issue. *Families in Society: The Journal of Contemporary Human Services,* 73, (2), 67-77.

Hutchinson, P. and McGill, J. (1992). *Leisure, integration and community.* Concord: Leisurability Publications, Inc.

Hutchison, S. and Webb S. (1988). Intergenerational geriatric remotivation: Elders' perspectives. *Journal of Cross Cultural Gerontology,* 3, 273-297.

Iacovetta, F. (1992). Making "new Canadians": Social workers, women, and the reshaping of immigrant families. In F. Iacovetta and M. Valverde (Eds.) *Gender conflicts: New essays in women's history* (pp.261-303). Toronto: University of Toronto Press.

Iacovetta, F. (1995). Remaking their lives: Women immigrants, survivors and refugees. In J. Parr (Ed.) *A diversity of women* (pp. 135-167). Toronto: University of Toronto Press.

Immigrant and Visible Minority Women in Ontario: Employment Issues. (1986). 5th Annual Conference of Federal-Provincial-Territorial Ministers Responsible for the Status of Women, Fairmont Hot Springs, B.C.

Infante-Rivard, C., David, M., Gauthier, R., and Rivard, G.E. (1993). Pregnancy loss and work schedule during pregnancy. *Epidemiology,* 4, (1), 73-75.

International Union of Food and Allied Workers Association. (1988). *Women at work: Women and night work.*

Irigaray, L. (1985). *This sex which is not one.* Ithaca: Cornell University Press.

Isajiw, W. (1985). Definitions of ethnicity. In R. Bienvenue, and J. Goldstein (Eds.) *Ethnicity and ethnic relations in Canada* (pp. 5-19). Toronto: Butterworths.

Isley, P. (1990). *Enhancing the volunteer experience.* San Francisco: Jossey-Bass Publishers.

Israel, B.A., Schurman, S.J., and House, J.S. (1989). Action research on occupational stress: Involving workers as researchers. *International Journal of Health Services,* 19, 135-55.

Jaggar, A.M. (1983). *Feminist politics and human nature.* Totowa, NJ: Rowman and Allanheld.

James, N. (1989). Emotional labour: Skill and work in the social regulation of feelings. *The Sociological Review,* 1, 14-42.

Jaskiewicz, J.A. and McAnarney, E.R. (1994). Pregnancy during adolescence. *Pediatrics in Review,* 15, 32-38.

Jayaratne, S. and Chess, W.A. (1985). Factors associated with job satisfaction and turnover among child welfare workers. In J. Laird and A. Hartman (Eds.) *A handbook of child welfare: Context, knowledge and practice* (pp. 760-766). New York: The Free Press.

Jhappan, R. (1996). Post modern race and gender essentialism or a post-mortem of scholarship. *Studies in Political Economy*, 51, 15-62.

Johnson, D.H. (1992). *Body: Recovering our sensual wisdom.* Berkeley: North Atlantic Books.

Johnson, J. and Lane, C. (1993) Role of support groups in cancer care. *Support Care Cancer*, 1, 52-56.

Jones Crigger, N. (1996). Testing an uncertainty model for women with multiple sclerosis. *Advances in Nursing Science*, 18, (3), 37-47.

Jongbloed, L. (1996). Factors influencing employment status of women with multiple sclerosis. *Canadian Journal of Rehabilitation*, 9, (4), 213-222.

Juhl, N., Dunkin, J., Stratton, T., Geller, J., and Ludtke, R. (1993). Job satisfaction of rural public and home health nurses. *Public Health Nursing*, 10, (1), 42-47.

Kahn, S.S. (1990). *The ex-wife syndrome.* New York: Random House.

Kamerman, S.B. and Kahn, A.J. (1987). *The responsive workplace: Employers and a changing labor force.* New York: Columbia University Press.

Karasek, R.A., Gardell, B., and Lindell, J. (1987). Work and non-work correlates of illness and behaviour in male and female Swedish white-collar workers. *Journal of Occupational Behaviour*, 8, 187-207.

Karasek, R. and Theorell, T. (1990). *Healthy work: Stress, productivity, and the reconstruction of working life.* New York: Basic Books.

Kay, F. (1997). Balancing acts: Career and family among lawyers. In S. Boyd (Ed.) *Challenging the public/private divide: Feminism, law and public policy* (pp.195-226). Toronto: University of Toronto Press.

Kaufert, P. (1996). Gender as a determinant of health. Women's Health Forum. Canada USA commissioned paper. http://www.hc-sg.ca/canusa/papers/Canada/english/gender.htm.

Keesling, B. and Friedman, H.S. (1994). Psychosocial factors in sunbathing and sunscreen use. *Health Psychology*, 6, (5), 477-93.

Kelly, J.R. (1990). *Leisure*, 2nd Edition. Englewood Cliffs: Prentice Hall.

Kent, D. (1994). A movement or a monolith? Review of feminism and disability by Barbara Hillyer. *Women's Review of Books*, 9, (7), 10-11.

Khanlou, N., Hajdukowski-Ahmed, M. (1997). *Mental health promotion among female adolescents living within a cross-cultural context: Participatory action research with south Asian-Canadian high school students.* MRCPOWH Technical Report Series #4. Hamilton, Ontario: McMaster University.

King, G. and Williams, D.R. (1995). Race and health: A mutltidimensional approach to African-American health. In B.C. Amick, S. Levine, A.R. Tarlov and D.C. Walsh (Eds.) *Society and health* (pp.93-130). New York: Oxford University Press.

King, P.M, Gratz, R., Scheuer, G., and Claffey, A. (1996). The ergonomics of child care: Conducting worksite analyses. *Work: A Journal of Prevention, Assessment and Rehabilitation*, 6, 25-32.

Kingston, M.H. (1981). *The woman warrior: Memoirs of a girlhood among ghosts.* London: Picador.

Kishwar, M. (1990). Learning to take people seriously. The subjectivity of the researcher versus the subjectivity of the researched. *Manushi*, 56, 2-10.

Kitchen, B. (1992). Framing the issues: The political economy of poor mothers. *Canadian Woman Studies*, 12, (4), 10-15.

Kitzinger, J. (1994). The methodology of focus groups: The importance of interaction between research participants. *Sociology of Health and Illness*, 16, (1), 103-121.

Knoff, H. M. (1986). Assessing adolescent identity, self-concept, and self-esteem. In R. G. Harrington (Ed.), *Testing adolescents: A reference guide for comprehensive psychological assessments* (pp. 51-81). Kansas City: Test Corporation of America.

Knopp, L. (1987). Social theory, social movements and public policy: Recent accomplishments of the gay and lesbian movements in Minneapolis, Minnesota. *International Journal of Urban and Regional Research*, 11, (2), 243-261.

Koch, P.B., Boose, L., Cohn, M.D., Mansfield, P.K., Vicary, J.R. and Young, E.W. (1991). Coping Strategies of traditionally and non-traditionally employed women at home and at work. *Health Values*, 15, (1), 19-31.

Kong, F., Perucci, C.C., and Perucci, R. (1993). The impact of unemployment and economic stress on social support. *Community Mental Health Journal*, 29, (3), 205-221.

Kopp, R.G. and Ruzicka, M.F. (1993). Women's multiple roles and psychological well-being. *Psychological Reports*, 72, (3), 1351-1354.

Korabik, K., McDonald, L.M., and Rosin, H.M. (1993). Stress, coping, and social support among women managers. In B.C. Long, S.E. Kahn, K. Korabik, L.M. McDonald and H.M. Rosin (Eds.) *Women, work, and coping: A multidisciplinary approach to workplace stress* (pp.73-89). Montreal and Kingston: McGill-Queen's University Press.

Kraus, R. and Shank, J. (1992). *Therapeutic recreation services*. Dubuque: Wm. Brown Publishers.

Krieger, S. (1985). Beyond 'subjectivity': The use of the self in social science. *Qualitative Sociology*, 8, (4), 309-324.

Krueger, R.A. (1988). *Focus groups: A practical guide for applied research*. California: Sage Publications.

Krueger, R. A. (1995). The future of focus groups. *Qualitative Health Research*, 5, (4), 524-530.

Kuehne, V.S. and Sears, H.A. (1993). Beyond the call of duty: Older volunteers committed to children and families. *Journal of Applied Gerontology*, 12, 425-438.

Kulick, D. (1993). Speaking as a woman: Structure and gender in domestic arguments in a New Guinea village. *Cultural Anthropology*, 8, (4), 510-541.

Kurian, G. (1991). Socialization of South Asian immigrant youth. In S. P. Sharma, A. M. Ervin, and D. Meintel (Eds.), *Immigrants and refugees in Canada: A national perspective on ethnicity, multiculturalism and cross-cultural adjustment* (pp. 47-57). Saskatchewan: University of Saskatchewan.

Kutza, E.A. (1981). Benefits for the disabled: How beneficial for women? *Journal of Sociology and Social Welfare*, 8, (2), 298-319.

Labonte, R. (1989). Community empowerment: The need for political analysis. *Canadian Journal of Public Health*, 80, 87-88.

Labonte, R. (1992). Health inequalities in Canada: Models, theory, and planning. *Health Promotion International*, 7, (2), 119-128.

Labonte, R. (1993). *Health promotion and empowerment: Practice frameworks*. Toronto: Centre for Health Promotion and ParticipACTION.

Labonte, R. (1995). Population health and health promotion: What do they have to say to each other? *Canadian Journal of Public Health*, 86, (3), 165-68.

Labonte, R. and Feather, J. (1996). *Handbook on using stories in health promotion practice.* Ottawa: Minister of Supply and Services.

Labonte, R. and Penfold, S. (1981). Canadian perspectives in health promotion: A critique. *Health Promotion*, 20, (2), 4-9.

Labonte, R. and Robertson, A. (1998). Delivering the goods, showing our stuff: The case for a constructivist paradigm for health promotion research and practice. In Thurston et al. (Eds.) *Doing health promotion research: The science of action* (pp. 41-63). University of Calgary Health Promotion Research Group.

Lalonde, M. (1974). *A new perspective on the health of Canadians.* Ottawa: Health and Welfare Canada.

Landau, R. (1995) Locus of control and socioeconomic states: Does internal locus of control reflect real resources and opportunities or personal coping abilities. *Social Science and Medicine*, 41, (11), 1499-1505.

Landsberg, M. (1988). In S. Crean (Ed.) *In the name of the fathers: The story behind child custody.* Toronto: Amenita Enterprises.

Lather, P. (1995). Feminist perspectives on empowering research methodologies. In Holland and Blair (Eds.) *Debates and issues in feminist research and pedagogy* (pp. 292-308). Clevendon: Multicultural Matters. The Open University.

Laurence, M. (1990). Womancare--health care: Power and policy. *Canadian Woman Studies*, 12, 31-34.

Lawry, S. (1987). Preface. In L.C. Scheinberg, N.J. Holland (Eds.). *Multiple sclerosis: A guide for patients and their families* (pp. vii-viii). New York: Raven Press.

Lazarus, R.S. and Folkman, S. (1984). *Stress, appraisal and coping.* New York: Springer.

Lee, R.P.L. (1996). Editorial. Traditional reaction to modern stress. *Social Science and Medicine*, 5, 639-641.

Leeflang, R.L.I., Klein-Hesselink, D.J., and Spruit, I.P. (1992). Health effects of unemployment-II. Men and women. *Social Science and Medicine*, 34, (4), 351-363.

Leiter, M. (1988). Commitment as a function of stress reactions among nurses: A model of psychological evaluations of work settings. *Canadian Journal of Community Mental Health*, 7, 117-133.

Lennon, M.C. (1994). Women, work and well-being: The importance of work conditions. *Journal of Health and Social Behavior*, 35, (Sept.), 235-247.

Lenny, J. (1993). Do disabled people need counselling? In J. Swain, V. Finkelstein, S. French, and M. Oliver (Eds.) *Disabling barriers—enabling environments* (pp. 233-240). London: Sage Publications.

Letts, L., Fraser, B., Finlayson, M., and Walls, J. (1993). *For the health of it! Occupational therapy within a health promotion framework.* Toronto: CAOT Publications ACE.

Levine, H. (1987). The personal is political: Feminism and the helping professions. In A. Miles and G. Finn (Eds.) *Feminism in Canada: From pressure to politics* (pp.175-209). Montreal: Black Rose Books.

Levy, S., Herberman, R., and Whiteside, T. (1990). Perceived social support and tumour estrogen/progesterone receptor status as predictors of natural killer cell activity in breast cancer patients. *Psychosomatic Medicine*, 52, 73-85.

Lincoln, Y.S. and Guba, E.G. (1985). *Naturalistic inquiry*. Newbury: Sage.

Linder, S. (1995). Contending discourses in the electric and magnetic fields controversy: The social construction of EMF risk as a public problem. *Policy Sciences*, 28, 209-230.

Lindsay, C. (1992). *Lone-parent families in Canada: Target groups project*. Ottawa: Statistics Canada.

Link, B.G., Lennon, M.C., and Dohrenwend, B.P. (1993). Socioeconomic status and depression: The role of occupations involving direction, control and planning. *American Journal of Sociology*, 98, (6), 1351-1387.

Link, B.G. and Phelan, J.C. (1994). Editorial: Understanding sociodemographic differences in health: The role of fundamental social causes. *American Journal of Public Health*, 86, (4), 471-473.

Lipson, J. (1991). Afghan refugee health: Some findings and suggestions. *Qualitative Health Research*, 1, (3), 349-369.

Lipson, J. (1992). The health and adjustment of Iranian immigrants. *Western Journal of Nursing Research*, 14 (1), 10-29.

Lloyd, B. (1987). My story, our story: No longer silently disabled. *Healthsharing*, Fall, 26-28.

Lloyd, M. (1992). Does she boil eggs? Towards a feminist model of disability. *Disability, Handicap and Society*, 7, (3), 207-221.

Lock, M. (1993). Ideology, female midlife, and the greying of Japan. *Journal of Japanese Studies*, 19, (1), 43-78.

Long, B.C. and Kahn, S.E. (1993). *Women, work and coping*. Montreal and Kingston: McGill-Queen's University Press.

Longino, H. (1987). Can there be a feminist science? *Hypatia*, 12, (3), 45-57.

Lonsdale, S. (1990). *Women and disability: The experience of physical disability among women*. New York: St. Martin's Press.

Lorber, J. (1994). *Paradoxes of gender*. New Haven: Yale University Press.

Lord, J. and Farlow, D.M. (1990). A study of personal empowerment: Implications for health promotion. *Health Promotion*, 29, (2), 2-8.

Lorde, A. (1986). The transformation of silence into language and action. *Sister outsider: Essays and speeches*. New York: The Crossing Press.

Love, R., Jackson, L., Edwards, R., and Pederson, A. (1997). *Gender and its relationship to other determinants of health*. Synthesis paper, 5th National Health Promotion Research Conference: Gender and Health. Dalhousie University, Halifax: Atlantic Health Promotion Research Centre.

Lowe, G. (1989). *Women, paid/unpaid work, and stress*. Ottawa: Canadian Advisory Council on the Status of Women.

Lugones, M. and Spelman, E. (1999). Have we got a theory for you! Feminist theory, cultural imperialism, and the demand for "the woman's voice". In J.P. Kourany, J.P. Sterba and R. Tong (Eds.) *Feminist philosophies* (pp.474-487). London: Prentice Hall.

Lupton, D. (1995). *The imperative of health: Public health and the regulated body*. Thousand Oaks: Sage.

Lyons, R.F. and Meade, L.D. (1993). The energy crisis: Mothers with chronic illness. *Canadian Woman Studies*, 13, (4), 34-37.

MacBride-King, J. (1990). *Work and family: Employment challenge of the '90s*. Ottawa: Conference Board of Canada.

Macdonald, C.L. (1996). Shadow mothers: Nannies, au pairs, and invisible work. In C.L. Macdonald and C. Sirianni (Eds.) *Working in the service society* (pp.243-263). Philadelphia: Temple University Press.

MacIntyre, S., Hunt, K., and Sweeting, H. (1996). Gender differences in health: Are things really as simple as they seem? *Social Science and Medicine*, 42, (4), 617-624.

MacMillan, T., Harmer, M., and Long, N. (1994). *Isolation among older adults*. Regional Municipality of Hamilton-Wentworth: Department of Health Services, Nursing Division, Seniors Program.

Macran, S., Clarke, L., and Joshi, H. (1996). Women's health: Dimensions and differentials. *Social Science and Medicine*, 42, (9), 1203-1216.

Maguire, P. (1987). *Doing participatory research: A feminist approach*. Amherst, Massachusetts: The Center for International Education.

Mairs, N. (1986). *Plaintext: Deciphering a woman's life*. Tucson, Arizona: University of Arizona Press.

Mairs, N. (1989). *Remembering the bone house*. New York: Harper Collins.

Mairs, N. (1990). *Carnal acts: Essays*. New York: Harper Collins.

Mairs, N. (1996). *Waist-high in the world: A life among the non-disabled*. Boston: Beacon Press.

Majumdar, B., Browne, G. and Roberts, J. (1995). The prevalence of multicultural groups receiving in-home service from three community agencies in Southern Ontario: Implications for culture sensitivity training. *Canadian Journal of Public Health*, 86, (3), 206-211.

Majumdar, B. and Ladak, S. (1998). Management of family and workplace stress experienced by women of colour from various cultural backgrounds. *Canadian Journal of Public Health*, 89, (1), 48-52.

Malec, C. (1993). The double objectification. *Canadian Women's Studies*, 13, (4), 22-23.

Maracle, L. (1994). Oratory. Coming to theory. In W. Waring (Ed.) *By, for and about: Feminist cultural politics* (pp. 235-240). Toronto: Women's Press.

Marcia, J. E. (1966). Development and validation of ego-identity status. *Journal of Personality and Social Psychology*, 3, (5), 551-558.

Marcia, J. E. (1967). Ego identity status: Relationship to change in self-esteem, "general maladjustment," and authoritarianism. *Journal of Personality*, 35, 118-133.

Mariniello, S. and Bove, P. (1998). *Gendered agents: Women and institutional knowledge*. London: Duke University Press.

Marchand, M.H. and Parpart, J. (1995). *Feminism/ postmodernism/ development*. New York: Routledge.

Marks, R. (1992). From slip! slop! slap! to sunsmart—the public health approach to skin cancer control in Australia in the 1990s. In R. Marks and G. Plewig (Eds.) *The environmental threat to the skin* (pp. 39-42). London: Martin Dunitz.

Markus, H. R., Mullally, P. R., and Kitayama, S. (1997). Selfways: Diversity in modes of cultural participation. In U. Neisser and D. A. Jopling (Eds.) *The conceptual self in context: Culture, experience, self-understanding* (pp. 13-61). Cambridge: Cambridge University Press.

Marmot, M.G., Rose, G., Shipley, J.J., and Hamilton, P.J.S. (1978). Employment grade and cornorary heart disease in British civil servants. *Journal of Epidemiology and Community Health*, 32, 244-240.

Marsh, E. (1989). *Black patent shoes; Dancing with MS.* Copetown, Ontario: Sideroad Press.

Marshall, C. and Rossman, G. (Eds.) (1989). *Designing Qualitative Research.* London: Sage Publications.

Martin Matthews, A. (1992). *Homemaker services to the elderly: Provider characteristics and client benefit.* Gerontology Research Centre, University of Guelph. Report prepared for the Ontario Ministry of Community and Social Services.

Martindale, K. (1994a). Can I get a witness? My lesbian breast cancer story. *Fireweed*, 42, 9-15.

Martindale, K. (1994b). Power, ethics and polyvocal feminist theory. In B. Godard (Ed.) *Collaboration in the feminine: Writings on women and culture* (pp. 108-119). Toronto: Second Story Press.

Mason, R. and Boutilier, M. (1996). The challenge of genuine power sharing in participatory research: The gap between theory and practice. *The Canadian Journal of Community Mental Health*, 15, (2), 145-152.

Maunsell, E. (1993). Social support and survival among women with breast cancer. Abstract. National Forum on Breast Cancer. Montreal.

Mawson, D. (1993). Implications for employment intervention and policy. In B. Long and S. Kahn (Eds.) *Women, work and coping: A multidisciplinary approach to workplace stress* (pp.51-72). Montreal: McGill-Queen's University Press.

Mayhew, C., Quinlan, M., and Bennett, L. (1996). *The effects of subcontracting/outsourcing on occupational health and safety.* Sydney, NSW, Australia: UNSW Studies in Australian Industrial Relations.

McDade, K. (1988). *Barriers to recognition of the credentials of immigrants in Canada.* Discussion paper no. 88-B1. Ottawa: Institute for Public Policy.

McDaniel, S.A. (1987). Women, work and health: Some challenges to health promotion. *Canadian Journal of Public Health*, 78, S9-S13.

McDaniel, S.A. (1988). Challenges to health promotion among older working women. *Canadian Journal of Public Health*, 79, S29-S32.

McGovern, P.M., Gjerdingen, D.K., and Froberg, D.G. (1992). The parental leave debate: Implications for policy relevant research. *Women and Health*, 18, (1), 97-118.

McGowan, T.G. (1994). Mentoring reminiscence: A conceptual and empirical analysis. *International Journal of Aging and Human Development*, 39, (4), 321-336.

McKeary, M. (1993). Gendered spaces: Health hazards of a hidden occupation. Paper presented at the annual meeting of the Canadian Sociology and Anthropology Association, Ottawa.

McKeen, C. and Bujaki, M. (1994). Taking women into account. *CA Magazine*, March, 29-35.

McKinnon, C. (1982). Feminism, marxism, method and the state. An agenda for theory. *Signs*, 7, (3), 543-562.

McLean, B. (1995). Social support, support groups and breast cancer: A literature review. *Canadian Journal of Community Mental Health*, 14, (2), 207-226.

McRobbie, A. (1991). *Feminism and youth culture*. London: McMillian.

McTaggart, R. (1991). Principles for participatory action research. *Adult Education Quarterly*, 41, (3), 168-187.

Meister, J. (1992). Keynote address: The more we get together. In H. Stewart, B. Percival and E.R. Epperly (Eds.) *The more we get together....* Charlottetown, P.E.I.: Gynergy Books and CRIAW.

Meleis, A. (1991). Between two cultures: Identity, roles and health. *Health Care Women International*, 12, (4), 365-377.

Mergler, D., Braband, C., Vezina, N., and Messing, K. (1987). The weaker sex? Men in women's working conditions report similar health symptoms. *Journal of Occupational Medicine*, 29, (5), 417-421.

Messias, H.A., Hall, J., and Melies, A.I. (1996). Voices of impoverished Brazilian women: Health implications and resources. *Women and Health*, 4, (1), 1-19.

Messing, K. (1991). *Occupational safety and health concerns of Canadian women*. Labour Canada Catalogue No. L016-1748/91E. Ottawa: Ministry of Labour, Women's Bureau.

Messing, K. (1995). Don't use a wrench to peel potatoes. Biological science constructed on male model systems is a risk to women worker's health. In S. Burt and L. Code (Eds.) *Changing methods: Feminist transforming practice* (pp. 217-265). Peterborough: Broadview Press.

Messing, K. (1997). Women's occupational health: A critical review and discussion of current issues. *Women and Health*, 25, (4), 39-68.

Messing, K., Neis, B., and Dumais, L. (Eds.) (1995). *Issues in women's occupational health: Invisible, la sante des travailleuses*. Charlottetown, PEI: Gynergy:

Meyer, C. (1985). A feminist perspective on foster family care: Redefinition of the categories. *Child Welfare*, 54, (3), 249-257.

Meyer, C. (1982). Issues for women in a women's profession. In Weick A. and Anadiver S. (Eds.) *Women, power and change* (pp. 187-205). Washington, D.C.: NASW.

Meyer, H. and Lee, M. (1978). *Women in traditionally male jobs: The experience of ten public utility companies*. R and D Monograph 65, US Department of Labour, E.T.A., Washington, D.C.

Mies, M. (1991). Women's research or feminist research? The debate surrounding feminist science and methodology. In M. Fonow and J. Cook (Eds.) *Beyond methodology: Feminist scholarship as lived research* (pp. 60-84). Bloomington: Indiana University Press.

Miles, A. (1991). *Women, health and medicine*. Milton Keynes: Open University Press.

Miller, A.G., Ashton, W.A., McHoskey, J.W., and Gimbel, J. (1990). What price attractiveness? Stereotype and risk factors in suntanning behavior. *Journal of Applied Social Psychology*, 20, (15), 1272-1300.

Miller, C. and Cummins, G. (1992). An examination of women's perspectives on power. *Psychology of Women Quarterly*, 16, (4), 415-428.

Miller L. and Findlay, D. (1994). Through medical eyes. The medicalization of women's bodies and women's lives. In B.S. Bolaria and H. D. Dickinson (Eds.) *Health, illness and health care in Canada*, 2nd edition (pp. 276-307). Toronto: Harcourt Brace and Co.

Miller, S.M., Blalock, J., and Ginsburg, H.J. (1984). Children and the aged: Attitudes, contact, and discriminative ability. *Aging and Human Development*, 19, 47-53.

Minister, K.A. (1991). Feminist frame for the oral history interview. In S. Berger Gluck and D. Patai (Eds.) *Woman's words*. New York: Routledge.

Minister of Supply and Services. (1990). *Selected Socio-economic Consequences of Disability for Women in Canada*. Ottawa: Queen's Printer.

Minister of Supply and Services Canada. (1994). *Strategies for population health: Investing in the health of Canadians*. Ottawa: Minister of Supply and Services Canada.

Ministry of Citizenship, Office of Disabled Persons. (1990). *Statistical profile of disabled persons in Ontario, volume II*. Toronto: Queens Printer.

Ministry of Health. (1992). *Goals and strategic priorities document*.

Ministry of Industry, Science and Technology. (1991). *Industry profile: Public accounting*. Ottawa.

Mitchell, A. (1997). Women's evolving role confuses Canadians. *Globe and Mail*. Sept. 17: A1, A10.

Mohanty, C.T. (1991). Introduction: Cartographies of struggle: Third world women and the politics of feminism. In Mohanty, C.T., Russo, A., and Torres, L. (Eds.) *Third world women and the politics of feminism*. Bloomington: Indiana University Press.

Monk, A. and Cryns, A.G. (1974). Predictors of voluntaristic intent among the aged. *Gerontologist*, 14, 425-429.

Montecinos, C. (1995). Culture as an ongoing dialogue: Implications for a multicultural teacher education. In Sleeter, C. and McLaren, P. (Eds.) *Multicultural education*. New York: SUNY Press.

Morgan, D.L. (1988). *Focus groups as qualitative research*. Thousand Oaks, Ca.: Sage Publications.

Morgan, D. L. (1995). Why things (sometimes) go wrong in focus groups. *Qualitative Health Research*, 5, (4), 516-523.

Morris, J. (1989). *Pride against prejudice: Transforming attitudes to disability*. London: The Women's Press Ltd.

Morris, J. (1992). Personal and political: A feminist perspective on research physical disability. *Disability, Handicap and Society*, 7, (2), 157-166.

Morris, J. (1993). Feminism and disability. *Feminist Review*, 43, Spring, 57-70.

Morris, J. (1995). Creating a space for absent voices: Disabled women's experience of receiving assistance with daily living activities. *Feminist Review*, 51, Autumn, 68-93.

Morissette, P. and Dedobbeleer, N. (1997). Is work a risk factor in the prescribed psychotropic drug consumption of female white-collar workers and professionals? *Women and Health*, 25, (4), 105-123.

Mothers On Trial. (1993). *Family Law = Family Violence*. Toronto, Ontario.

Mullings, L. (1984). Minority women, work and health. In W. Chavkin (Ed.) *Double exposure: Women's health hazards on the job and at home* (pp. 121-138). New York: Monthly Review Press.

Mustard, J.F. and Frank, J. (1991). *The determinants of health*. Toronto: Canadian Institute for Advanced Research, Population Health Program.

Muuss, R. E. (1975). *Theories of adolescence* (3rd ed.). New York: Random House.

Myles, H. and Tarrago, I. (1988). Some good long talks: Cross-cultural feminist practice. In S. Walters and L. Manicom (Eds.) *Gender in popular education* (pp. 181-202). London: Zed Books.

Naidoo, J. and Wills, J. (1994). *Health promotion: Foundations for practice*. London: Bailiere Tindall.

Nakagawa-Kogan, H. (1976). *Symptoms of stress inventory*. Washington: Management of Stress Response Clinic.

Naples, N.A. and Clark, E. (1996). Feminist participatory research and empowerment. In H. Gottfried (Ed.) *Feminism and social change* (pp. 160-183). Chicago: University of Illinois Press.

Narayan, U. (1988) Working together across difference: some considerations on emotions and political practice. *Hypatia*, 3, (2),31-47.

National Cancer Institute of Canada. (1997). *Canadian cancer statistics 1997*. Toronto: National Cancer Institute of Canada.

National Council of Welfare. (1993). *Poverty profile 1993*. Ottawa: Health and Welfare Canada. Spring.

Nault, F. (1997). Narrowing mortality gaps, 1978 to 1995. *Health Reports*, 9, (1), 35-41. Ottawa: Statistics Canada (Catalogue 82-003-XPB).

Navarro, V. (1986). *Crisis, health and medicine: A social critique*. New York: Tavistock.

Neis, B. (1995). Can't get my breath: Snow crab workers' occupational asthma. In K. Messing, B. Neis, and L. Dumais (Eds.) *Issues in women's occupational health: Invisible, la sante des travailleuses* (pp. 3-28). Charlottetown, PEI: Gynergy.

Neisser, U. (1997). Concepts and self-concepts. In U. Neisser and D. A. Jopling (Eds.) *The conceptual self in context: Culture, experience, self-understanding* (pp. 3-12). Cambridge: Cambridge University Press.

Nelson, D.L. and Hitt, M.A. (1992). Employed women and stress: Implications for enhancing women's mental health in the workplace. In J.C. Quick, L. Murphy, and J.J.Jr. Hurrell (Eds.) *Stress and well-being at work: Assessments and interventions for occupational mental health* (pp. 146-177). Washington, D.C.: American Psychological Association.

Nettleton, S. (1996). Women and the new paradigm of health and medicine. *Critical Social Policy*, 16, 33-53.

Neuling, S. (1988). Social support and recovery after surgery for breast cancer: Frequency and correlates of supportive behaviours by family, friends, and surgeon. *Social Science and Medicine*, 27, (4), 385-392.

Newman, S., Lyons, C.W., and Onawola, R.S.T. (1985). The development of an intergenerational service-learning program at a nursing home. *The Gerontologist*, 25, (2), 130-133.

Newman, S. and Ward, C. (1993). An observational study of intergenerational activities and behaviour change in dementing elders at adult day care centers. *International Journal of Aging and Human Development*, 36, (3), 253-265.

Neysmith, S. and Aronson, J. (1997). Working conditions in home care: Negotiating race and class boundaries in gendered work. *International Journal of Health Services*, 27, (3), 479-499.

Neysmith, S. and Nichols, B. (1994). Working conditions in homecare: Comparing three groups of workers. *Canadian Journal on Aging*, 3, (2), 170-186.

Ng, R. (1986). Immigrant women in Canada: A socially constructed category. *Resources for Feminist Research*, 15, (1), 13-15.

Ng, R. (1987). The social construction of immigrant women in Canada. In R. Hamilton and M. Barrett (Eds.) *The politics of diversity* (pp.269-287). Montreal: Book Centre.

Ng, R. (1993). Racism, sexism and immigrant women. In F. Burt and L. Dorney (Eds.) *Changing patterns: Women in Canada* (pp. 279-308). Toronto: MNS.

Ng, R. and Estable, A. (1987). Immigrant women in the labour force: An overview of present knowledge and research gaps. *Resources for Feminist Research*, 16, (1), 29-33.

Ng, R. and Gupta, T.D. (1981). Nation builders?—the captive labour force of non-English speaking immigrant women. *Canadian Women's Studies*, 13, (1), 83-85.

Ng, R. and Ramirez, C. (1981). Constituting ethnic phenomenon: An account from the perspective of immigrant women. *Canadian Ethnic Studies*, 13, (1), 97-108.

Nixon, H.L. (1984). Handicapism and sport: New directions for sport sociology research. In N. Theberge and P. Donnelly (Eds.) *Sport and the sociological imagination* (pp.162-176). Fort Worth, Texas: Texas Christian University Press.

Northcraft, G.B. and Gutek, B.A. (1993). Point-counterpoint: Discrimination against women in management—going, going, gone or going but never gone? In T. Fagenson (Ed.) *Women in management: Trends, issues and challenges in managerial diversity* (pp.219-245). Newbury Park, CA: Sage Publ.

Novak, M. (1993). *Aging and society: A Canadian perspective*. Scarborough: Nelson Canada.

Oakley, A. (1981). Interviewing women: A contradiction in terms. In H. Roberts (Ed.) *Doing feminist research* (pp. 30-61). London: Routledge and Kegan Paul.

Oakley, A. (1989). Smoking in pregnancy: Smokescreen or risk factor? Towards a materialist analysis. *Sociology of Health and Illness*, 11, (4), 311-335.

Oakley, A. (1992). *Social support and motherhood*. Oxford: Basil Blackwell.

Oakley, A. (1993). *Essays on women, medicine and health*. Edinburgh: Edinburgh University Press.

O'Brien, C. and Weir, L. (in press). Lesbians and gay men inside and outside families (ch 8). *Canadian families: Diversity, conflict and change*. Toronto: Harcourt Brace and Co.

O'Brien, E. (1995). Skin and the sun: How much is too much? *Canadian Journal of Continuing Medical Education*, 7, (7), 43-51.

O'Brien-Pallas, L. and Bauman, A. (1992). Quality of nursing work life issues—a unifying framework. *Canadian Journal of Nursing Administration*, May/June, 12-16.

O'Connor, M. (1995). Les femmes et l'augmentation de travail non-recensé (women and the increase in invisible labour). Paper presented at the annual conference of l'Association Latine pour l'analyse de systèmes de santé, Montreal, May.

O'Connor, M., Denton, M., Hajdukowski Ahmed, M., Williams, K., and Zeytinoglu, I.U. (1998). Women and health promotion: A feminist participatory model. In W.E. Thurston, J.D. Sieppert, and V.J. Wiebe (Eds.) *Doing health promotion research: The science of action* (pp.63-80). Calgary: Health Promotion Research Group, University of Calgary.

O'Connor, M., Low, J., and Shelley, J. (1996). *Support needs for women with multiple sclerosis*. MRCPOWH Technical Report Series #2. Hamilton: McMaster Research Centre for the Promotion of Women's Health.

Offerman, L.R. and Armitage, M. (1993). Stress and the woman manager: Sources, health outcomes, and interventions. In T. Fagenson (Ed.) *Women in management: Trends, issues and challenges in managerial diversity* (pp. 131-160). Newbury Park, CA: Sage Publ.

O'Hearn, C. (Ed.) (1998). *Half and half.* New York: Pantheon Books.

Okley, J. (1994). Thinking through fieldwork (ch.1). In A. Bryman and R. Burgess (Eds.) *Analyzing qualitative data* (pp. 18-34). London: Routledge.

Oliver, M. (1983). *Social work with disabled people.* London: MacMillan Press.

Oliver, M. (1990). *The politics of disablement: A sociological approach.* New York: St. Martin's Press.

OML (Ontario Ministry of Labour). (1985). *VDT workstations: Layout and lighting.* Toronto: Ontario Ministry of Labour.

O'Neill, M. (1996). La promotion de la sante au Canada au XXI siecle: Quel Canada? Quelle sante? Quelle promotion? Unpublished paper.

O'Neill, M. (1998). Appropriate methodological attitudes for conducting health promotion research. In W. Thurston et al. (Eds.) *Doing health promotion research. The science of action* (pp. 15-27). Health Promotion Research Group. University of Calgary.

Ontario Premier's Council on Health Strategy. (1991). *Towards a strategic framework for optimizing health.* Toronto: The Council.

Opie, A. (1992). Qualitative research, appropriation of the 'other' and empowerment. *Feminist Review,* 40, 52-69.

Ornelas, A. (1997). Pasantias and social participation: Participatory action research as a way of life. In S. Smith and D. Willms and N. Johnson (Eds.) *Nurtured by knowledge: Learning to do participatory action research* (pp. 138-172). New York: Apex.

Orton, H.J. and Rosenblatt, E. (1991). *Progress in prevention.* Report No. 2 Planned Parenthood, Ontario.

Overholser, J. C., Norman, W. H. and Miller, I. W. (1990). Life stress and social supports in depressed inpatients. *Behavioural Medicine,* 6, 125-132.

Ozawa, M. and Law, S. (1993). Earnings history of social workers: A comparison to other professional groups. *Social Work,* 38, (5), 542-551.

Palmer, S. (1995). *Maintaining family ties: Inclusive practice in foster care.* Washington, D.C.: Child Welfare League of America.

Pandakur, K. and Pandakur, R. (1996). *The colour of money: Earning differentials among ethnic groups in Canada.* Ottawa: Department of Canadian Heritage.

Paredes, M. (1987). Immigrant women and second language education: A study of unequal access to linguistic resources. *Resources for Feminist Research,* 16, (1), 23.

Park, P., Brydon-Miller, M., Hall, B., and Jackson, T. (Eds.) (1993). *Voices of change: Participatory research in the U.S. and Canada.* Toronto: OISE Press.

Pasmore, W. and Friedlander, F. (1982). An action-research program for increasing employee involvement in problem solving. *Administrative Science Quarterly,* 27, 343-362.

Peacock, W.E. and Talley, W.H. (1984). Intergenerational contact: A way to counteract ageism. *Educational Gerontology,* 10, 13-24.

Pennock, M., Westmorland, M., and Baker, M. (1994). Work-Able Services Inc. Labour market intelligence project. Funded by Jobs Ontario. Mimeo.

Perez-Foster, R.M. (1996). The bilingual self: Duet in two voices. *Psychoanalytic Dialogues,* 16, (1), 99-111.

Peters, B. (1991). Disparate voices: The magic show of sociology. *The American Sociologist,* Fall/Winter, 246-260.

Peters, S.L. (1993). Having a disability 'sometimes'. *Canadian Woman Studies*, 13, (4), 26-27.

Phinney, J. S. (1990). Ethnic identity in adolescents and adults: Review of research. *Psychological Bulletin*, 108, (3), 499-514.

Phoenix, A. (1991). Mothers under twenty: Outsider and insider views. In A. Phoenix, A. Woollett, and E. Lloyd (Eds.) *Motherhood: Meanings, practices and ideologies* (pp. 86-102). London: Sage.

Poland, B., Coburn, D., Robertson, A., and Eakin, J. (1998). Wealth, equity and health care: A critique of a 'population health' perspective on the determinants of health. *Social Science and Medicine*, 46, (7), 785-798.

Polanyi, L. (1981). What stories can tell us about their teller's world. *Poetics Today*, 2, (2), 91-112.

Polit, D. P. and Hungler, B. P. (1997). *Essentials of nursing research methods, appraisal and utilization* (4th ed). New York: Lippincott.

Pond, M. (1992). The perceptions and experiences of newcomers to Canada in English as a second language. M.A. Thesis, McMaster University.

Poser, C.M. (1987). Epidemiolgy and genetics of multiple sclerosis. In L.C. Scheinberg and N.J. Holland (Eds.) *Multiple sclerosis: A guide for patients and their families* (2nd Edition) (pp.3-12). New York: Raven Press.

Poser, C.M. and Aisen, M. (1987). Signs and symptoms of multiple sclerosis. In L.C. Scheinberg and N.J. Holland (Eds.) *Multiple sclerosis: A guide for patients and their families* (2nd Edition) (pp. 25-42). New York: Raven Press.

Posterski, D. and Bibby, R, (1988) *Canada's youth: ready for today*. Canadian Youth Foundation, Ottawa.

Prentice, A., Bourne, P., Cuthbert-Brandt, G., Light, B., Mitchinson, W., and Black, N. (1996). *Canadian women: A history*. Toronto: Harcourt, Brace, Jovanovich.

Primono, J. and Yates, B. (1990). Social support for women during chronic illness: The relationship among sources and types to adjustment. *Research in Nursing and Health*, 13, 153-161.

Pugliesi, K. (1992). Women and mental health: Two traditions of feminist research. *Women and Health*, 19, (2/3), 43-68.

Pugliesi, K. (1995). Work and well-being: Gender differences in the psychological consequences of employment. *Journal of Health and Social Behavior*, 36, (March), 57-71.

Quinn, P. (1994). America's disability policy: Another double standard? *Affilia*, 9, (1), 45-59.

Racism and Gender. (1994). *Canadian Women Studies/Les cahiers de la femme*, 14, (2).

Raeburn, J. and Rootman, I. (1998). *People-centered health promotion*. Toronto: John Wiley and Sons.

Rains, J.W. and Ray, D.W. (1995). Participatory action research for community health promotion. *Public Health Nursing*, 12, (4), 256-261.

Ralph, D. (1988). Researching from the bottom: Lessons participatory research has for feminists. *Canadian Review of Social Policy/ Revue canadienne de politique sociale*, 22, 36-40.

Ramkhalawansingh, C. (1981). Language and employment training for immigrant women. *Canadian Ethnic Studies*, 13, (1), 91-96.

Ramsay, H. (1994). Lesbians and the health care system: Invisibility, isolation and ignorance. You say you are what? *Canadian Women's Studies*, 14, (3), 29-33.

Rappaport, J. (1984). Studies in empowerment: Introduction to the issue. *Prevention in Human Services*, 3, 1-7.

Razack, S. (1998). The gaze from the other side: Storytelling for social change. *Looking white people in the eye: Gender, race and culture in courtrooms and classrooms*. Toronto: University of Toronto Press.

Reinharz, S. (1992). *Feminist methods in social research*. Oxford: Oxford University Press.

Reinharz, S. (1993). Neglected voices and excessive demands in feminist research. *Qualitative Sociology*, 1, 69-76.

Report on the Health of Canadians. Health Canada, 1996.

Rerales, C. and Young, L.S. (1988). *Too little too late: Dealing with the health needs of women in poverty*. New York: Harrington Park Press.

Responding to diversity in the metropolis: Building an inclusive Research agenda. (1997). Proceedings of the First Metropolis National Conference on Immigration. Edmonton, Alberta.

Rice, J. (1990). Volunteering to build a stronger community. *Perception*, 14, (4), 9-14.

Richmond, A. (1982). *Comparative studies in the economic adaptation of immigrants in Canada*. Toronto: York University, Institute of Behavioural Research.

Ridington, J. (1989a). *Who do we think we are?: Self-image and women with disabilities*. Vancouver: DisAbled Women's Network Canada.

Ridington, J. (1989b). *Beating the "odds": Violence and women with disabilities*. Vancouver: DisAbled Women's Network Canada.

Ridington, J. (1989c). *The only parent in the neighbourhood: Mothering and women with disabilities*. Vancouver: Disabled Women's Network Canada.

Ridington, J. (1989d). *Different therefore unequal? Employment and women with disabilities*. Vancouver: Disabled Women's Network Canada.

Riessman, C.K. (Ed.) (1994). *Qualitative studies in social work research*. California: Sage.

Ristock, J.L. and Pennell, J. (1996). *Community research as empowerment: Feminist links, postmodern interruptions*. Oxford: Oxford University Press.

Roberts, H. (1990). *Women's health counts*. London: Routledge.

Roberts, H., Smith, S., and Lloyd, M. (1992). Safety as social value: A community approach In S. Scott, G. Williams, S. Platt, and H. Thomas (Eds.) *Private risks and public dangers*. (pp. 184-200). Aldershot: Avebury.

Robertson, A. and Minkler, M. (1994). New health promotion movement: A critical examination. *Health Education Quarterly*, 21, (3), 295-312.

Robinson, I. (1988). *Multiple sclerosis*. London: Routledge.

Robson, S. (1992). Women at work. *Practitioner*, 236, 133-137.

Rodmell, S. and Watt, A. (Eds.) (1986). *The politics of health education*. London: Routledge and Kegan Paul.

Rollins, J. (1996). Invisibility, consciousness of the other and resentment among Black domestic workers. In C.L. Macdonald and C. Sirianni (Eds.) *Working in the service society* (pp.223-243). Philadelphia: Temple University Press.

Roman, C., Juhasz, S., and Miller, C. (1994). *The women and language debate*. New York: Rutgers University Press.

Roman, E., Doyle, P., Ansell, P., Bull, D., and Beral, V. (1996). Health of children born to medical radiographers. *Occupational and Environmental Medicine*, 53, (2), 73-79.

Rosenberg, H. (1990). The home is the workplace: Hazards, stress and pollutants in the household. In M. Luxton, S. Rosenberg, and S. Arat-Koc (Eds.) *Through the kitchen window: The politics of home and family*, 2nd Ed (pp. 57-80). Toronto: Garamond Press.

Rosenberg, M. (1965). *Society and the adolescent self-image*. Princeton, New Jersey: Princeton University Press.

Rosenthal, D. A. (1987). Ethnic identity development in adolescents. In J. S. Phinney and M. J. Rotheram (Eds.) *Children's ethnic socialization: Pluralism and development* (pp. 157-179). Newbury Park, CA: Sage Publications.

Rosenthal, D. A. and Feldman, S. S. (1992). The nature and stability of ethnic identity in Chinese youth: Effects of length of residence in two cultural contexts. *Journal of Cross-Cultural Psychology*, 23, (2), 214-227.

Rosenthal, D.B. (1996). Rheumatoid arthritis and household work limitations in women. *Work: A Journal of Prevention, Assessment and Rehabilitation*, 6, 33-40.

Ross, C.E. and Bird, C.E. (1994). Sex stratification and health lifestyle: Consequences for men's and women's perceived health. *Journal of Health and Social Behavior*, 35, (June), 161-178.

Ross, D. (1990). *Economic dimensions of volunteer work in Canada*. Ottawa: Minister of Supply and Services Canada.

Russell, M.N. (1989). Feminist social work skills. *Canadian Social Work Review*, 6, (1), 69-81.

Russell, S. (1985). Social dimensions of disability: Women with MS. *Resources for Feminist Research*, 14, (1), 56-58.

Ruth, S. (1998). *Issues in feminism*. Mountain View, CA: Mayfield Publishing Company.

Rutten, A. (1995). The implementation of health promotion: A new structural perspective. *Social Science and Medicine*, 41, (12), 1627-1637.

Saint-Germain, M.A., Bassford, R. L., and Montans, G. (1993). Surveys and focus groups in health research with older Hispanic women. *Qualitative Health Research*, 3, (3), 341-343.

Satzevich, V. (Ed.) (1992). *Deconstructing a nation: Immigration, multiculturalism and racism in the 90s*. Halifax: Fernwood.

Schamess, G. (1990) Towards an understanding of the etiology and treatment of psychological dysfunction among single teenage mothers: Parts 1 and 2. Smith College. *Study in Social Work*, 60, (2-3), 153-156, 245-262.

Scheinberg, L.C. and Holland, N.J. (Eds.) (1987). *Multiple sclerosis: A guide for patients and their families* (2nd Edition). New York: Raven Press.

Scheinberg, L.C. and Geisser, B.S. (1987). Drug therapy. In L.C. Scheinberg and N.J. Holland (Eds.) *Multiple sclerosis: A guide for patients and their families* (2nd Edition) (pp.53-66). New York: Raven Press.

Scheinberg, L.C. and Smith, C.R. (1987). Signs and symptoms of multiple sclerosis. In L.S. Scheinberg and N.J. Holland (Eds.) *Multiple sclerosis: A guide for patients and their families* (2nd Edition) (pp.43-52). New York: Raven Press.

Schor, J. (1991). *The overworked American*. New York: Basic Books.

Schwartz, F. (1992). *Breaking with tradition*. New York: Warner Books.

Schuster, M. (1995a) Impact of July 21st provincial statement on Hamilton-Wentworth:Social Services, Report to Health and Social Service Committee. Hamilton: Region of Hamilton-Wentworth, August 3.

Schuster, M. (1995b) Jobs Ontario child care spaces. Report to Health and Social Services Committee. Hamilton: Region of Hamilton-Wentworth, September 6.

Scott, J. (1992). Experience. In J. Butler and J. Scott (Eds.) *Feminists theorize the political*. New York: Routledge: 22-41.

Scott, K. (1993). Women, education and disability research project. *Canadian Woman Studies/ Les cahiers de la femme*, 13, (4), 93-95.

Senior Key Informant Survey. (1991). Hamilton-Wentworth Department of Public Health Services.

Seniors' Community Forum Report. (1993). Hamilton-Wentworth Department of Public Health Services: Nursing Division, Seniors Program.

Seward, S.B. and McDade, K. (1988). A new deal for immigrant women. *Policy Options Politiques*, 9, (5), 15-18.

Seward, S.B. and Tremblay L. (1989). *Immigrants in the labour force: Their role in structural change*. Ottawa: Institute for Research in Public Policy.

Shaul, S., Dowling, P., and Laden, B. (1981). Like other women: Perspectives of mothers with physical disabilities. *Journal of Sociology and Social Welfare*, 8, (2), 364-374.

Sherrill, C. (1993). Women with disabilities. In G.L. Cohen (Ed.) *Women in sport: Issues and controversies* (pp. 238-248). Newbury Park: Sage Publications Inc.

Sidell, M. (1993). Interpreting. In P. Shakespeare, D. Atkinson, and S. French (Eds.) *Reflecting of research practice: Issues in health and social welfare* (pp. 106-118). Buckingham: Open University Press.

Simard, P., O'Neill, M., Frankish, K. George, A., Daniel, M., and Doyle-Walters, M. (1997). Guide de réflexion sur la recherche participative en promotion de le santé au Canada francophone. Préparé pour la direction du développement de la promotion de la santé de Santé-Canada, par le groupe de recherche et d'intervention en promotion de la santé de l'université Laval.

Simkin, R. (1993). Unique health care concerns of lesbians. *The Canadian Journal of Ob/ Gyn and Women's Health Care*, 5, (5), 516-522.

Simon, B.K. (1986). Never-married women as caregivers to elderly parents: Some costs and benefits. *Affilia*, 9, 29-42.

Skillen, D.L. (1995). Nurses' work hazards in public health units. In K. Messing, B. Neis, and L. Dumais (Eds.) *Issues in women's occupational health: Invisible, la sante des travailleuses* (pp. 150-173). Charlottetown. PEI: Gynergy.

Smeltzer, S.C. (1994). The concerns of pregnant women with multiple sclerosis. *Qualitative Health Research*, 4, (4), 480-502.

Smith, B.E. (1981). Black lung: The social production of disease. *International Journal of Health Services*, 11, (3), 343-359.

Smith, D. (1986). Institutional ethnography. *Resources for Feminist Research*, 15, 6-13.

Smith, D.E. (1987). *The everyday world as problematic: A feminist sociology*. Toronto: University of Toronto Press.

Smith, M. W. (1995). Ethics in focus groups: A few concerns. *Qualitative Health Research*, 5, (4), 478-486.

Smith, S. (1997). Deepening participatory action research. In Smith, S., Willms, D., and Johnson, N. (Eds.) *Nurtured by knowledge: Learning to do particpatory action research* (pp. 173-263). New York: The Apex Press.

Smith, S. E., Pyrch, T., and Lizardi, A. O. (1993). Participatory action research for health. *World Health Forum*, 14, 319-324.

Smith, V. (1998). Corporate culture: A delicate balance for women. *Globe and Mail*. Feb. 7: D1, D3.

Sohng, S. (1996) Participatory research and community organizing. *Journal of Sociology and Social Welfare*, 23, 77-97.

Solomon, C. (1994). Work/family's failing grade: Why today's initiatives aren't enough. *Personnel Journal*, 91, 72-83.

Spalding, A.D. (1995). Racial minorities and their high-risk groups with HIV and AIDS at increased risk for psychological adjustment problems in association with health locus of control orientation. *Social Work in Health Care*, 21, (3), 81-114.

Spencer, M. (1996). *Foundations of modern sociology*, 7th ed. Scarborough, ON: Prentice-Hall Canada Inc.

Spiegel, D., Bloom, J., and Kraemer, J. (1989). Effects of psychosocial treatment on survival of patients with metastatic breast cancer. *The Lancet*, 2, (8668), 888-891.

Spitzer, D. (1995). Innovating in hard times: Reflections and some thoughts for the future. *Health and Cultures*, 11, (2), 1.

Spivak, G. (1990). *The post-colonial critic: Interviews, strategies, dialogues*. New York: Routledge.

Sprout, J. and Yassi, A. (1995). Occupational health concerns of women who work with the public. In K. Messing, B. Neis, and L. Dumais (Eds.) *Issues in women's occupational health: Invisible, la sante des travailleuses* (pp. 104-124). Charlottetown, PEI: Gynergy.

St Hilaire, C. (1993). Femme blanche et Canadian aux philippines. Une reflexion sur nos pratiques feministes de developpement. In M. Assheton and B. Spronk (Eds.) *Women and social locations. Nos vies, nos recherches. Reflet de notre societe* (pp.145-155). Criaw/ICREF.

Stacey, J. (1988). Can there be a feminist ethnography? *Women's Studies International Forum*, 11, (1), 21-27.

Stacey, J. (1996). Can there be a feminist ethnography? In H. Gottfried (Ed.) *Feminism and social change. Bridging theory and practice* (pp.88-105). Illinois: University of Illinois Press.

Stanley, L. and Wise, S. (1983). *Breaking out: Feminist consciousness and feminist research*. London: Routledge and Kegan Paul.

Stanley, L. and Wise, S. (1990). Method, methodology and epistomology in feminist research processes. In L. Stanley and S. Wise (Eds.) *Feminist praxis: Research, theory and epistomology in feminist scholarship* (pp. 20-60). London: Routledge.

Statistics Canada. (1987). *National survey on volunteer activity*. The Special Surveys Group, Statistics Canada.

Statistics Canada. (1991). *Immigration and citizenship*. Census.

Statistics Canada. (1992). *Labour force survey*. Ottawa: Bureau of Statistics.

Statistics Canada, (1993) *Fertility*. Ottawa: Industry, Science and Technology Canada, 1991 Census of Canada. Catalogue Number 93-321.

Statistics Canada. (1995a). *National population health survey overview 1994-95*. Ottawa: Minister of Industry. Catalogue no. 82-567.

Statistics Canada. (1995b) National Council of Welfare. *Poverty Profile 1993*, Spring.

Statistics Canada. (1995c). *Women in Canada: A Statistical Report* 3rd edition. Minister of Industry. Canada.

Statistics Canada. (1996a). *Births and deaths, 1995*. (Catalogue 84-210-XPB) Ottawa: Minister of Industry.

Statistics Canada. (1996b). *Focus on Canada: Canada's changing immigrant population*. Catalogue no. 96-311E. Statistics Canada and Prentice Hall Canada Inc.

Statistics Canada. (1998). [cited 1999 January 5]. *Single and multiple ethnic origin responses, 1996 Census*. [On-line]. Available URL: http://www.statcan.ca:80/english/Pgdb/People/ Population/demo28b.htm

Stein, J. (1997). Fact sheet: Major causes of death in Canada, 1993-1995. *Chronic Diseases in Canada*, 18, (2), 91-92.

Stenberg, B. and Wall, S. (1990). Why do women report 'sick building symptoms' more often than men? *Social Science and Medicine*, 40, (4), 491-502.

Stephens, C. and Smith, M. (1996). Occupational overuse syndrome and the effects of psychosocial stressors on keyboard users in the newspaper industry. *Work and Stress*, 10, (2), 141-153.

Stevens, E.S. (1991). Toward satisfaction and retention of senior volunteers. *Journal of Gerontological Social Work*, 16, (3/4), 33-41.

Stevens, P. E. (1996). Focus groups: Collecting aggregation level data to understand community health phenomena. *Public Health Nursing*, 13, (3):170-176.

Stimpson, L. and Best, M.C. (1991). *Courage above all: Sexual assault against women with disabilities*. Toronto: DisAbled Women's Network.

Stivers, C. (1993). Reflections on the role of personal narrative in social science. *Signs*, 18, (2), 408-421.

Stock, S. (1995). A study of musculoskeletal symptoms in daycare workers. In K. Messing B. Neis, and L. Dumais (Eds.) *Issues in women's occupational health: Invisible, la sante des travailleuses* (pp.62-74). Charlottetown, PEI: Gynergy.

Stoller, E. (1993). Gender and the organization of lay health care: A socialist-feminist perspective. *Journal of Aging Studies*, 7, (2), 151-170.

Strong-Boag, V. (1986). Keeping house in God's country: Canadian women at work in the home. In C. Heron and R. Storey (Eds.) *On the job: Confronting the labour process in Canada* (pp.124-151). Kingston, ON: McGill-Queen's University Press.

Strong-Boag, V. (1995). Their side of the story: Women's voices from Ontario suburbs, 1945-1960. In J. Parr (Ed.) *A diversity of women* (pp.46-75). Toronto: University of Toronto Press.

Stuifbergen, A.K. and Rogers, S. (1997). Health promotion: An essential component of rehabilitation for persons with chronic disabling conditions. *Advances in Nursing Science*, 19, (4), 1-20.

Sundquist, J. (1993). Ethnicity as a risk fact for mental illness. *Acta Psychiatrica Scandinavica*, 87, (3), 208-212.

Sundquist, J. (1995). Ethnicity, social class and health. A population-based study on the influence of social factors on self-reported illness in 223 Latin American refugees, 333 Finnish and 126 south European labour migrants and 841 Swedish controls. *Social Science and Medicine*, 40, 777-787.

Suprin, R., Haslanger, K., and Dawson, S. (1994). Quality paraprofessional home care. *Caring*, (April), 12-22.

Susman, G. and Evered, R. D. (1978). An assessment of the scientific merits of action research. *Administrative Science Quarterly*, 23, 582-603.

Swift, K. (1991). Contradictions in child welfare: neglect and responsibility. In C. Baines, P. Evans, and S. Neysmith (Eds.) *Women's caring* (pp.234-271). Toronto: McClelland and Stewart.

Swift, K. (1995). Missing persons: Women in child welfare. *Child Welfare*, 74, (3), 486-502.

Swigonski, M.E. (1994). The logic of feminist standpoint theory for social work research. *Social Work*, 39, (4), 387-393.

Swigonski, M.E. (1996). Women, poverty, and welfare reform: A challenge to social workers. *Affilia*, 11, (1), 95-110.

Tandon, R. (1991). Participatory research in the empowerment of people. *Convergence*, 14, (3), 20-29.

Taylor, C. (1983). *Social theory as practice*. Oxford: Oxford University Press.

Taylor, C. (1992). *Multicuturalisme. Différence et démocratie*. Paris-Aubier.

Taylor, G., Barnsley, J., and Goldsmith, P. (1996). *Women and children last: Custody disputes and the family "justice" system*. Vancouver: Best Book Manufacturers.

Taylor, S.M. (1993). Geography of urban health. In L.S. Bourne and D.F. Ley (Eds.) *The changing social geography of Canadian cities* (pp. 309-325). Montreal and Kingston: McGill-Queen's University Press.

Taylor, S. (1994). Communicating for empowerment: Women's initiatives to overcome poverty in rural Thailand and Newfoundland. In P. Riano P. (Ed.) *Women in grassroots communication: Furthering social change*. Newbury Park: Sage.

Teghtsoonian, K. (1997). Who pays for caring for children? Public policy and the devaluation of women's work. In S. Boyd (Ed.) *Challenging the public/private divide: Feminism, law and public policy* (pp. 113-143). Toronto: University of Toronto Press.

Teiger, C. (1995). Les barrieres cachees a l'integration securitaire des femmes au travail. In K. Messing, B. Neis, and L. Dumais (Eds.) *Issues in women's occupational health: Invisible, la sante des travailleuses* (pp. 202-216). Charlottetown, PEI: Gynergy.

Theriot, B. (1993). Women's voices in nineteenth-century medical discourse: A step towards deconstructing science. *Signs*, 19, (1), 1-31.

Thompson, S.C. and Spacapan, S. (1991). Perceptions of control in vulnerable populations. *Journal of Social Issues*, 47, (4), 1-21.

Thornton, H.B. and Lea, S.J. (1992). An investigation into needs of people living with multiple sclerosis and their families. *Disability, Handicap and Society*, 7, (4), 321-338.

Thurston, W.E. and O'Connor, M. (1996). Health promotion for women: A Canadian perspective. In Canada/USA Women's Health Forum, *Preventive health promotion strategies* (pp. 1-24). Ottawa: Canada/USA Women's Health Forum.

Thurston, W.E., Scott, C., and Crow, B. (1997). Social change, policy development and the influence on women's health. Presented at the Fifth National Health Promotion Research Conference, Dalhousie University.

Thurston, W.E., Sieppert, D., and Wiebe, V.J. (1998). *Doing health promotion research: The science of action*. Health Promotion Research Group, University of Calgary.

Tierney, D., Romito, P., and Messing, K. (1990). She ate not the bread of idleness: Exhaustion as related to domestic and salaried working conditions among 539 Quebec hospital workers. *Women and Health*, 16, (1), 21-42.

Tobacyk, J. J. and Tobacyk, Z. S. (1992). Comparisons of belief-based personality constructs in Polish and American university students. *Journal of Cross-Cultural Psychology*, 23, (3), 311-325.

Tom, A. (1993). Women's lives complete: Methodological concerns. In B. Long and S. Kahn (Eds.) *Women, work and coping: A multidisciplinary approach to workplace stress* (32-50). Montreal: McGill-Queen's University Press.

Tomm, W. (Ed.) (1989). *The effects of feminist approaches on research methodologies*. Waterloo, ON.: Wilfrid Laurier University Press.

Toombes, S.K. (1992). *The meaning of illness: A phenomenological account of the different perspectives of physician and patient*. Dordrecht: Kluwer Academic Publisher.

Townsend, P., Davidson, N., and Whitehead, M. (1992). *Inequalities in health: The Black report and health divide*. Harmondsworth: Penguin.

Tremain, S. (1992). *Peeling off the labels: Women, sexuality and disability*. Toronto: DisAbled Women's Network.

Trinh Minh-Ha (1986). *Woman, native, other: Writing postcoloniality and feminism*. Bloomington: Indiana University Press.

Trollope, K. (1996). *Towards indigenous notions of women's empowerment in India*. MRCPOWH Working Paper 4, McMaster University.

Trovato, F. and Grindstaff, K. (1986). *Economic status: A census analysis of immigrant women at age 30 in Canada*. Discussion Paper, Department of Sociology, University of Western Ontario.

Turner, H. (1992). Older volunteers: An assessment of two theories. *Educational Gerontology*, 18, 41-55.

Ungerson, C. (Ed.) (1991). *Gender and caring*. London: Harvester Wheatsheaf.

Valentich, M. (1986). Feminist theory. In F.J. Turner (Ed.) *Social work treatment* (pp.564-589). New York: The Free Press.

Verbrugge, L. (1980). Health diaries. *Medical Care*, 18, (1), 73-95.

Verbrugge, L. (1989). Gender, aging and health. In S.K. Markides (Ed.) *Aging and health: Perspectives on gender, race, ethnicity, and class* (pp. 23-77). Newbury Park, CA: Sage.

Vertinsky, P. (1992). *The role of women in a healthy university (or from pathology and intervention to involvement and empowerment)*. Occasional Working Papers in Women's Studies and Gender Relations #1. Vancouver: University of British Columbia: The Centre for Research in Women Studies and Gender Relations.

Vezina, N., Courville, J., and Geoffrion, L. (1995). Problemes musculo-squelletiques, caracteristiques des postes des travailleurs et des postes des travailleuses sur une meme

chaine de decoupe de dinde. In K. Messing, B. Neis, and L. Dumais (Eds.) *Issues in women's occupational health: Invisible, la sante des travailleuses* (pp. 29-61). Charlottetown, PEI: Gynergy.

Villeneuve, M., Semogas, D., Peereboom, E., Irvine, D., McGillis-Hall, L., Walsh, S., O'Brien-Pallas, L., and Baumann, A. (1995). *The work life concerns of Ontario nurses*. McMaster University, Hamilton, Ontario: Quality of Nursing Work life Research Unit, Working Paper.

Vinovskis, M. (1988). *An epidemic of adolescent pregnancy? Some historical and policy considerations*. New York: Oxford University Press.

Von Kotze, A., S. Walters and L. Manicom. (1991). The creaking of the word: A feminist model. *Gender in Popular Education* (pp. 149-169). London: Zeol.

Wadera, S. and Strachan, J. (1991) Teenage pregnancies in Canada 1975-1989. *Health Reports*, 3, (4), 327-347.

Waitzkin, H. (1983). *The second sickness: Contradictions of capitalist health care*. New York: Free Press.

Walsh, D.C., Sorenson, G., and Leonard, L. (1995). Gender, health and cigarette smoking. In B.C. Amick, S. Levine, A.S. Tarlov, and D.C. Walsh (Eds.) *Society and health* (pp.131-171). New York: Oxford University Press.

Walcott-McQuigg, J. (1994). Worksite stress: Gender and cultural diversity issues. *AAOHN Journal*, 42, (11), 528-533.

Walters, V. (1991). Beyond medical and academic agendas: Lay perspectives and priorities. *Atlantis*, 1, (2), 29-34.

Walters, V. (1992a). Women's views on their main health problems. *Canadian Journal of Public Health*, 83, (5), 371-374.

Walters, V. (1992b). Stress, anxiety and depression: Women's accounts of their health problems. *Social Science and Medicine*, 36, 393-402.

Walters, V. (1994). Women's perceptions regarding health and illness. In B.S. Bolaria and H. Dickinson (Eds.) *Health, illness, and healthcare in Canada* (pp.307-326). Toronto: Harcourt Brace.

Walters, V. and Denton, M. (1994). Common themes and variations in women's own accounts of their main health problems. A report on a Canadian study. (Unpublished).

Walters, V., Lenton, R., French, S., Eyles, J., Mayr, J. and Newbold, B. (1996). Paid work, unpaid work and social support: a study of the health of male and female nurses. *Social Science and Medicine*, 43, (11), 1627-1636.

Walters, V., Lenton, R., and McKeary, M. (1995a). *Women's health in the context of women's lives: A report submitted to the health promotion directorate, Health Canada*. Ottawa: Minister of Supply and Services Canada.

Walters, V., Beardwood, B., Eyles, J., and French, S. (1995b). Paid and unpaid work roles of male and female nurses. In K. Messing, B. Neis, and L. Dumais (Eds.) *Issues in women's occupational health: Invisible, la sante des travailleuses* (pp. 125-149). Charlottetown, PEI: Gynergy.

Walters, V. and Denton, M. (1997). Stress, depression and tiredness among women: The social production and social construction of health. *Canadian Review of Sociology and Anthropology*, 31, (1), 53-70.

Ward-Griffin, C. and Ploeg, J. (1997). A feminist approach to health promotion for older women. *Canadian Journal on Aging*, 6, (2), 279- 296.

Waring, W. (Ed.) (1994). *By, for and about feminist cultural politics*. Toronto: Women's Press.

Watson, J., Cunningham-Burley, S., Watson, N., and Milburn, K. (1996). Lay theorizing about 'the body' and implications for health promotion. *Health Education Research*, 11, (2), 161-172.

Wattenberg, E. (1986). In a different light: A feminist perspective on the role of mothers in father-daughter incest. *Child Welfare*, 54, (3), 203-211.

Waxler-Morrison, N. and Hislop, G. (1991). Effects of social relationships on survival for women with breast cancer: A prospective study. *Social Science and Medicine*, 33, (2), 177-183.

Weeks, J. (Ed.) (1991). *Against nature*. London: Rivers Oram Press.

Weil, M. (1988). Creating an alternative work culture in public service setting. *Administration in Social Work*, 12, (2), 69-82.

Weiss, G.L. and Lonnquist, L.E. (1997). *Sociology of health, healing, and illness*. Upper Saddle River: Prentice Hall Inc.

Wendell, S. (1989). Towards a feminist theory of disability. *Hypatia*, 4, (2), 104-124.

Wendell, S. (1993). Feminism, disability and transcendence of the body. *Canadian Women Studies*, 13, (4), 116-122.

Wescott, S. and Seiler, R. (1986). *Women in the accounting profession*. New York: Markus Wiener Publishing.

Westkott, M. (1990). Feminist criticism of the social sciences. In J. Nielsen (Ed.) *Feminist research methods: Exemplary readings in the social sciences* (pp. 58-68). Colorado: Westview Press.

Wharf, B. (1983). Rethinking child welfare. *Rethinking child welfare in Canada* (pp. 290-305). Toronto: McClelland and Stewart.

White, E. (Ed.) (1990). *The black women's health book*. Washington: Seal Press.

Whitaker, J.N. and Mitchell, G.W. (1997). Clinical features of multiple sclerosis. In C.S. Raine, H.F. McFarland, and W.W. Tourtellote (Eds.) *Multiple sclerosis: clinical and pathogenetic basis* (pp. 3-19). London: Chapman and Hall.

Whitmore, E. and Kerans, P. (1988). Participation, empowerment and welfare. *Canadian Review of Social Policy*, 22, 51-60.

Whyte, W. (1991). *Participatory action research*. Newbury Park, CA: Sage.

Wikler, L., Wasow, M., and Hatfield, E. (1981). Chronic sorrow revisited: Parent vs. professional depiction of the adjustment of parents of mentally retarded children. *American Journal of Orthopsychiatry*, 51, (1), 63-70.

Wilkins, K. and Park, E. (1996). Chronic conditions, physical limitations and dependency among seniors living in the community. *Health Reports*, 8, (3), 7-15.

Wilkins, R. (1993). Taking it personally: A note on emotion and autobiography. *Sociology*, 27, (1), 93-100.

Wilkinson, RG. (1996). *Unhealthy societies: The afflictions of inequality*. London: Routledge.

Wilkinson, S. and Kitzinger, C. (1993). Whose breast is it anyway? A feminist consideration of advice and 'treatment' for breast cancer. *Women's Studies International Forum*, 16, (3), 229-238.

Williams, K. and O'Connor, M. (1994). *Theories and methods of participatory research.* McMaster Research Centre for the Promotion of Women's Health. Hamilton, Ontario.

Winnow, J. (1992). Lesbian's evolving health care: Cancer and AIDS." *Feminist Review*, 41, 68-76.

Women and Mental Health Committee. (1987). *Women and mental health in Canada: An agenda for change.* Toronto: Canadian Mental Health Association.

The Women's Health Bureau. (1993). Immigrant, refugee and racial minority women and health care needs. *Report of Community Consultations.* Toronto: Ministry of Health.

Women's Research Centre. (1990). *Strategies for change: From women's experience to a plan for action.* Vancouver.

Women's Research Centre. (1992). *Research for change: Participatory action research for community groups.* Vancouver.

Women's Wellness Project. (1993). Final Report (prepared by Michele Gold). Hamilton: Hamilton-Wentworth District Health Council.

Wong, C.H. and McKilligin, H. (1994) Trends in births to teenagers in Ontario, 1971-1992. *Public Health and Epidemiology Reports of Ontario*, 5, (7),167-169.

Wong, G., Li, V., Burris, M.A., and Xiang, Y. (1995). Seeking women's voices: Setting the context for women's health interventions in two rural counties in Yunnan, China. *Social Science and Medicine*, 41, (8), 1147-1157.

World Health Organization. (1978) *Alma-Ata 1978 primary health care.* Switzerland: World Health Organization.

World Health Organization. (1980). *International classification of impairments, disabilities and handicaps.* Geneva: World Health Organization.

World Health Organization. (1986). *Ottawa charter for health promotion.* Copenhagen: World Health Organization Regional Office for Europe.

World Health Organization. (1988). *Targets for health for all.* Geneva: World Health Organization Regional Office for Europe.

World Health Organization. (1994). *Constitution.* Basic Documents. 40th ed. Geneva.

Wortman, S. (1994). The unhealthy business of making clothes. In E. Dua, M. FitzGerald, L. Gardner, D.Taylor, and L. Wyndels (Eds.) *On women healthsharing* (pp. 77-83). Toronto: Women's Press.

Wuest, J. (1994) Professionalism and the evolution of nursing as a discipline: A feminist perspective. *Journal of Professional Nursing*, 10, (6), 357-367.

Wuest, J. (1996). Institutionalizing women's oppression: The inherent risk in health policy that fosters community participation. *Health Care for Women International*, 14, (5), 407-417.

Yee, M. (1994). Voice in context, writing "for" our lives. In W. Waring (Ed.) *By, for and about, feminist cultural politics* (pp. 241-255). Toronto: Women's Press.

Young, D. and Aries, B. (1993). Women speak: A participatory research project. *Canadian Woman Studies*, 13, (4), 105-108.

Yuval-Davis, N. (1998). Women, ethnicity and empowerment. *Feminism and Psychology, 4,* (1), 179-197.

Zaharna, R. S. (1989). Self-shock: The double binding-challenge of identity. *International Journal of Intercultural Relations, 13,* 501-525.

Zeytinoglu, I.U. (1992). *Technological innovation and the creation of a new type of employment: telework.* McMaster University, MGD School of Business, Innovation Research Working Group, Working Paper, No.14.

Zeytinoglu, I.U. (1994). Part-time and other non-standard forms of employment: Why are they considered appropriate for women? In J. Niland, R.D. Landsbury, and C. Verevis (Eds.) *The future of industrial relations: Global change and challenges* (pp. 435-450). Thousand Oaks, California: Sage.

Zeytinoglu, I.U. (Ed.) (1999). *Changing work relationships in industrialized economies.* Amsterdam, Netherlands: John Benjamins Publishing.

Zeytinoglu, I.U., Denton, M., Hajdukowski-Ahmed, M., and O'Connor, M. (1997). The impact of work on women's health: A review of recent literature and future research directions. *Canadian Journal of Women's Health Care,* 8, (2), 18-27.

Zola, I.K. (1989). Toward the necessary universalizing of disability policy. *The Milbank Quarterly,* 67, (2), 401-429.

INDEX

[introductory note:] The letter *f* denotes a figure, the letter *t* a table.

health promotion, 38; definition of, 221; effecting structural change through, 2, 4, 20; feeling of control over work and, 25; of home-care workers, 59-60; of immigrant women, 7, 123, 130-31, 133-37, 153-54, 163; individual and community, 162-63; of minority women, 153; of people with disabilities, 39, 85, 88, 97, 112; public policy and, 16-17, 220-21; of refugee women, 153; the research process and, 4, 17-18, 20, 31, 36-37, 41, 59, 62, 72, 130, 137, 155, 221, 231; volunteering and, 7; of women in the family law system, 220, 230-32; women's voices and, 31, 33-37, 40-41, 44, 59, 232; of women with multiple sclerosis, 85, 97
endometriosis, 66
Eng, E., 155
Epp, J., 2, 10, 72
Esposito, G., 64
ethnicity, definition of, 140
Evans, R.G., 13-14
exercise, 11-13, 68, 79, 90, 94, 145, 161

falls, 59, 252
families: Canadian, 74; lesbian women and, 192; new models of, 265-66; same-sex, 193; South Asian, 140-41; young mothers and, 169-73, 177. *See also* domestic work and responsibilities
Family Benefits (Ontario), 115, 119
family law system, 7, 218-32
family leave provisions, 82
Farlow, D.M., 230
fathers, 172-73, 177, 218-19, 223-26, 228
fatigue and exhaustion: among chartered accountants, 260; among child-welfare agency workers, 6, 66-67; domestic work and responsibilities as a source of, 26-27, 78-79, 102; among home-care workers, 50-52; among immigrant women, 126, 160; among nursing professionals, 48; among people with multiple sclerosis, 85-87, 89, 95-96, 98; among public sector employees, 6, 78-79; among volunteers, 250; among women in the family law system, 227

Feather, J., 37
Fine, M., 64
Fischer, L., 190, 246
flexitime, 82
flus, 66, 250
fotonovellas, 37-38
"Framework for Research in the Community" (MRCPOWH), 43
Freire, M., 139
From Research to Policy (conference), 40

Gardell, B., 72
General Social Survey (Canada; 1990), 50
gerontology, feminist, 201
Gilligan, C., 34
Globe and Mail, 134n
Goldsmith, P., 219, 227, 230
Graham, H., 192
Greaves, L., 39n
Gupta, T.D., 125
Guterman, N.B., 71

Hajdukowski-Ahmed, M., 33, 128
Hamilton (Ontario), 4, 6-7, 75-76, 127-30, 136, 195, 207, 218-22, 235; description of, 234; immigrants in, 126, 126n; new family law system initiatives in, 231-32
Hamilton Amateur Sports Council, 241
Hamilton Automobile Club, 103
Hamilton Community Foundation, 239
Hamilton Convention Centre, 238, 241
Hamilton Family Law Association, 232
Hamilton, N., 5, 14-15, 139, 151, 194, 255, 265
Hamilton, R., 111
Hamilton Social Planning and Research Council, 240
Hamilton Spectator, The, 232
Hamilton-Wentworth, 75-76, 100, 126, 181, 183, 234-42, 235n
Hamilton-Wentworth Department of Public Health Services, 179, 181
Hamilton-Wentworth Multiple Sclerosis Society, 89n
Hamilton-Wentworth Police Association, 75, 81
Hamilton-Wentworth Regional Police, 235, 235n

environments and, 126; health of, 7, 25, 29, 153-54, 162; "immigrant women" stereotype and, 124n; as visiting homemakers, 49

mobility disabilities, women with, 6, 111-21

Morris, J., 88

mothers, 12, 27, 67n, 71, 88, 94; in the family law system, 218-25; poverty and, 167, 228-29; young, 4-5, 7, 164-77

Mothers' Family Law Advocacy Project, 220-22, 231-32

motor control problems, 96

MRCPOWH. *See* McMaster Research Centre for the Promotion of Women's Health

Mullen, R., 155

multiple sclerosis, 4-6, 10, 18-19, 39, 84-98, 85-89nn, 114-15

musculoskeletal problems; 24, 48, 52, 66, 131, 250. *See also specific musculoskeletal problems*

mutual aid, 16, 18-19, 19f. *See also* self-help groups; social support networks; support groups

National Conference on Multicultural Health (Montreal; 1995), 133

National Health Promotion Research Conference, 3

National Population Health Survey (NPHS) (Canada; 1994), 13, 50-52, 55, 247-48, 250

National Survey of Volunteer Activity (Canada; 1987), 245

nausea, 48

neck problems, 250

Neisser, U., 139

Nettleton, S., 16

Neysmith, S., 245-46

Ng, R., 124-125

Nichols, B., 245-46

North America, 230

NPHS. *See* National Population Health Survey

nursing professionals, 48-49, 52-53, 57

nutrition. *See* diet and nutrition

occupational health and safety, 4, 23-24, 74, 154; child-welfare agency workers and, 62, 65-67, 66n, 71; domestic work and, 27; home-care workers and, 46, 48-50,

52-53, 59; immigrant women and, 6-7, 24, 123, 127-37; public sector employees and, 79; volunteering and, 250-52. *See also* mental health

Occupational Health Clinics for Ontario Workers, 130

occupational therapy, 90

O'Connor, M., 189, 202

office workers, 48

OHIP (Ontario Health Insurance Plan), 116

Oliver, M., 121

Ontario, 140, 165, 177, 228

Ontario Campaign for Equal Families, 193

Ontario Health Insurance Plan (OHIP), 116

Ontario Worker Co-op Federation, 130

Opie, A., 195, 199

osteoporosis, 11, 94

Ottawa Charter for Health Promotion: empowerment and, 2, 10, 16, 38, 163; health promotion strategies of, 2, 5-6, 10, 14, 38, 68, 72-73, 81, 85, 108-09, 194, 202, 244, 251, 255, 266

pain: in data entry work, 24; in food processing work, 24, 131-32; among home-care workers, 52; among office workers, 48; among people with disabilities, 88, 97; among volunteers, 250; among women with multiple sclerosis, 89, 92, 95-98

Palmer, S., 65n

panic attacks, 227

Papua New Guinea, 38

PAR. *See* participatory action research

parental access to children, 7, 218-20, 225, 227-28, 231-32

participatory action research (PAR), 1, 3-6, 8, 31, 46, 59-60, 62-63, 62n, 69, 71-72, 89, 100, 102, 109, 130, 135, 137-38, 141-42, 151, 155, 166, 176, 179, 182, 195, 218, 220-22, 231, 244, 258; empowerment and, 4, 17-18, 20, 31, 36-37, 59, 62, 130, 137, 155, 221, 231; feminism and, 16-20, 19f, 36, 43, 62; principles of, 3-4, 166, 258; voices in, 36-38, 43, 46, 59, 151, 258

pasantias, 37-38

Path Employment Services, 103